Dada, Surrealism, and Their Heritage

Dada, Surrealism, and Their Heritage

by William S. Rubin

The Museum of Modern Art, New York

Distributed by New York Graphic Society Ltd, Greenwich, Connecticut

Schedule of the exhibition

The Museum of Modern Art, New York March 27–June 9, 1968

Los Angeles County Museum of Art July 16–September 8, 1968

The Art Institute of Chicago October 19–December 8, 1968

Published by The Museum of Modern Art
11 West 53rd Street, New York, N.Y. 10019
All rights reserved
Library of Congress Catalog Card No.: 68–17466
Designed by Hiram Ash, Inc.
Jacket and cover design by Joseph B. Del Valle
Printed in West Germany by Brüder Hartmann, Berlin (Schöneberg)

Acknowledgments

In the preparation of this exhibition and book I have been fortunate to have received the generous help of many people who were directly or indirectly part of the Dada and Surrealist movements. Foremost among those to whom I owe a debt of gratitude are two men intimately connected with The Museum of Modern Art, who were among the first to bring the Dada and Surrealist artists to the attention of the American public. Alfred H. Barr, Jr., who in 1936 organized the Museum's exhibition *Fantastic Art, Dada, Surrealism,* has provided encouragement and valuable advice. His generosity has been matched by that of James Thrall Soby, whose many monographs on Surrealist artists form the backbone of the literature in this field.

Marcel Jean, Surrealist poet and artist, and himself the author of a major text on Surrealist painting, has been unstinting in his assistance. Mrs. Kate Steinitz, who was a close friend of Kurt Schwitters, has made available to me texts and photographs bearing on the *Merzbau* and other phases of Schwitters' work, which would have been otherwise unavailable. Moreover, her unfailing good humor has been a great boost at just those moments when the work attendant on this kind of exhibition and book begins to seem overwhelming. William N. Copley, Richard Hamilton, Julien Levy, Pierre Matisse, Arturo Schwarz, and Patrick Waldberg have also done me many special favors.

Among the Dada and Surrealist artists who have been especially liberal in providing material and memories are the late Jean Arp, his widow Marguerite Arp-Hagenbach,

and his brother François Arp, Mr. and Mrs. Marcel Duchamp, Hannah Höch, Richard Huelsenbeck (Dr. Charles R. Hulbeck), Marcel Janco, Man Ray, and Hans Richter; also Joseph Cornell, André Masson, Joan Miró, Gordon Onslow-Ford, Sir Roland Penrose, and Mrs. Frederick Kiesler, the widow of the architect and sculptor.

William Camfield and Mlle Rosie Vronski have helped in elucidating some historical questions. Dr. Haide Russell, Cultural Affairs Consul of the Consulate General of the Federal Republic of Germany, John de Menil, and Bernard Reis have gone out of their way to assist in solving various problems.

On behalf of the Trustees of The Museum of Modern Art, Los Angeles County Museum of Art, and The Art Institute of Chicago, I wish to express thanks to all the lenders whose names are listed at the head of the exhibition catalogue. Collectors have lent works of art to the exhibition knowing that they would thus be deprived of them for many months. Edwin Bergman and Joseph Shapiro have been particularly generous in their loans.

Many museums have made special concessions so that certain pictures could be in this exhibition. K. G. Pontus Hultén of the Moderna Museet, Stockholm, has been outstanding in his generosity. Gordon Smith has struggled with programming dates to enable us to have certain pictures from the Albright-Knox Art Gallery, Buffalo. The Art Institute of Chicago has especially relined its Picabia in order to make it available for this exhibition.

Among the art dealers who have gone to much trouble tracing specific works and making photographs and information available are Leo Castelli, New York; Richard Feigen, New York, and his Chicago associate, Miss Lotte Drew-Bear; Xavier Fourcade of M. Knoedler & Co., Inc., New York; Sidney Janis, New York; Pierre Matisse, New York; also Max Clarac of Galerie du Dragon, Paris; Jacques Dupin of Galerie Maeght, Paris; Mme Jean Krebs, Brussels; Mme Louise Leiris and her associate Maurice Jardot, Paris; and Arturo Schwarz, Milan.

The publishing firm Harry N. Abrams, Inc., has generously allowed me to cite some paragraphs and sentences virtually verbatim from my more extensive text, *Dada and Surrealist Art*, written before the formulation of this exhibition and book, and now in process of publication.

Harry N. Abrams, Barbara Adler, Annette Allwardt, and Milton Fox have shown constant patience and good will.

An exhibition and book of this order can be achieved only with the co-operation of an expert staff. Many members of the Museum's various departments working over a long period of time have participated. I should like to express my thanks first to the Director, René d'Harnoncourt, for many kindnesses and especially for consenting to install the sculpture and objects. Dorothy H. Dudley, Registrar, and Therese Varveris, Senior Cataloguer of Loan Exhibitions, have overcome the many difficulties involved in assembling some 300 works of art. Bernard Karpel and the staff of the Library continued to help and somehow maintain their good humor even during the period of their move to new quarters.

The debt owed to the Department of Painting and Sculpture is immeasurable, especially to Alicia Legg, Associate Curator, Sarah Weiner, Curatorial Assistant, and Cintra Lofting, my secretary, who have worked relentlessly. They have been helped frequently by Jennifer Licht, Assistant Curator, and Christie Kaiser, Jane Necol, Susan Pierce, and Jean-Edith Weiffenbach.

Irene Gordon, though nominally editor of this book, can hardly be contained within such a category. She has been of crucial assistance in problems involving scholarship as well as in preparing the publication. No one has worked harder than she to see this project through.

New York, November 1967 W. S. R.

Contents

An asterisk at the end of a caption indicates that the work illustrated is not included in the exhibition.

Dada, Surrealism, and Their Heritage

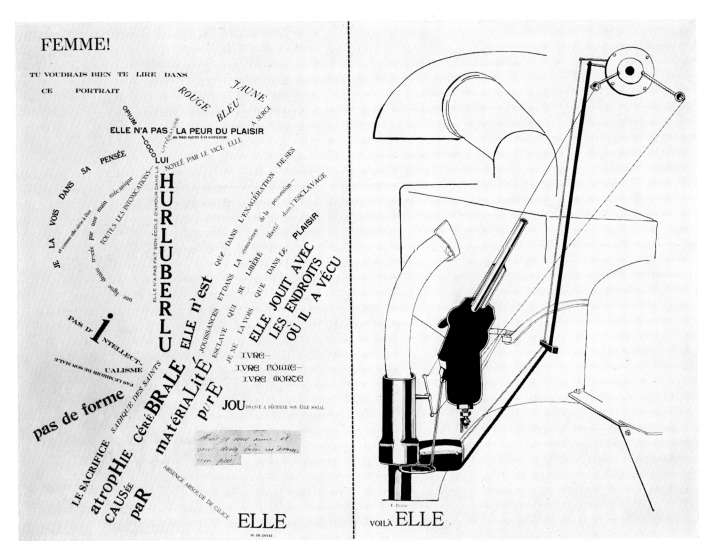

1 left-hand portion MARIUS DE ZAYAS. *Elle*; right-hand portion FRANCIS PICABIA. *Voilà Elle.* (1915). Whereabouts unknown, reproduced from *291* (New York), November 1915

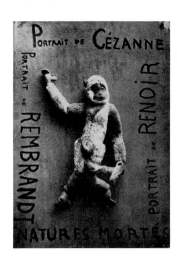

Dada

The plastic arts played only an ancillary role in Dada and Surrealism; they were held useful as means of communicating ideas, but not worthy of delectation in themselves.[1] The more pressing concern of these movements with philosophy, psychology, poetry, and politics stamped the art they encouraged with a character much in contrast to that of prevailing avant-garde ideals. At a time when modernist abstraction seemed to be claiming autonomy for painting, the Dadaist reaction was to "humiliate" art, as Tristan Tzara advocated, by assigning it "a subordinate place in the supreme movement measured only in terms of life."[2] Later, the founder of Surrealism, André Breton, would call painting "a lamentable expedient"[3] in a world whose "more and more necessary transformation" was "other than that which can be achieved on canvas."[4]

Dada and Surrealism proposed life attitudes that, particularly in the case of the latter, coalesced into comprehensible philosophies. But they fostered activities in the plastic arts so variegated as almost to preclude the use of the terms as definitions of style. "Impressionism" and "Cubism" designated particular painting styles that already existed; the terms "Dada" and "Surrealism" pre-existed the art to which they were applied. Obviously, a definition of style that, for Dada, must comprehend the work of Duchamp and Arp and, for Surrealism, that of Miró and Dali, will be problematic. Yet the alternative is not simply to accept confusion. We can distinguish in Dada and Surrealist art some common properties of style and many

2 FRANCIS PICABIA. *Portrait of Cézanne.* (1920). No longer extant, reproduced from *Cannibale* (Paris), April 25, 1920

common denominators of character, iconography, and intent.

Dada was baptized in Zurich in 1916, but the instantaneous success of its name reflected the fact that the attitudes and activities it identified had been in the air for some years, in fact since 1912. It arose in a number of cities in Europe, and in New York, in part spontaneously and in part through the interchange of ideas. The *détente* following the end of World War I created a less fertile environment for Dada and by the early twenties the movement had dissolved. By 1924 much of what remained viable in it had been assimilated into the more programmatic Surrealist movement, whose formal beginnings were marked by the publication of its manifesto in Paris that year. Surrealism survived a number of crises in the interwar period as well as exile in America during World War II, but it lost its leadership of the avant-garde in the wake of that holocaust and for all intents and purposes ceased to exist.

The spread of Dada—the nonsense vocable perfectly connoted its attitudes—was inseparable from the first World War, which seemed to confirm the bankruptcy of nineteenth-century bourgeois rationalism. That logic could be used to justify the killing and mutilation of millions revolted some men of sensibility. "The beginnings of Dada," Tzara recalled, "were not the beginnings of art, but of disgust."[5] Bourgeois society might, of course, simply destroy itself in carnage, but its end could be hastened, the Dadaists felt, by subverting what remained of its premises. However they may have differed in their visions of the future, all agreed that it would have to be built around a life that better comprehended and accommodated the irrational in human behavior. "Dada," wrote Jean Arp, "wished to destroy the hoaxes of reason and to discover an unreasoned order" (*ordre déraisonnable*).[6]

At the heart of Dada lay the "gratuitous act,"[7] the paradoxical, spontaneous gesture aimed at revealing the inconsistency and inanity of conventional beliefs. When Breton described "the most simple Surrealist act" as "going down into the street . . . and shooting at random into the crowd,"[8] he was recalling the scandalous *gestes* of two Dada heroes, Arthur Cravan, who punctuated a lecture at the Salle des Sociétés Savantes with random pistol

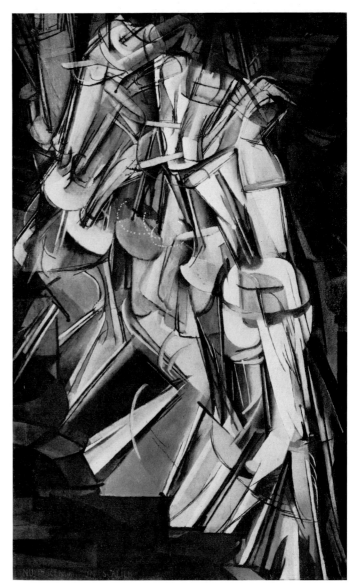

3 MARCEL DUCHAMP. *Nude Descending a Staircase, No. 2.* 1912. Oil on canvas, 58 × 35 inches. Philadelphia Museum of Art, the Louise and Walter Arensberg Collection*

opposite
4 MARCEL DUCHAMP. *The Passage from Virgin to Bride.* 1912. Oil on canvas, 23³/₈ × 21¹/₄ inches. The Museum of Modern Art, New York

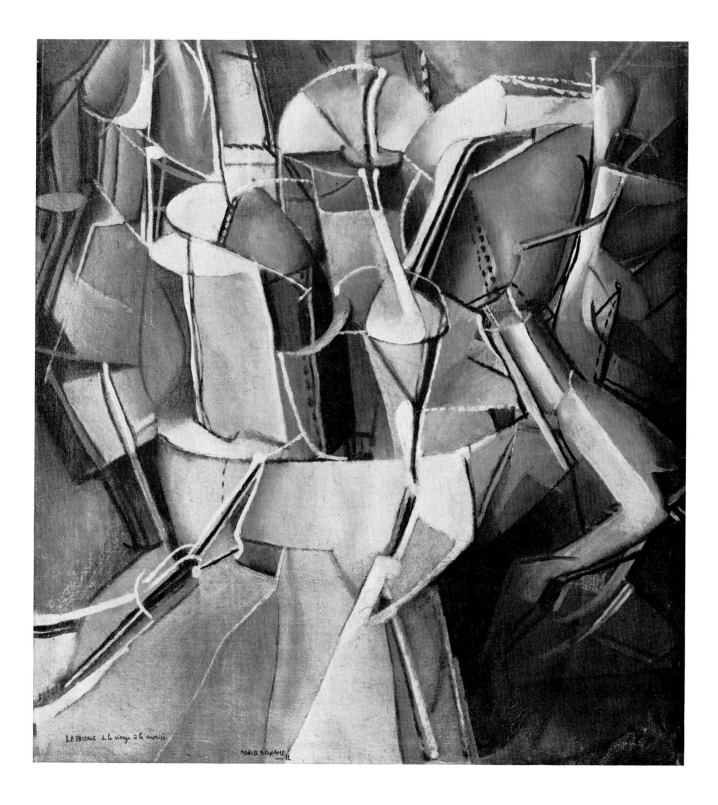

LE PASSAGE de la vierge à la mariée MARCEL DUCHAMP 12

opposite

7 MARCEL DUCHAMP. *Bicycle Wheel*. (Original 1913, lost; replica 1951). Bicycle wheel on wooden stool, 50¹/₂ inches high × 25¹/₂ inches wide × 16⁵/₈ inches deep. The Museum of Modern Art, New York, the Sidney and Harriet Janis Collection

5 MARCEL DUCHAMP. *The Bride*. 1912. Oil on canvas, 35¹/₈ × 21³/₄ inches. Philadelphia Museum of Art, the Louise and Walter Arensberg Collection

6 MARCEL DUCHAMP. *Chocolate Grinder, No. 1*. 1913. Oil on canvas, 24³/₄ × 25⁵/₈ inches. Philadelphia Museum of Art, the Louise and Walter Arensberg Collection

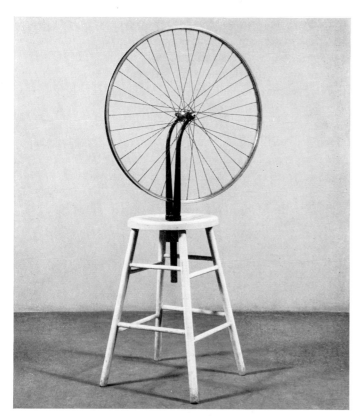

hence the logic of the manifestation in which Picabia made drawings that Breton erased as Picabia went along.

Dada's positive contribution varied from center to center; its nihilism was held in common. All Dadaists called for a *tabula rasa* and concentrated on subverting middle-class culture. The Surrealists accepted the end of the bourgeois world as given, and were more concerned with what would come afterward. They would replace anarchic Dada *gestes* by constructive, collective action. With the aid of Freudian theory, they would systematize Dada's concern with the irrational. Through alliances in the milieu of radical politics, a new and better world was to be implemented. The Surrealist goal of self-knowledge was to be achieved through a variety of methods—automatism and dream interpretation foremost among them—and art would be of interest insofar as it provided revelations by such means.

But art cannot be made from life alone, even less from particular psychological methodologies; more than anything else it is made from art. No matter what the radicality of an artist's *démarche*, or his commitment to extrapictorial concerns, he sets out from some definition of art. Hence, despite the postures assumed by some of the Dada and Surrealist artists, they were all in an enforced dialogue with the art that preceded them. The "anti-art" created by Dada pioneers such as Marcel Duchamp and Francis Picabia seemed to reject out of hand the premises of modern painting as they stood on the eve of World War I. But "anti-art" depended from the first on the very presence of the "pure painting" against which it reacted, and it incorporated more of that "art-art" than its authors knew.[10]

The pure painting that the Dadaists opposed seemed to them incapable of acting—or even commenting—upon a world sorely in need of change. It struck them as escapist, hermetically isolated in its aestheticism. "The Dadaist," wrote Richard Huelsenbeck, "considers it necessary to come out against art, because he has seen through its fraud as a moral safety valve."[11] Anti-art implied primarily anti-Cubism, the rejection of a tradition that derived from Cézanne, whose "portrait" by Picabia was a collage-relief of a stuffed monkey (fig. 2). Yet despite the infinite disparagement of art in their manifestoes, it was not so much art itself that the Dadaists opposed as "the idea that had been made of it,"[12] that is, the autonomy of pure painting.

shots, and Jacques Vaché, who attended the première of Apollinaire's *Mamelles de Tirésias* dressed as an English officer and disrupted the intermission by threatening to "shoot up" the audience. Vaché's was a Dadaist provocation par excellence, as it implicitly criticized the central adventure in which the world was then engaged: if it was realism to shoot a human being because he wore a German uniform, it would be superrealism to apply the principle more broadly.

Not all Dadaist acts were so radical, though each constituted, Tzara proclaimed, "a cerebral revolver shot."[9] Many touched in one way or another on the various arts, and if improvisation was always central, there was nevertheless a good deal of "programming" as well. Dada *soirées* or "manifestations," made up of seemingly inane skits, pranks, and performances, were the ancestors of post-World War II "Happenings." The value of art was located more in the act of making it than in the work produced,

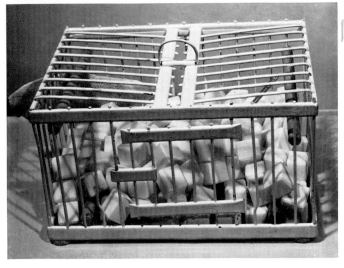

8 above MARCEL DUCHAMP. *Bottlerack*. (Original 1914, lost). Man Ray photograph included in Duchamp's *Valise* (1943), a leather case containing reproductions of works by Duchamp. The Museum of Modern Art, New York, James Thrall Soby Fund

9 below MARCEL DUCHAMP. *Why Not Sneeze?* (Original 1921; replica 1964). Painted metal cage, marble cubes, thermometer, and cuttlebone, $4^{7}/_{8}$ inches high × $8^{3}/_{4}$ inches wide × $6^{3}/_{8}$ inches deep. The Museum of Modern Art, New York, Gift of Galleria Schwarz

Marcel Duchamp was the principal pioneer of Dada. In a period when painting had assumed deep conviction as a way of life, Duchamp gave it up in the midst of success as "not a goal to fill an entire lifetime."[13] Emerging from the Cubist context of Parisian painting in 1912, he shortly sacrificed paints, brushes, and canvas almost entirely to create an anti-art of "Readymade" objects and images on glass. By 1920 he had become an "engineer" and, after "incompleting" the *Large Glass* three years later, he retired to a life of chess, punctuated occasionally by the creation of ironic machines, environmental installations for Surrealist exhibitions, and a variety of *gestes*.

In 1912, Analytic Cubism was poised on the verge of total abstraction. But Duchamp's paintings of that year, though still retaining the fragmentary planes and monochromatic palette of that style, were clearly moving toward a more descriptive illusionism. "I was interested in ideas—not merely in visual products," he recalled.

> I wanted to put painting once again at the service of the mind. And my painting was, of course, at once regarded as "intellectual" "literary" painting. It was true I was endeavoring to establish myself as far as possible from "pleasing" and "attractive" physical paintings. . . . The more sensual appeal a painting provided—the more animal it became—the more highly it was regarded.[14]

Duchamp's most famous painting, the *Nude Descending a Staircase, No. 2* (fig. 3), was neither so original nor Dadaistic in character as his work would shortly become. This "static representation of movement,"[15] as he called it, retained a largely Analytic Cubist vocabulary used cinematically, as in Italian Futurism; it involved a narrative not a plastic invention. The schematism of the *Nude* already pointed, however, to the principle that would inform Duchamp's next paintings, that of *reduction,* as opposed to *abstraction,* with which reduction is often confused. "Reduce, reduce, reduce was my thought," Duchamp recounts. "But at the same time *my aim was turning inward* . . . I came to feel that an artist might use anything—a dot, a line, the most conventional or unconventional symbol—to say what he wanted to say . . . for all this reduction I would never call it an 'abstract' painting."[16]

Duchamp's problem now became one of using his new

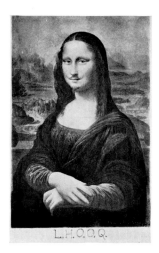

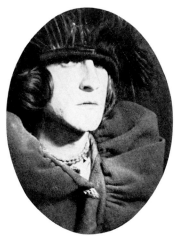

10 above MARCEL DUCHAMP. *L.H.O.O.Q.* 1919. Color reproduction of the *Mona Lisa* altered with pencil, 7³/₄ × 4⁷/₈ inches. Collection Mrs. Mary Sisler, New York*

11 below MAN RAY. Photograph of Marcel Duchamp Dressed as Rrose Sélavy. (c. 1920–1921)

symbolic language to "illustrate" the invisible dramas of experience; *The Passage from Virgin to Bride* (fig. 4) was one of his first pictures to propose the plastic realization of an internal event. Here the morphology of Analytic Cubism has been altered in the direction of both the organic and mechanical, and its austere coloring has been tinted with appropriate pink fleshy tones. The deflowering of the virgin is expressed through a psycho-biological mechanism —a subjective counterpart to the objective transcription of motion in the *Nude*. The word "passage" in the title is also a pun on that which separates a "bride" from a "virgin."

The internalized human-cum-machine images in *The Passage from Virgin to Bride* and the contemporaneous *Bride* (fig. 5) were still fanciful. But in the spring of 1913 Duchamp became obsessed with a real machine, which engendered a decisive break in his style. "One day, in a shop window," he recalls, "I saw a real chocolate grinder in action and this spectacle so fascinated me that I took this machine as a point of departure."[17]

Duchamp's *Chocolate Grinder* (fig. 6) was executed in oil on canvas, but it differed from his earlier, more imaginative pictures in being simply a dry perspective study of a real object. And though Dali would later show that tightly painted academic illusionism could constitute a kind of anti-art, Duchamp was dissatisfied with his image of the chocolate grinder for it was still too freighted with the baggage of aesthetic convention that inevitably informs any three-dimensional illusion on a flat, regular field. There seemed to be no escape from aesthetics within the minimal conditions, or definition, of the art of painting. The solution lay in taking the logical step from the *trompe-l'œil* replica of an object to the object itself. Hence the origin by fiat of the Readymades: man-designed, commercially produced utilitarian objects endowed with the status of anti-art by Duchamp's selection and titling of them. In 1913 he placed a bicycle wheel upside down on a stool (fig. 7); singled out for contemplation in isolation from its normal context and purpose, it seemed strangely enigmatic, especially when the wheel turned pointlessly.

As intended epiphanies of irrational and even extra-sensory experience the Readymades presuppose the existence of a "meta-world," which Duchamp has described as "fourth-dimensional." He explains that if a shadow is

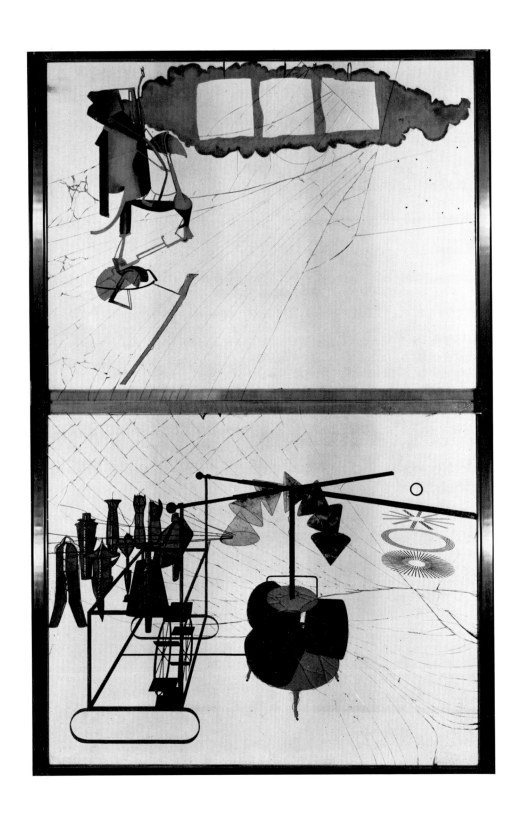

a two-dimensional projection of a three-dimensional form, then a three-dimensional object must be the projection of a four-dimensional form. Thus the simplest object holds the possibility of a revelation.

The process of *dissociation* or *displacement* entailed in the nomination of a Readymade was comparable to that which the Symbolist poets had used in their attempts to liberate the hidden meanings of words. The poet Isidore Ducasse, the "comte de Lautréamont," who was claimed as a precursor by the Surrealists, had provided the classic example in writing of "the chance encounter of a sewing machine and an umbrella on a dissection table." In this image he not only employed commercial objects that adumbrated the Readymades, but dissociated them from their familiar contexts and unlocked new expressive possibilities by unexpected juxtaposition. Lautréamont thus provided a verbal model for what Dada and Surrealist artists would make of the Cubist technique of collage. Duchamp later applied this principle to the creation of hybrid, or "assisted," Readymades. *Why Not Sneeze?* (fig. 9) is a bird cage filled with sugar lumps into which a thermometer and cuttlebone have been thrust. Lifting the cage the spectator discovers by its weight that the "sugar cubes" are really cut white marble and that Duchamp has thus gone illusionistic art one better in creating illusionistic anti-art: the *trompe-l'œil* object.

The relation of the Readymades to their titles varied. *Bottlerack* was a simple description of the object in question. *In Advance of a Broken Arm* gave a dimension of black humor to a common snow shovel. Sometimes, however, as in *Why Not Sneeze?*, the dissociation of object and title rendered the latter enigmatic. *L.H.O.O.Q.*, the title of Duchamp's famous bearded and mustached reproduction of the *Mona Lisa* (fig. 10), is a puzzle whose scurrilous solution[18] is perhaps meant to explain the mysterious smile of the lady. In adding the beard and mustache Duchamp was engaging in more than just a Dada attack on high art, or indulging in the popular type of defilement

to which public images are subjected. He was drawing attention to a sexual ambiguity in Leonardo's life and work, noteworthy in relation to the quite different dualism reflected in his own creation of a female alter ego, Rrose Sélavy. This incarnation—consecrated by Man Ray's photographs of Duchamp dressed in women's clothes (fig. 11)—was consistent with the Dadaist tendency to "fabricate" personalities, which represented a realization on the plane of action of Rimbaud's "*I* is another."

Readymades were intended by Duchamp to be devoid of aesthetic interest. Their selection, he has said, took place in a moment of total visual anesthesia.[19] But though Robert Motherwell exaggerates when he says that the *Bottlerack* of 1914 (fig. 8) appears in retrospect to have a more beautiful form than almost any deliberate sculpture made that year,[20] there is no question that after years of the assimilation of real objects into sculptures of all sorts, many of the Readymades have taken on an inescapably "arty" look.[21] The fact is that sculpture does not separate itself as clearly as does painting from the world of objects. Almost any three-dimensional form can be *seen as sculpture*, if not necessarily as good sculpture. The determination is largely based on the observer's expectations or mental set. The answer as to whether the Readymades were art or not lay in the eye of the beholder. This equivocal hovering was part of their enigma. But if they had—and still have—the value of throwing received definitions of art into doubt, they also failed to satisfy Duchamp in his search for an expressive activity wholly beyond aesthetics, which may be why he ceased making Readymades.

The ineluctable solution to the aestheticism that pursued anti-art was to cease being an artist. But before taking this radical decision Duchamp executed a variety of works of which *The Bride Stripped Bare by Her Bachelors, Even* (the *Large Glass*) begun in 1915 is the summa (fig. 12).† On two panes of glass joined together to form a freestanding transparent field about nine feet high and six feet wide,

† In this exhibition the *Large Glass* is represented by a replica executed by the English artist Richard Hamilton with Duchamp's co-operation. The materials used are the same, and the intended effect is that of the original before its color changed and its glass was accidentally broken.

Duchamp applied, in wire and paint, a variety of images that had developed in his iconography of the previous years. The Chocolate Grinder, Water Mill, "Malic" Molds (fig. 13), and a host of other elements, though non sequiturs in any rational sense, are connected mechanically to form two fantastic "machines," the Bride on the upper panel, the Bachelor on the lower.

The iconography of older art was largely drawn from a store of familiar symbols—religious, mythological, historical—that were ready at hand for the artists. Even a cursory glance at the art of the last century reveals that these symbols have no longer seemed viable; while the modern artist has moved toward abstraction he has largely eschewed iconographic schemes and narrative situations. The Dadaist and Surrealist attempts to reinvest painting with these symbols and stories led paradoxically not to greater illumination but greater mystification. Seen apart from Duchamp's explanatory notes in the *Green Box*, the *Large Glass* is surely one of the most obscure and hermetic works ever produced. This, despite the fact that its subject matter—"a mechanistic and cynical interpretation of the phenomenon of love"[22]—would seem to be a most universal one, especially in an age when the myths that informed the art of the past are no longer tenable. Indeed, the myth of sexuality would become the only iconographic common denominator in all Dada and Surrealist art and literature.

The intricate amatory iconography of the *Large Glass* has been explicated many times.[23] Suffice it to say here that if the *Glass*, and hence the "love operation"[24] of the two machines, had been completed—the "ideal fourth-dimensional situation"—the Bachelor Machine, "all grease and lubricity," would have received "love gasoline" secreted by

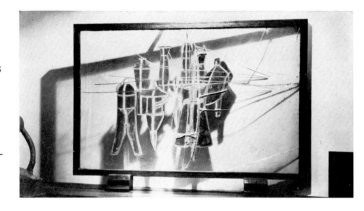

13 MARCEL DUCHAMP. *Nine Malic Molds*. (1914–1915). Oil, lead wire, and foil on glass, 26 × 41 inches. Collection Mrs. Marcel Duchamp, New York

opposite

15 top left MARCEL DUCHAMP. *Rotary Glass Plate (Precision Optics)*. (1920). Motorized construction; painted glass and metal, 73 inches high × 48 inches wide × 40 inches deep. Yale University Art Gallery, New Haven, Collection Société Anonyme

16 top right MARCEL DUCHAMP. *Rotorelief (Optical Disk)*. (1935). One of six cardboard disks printed on both sides, 7⅞ inches diameter. The Museum of Modern Art, New York, Gift of Rose Fried

17 center ROBERT RAUSCHENBERG. *Revolvers*. (1967). Motorized construction; silk-screened plexiglass and metal, 78 inches high × 77 inches wide × 24½ inches deep. Leo Castelli Gallery, New York*

18 bottom JASPER JOHNS. *Light Bulb*. (1960). Bronze, 4¼ inches high × 6 inches wide × 4 inches deep. Collection Mr. and Mrs. Leo Castelli, New York

14 MARCEL DUCHAMP. *Tu m'*. 1918. Oil and graphite on canvas, with bottle-washing brush, safety pins, nut and bolt, 27½ inches × 10 feet 2¾ inches. Yale University Art Gallery, New Haven, Bequest of Katherine S. Dreier

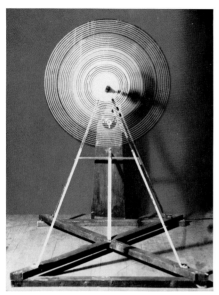

the Bride's "sexual glands" in its "malic" cylinders for ignition by the "electric sparks of the undressing," and, mixing with the secretions of the Grinder—"the Bachelor grinds his own chocolate"—would have produced union. As "incompleted" in 1923, the *Large Glass* constituted, rather, an assertion of the impossibility of union, hence, of sexual futility and alienation.

Though knowledge of the iconographic program adds a dimension—and for Duchamp, the crucial one—to our experience of the *Large Glass*, the work makes a remarkable impression on purely visual grounds. The transparent glass field literally became the "window" that the picture-plane of illusionistic painting had been posited to be.[25] As set up in Katherine Dreier's library one saw people, books, and furniture through it. This "Readymade continually in motion"[26] could sustain a potentially infinite series of effects, against which the images *on* the *Glass,* thrust by perspective drawing *into* the illusion of the space of the room, materialized as if some giant X-ray plate had suddenly revealed the extraretinal aspects of reality.

In 1918, five years after his last oil on canvas, Duchamp returned to painting for a definitive farewell to that art. It took the form of a long frieze-shaped picture entitled *Tu m'* (fig. 14), suggesting "tu m'emmerdes," which summarized the artist's attitude toward painting at the moment he left that art behind. The elements of *Tu m',* which Duchamp has called a dictionary of his main ideas prior to 1918,[27] splay out over the surface like a mobile. Drawn on its surface are shadows traced from projections of Readymades: the *Bicycle Wheel,* and the *Corkscrew* and *Hatrack* that actually hung from the ceiling of his studio. Below the largest of a series of superimposed color samples dominating the upper left, and emerging from the shadow of the *Corkscrew,* is a realistically painted hand, its index finger pointing in the manner of the old-fashioned directional signs. It was, in fact, executed by a signpainter, one A. Klang, whose minuscule signature is visible alongside it. Above and to the right of the hand, the canvas appears torn, but we soon discover that this is a *trompe-l'œil* illusion; however, the false tear is held together by real safety pins and has a real bottle brush inserted in it. The picture thus recapitulates the span from the shadow of an object to the illusion of an object to the object itself.

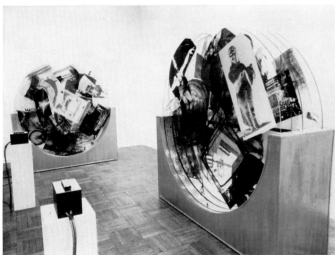

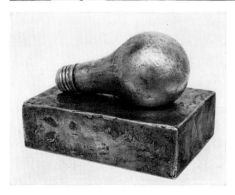

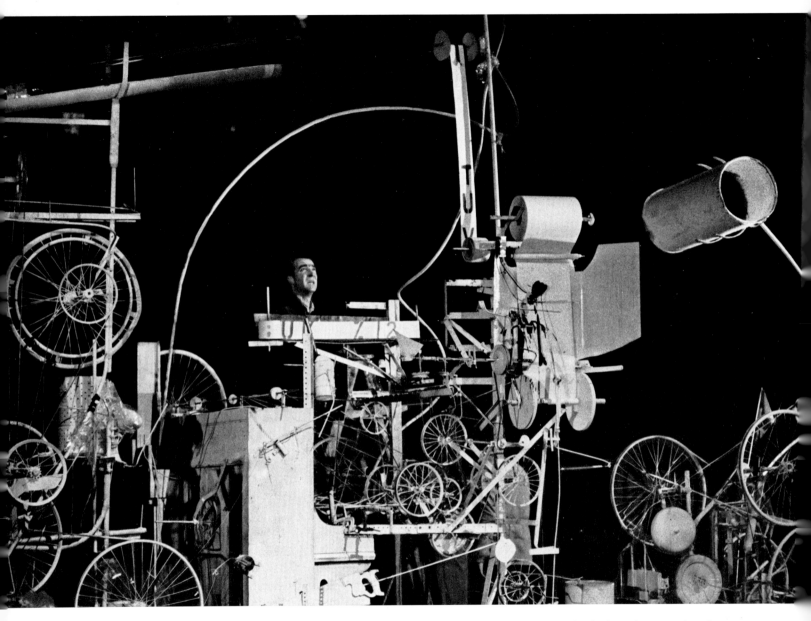

19 JEAN TINGUELY. *Homage to New York*. A self-constructing and self-destroying work of art. Demonstration in the sculpture garden of The Museum of Modern Art, New York, March 17, 1960

opposite
20 JEAN TINGUELY. *Méta-Matic No. 8, "Méta-Mauritz."* 1959.
Motorized construction; iron and steel, 12 × 25 inches. Moderna Museet, Stockholm*

Duchamp's progression from "anti-artist" to "engineer" was confirmed in 1920 when he ceased making images of machines and started to make actual ones. These, however, remained true to his ironic, Dadaistic view of experience in their absolute uselessness. Duchamp had always been fascinated by movement; the *Nude Descending a Staircase* was an attempt to introduce it by cinematic implication into an art that resisted it.[28] The anti-art *Bicycle Wheel* had somewhat accommodated it. Now, as an "engineer," Duchamp could explore movement as an end in itself.

Duchamp's machines were involved with optical as well as mechanical questions, but optical questions outside the framework of the plastic arts. The *Rotary Glass Plate (Precision Optics)*, constructed in 1920 in collaboration with Man Ray (fig. 15), consisted of painted sections of glass that created the illusion of a full circle when whirled on a metal axis by an electric motor. The Rotoreliefs of 1935 (fig. 16) were disks patterned with colored lines that created three-dimensional illusions when spun at the rate of thirty-three revolutions per minute (a kind of visual phonograph record).

In all this Duchamp emerges as a prophet of the concerns of recent artists; but their aim has been to reintegrate the kinetic and optical effects—and even those of accident— *into an experience of art.* Thus, Rauschenberg's *Revolvers* (fig. 17) differs from the *Rotary Glass Plate* by virtue of

the same aestheticism that separates Jasper Johns's *Light Bulb* (fig. 18), with its sensitive sculptural surface, from a Readymade. Jean Tinguely's machines have realized other implications of Duchamp's posture. In destroying itself, his *Homage to New York* (fig. 19) fused the machine concept and the idea of Dada action in a single nihilistic event, or would have, had the mechanism not broken down short of its goal. Tinguely's machines for making pictures (fig. 20) appeared to bring the wheel of Duchamp's logic full circle. But these "méta-matics" did not really make art; they only provided a kinetic instrumentality. The extent to which the images they produced were art depended upon the choices—settings controlling distance, color, contour, etc.—made in the construction and operation of the machines. Their perhaps unintentional revelation—one buried somewhere in the implications of Duchamp's reduction of "creation" to a matter of selection—was to confirm that painting is almost entirely a matter of decisions following from conception, as distinct from facility in the techniques of execution.[29]

Duchamp's friend Francis Picabia brought a new inflection to the "machinist style" and a dandyish flair to the Dada life style—"all my life I've smoked painting." Until his voyage to New York to visit the Armory Show of February 1913 there was nothing in his art to suggest a future fantasist. Like Duchamp, he was working out of the context of Cubism, but in a less sophisticated manner.

Some dissatisfaction with Cubism's "objective" confrontation of motifs was evident in a statement Picabia made on the eve of his American voyage when, echoing Mallarmé, he insisted that painters must set down on canvas, "not things, but emotions produced in our minds by things."[30] But by March he was writing that properties of things could "no longer be expressed in a purely visual or optical manner," and that a language had to be forged to express "the objectivity of a subjectivity."[31] Cubism was, after all, an extension of the Post-Impressionist styles, which still accepted nature as a starting point. The stuffed monkey in Picabia's *Portrait of Cézanne* (fig. 2) was not merely an insult; it was an allusion to the fact that Cézanne's painting from a model made him a descendant of those naturalistic old-master painters who had been satirized as *simiae na-*

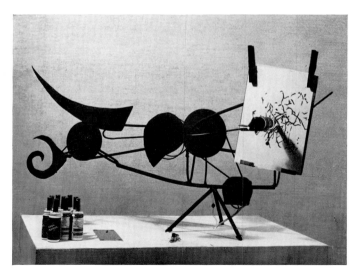

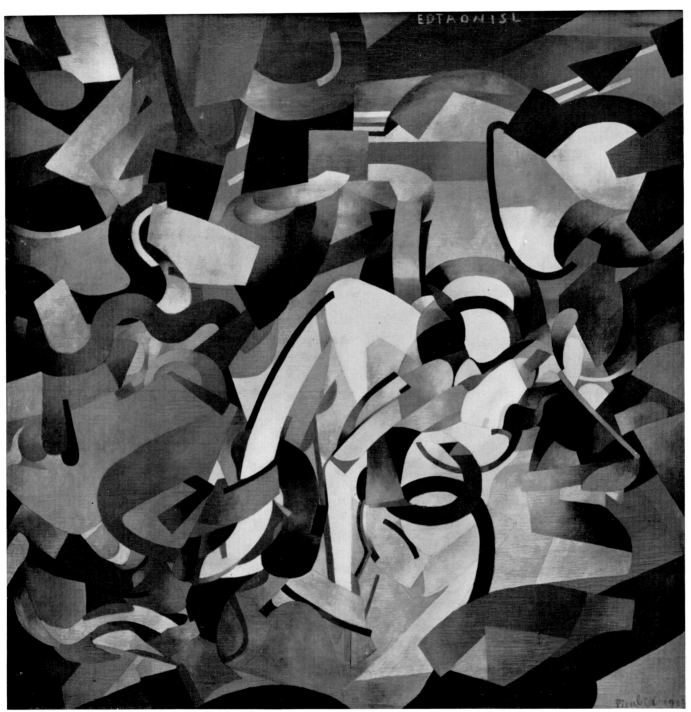

21 FRANCIS PICABIA. *Edtaonisl*. 1913. Oil on canvas, 9 feet 10³/₄ inches × 9 feet 10³/₈ inches. The Art Institute of Chicago, Gift of Mr. and Mrs. Armand Phillip Bartos

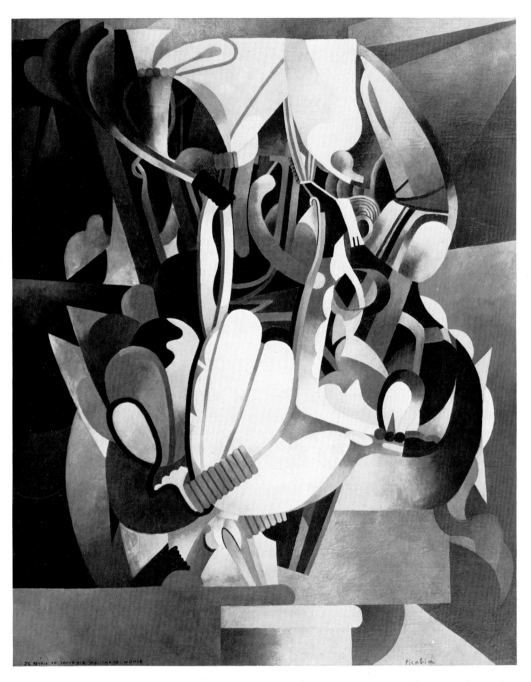

22 FRANCIS PICABIA. *I See Again in Memory My Dear Udnie.* (1914). Oil on canvas, 8 feet 2¹/₂ inches × 6 feet 6¹/₄ inches. The Museum of Modern Art, New York, Hillman Periodicals Fund

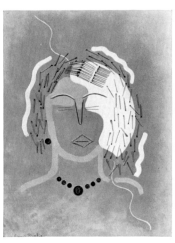

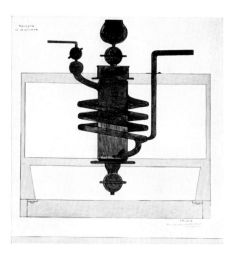

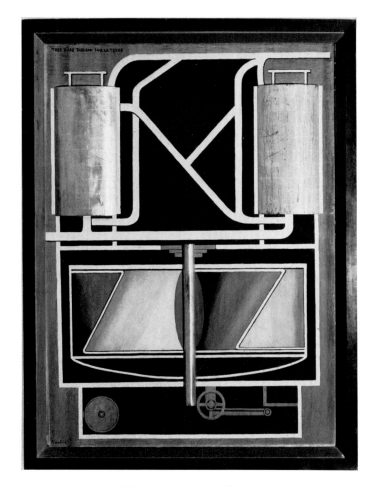

26 FRANCIS PICABIA. *Very Rare Picture on the Earth.* (1915). Gilt and silver paint with collage of raised wood and cardboard forms, 45¹/₂ × 34 inches. Collection Miss Peggy Guggenheim, Venice*

left

23 top FRANCIS PICABIA. *Ici, C'est Ici Stieglitz.* 1915. Pen and red and black inks, 29⁷/₈ × 20 inches. The Metropolitan Museum of Art, New York, the Alfred Stieglitz Collection, 1949*

24 center FRANCIS PICABIA. *The Match Woman II.* 1920. Oil on canvas, with pasted matchsticks, hairpins, zippers, and coins, 35¹/₂ × 28³/₈ inches. Collection Mme Simone Collinet, Paris

25 bottom FRANCIS PICABIA. *Paroxyme de la Douleur.* 1915. Oil on cardboard, 31¹/₂ × 31¹/₂ inches. Collection Mme Simone Collinet, Paris

turae.[32] Picabia wanted an art that would proceed wholly from fantasy; "We wanted to make something new," he later recounted, "something that nobody had ever seen before."[33]

But the symbols of this new "objectivity of a subjectivity" were nevertheless to come, if not specifically from nature, at least from the visual world; they constituted a hallucination of technology. New York City played a catalytic role in this regard. Picabia was astonished by the architecture and machinery; the Queensboro Bridge especially impressed him. Two years later Duchamp came to New York and described the bridges and the plumbing as the best art America had produced. By then, he and Picabia were working in their machinist style.

Picabia's metamorphosis from Cubist to Dada machine fantasist began immediately after the Armory Show and can be plotted through the three large canvases he painted on his return to Paris. The first and hence still most Cubist of these was cryptically titled *Edtaonisl* (fig. 21). The subject of the picture—derived from two passengers who had fascinated Picabia on the New York bound transatlantic steamer—is presumably the palpitating heart of a Dominican friar as he watches a young dance star and her troupe rehearse.[34]

The visual components of the putative iconography of *Edtaonisl* are as cryptic as the title. Vaguely suggestive anatomical fragments are swept up in the palpitating rhythm of the bold abstract composition whose musicality still owes much to Picabia's Orphic Cubism of late 1912. This incipient symbolic language became more illustrative by the last of the three compositions, *I See Again in Memory My Dear Udnie* (fig. 22),[35] where the allusions range from sexual organs to the coilsprings and spark plugs of Picabia's more literal machines of the following years.

The machinist style of Picabia was confirmed in 1915 in a series of object-portraits, drawings of isolated technological objects endowed with legends that identified them as particular personalities. The best of these is a portrait of the pioneer photographer and dealer Alfred Stieglitz, who is represented as a folding camera (fig. 23). The anti-art style of these drawings, which resemble the mail-order catalogue illustrations and newspaper ads on which some were in fact based,[36] reinforces the triteness inherent in the symbols themselves. But on closer inspection we realize that the drawings are as different from their commercial models as are Lichtenstein's paintings from the cartoons that inspired them. Their layout, distribution of accents, and firm contouring reflect a hand and eye still informed by the taste and discipline of Cubism.

The years 1915 through 1917 saw the finest of Picabia's machine images. Some machines, such as that of the handsome, summarily painted *Paroxyme de la Douleur* (fig. 25), refer to human experience only obliquely. Others, the transparently colored *Machine Tournez Vite* of 1916, for example (page 34), are manifest symbolic narratives. In this, a numbered legend on the picture itself identifies the meshing of the elaborate gears as a vision of the sexual union of man and woman. As was the case with Duchamp's imagery as early as 1912, there is at work here a kind of ironic humor that inheres, as Bergson observed,[37] in situations where a human being is reduced to the state of a machine. "Picabia found in anti-painting," his wife wrote, "a formula of black humor which gave him free rein to express his rancor against men and events, an inexhaustible vein of plastic and poetic sarcasms."[38]

Certain of Picabia's machines of 1915 had relief elements that were actually glued to the surface, as the raised cardboard cylinders of the *Very Rare Picture on the Earth* (fig. 26). But toward the end of the decade he began to employ found objects as collage elements, always using them illustratively however, as instanced by the hairpins that serve as eyes and the matches that represent the hair in *The Match Woman II* (fig. 24).

Between 1918 and 1922 Picabia's painting was in an equivocal state. His style was no longer developing coherently and real successes had become less frequent. Among the latter is the striking *M'Amenez-y* (fig. 27), its title based on a "verbal Readymade" by Duchamp,[39] and the handsomely abstract *Culotte Tournante* (fig. 28), the visual simplicity of which reflects Picabia's interest during the early twenties in arresting optical devices, for example, the target that makes up *Optophone* (fig. 29). By this time Picabia had deserted the Dada movement; he never joined Surrealism, though its influence is certainly reflected in his "transparencies" of the later twenties. With these superimpositions of crudely executed realistic images Picabia passed out of serious consideration as a painter.

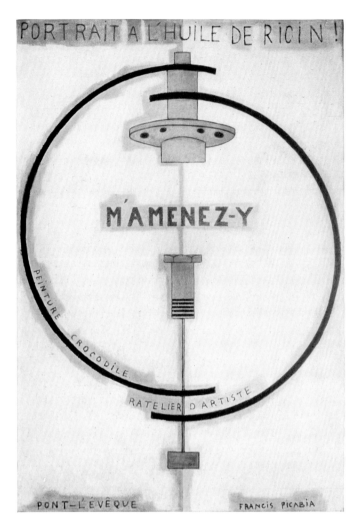

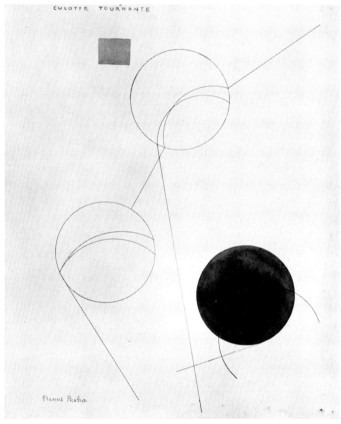

27 FRANCIS PICABIA. *M'Amenez-y.* (1919–1920). Oil on cardboard, 56¹/₈ × 40¹/₂ inches. Estate of Jean (Hans) Arp

28 FRANCIS PICABIA. *Culotte Tournante.* (1922). Watercolor, 28³/₈ × 23⁵/₈ inches. Collection Mme Simone Collinet, Paris

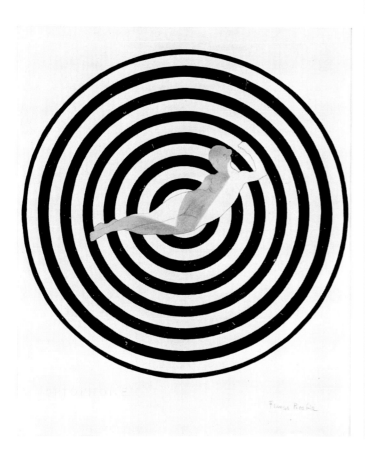

29 FRANCIS PICABIA. *Optophone*. (c. 1922). Watercolor, 28³/₈ × 23⁵/₈ inches. Collection André Napier, Neuilly-sur-Seine, France

30 JASPER JOHNS. *Target with Plaster Casts*. 1955. Encaustic and collage on canvas with plaster casts, 51 × 44 inches. Collection Mr. and Mrs. Leo Castelli, New York

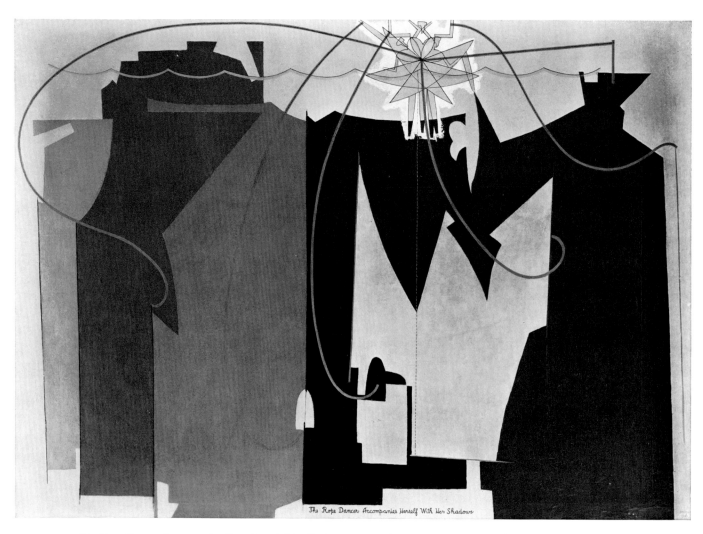

The Rope Dancer Accompanies Herself With Her Shadows

31 MAN RAY. *The Rope Dancer Accompanies Herself with Her Shadows.* 1916. Oil on canvas, 52 × 73³/₈ inches. The Museum of Modern Art, New York, Gift of G. David Thompson

32 MAN RAY. *The Rope Dancer Accompanies Herself with Her Shadows.* 1918. Airbrush, pen and ink, 13³/8 × 17³/8 inches. Collection Mr. and Mrs. Morton G. Neumann, Chicago

If the Armory Show confirmed Picabia's doubts about Cubism, it was precisely as an introduction to Cubism that the exhibition served for the young American painter Man Ray. Not until his friendship with Duchamp, who came to New York two years later, and with Picabia, when he returned there in 1916, did Man Ray undergo the transition from formalist to fantasist.

The success of his most important Dada-period painting, *The Rope Dancer Accompanies Herself with Her Shadows* (fig. 31), depends more on the vestiges of Cubism than on its novel iconography. Though executed entirely in oils, the picture is a transposition of ideas that Man Ray had been developing in a series of colored-paper collages influenced by Synthetic Cubism; it was, in effect, a *trompe-l'œil* of a collage. The dancer is a small schematic figure at the top of the canvas whose legs and skirts are shown simultaneously in different positions. The same Duchampesque principle allows the rope to be represented six times, forming lariat-like arabesques that swing out to enclose the "shadows," large flat abstract shapes of color.

Having moved away from painting via collage and its *trompe-l'œil* equivalent, Man Ray now took the next step along the road traveled by Duchamp by eliminating brush and traditional paints. From 1917 until the end of the Dada period, he was primarily a maker of objects and an

explorer of new mechanical methods of image-making. A new interpretation of the rope dancer in 1918 (fig. 32), now as a tightrope walker, combined the effects of a spray gun with pen drawing; the *Aerograph* of 1919 (fig. 33) was made entirely with a spray gun, using a freestanding, three-dimensional stencil. This oval picture is an excellent index of the persistence of Cubist syntax even in the teeth of an anti-art technique.

Man Ray's objects were often "assisted" Readymades, as in the flatiron and tacks of *Gift* (fig. 38), but they sometimes constituted more complex assemblages. His *Enigma of Isidore Ducasse* (fig. 34) was a mysterious object—actually the sewing machine of Ducasse-Lautréamont's famous image—wrapped in sackcloth and tied with a cord. It anticipated the recent *empaquetages* of Christo (fig. 35), who has even greater aspirations, such as packaging certain skyscrapers of Lower Manhattan (fig. 36).

Though Man Ray developed a reputation as a photographer of artists and art after his emigration to Paris in 1921, he thought of this activity primarily as a means of support. In photography, his "solarization," a technique already known to commercial photography, added an interesting minor note to his portrait photographs with their cameo-like effects (fig. 82), but his most important photographic contribution did not require a camera at all. "Rayographs" (fig. 39) were made by a process in which objects were placed on or near sensitized paper that was then exposed directly to the light. The process, discovered accidentally in the darkroom, gave results not unrelated to the "Schadographs" arrived at independently by Christian Schad. By controlling exposures and moving or removing the masking objects, this "automatic" process made possible images of a strangely abstract or symbolic character.

Though the machinist style interested American artists such as Morton Schamberg (fig. 40) and Joseph Stella, New York Dada had been primarily a question of the personal association of Duchamp, Picabia, and Man Ray. With the departure of all three for the Continent, the movement dissolved in New York. In Paris, Man Ray was associated with the Surrealists, who encouraged him in his role of object-maker; under their influence his painting and drawing was led into the more illusionist vein of his portrait of the Marquis de Sade (fig. 37).

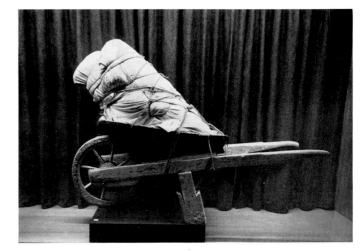

33 MAN RAY. *Aerograph*. 1919. Airbrush and watercolor, 29$\frac{1}{2}$ × 23$\frac{1}{2}$ inches. Cordier & Ekstrom, Inc., New York

34 above MAN RAY. *The Enigma of Isidore Ducasse*. (1920). Cloth and rope over sewing machine. No longer extant

35 below CHRISTO. *Package on Wheelbarrow*. 1963. Cloth, rope, wood, and metal, 35 inches high × 60 inches long × 23 inches wide. Collection the artist, New York

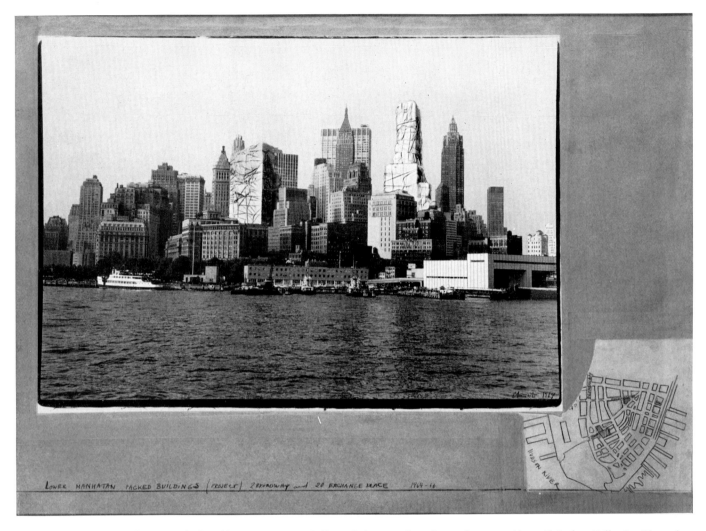

36 CHRISTO. *Lower Manhattan Packed Buildings.* 1964–1966. Collage of photographs and pasted paper, 20¹/₂ × 29¹/₂ inches. Collection Mr. and Mrs. Horace H. Solomon, New York

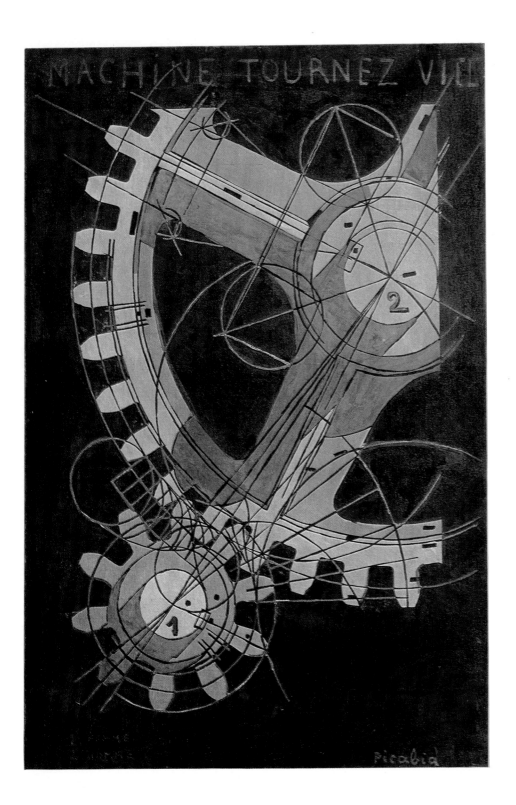

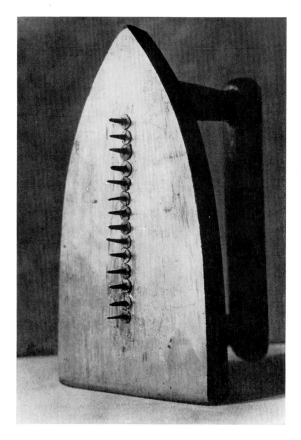

37 MAN RAY. *Portrait of the Marquis de Sade.* 1936. Pen and ink, 14 × 10 inches. Collection Mr. and Mrs. Joseph R. Shapiro, Oak Park, Illinois

38 MAN RAY. *Gift.* (1921). Flatiron with metal tacks. No longer extant

opposite
FRANCIS PICABIA. *Machine Tournez Vite.* (c. 1916–1917). Gouache, 19¹/₄ × 12⁵/₈ inches. Galleria Schwarz, Milan

Switzerland had been a haven from war for a variety of disaffected creative young men from all over Europe. In February 1916, the Cabaret Voltaire was launched in Zurich by a group of poets and artists; participants included Hugo Ball, Tristan Tzara, Hans (Jean) Arp, Marcel Janco, and Richard Huelsenbeck. With the accidental discovery of the word "Dada" in a Larousse dictionary, the group fell at once upon a name for their review and for a movement anticipated in Paris, already under way in New York, and soon to spread through Germany and France.[40] Experimental poetry, lectures, improvisational dance and music shared the programs of the Cabaret Voltaire with Dada *gestes* and a variety of outlandish pranks that also included audience participation.

From the point of view of the plastic arts the contribution of Zurich Dada was associated primarily with the pioneering work of Arp, though Marcel Janco made a contribution and Augusto Giacometti was briefly associated with the movement. Hans Richter, who with Viking Eggeling developed abstract motifs sequentially in long "scroll paintings" (fig. 50), was later to realize these aims of visual motion in his pioneer films, such as *Rhythmus 21* and *Rhythmus 23*.

Janco did a number of paintings which Arp described succinctly as "zigzag Cubism" and some handsome reliefs in a related spirit (fig. 42); his masks, created for *soirées* at the Cabaret, were more unusual (fig. 41). "What altogether fascinates us about [these]," Ball noted in his diaries, "is

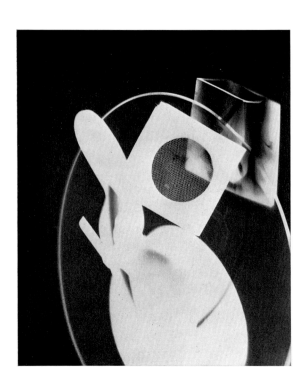

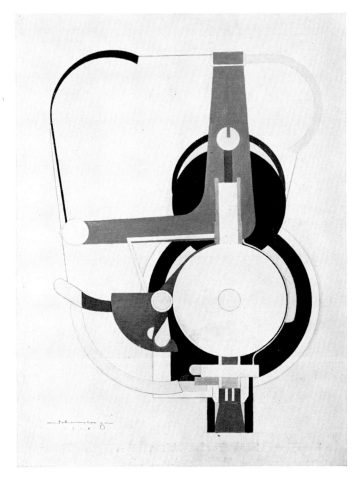

39 above MAN RAY. *Rayograph.* (1927). Photogram, 12 × 10 inches. The Museum of Modern Art, New York, Abby Aldrich Rockefeller Fund

40 right MORTON L. SCHAMBERG. *Machine.* 1916. Oil on canvas, 30 1/8 × 22 3/4 inches. Yale University Art Gallery, New Haven, Collection Société Anonyme

left

41 MARCEL JANCO. *Mask*. (1919). Paper, cardboard, twine, gouache, and pastel, 17³/₄ × 8⁵/₈ inches. Musée National d'Art Moderne, Paris

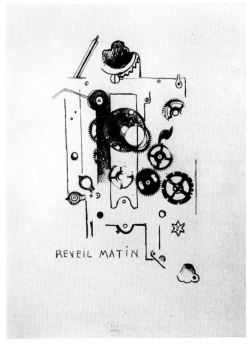

42 left MARCEL JANCO. *Wood Relief*. 1917. Wood (after a plaster original), 32⁵/₈ × 26 inches. Private collection

43 above FRANCIS PICABIA. *Réveil Matin*. 1919. Tempera on cardboard, 13 × 10¹/₈ inches. Galleria Schwarz, Milan

44 AUGUSTO GIACOMETTI. *Painting.* 1920. Oil on canvas, 41³/₈ × 41³/₈ inches. Collection Dr. G. Schaufelberger, Würenlos, Switzerland

45 JEAN (HANS) ARP. *Portrait of Tzara.* (1916). Painted wood relief, 19¹/₂ × 18¹/₂ inches. Estate of the artist

46 JEAN (HANS) ARP. *Enak's Tears (Terrestrial Forms).* (1917). Painted wood relief, 33¹/₂ × 23⁵/₈ inches. Collection F. C. Graindorge, Liège

that they personify beings and embody passions larger than life. The dread of our times, the paralyzing background of things is made visible."[41]

The Swiss painter Augusto Giacometti, uncle of the sculptor Alberto, had arrived independently at an abstract art anticipating the *informel* (fig. 44), which had its roots in Art Nouveau and remained untouched by the Cubism so ubiquitous as an underpinning in the work of other Dadaist painters. His brief personal association with the movement encouraged the radicality of his explorations but had no distinctive effect on his style. Giacometti's most Dadaist invention was a machine, inspired perhaps by those in Picabia's paintings and drawings. In 1917 he took the mechanism of a large clock, painted it, and attached colored forms to some of the moving parts,[42] which functioned in a manner that foreshadowed the 1959 mobile reliefs of his compatriot Jean Tinguely. The machine was accidently destroyed, but in a comical playlet by Arp,[43] Giacometti gives us a fanciful description of it: "Yesterday I finished

my kinetic Dadaist work of art. I don't believe anybody has ever created anything comparable to it. My kinetic work of art resembles a square cloud with a pendulum of blue smoke." Later, during a visit to Switzerland, Picabia would bow to the national product and use parts of an alarm clock to "print" a drawing (fig. 43).

Though many Dadaist and Surrealist artists were practicing poets, Arp is one of the very few whose poetry stands in both quality and quantity as an important contribution in its own right. The involvement of the painters of these movements with poetry produced a variety of rapports between the two arts, some of which endowed their *peinture-poésie* with new and unexpected dimensions, but others of which tended to vitiate their painting through a dilution of aesthetic modes. Arp's collages, reliefs, and sculpture share with his poetry an iconography—e. g., navels, mustaches, and clouds—a gentle whimsy, and a feeling of naturalness, but nowhere is their plasticity compromised.

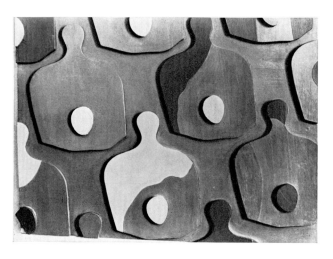

47 JEAN (HANS) ARP. *Automatic Drawing.* 1916. Brush and ink on gray paper, 16³/4 × 21¹/4 inches. The Museum of Modern Art, New York, Given anonymously

48 JEAN (HANS) ARP. *Egg Board.* (1922). Painted wood relief, 29³/4 × 39¹/8 inches. Collection F. C. Graindorge, Liège

For three years prior to the emergence of his personal style in the winter of 1915/1916, Arp had worked within the discipline of Cubism. Then in collages, and in machine-sawn reliefs such as the *Portrait of Tzara* of 1916 (fig. 45) and *Enak's Tears* of 1917 (fig. 46), the prevailing recti-linear structures of the Cubist work dissolved under the pressure of a new curvilinear, "organic" morphology.

This biomorphism had its roots in Art Nouveau, although there it was primarily linear in style and botanical in its associations. Arp established it in terms of closed flat forms that were endowed with anthropomorphic allusions as well. From that point on, biomorphism would be the near-est thing to a common form-language for the painter-poets of the Surrealist generations. An essential linguistic element in the work of all the "abstract" Surrealists—e.g., Miró, Masson, Matta, and Gorky—it was also fundamental to the illusionist painting of Tanguy, familiar in the "hand-painted dream photographs" of Dali, and not unknown even in the subversive, seemingly prosaic realism of Magritte.[44]

The Dadaist and Surrealist artists found the rectilinear vocabulary of Cubism alien to their expressive needs. Its prevailing verticality and horizontality are not so much the properties of man as of the man-made world, the structured environment that man creates in order to func-

tion with maximum stability. The Cubist picture speaks of this external order from a contemplative position in ideal-istic, abstract terms. To the Dada and Surrealist generations this attitude seemed too reserved, too disengaged from man's passions and fantasies. It is not surprising that in creating an art that would "return to man," they should have developed an anthropomorphic form-language capa-ble of evoking both physiological and psychological in-wardness. The very terms "organic" and "biomorphic" tes-tify to the new humanism.

In the face of Analytic Cubism's searching but ultimately assured equilibrium and stasis, Arp's reliefs unwind in an improvisational, meandering manner that implies growth and change. Here is no longer the sober, classical scaffold-ing of the external world of architecture. The forms of the *Portrait of Tzara* and *Enak's Tears,* while describing noth-ing specifically, multiply associations to physiological and botanical processes, to sexuality, and, through their very ambiguity, to humor.

Although biomorphism initiated a new vocabulary of forms, it did not in itself constitute a style in the sense that Impressionism or Cubism did; nor did it generate any new comprehensive principle of design or distribution of the total surface, or of the illusion of space, in pictures. Rather it provided constituent shapes for paintings in a variety of

49 left JEAN (HANS) ARP. *Collage with Squares Arranged According to the Laws of Chance.* (c. 1917). Collage of colored papers, 12³/₄ × 10⁵/₈ inches. Collection P. G. Bruguière, Issy-les-Moulineaux, France

50 right HANS RICHTER. *Rhythm 23.* 1923. Oil on canvas, 27 inches × 13 feet 5¹/₂ inches. Collection the artist, Southbury, Connecticut

styles. When more than one or two such shapes are used by the "abstract" Surrealists we almost always find them disposed in relation to one another and to the frame in a Cubist manner. Thus, while we may speak of the form-language or morphology of Arp, Masson, and Miró as anti-Cubist, this does not apply to the over-all structure of their compositions, since on that level these painters cling to organizational principles assimilated from the Cubism that all of them had practiced earlier.

Though the philosophic and aesthetic implications of accident had been of interest to Duchamp, it was only with Zurich Dada that accident, and its near corollary, automatism, began to be exploited. Accident played an important role in many of the improvisations at the Cabaret Voltaire. Tzara invented the "accidental poem," made by cutting out the individual words of any newspaper article, throwing them in a bag, shaking them, and recording them in the order that they were taken out. Arp explored comparable possibilities in a series of collages (fig. 49), and later in reliefs, generically entitled *According to the Laws of Chance.* Certain historians of Dada have taken this title at face value and have mistakenly described Arp as dropping pieces of paper on a ground and then "pasting them on the cardboard *just as they had fallen.*"[45] One glance at these collages is enough to suggest the unlikelihood of this

procedure, and Arp has since confirmed[46] that he had used chance in these works only as a point of departure for images that were afterward consciously rearranged.

Automatism played a comparable role in a number of Arp's Dada drawings (fig. 47). Their starting point was the notion of vitality, the movement of the creative hand. There were no preconceived subjects, but as outlines contoured the surface, they provoked associations to human physiognomies and organs, to plant and animal life. These were never defined in a literal manner, Arp always preferring the ambiguous form that suggests much but identifies nothing. The pencil outlines once drawn, he filled in the contours with black ink, often changing and adjusting them, and even eliminating shapes as he brought the drawing to completion.

Arp's automatism was much less rapid and spontaneous than that practiced in the later twenties by Masson and Miró; it resembled more the "doodling" of Klee.[47] The value of automatism for all these artists lay in its help in "overcoming" their own painting culture. Accidentality and, even more, automatism facilitated the challenging of inherited assumptions of style and habits of the hand, and suggested the possibility of rendering experience dredged more deeply from the unconscious than prevailing art-making practices seemed to allow.

Richard Huelsenbeck returned to Berlin in 1917 and carried with him the gospel of Zurich Dada. Food was scarce in the German capital, despair was spreading, and the authorities seemed unable to cope with the situation. Here was a city ripe for a more aggressive and more politically oriented Dadaism than well-fed Zurich would have tolerated. Huelsenbeck's communism had never jibed with the more apolitical, anarchistic ideas of the other Zurich Dadaists anyway. Led by Huelsenbeck and John Heartfield, who had anglicized his name, Herzfelde, as an antinationalist gesture, the Dada manifestations in Berlin were resolutely collective in character. Not content with vilifying revered values—"What is German culture? (Answer: Shit)"—Dadaists there called for their eradication by "all the instruments of satire, bluff, irony, and, finally, violence . . . in a great common action."[48]

Berlin produced less work of interest in the plastic arts than other Dada centers. Much of it was intentionally ephemeral: posters, impromptu pieces, propagandistic inventions manufactured for particular manifestations. Whether in collages such as Raoul Hausmann's *Head* (fig. 53) and Johannes Baader's *Collage a* (fig. 54), in its reviews, or in its posters, the Berlin group showed itself particularly interested in typography, which it exploited in a more daring and inventive way than had the Zurich Dadaists.

The most significant contribution of the Berlin group was the elaboration of the so-called photomontage, actually a photo-collage, since the images were not montaged in the darkroom. Indeed, very few of these consisted, as did Paul Citroen's obsessional *Metropolis* (fig. 55), entirely of photographic images; most of the Berlin photomontages involved a combination of images from different sources—many from newspapers and magazines—as in Hausmann's *Tatlin at Home* (fig. 51) and Hannah Höch's *Cut with the Kitchen Knife* (fig. 52). Though Max Ernst had independently invented a comparable technique, Hausmann was the first Berliner to hit upon the photomontage. It was suggested to him by the German army photographers' device of inserting portrait heads in oleographic mounts of idealized settings. In its pure form, photomontage entirely eliminated any need to paint or draw; the mass media could provide all the material. One could attack the bourgeoisie with distor-

51 RAOUL HAUSMANN. *Tatlin at Home.* 1920. Collage of pasted papers and gouache, 16¹/₈ × 11 inches. Moderna Museet, Stockholm

opposite
52 HANNAH HÖCH. *Cut with the Kitchen Knife.* (1919). Collage of pasted papers, 44⁷/₈ × 35¹/₂ inches. Nationalgalerie, Staatliche Museen, Berlin

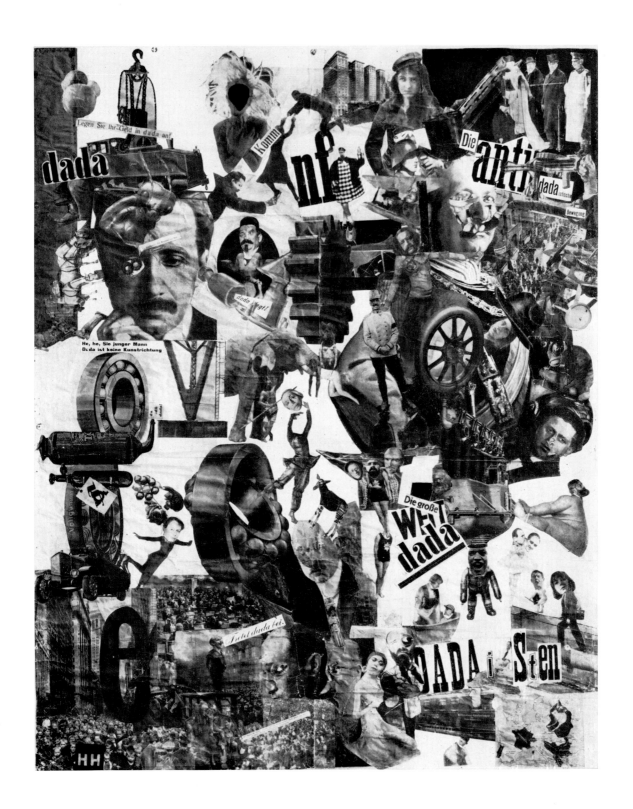

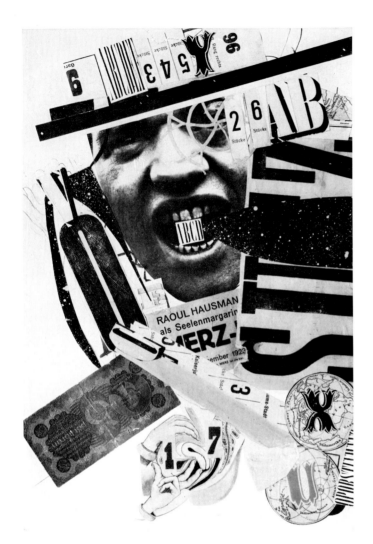

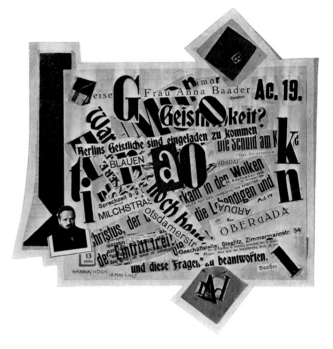

53 RAOUL HAUSMANN. *Head.* (1923). Collage, 15³/₈ × 10¹/₂ inches.
Collection the artist, Limoges*

54 JOHANNES BAADER. *Collage a.* (1920–1922). Collage of pasted
papers, 13⁷/₈ × 19⁷/₈ inches. Musée National d'Art Moderne, Paris

opposite
55 PAUL CITROEN. *Metropolis.* (1923). Collage of photographs, prints,
and post cards, 30 × 23 inches. Prentenkabinet, Rijksuniversiteit,
Leiden, The Netherlands

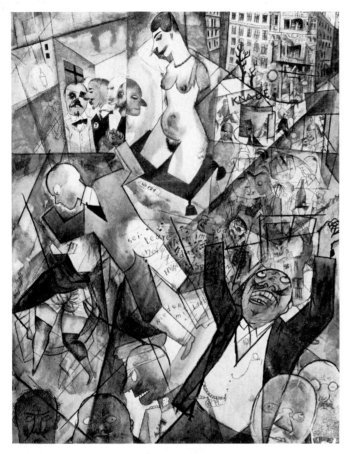

tions of its own communications imagery. The man on the street would be shocked to see the components of familiar realistic photography used to turn his world topsy-turvy, and the familiar lettering of his newspapers and posters running amuck.

George Grosz's savagely antimilitaristic, antibourgeois satire, though stylistically allied to Expressionism and Futurism, was put in the service of Dada "provocation" in Berlin. His vision of the corruption of the city's *grand-* and *demi-monde* stressed the omnipresence of irrational violence. Grosz and Heartfield had both been soldiers and were revolted by their experiences. Grosz paraded through the Berlin streets wearing a death's-head and carrying a placard emblazoned "Dada über Alles," while Heartfield continued to wear his uniform after demobilization as a form of protest. In order to "dis-honor" it, he wore a particularly dirty and disgusting one, and on the pretext of suffering from a skin disease he shaved only one cheek, becoming thus a living counterpart of the grotesque caricatures in Grosz's antimilitarist drawings (fig. 58). The climax of Berlin Dada was the International Dada Fair of 1920, the central symbol of which was a dummy of a German officer, fitted with the head of a pig, that hung from the ceiling of the main gallery (fig. 59).

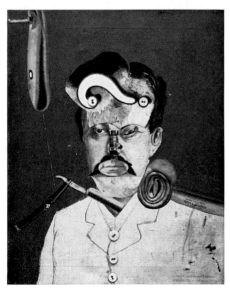

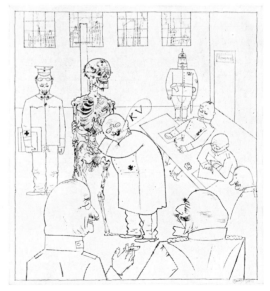

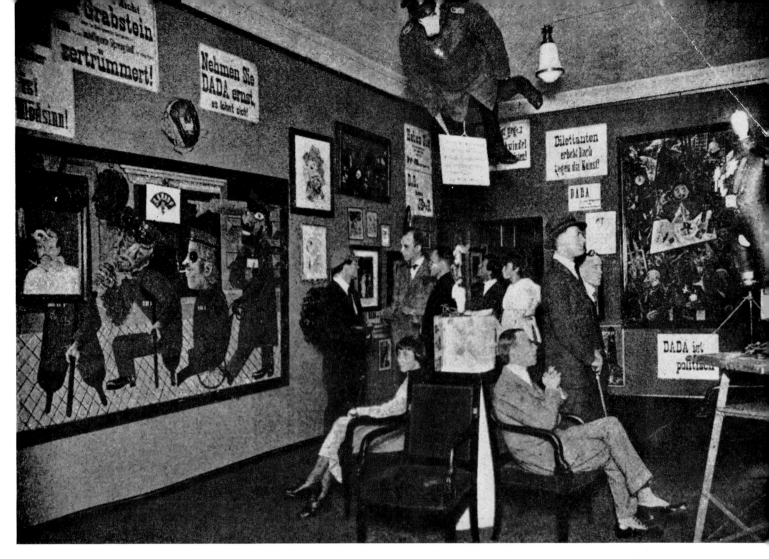

59 *Erste Internationale Dada-Messe*. Kunsthandlung Dr. Otto Burchard, Berlin, June 1920. From left to right: Raoul Hausmann, Hannah Höch, Dr. Burchard, Johannes Baader, Wieland Herzfelde, Mrs. Herzfelde, Otto Schmalhausen (Dadaoz), George Grosz, John Heartfield

opposite
56 above left GEORGE GROSZ. Untitled. 1919. Watercolor, 19¼ × 13⅝ inches. Collection Mr. and Mr. Richard L. Feigen, New York.

57 below left GEORGE GROSZ. *Remember Uncle August, the Unhappy Inventor*. (1919). Oil on canvas, with cut-and-pasted magazine advertisements and buttons, 19¼ × 15⅝ inches. Collection Mr. and Mrs. Bernard J. Reis, New York

58 below right GEORGE GROSZ. *Fit for Active Service*. (1916–1917). Pen and brush and India ink, 20 × 14⅜ inches. The Museum of Modern Art, New York

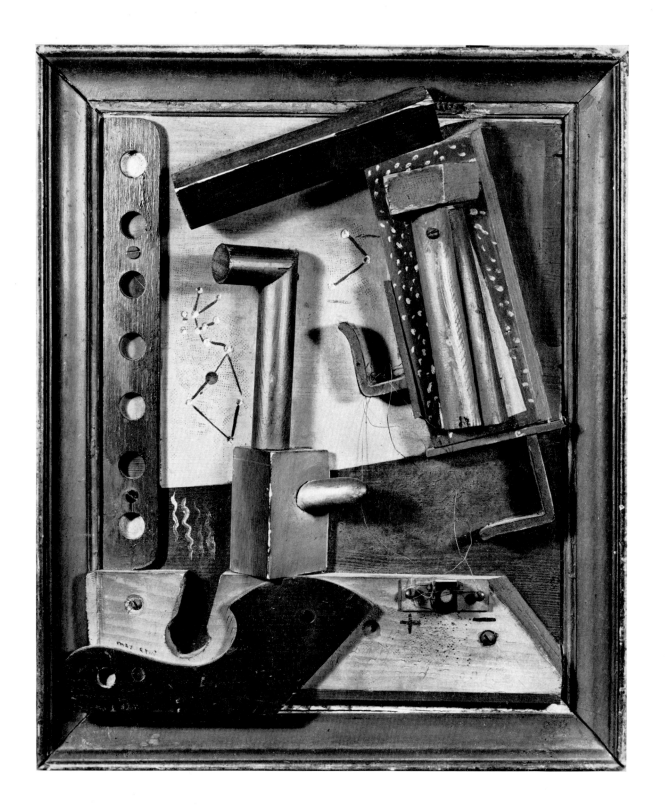

No artist more completely personified the interwar avant-garde than Max Ernst. His Dada activities in Cologne following demobilization—with Baargeld[49] he founded the "Dada Conspiracy of the Rhineland"—initiated a career that extended through the entire history of Surrealism and beyond. In the extraordinary variety of his styles and techniques he is to Dada and Surrealism what Picasso is to twentieth-century art as a whole.

Ernst executed a few sculptures and reliefs during the Dada period. The freestanding, wood-slat *Bird* (fig. 61) and the wood-and-metal relief *Fruit of a Long Experience* (fig. 60) give a personal twist to suggestions present in Picasso's construction sculptures of 1912–1916, and somewhat parallel the early *Merz* reliefs of Kurt Schwitters. But despite the readability of the former and the somewhat more cryptic iconographic suggestions of the latter, both necessarily remained on a more formal plane than the collages. It was primarily as a collagist that Ernst discovered himself as an artist, for in collage he could give free rein to his taste for a more detailed literal imagery. Ernst described the experience that engendered the collages as follows:

> One rainy day in 1919 . . . my excited gaze was provoked by the pages of a printed catalogue. The advertisements illustrated objects relating to anthropological, microscopical, psychological, mineralogical, and paleontological research. Here I discovered the elements of a figuration so remote that its very absurdity provoked in me a sudden intensification of my faculties of sight—a hallucinatory succession of contradictory images, double, triple, multiple. . . . By simply painting or drawing, it sufficed to add to the illustrations a color, a line, a landscape foreign to the objects represented—a desert, a sky, a geological section, a floor, a single straight horizontal expressing the horizon, and so forth. These changes, no more than docile reproductions of *what was visible within me*, recorded a faithful and fixed image of my hallucination. They transformed the banal pages of advertisement into dramas which revealed my most secret desires.[50]

The collage, as Ernst re-created it, had little in common either technically or plastically with the *papiers collés* of the Cubists. For them, collage elements were a counterpoint

61 above MAX ERNST. *Bird*. (c. 1916–1920). Wood, 40¹/₈ inches high × 8¹/₄ inches wide × 11⁷/₈ inches deep. Private collection

62 below BAARGELD (ALFRED GRÜNEWALD). *The Human Eye and a Fish, the Latter Petrified*. 1920. Pen and ink with collage, 12¹/₄ × 9³/₈ inches. The Museum of Modern Art, New York

opposite
60 MAX ERNST. *Fruit of a Long Experience*. 1919. Painted wood and metal, 18 × 15 inches. Penrose Collection, London

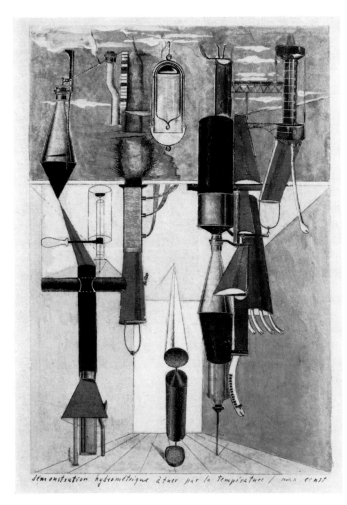

63 MAX ERNST. *Démonstration Hydrométrique à Tuer par la Température.* (1920). Collage of pasted papers, 9¹/₂ × 6³/₄ inches. Galerie Jacques Tronche, Paris

to the painted lines and shapes in a whole oriented toward formal values. To Ernst, who wanted to go "beyond painting" but not, like Duchamp, beyond art, plasticity was of secondary interest; he used the borrowed elements primarily for their image value, joining them in irrational, disconcerting ways. In conceiving of the collage as "a meeting of two distant realities on a plane foreign to them both," or as a "culture of systematic displacement and its effects,"[51] Ernst was postulating a mode that hardly necessitated gluing elements together. Of the fifty-six collages he showed in Paris in 1921, only ten were, technically speaking, collages. The rest were printed images turned into visual collages by being painted and drawn upon.[52]

The imagery of Ernst's collages diverges into the two main directions previously laid out by Dada: the mechanical and the organic. *Démonstration Hydrométrique à Tuer par la Température* (fig. 63) is made up of cylinders, funnels, pipes, and other vaguely mechanical elements that form a strange apparatus of unclear purpose, as if demonstrating some as yet undiscovered principle of hydrodynamics. *Stratified Rocks* (fig. 64) contains biomorphic shapes that originally delineated vertebral systems and circulatory patterns. By retaining parts of the original illustration as reserve areas and painting over the rest with geological striations and vegetal forms, Ernst turned the whole into an eery world of enigmatic forms and fantastic beasts.

In *Démonstration Hydrométrique* and other collages, there are linear perspective schema that were suggested by contact with de Chirico's painting, an influence that is, however, more manifestly reflected in Ernst's series of lithographs called *Fiat Modes* (fig. 65). But the absence of aerial perspective and, above all, modeling in the round, combined with the abstract nature of these linear schemas, impeded three-dimensional illusions and kept the forms clinging close to the picture plane. Later, from 1921 to 1924, Ernst made large paintings, such as *The Elephant Celebes* (page 84) and *Œdipus Rex* (fig. 109), in which comparable collage elements were painted in *trompe-l'œil.* In these, the simpler, more narrative iconographies and more modeled, illusionistic handling created a dreamlike deep space that anticipated Magritte, Tanguy, and Dali. These pictures, which stand between de Chirico and these later painters, are best thought of as proto-Surrealist.

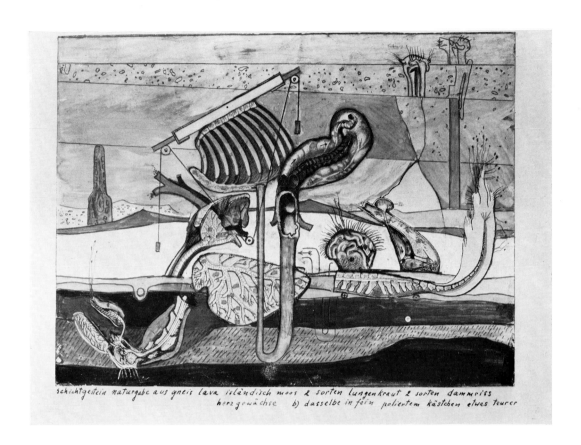

schichtgestein naturgabe aus gneis lava isländisch moos 2 sorten lungenkraut 2 sorten dammriss
herzgewächse b) dasselbe in fein poliertem kästchen etwas teurer

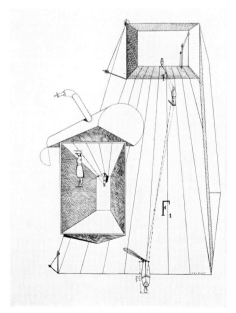

64 MAX ERNST. *Stratified Rocks.* (1920). Anatomical engraving altered
with gouache and pencil, 6 × 8¹/8 inches. The Museum of Modern Art,
New York

65 left MAX ERNST. *Fiat Modes:* Plate 1, *Composition with Letter F_1.*
(c. 1919). Lithograph, 17¹/8 × 12 inches. The Museum of Modern Art,
New York, Given anonymously*

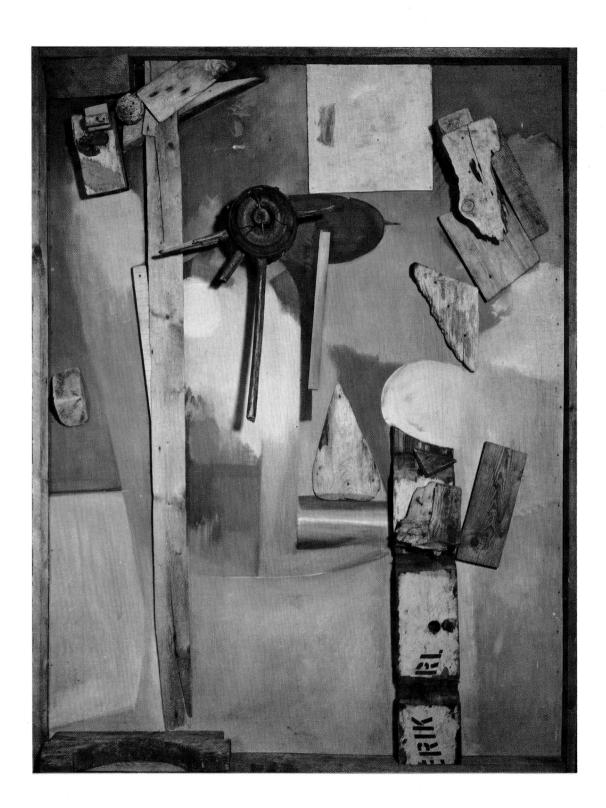

The machine-sawn reliefs of Arp and the collages of Ernst already constituted a compromise with Duchamp's rigorous aesthetic nihilism; the personal form of Dada developed by Kurt Schwitters in Hanover represented an even further attrition of that early Dada ideal. Schwitters, who called his work *Merz* to distinguish it from other forms of Dada, felt no embarrassment about his delight in art, which he considered "a primordial concept, exalted as the godhead." "As a matter of principle," he insisted, "*Merz* aims only at art. . . ."[53]

Judged only on the basis of the collages—by which he is best known—there is little that identifies Schwitters as specifically Dadaist. The structural framework of the collages derives from the grid scaffoldings of Cubism and the radiating patterns of Futurism. And the articulation of these patterns with refuse—bus tickets, advertisements, letterheads, bottle labels, and the like—had been foreshadowed, at least in principle, by the Cubists.

But while the iconography of Cubist collage had a certain poetry, which evoked the haphazard studio-world in which the artist lived, this was incidental to its mainly formal expressive aims. The greater range and more personal selection of Schwitters' collage materials allowed him to conjure from them an intimate nostalgic poetry— even a pathos—that frequently contains more than a hint of anecdote. This autobiographical bias reflected a typically Dadaist desire to fuse art and life, a compound that became fully realized only when Schwitters' anti-art materials left the surfaces of his collages and reliefs and began to form the components of the *Merzbau*, or "*Merz* structure," into which he transformed his home.

> I could not, in fact, see the reason why old tickets, driftwood, cloakroom tabs, wires and parts of wheels, buttons and old rubbish found in attics and refuse dumps should not be as suitable a material for painting as the paints made in factories. This was, as it were, a social attitude, and artistically speaking, a private enjoyment, but particularly the latter. . . .
> I called my new works utilizing such materials *Merz*. This is the second syllable of *Kommerz*. It originated

in the *Merzbild* [*Merz Picture*], a work in which the word *Merz*, cut out from an advertisement of the *Kommerz und Privatbank* and pasted on, could be read among the abstract elements. . . . I looked for a collective term for this new style, since I could not fit my pictures into the older categories . . . So I called all my work as a species *Merz* pictures, after the characteristic one. Later I extended the use of the word *Merz*, first to my poetry, which I have written since 1917, and finally to all my related activities. Now I call myself *Merz*.[54]

The overwhelming majority of Schwitters' collages are very small.[55] The materials he loved did not lend themselves to large-size works, and he wanted to preserve in the finished pictures the intimacy he felt toward this detritus. But such miniaturism was not an unalloyed asset, because Schwitters, unlike Klee, was not able to sustain the rhythm of invention that keeps a small-scale art from becoming monotonous.

Schwitters' poetry, centering largely around *Anna Blume* and his sound poem, *Die Ursonate*, had a reciprocal relation to his collages, which often constitute visual poems of different degrees of fragmentation, *Fec. 1920* representing the type of the least atomized. The union of painting and poetry could begin at either end. "I pasted words and sentences into poems in such a way as to produce a rhythmic design [fig. 66]. Reversing the process, I pasted up pictures and drawings so that sentences could be read in them [fig. 67]."[56] Exploration in this kind of amalgamation of words and images was pressed further just after World War II by the Dada-inspired Letterists in Paris[57] such as Maurice Lemaître (fig. 68); words even became the basis of an Environment by Allan Kaprow (fig. 70).

Schwitters' large-scale reliefs, though relatively few in number, diverge from the collages in spirit as well as materials. The wood slats, wheels, wire mesh, nails, and other objects used in *Weltenkreise* and in *The "Worker" Picture* (fig. 71) produce a bold, often geometrical, effect recalling Picasso's relief constructions. The first years of *Merz* activity, 1919–1920, saw many of the best of these, but Schwit-

opposite
KURT SCHWITTERS. *Merz Picture with Rainbow.* (1939). Oil and wood on plywood, 61⅝ × 47¾ inches. Collection Mr. and Mrs. Charles B. Benenson, Scarsdale, New York

66 KURT SCHWITTERS. *Fec. 1920.* 1920. Collage of pasted papers, 7¹/₈ × 9³/₄ inches. Marlborough-Gerson Gallery, Inc., New York

67 KURT SCHWITTERS. Illustration in *Memoiren Anna Blumes in Bleie* (Freiburg, 1922)

opposite

68 above right MAURICE LEMAÎTRE. *Document on a Woman of My Life.* 1966. Oil and pasted photographs on canvas, mounted on plywood, 44⁷/₈ × 63³/₄ inches. Collection the artist, Paris

69 below right KURT SCHWITTERS. *The "And" Picture (Das Undbild).* 1919. Collage of pasted papers, wood, and metal, 14 × 11 inches. Marlborough-Gerson Gallery, Inc., New York

70 far right ALLAN KAPROW. *Words.* Rearrangeable environment with lights and sounds, at the Smolin Gallery, New York, September 1962

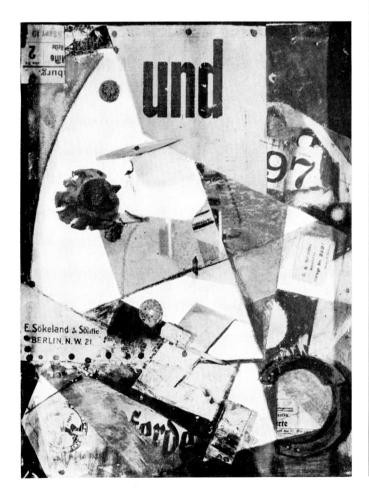

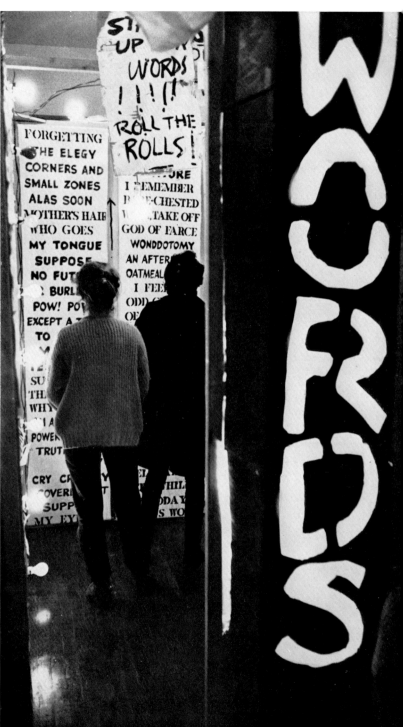

ters had occasional success with them throughout his career, as witness the *Merz Picture with Rainbow* of 1939 (page 52), which points clearly to the Combines and reliefs of Rauschenberg.

The process by which Schwitters' home was converted into the private Environment he called the *Merzbau* (figs. 73–75) followed naturally from his additive, improvisational manner of composing collages and from his Dadaist desire to extend art from an aesthetic discipline to a way of life. Already in 1919 the walls of Schwitters' home overflowed with collages and reliefs, and the floors had become crowded with freestanding objects that began to merge with the furniture. Soon there was no distinction between the independent collage or relief and the wall as a backdrop for the junk Schwitters installed. The piles of freestanding rubbish grew, constantly refreshed with every new *trouvé* the painter "merzed" on during a sixteen-year period.

With the blurring of the discrete pictorial field of the collage on the wall and the extension of the relief material out into the room, Schwitters' improvised Environment gradually obliterated the architectonic sense of his house. The *Merz* accumulations began to be surrounded by an organic growth of wood and plaster which in time extended through two floors of the building and down into a cistern. As this shell was realized it became increasingly Constructivist in style, in keeping with the general reorientation of Schwitters' art in the mid-twenties. It is this more purely plastic apparatus that the photographs best preserve for us (the house was destroyed by bombs in 1943);[58] the inner core, formed of *Merz* agglomerations, amounted to a kind of Dada grotto, part of which was accessible only through "doors" and "windows" in the surrounding timber structure. Among the names Schwitters gave to sections of the *Merzbau* were Nibelungen Treasure, Cathedral of Erotic Misery, Goethe Grotto, Great Grotto of Love, Lavatory Attendant of Life; there was also a Sex-Murder Cave, which contained a red-stained broken plaster cast of a female nude.[59]

In letting his relief material spill out into the room and in constructing the forms of the *Merzbau* around him—a prototype for "environmental" sculpture—Schwitters proved to be a prophetic artist. Rauschenberg's *Interview*

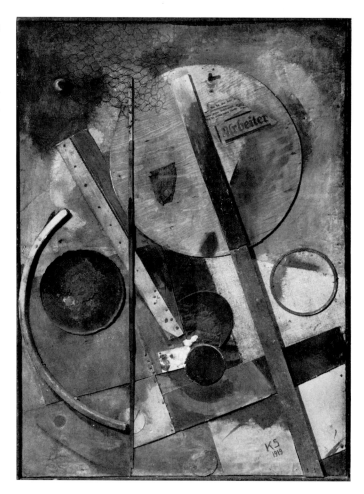

71 KURT SCHWITTERS. *The "Worker" Picture (Das Arbeiterbild).* 1919. Collage of wood and pasted papers, 49^1/$_4$ × 36 inches. Moderna Museet, Stockholm

opposite
72 KURT SCHWITTERS. *For Kate.* 1947. Collage of pasted papers, 4^1/$_8$ × 5^1/$_8$ inches. Collection Mrs. Kate T. Steinitz, Los Angeles

(fig. 77) evokes, in a personal way, a comparable metamorphosis of everyday living structures under the impact of the will to art. During the same year in which he converted his own pillow and quilt into the painting called *Bed* (fig. 76), Rauschenberg plastered and hung this closet-like structure with a variety of images and materials—from old family photographs to a baseball—that might have come out of the attic. Together they suggest an autobiographical iconography that turns the cupboard almost into a confessional, and exemplifies Rauschenberg's Dada-inspired remark that he operates "in that gap between" art and life.[60] The Swiss *nouveau réaliste* Daniel Spoerri was inspired by similar aims in his *tableaux-pièges*, or "snare pictures." In these, various objects—like the remains of Duchamp's dinner (fig. 78)—found in chance positions on tables, in boxes, drawers, or elsewhere were fixed or "frozen" as they lay. They became "pictures" by the simple expedient of being turned vertically and hung on a wall.

But Schwitters had a vision of an even more radical and hallucinatory *Merz* experience, one that would have turned an Environment into a Happening. Some of the *Merz* manifestations or *soirées* pointed in this direction, but never arrived at the "*Merz* total work of art," which would, in Schwitters' words, "embrace all branches of art in a single unit." To accomplish this he projected a *Merz*-stage:

> The materials used for staging should be made up of solid, liquid, and gaseous substances: the white wall,

a man, a mass of wires, a jet of water, a blue vista, a cone of light. Surfaces should be used which can fold like draw curtains, which can expand and contract. Things should turn and move . . . it should be possible to add parts to the stage flats or subtract them.[61]

While the theater has always been the locus of a fusion of the arts, it is only in the nineteenth-century, Wagnerian, conception of the *Gesamtkunstwerk* that such a notion was spelled out. However, Schwitters' *Gesamtkunstmerz*, if the word may be coined for him, differed from the *Gesamtkunstwerk* in being not an orderly synthesis of genres but a Dadaistic confusion of them:

> Take gigantic surfaces, conceived as infinite [he instructs], cloak them in color and shift them menacingly . . . Paste smoothing surfaces over one another. . . . Make lines fight together and caress one another in generous tenderness. . . . Bend the lines, crack and smash angles . . . let a line rush by, tangible in wire. . . . Then take wheels and axles, hurl them up and make them sing (mighty erections of aquatic giants). Axles dance mid-wheel roll globes barrels. Cogs flair teeth, find a sewing machine that yawns. . . . Take a dentist's drill, a meat grinder, a car-track scraper, take buses and pleasure cars, bicycles, tandems, and their tires, also ersatz wartime tires and deform them. . . . Take petticoats and other kindred articles, shoes and false hair, also ice skates and throw them into place where they belong, and always at the right time. . . . Inner tubes are highly recommended. Take in short everything from the hairnet of the high-class lady to the propeller of the S/S *Leviathan*, always bearing in mind the dimensions required by the work.
> Even people can be used. . . .
> Now begin to wed your materials to one another. For example, you marry the oilcloth table cover to the Home Owners' Loan Association, you bring the lamp cleaner into a relationship with the marriage between Anna Blume and A-natural, concert pitch. . . . You make a human walk on his (her) hands and wear a hat on his (her) feet . . . A splashing of foam.
> And now begins the fire of musical saturation. Organs backstage sing and say: "Futt, futt." The sewing machine rattles along in the lead. A man in the wings

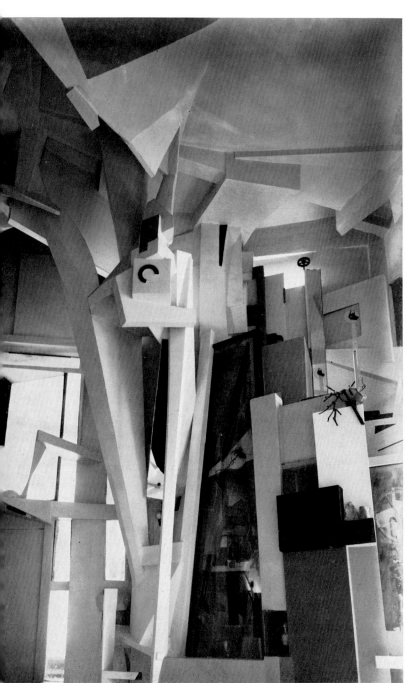
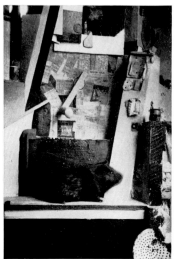
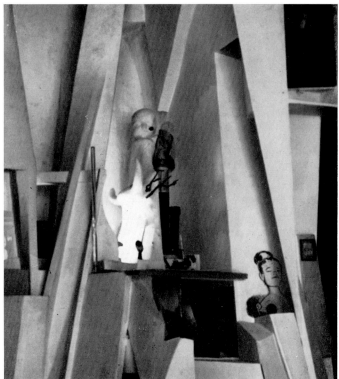

73–75 KURT SCHWITTERS. Views of the *Merzbau*, Hanover, c. 1924–1933. The view at upper right includes Schwitters' pet guinea pig.

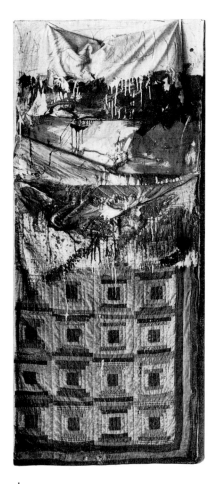

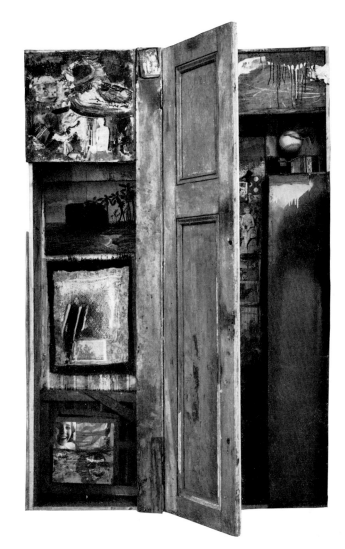

above
76 left ROBERT RAUSCHENBERG. *Bed*. (1955). Combine painting,
75^{1}/$_{8}$ × 31^{1}/$_{2}$ inches. Collection Mr. and Mrs. Leo Castelli, New York

77 right ROBERT RAUSCHENBERG. *Interview*. (1955). Construction
with wooden door, 72 inches high × 49 inches wide × 8^{1}/$_{2}$ inches deep.
Collection Dr. Giuseppe Panza di Biumo, Milan*

78 right DANIEL SPOERRI. *Marcel Duchamp's Dinner*. (1964). Cutlery,
dishes, and napkins mounted on wood, 24^{7}/$_{8}$ inches wide × 21^{1}/$_{8}$ inches
deep × 8^{1}/$_{4}$ inches high. Collection Arman, Nice

79 KURT SCHWITTERS. Design for a *Normalbühne Merz* showing the mechanism of a space stage. 1925. Whereabouts unknown

says: "Bah." Another suddenly enters and says: "I am stupid." (All rights reserved.) Between them a clergyman kneels upside down and cries out and prays in a loud voice: "Oh mercy seethe and swarm disintegration of amazement Hallelujah boy, boy marry drop of water." A water pipe drips uninhibited monotony. Eight.[62]

Schwitters' ideas for the *Merz*-stage remained in the realm of theory. Although they represent his urge to erase the boundaries that exist among the arts, he himself felt that they were unrealizable. In 1923 he began to develop his ideas for a *Normalbühne Merz*, which lacked the radicality of the *Merz*-stage but for which he conceived a space stage in which the machinery constituted part of the visible aesthetic of the event (fig. 79).

The history of modern art, from its inception with the generation of Manet and the Impressionists, has moved in a direction opposite to the *Gesamtkunstwerk;* it was only with Dada that theater influenced it. Clement Greenberg has observed that the informing dialectic of modern painting, indeed, of all the modern arts, has been the search for those qualities that are both indispensable and peculiar to them.[63] It is no accident that Dada, reacting to the implied autonomy of painting at the very moment that it was going over into total abstraction, should have wanted "to dissolve the rigid frontiers" of the various arts even as it wanted "to put them once again under the dependency of man."[64] Nor does it seem to be an accident that the reaffirmation of abstract painting by the "first generation" of post-World War II artists should in turn have engendered a reaction in the form of Environments, Happenings, and other mixtures of the arts which are still under way.

The relationship of the Dadaist conception of the gratuitous or spontaneous act to the theory of Action Painting and the relationship of this, in turn, to the vogue of Happenings is too complicated to be treated here,[65] but there is no question that historical consciousness of Dada and Surrealism in New York during and after World War II had an important role in these developments.[66] But the fact that most of the artists and critics involved in our recent history had no firsthand knowledge of the earlier experiments proved to be a virtue, since the distance made them freer to judge and to develop what was still viable in them.

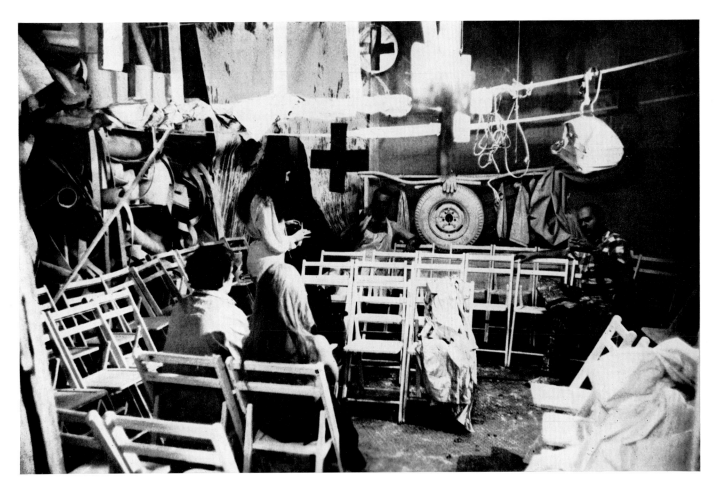

80 JIM DINE. *Car Crash*. Rehearsal of a Happening at the Reuben Gallery, New York, November 1960

Insofar as the ideas that would later be called Dada were first proposed and enacted by Duchamp and others in Paris, it was only poetic justice that after shifting between two continents, the axis of the movement should have returned there a few years after the first World War. Infused with new blood in the shape of the young poets associated with *Littérature*—among them Breton, Paul Eluard, and Louis Aragon—and supported by pioneer Dadaists who flocked to Paris from New York and various Continental centers, Paris became the scene of some of Dada's most glorious *gestes* and manifestations. But what would constitute the final chapter of any book on Dada as a whole,

shrinks in importance in a discussion of the plastic arts. For while much of the work done in other centers was exhibited in Paris, and while many of the artists emigrated or at least visited there, postwar Paris witnessed no radical artistic departures comparable to those we have been describing. For the purposes of our discussion, Paris Dada is important primarily as the formative environment of the men and ideas that would soon constitute Surrealism. In the years 1922–1924, sometimes referred to in the history of the Parisian avant-garde as the *époque floue*—the "indistinct" period of transition—these young poets dialectically transformed moribund Dada into the new movement.

AVRIL 1922

LE CŒUR A BARBE

JOURNAL TRANSPARENT

1 Fr.

Administration: **AU SANS PAREIL**
37, Avenue Kléber - PARIS (XVIᵉ)

Ont Collaboré à ce 1ᵉʳ numéro:
Paul ELUARD, Th. FRAENKEL, Vincent HUIDOBRO, Mathew JOSEPHSON, Benjamin PÉRET, Georges RIBEMONT-DESSAIGNES, Erik SATIE, SERNER, Rrose SÉLAVY, Philippe SOUPAULT, Tristan TZARA.

82 MAN RAY. *André Breton.* (1931). Photograph, 11½ × 8¾ inches.
The Museum of Modern Art, New York, Gift of James Thrall Soby

The Pioneer Years
of Surrealism

1924–1929

The years of the *époque floue* found Breton and his friends
attempting to flesh out a definition of Surrealism that
would satisfactorily differentiate it from Dada. Many of
the essentials of Surrealism—the experimentation with
automatism, accident, biomorphism, and found objects
within the framework of an overriding commitment to so-
cial revolution—had been present in Dada to some degree,
but in a chaotic state. These would be systematized within
the Freud-inspired dialectic of Surrealism. What had been
a therapy for Freud would become a philosophy and a lit-
erary point of departure for Breton.

The word "surrealism" had been used first by Apollinaire
in 1917 in a context that coupled avant-garde art with
technological progress;[67] his neologism possessed none of
the psychological implications that the word would later
take on. Subsequently, the term was used by Ivan Goll,
founder of a short-lived review called *Surréalisme*, and
others. But their usages, e.g., "the transposition of reality
onto a higher plane," was vague or contradictory. "Up to
a certain point," Breton wrote in November 1922, "one
knows what my friends and I mean by Surrealism. This
word, which is not our invention and which we could have
abandoned to the most vague critical vocabulary, is
used by us in a precise sense. By it, we mean to designate
a certain psychic automatism that corresponds rather

closely to the state of dreaming, a state that is today extremely difficult to delimit."[68]

By autumn of 1924, Breton had assumed exclusive rights to the magic word and in the Surrealist manifesto published then he gave it formal definition:

SURREALISM. noun, masculine. Pure psychic automatism, by which one intends to express verbally, in writing or by any other method, the real functioning of the mind. Dictation by thought, in the absence of any control exercised by reason, and beyond any aesthetic or moral preoccupation.

ENCYCL. *Philos.* Surrealism is based on the belief in the superior reality of certain forms of association heretofore neglected, in the omnipotence of dreams, in the undirected play of thought....[68a]

"I believe," Breton proclaimed, "in the future resolution of the states of dream and reality, in appearance so contradictory, in a sort of absolute reality, or *surréalité*, if I may so call it."[69]

At the time of the publication of the manifesto no conception of Surrealist painting existed. The lengthy text mentioned the plastic arts only in a footnote, which grouped Ernst, Masson, Man Ray, de Chirico, Duchamp, Picabia, and Klee with Picasso, Matisse, Derain, Seurat, Moreau, and—Paolo Uccello. Had the formal definition of Surrealism cited above been taken at face value, Surrealist painting could never have existed, since it could hardly have transcended "any aesthetic . . . preoccupation." Indeed, in 1925 Pierre Naville and some other members of the Surrealist group wholly rejected the idea as a contradiction in terms.[70] Breton, however, was unwilling to take his own manifesto so literally. Painting might be a "lamentable expedient," but it was an expedient nevertheless. The automatic drawings of André Masson, reproduced in the first number of *La Révolution Surréaliste*, were Surrealist in inspiration yet unquestionably art; the same was true of Miró's fantasies and Ernst's disturbing dream images of that period. Though at the time of the manifesto Surrealist art was more a possibility than an actuality, four years later, in *Le Surréalisme et la peinture*, Breton was able to describe if not define it by its entelechy. It was generally agreed that the mere presence of form did not prevent paintings from being Surrealist. Art would be a *means* of expression,

an instrument of self-discovery, not an *end* to be savored. *Surrealist identity would hinge on the methodological and iconographic relevance of the picture to the main ideas of the movement, that is, automatism and the "dream image."*

As Surrealist painting emerged in its heroic period—between the first (1924) and the second (1929) manifestoes—it bipolarized stylistically in accord with the two Freudian essentials of its definition. Automatism (the draftsmanly counterpart of verbal free association) led to the "abstract"[71] Surrealism of Miró and Masson, who worked improvisationally with primarily biomorphic shapes in a shallow, Cubist-derived space. The "fixing" of dream-inspired images influenced the more academic illusionism of Magritte, Tanguy, and Dali. We tend to think of Miró and Masson primarily as painters (*peintres*), in the sense that the modernist tradition has defined painting; we think of the latter artists more as image-makers (*imagiers*). The styles of all Surrealist painters are situated on the continuum defined by these two poles. That of Max Ernst—the "compleat Surrealist"—oscillated between them. Both kinds of painting were done virtually throughout the history of the movement, though the automatist-"abstract" vein dominated the pioneer years and the period of World War II. In between, oneiric illusionism held sway.

The common denominator of all this painting was a commitment to subjects of a visionary, poetic, and hence, metaphoric order, thus the collective appellation, *peinture-poésie*, or poetic painting, as opposed to *peinture-pure*, or *peinture-peinture*, by which advanced abstraction was sometimes known in France. Surrealists never made nonfigurative pictures. No matter how abstract certain works by Miró, Masson, or Arp might appear, they always allude, however elliptically, to a subject. The Cubists and Fauvists selected motifs in the real world but worked *away* from them. The Surrealists eschewed perceptual starting points and worked *toward* an interior image, whether this was conjured improvisationally through automatism or recorded illusionistically from the screen of the mind's eye.

This visionary iconography, which was intended to reveal unconscious truths that were heretofore assumed to be inaccessible, was sometimes inspired by the literature that interested Surrealism,[72] but was more often of an entirely

JOAN MIRÓ. *Landscape with Rooster*. 1927. Oil on burlap, 51¼×77 inches. Collection Mr. and Mrs. John Gilbert Dean, North Scituate, Rhode Island

personal order, though certain psychological constants in human nature—and their concomitant symbols—naturally tended to manifest themselves. However "abstract" its figuration, the Surrealist picture almost always contained those irrational juxtapositions of images common in free association and dreams.

The first phase of Surrealist painting was improvisational and "abstract." Both Miró and Masson made the transition from Cubism to fantasy art in 1924, and the following year Ernst, under the direct influence of the text of the manifesto, began the *frottage* drawings that redirected his art into a non-illusionist vein.

Joan Miró: 1924–1929

Despite his considerable success as a decorative Cubist, Miró had found himself constrained and frustrated by that style's rigor and objectivity. Introduced into the Surrealist circle in 1924 by Masson, with whom he had adjoining

studios, Miró felt suddenly liberated. He became obsessed with poetry—"I gorged myself on it all night long"[73]— and was excited by the possibilities of automatism as a way of realizing poetry in visual form.

The Tilled Field (fig. 83) is a major document of Miró's transition. The flat surface of this decorative farm vista is bisected by an absolutely straight horizon line which, with salient diagonals, divides the surface into geometrical shapes that in turn enclose the small ornamental forms of the farmyard denizens. If the stylized realism that dominates the picture adheres to the Synthetic Cubist manner in which Miró was then painting, the lizard in a dunce cap who scans a newspaper is a harbinger of his Surrealist whimsy, as are the giant ear and eye that sprout from the trunk and foliage of a tree. The shapes of this ear and eye also announce the biomorphology that by the end of 1925 would dominate Miró's painting and serve as a vehicle for his fantasy. The evenly painted, sharply contoured execution continued to remain an option for Miró throughout

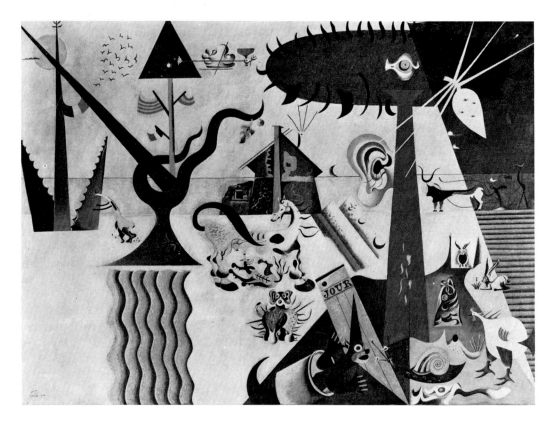

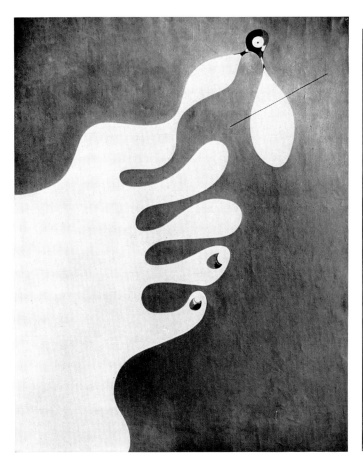

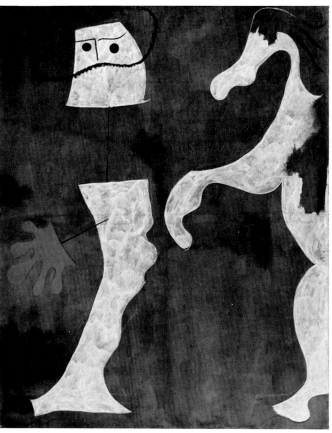

84 JOAN MIRÓ. *Hand Catching a Bird*. 1926. Oil on canvas, 36¼ × 28¾ inches. Collection Vicomtesse de Noailles, Paris

85 JOAN MIRÓ. *The Gendarme*. 1925. Oil on canvas, 8 feet 1¾ inches × 6 feet 4⅞ inches. Collection Mrs. Ernest Zeisler, Chicago

opposite
83 JOAN MIRÓ. *The Tilled Field*. 1923–1924. Oil on canvas, 26 × 37 inches. Collection Mr. and Mrs. Henry Clifford, Radnor, Pennsylvania

the twenties, but the Surrealist content prompted a freer alternative method of picture-making.

Miró was now leaving the Cubists behind with a vengeance—"I shall break their guitar"[74]—and although Cubist space and certain Cubist compositional distributions continued to inhabit the infrastructure of his pictures,[75] the over-all appearance of these images was decidedly new. During the next few years, and to a lesser extent, until World War II, Miro's work oscillated between the poles of carefully planned, tightly painted, flat patterning, exemplified by the whimsical *Hand Catching a Bird* (fig. 84), and the loosely painted, "automatic" improvisations, of which the monumental *The Birth of the World* (fig. 87) constitutes the most remarkable example. *Landscape with Rooster* (page 65) typifies the bulk of Miró's work, which fell stylistically between these extremes.

The most "automatic" pictures have been much appreciated by post-World War II painters, but unfortunately many of the best of these, including *The Birth of the World* and *The Gendarme*, have never been exhibited in this country. In *The Birth of the World*, Miró poured a blue wash over lightly primed burlap and then, using rags and a sponge, spread it rapidly in a "random" manner. Within the pictorial chaos of these patches, which suggested iconographically a primordial sea, he began to improvise with painted lines that in turn led to flat percussive shapes of black and primary colors. Together these suggested an incipient iconography of living creatures. *The Gendarme* (fig. 85) exemplifies the boldness and spareness characteristic of the automatic manner. Letting his brush wander freely over the brown ground, Miró found forms that began to suggest a horse's head and a human hand; a few lines and touches of color sufficed to conjure a policeman signaling "Stop."

"Rather than setting out to paint something," Miró said later of his method, "I begin painting and as I paint the picture begins to assert itself, or suggest itself under my brush. The form becomes a sign for a woman or a bird as I work. . . . The first stage is free, unconscious."[76] Such pictures as *The Birth of the World* had prompted Breton to write that it was "by such pure psychic automatism that [Miró] might pass for the most 'surrealist' of us all."[77] But in fact Miró's automatism was not pure, nor even as rapid or little edited as some of Masson's. Pure automatism, like pure accident, is inimical to art and it is noteworthy that Miró qualified the description of his procedures cited above by adding that "the second stage is carefully calculated."

Though Miró's genius as a colorist was not entirely realized until the thirties, his earlier pictures already established him as the greatest colorist in the generation after Matisse. From the latter he learned to stay away from the heavy impastos that are alien to the insubstantial, essentially optical nature of color; Miró's paint is either brushed out so as to look transparent, as in the blue ground of the *Man with a Pipe* (fig. 88), or brushed over until a texture-less evenness is obtained.

Certain of Miró's collages of the late twenties are among the few exceptions to this reluctance to draw attention to the physical presence of the picture surface. In the two versions of *Spanish Dancer* (figs. 90, 91), the sandpaper, metal, and string force the eye to adjust successively to their various surfaces. But Miró provides such experiences only in contexts where color is not an issue.

86 below JOAN MIRÓ. *The Harlequin's Carnival.* 1924–1925. Oil on canvas, 25¼ × 35⅞ inches. Albright-Knox Art Gallery, Buffalo

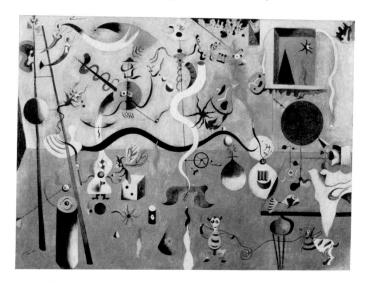

opposite
87 JOAN MIRÓ. *The Birth of the World.* 1925. Oil on canvas, 8 feet ½ inch × 6 feet 4¾ inches. Collection René Gaffé, Cagnes-sur-Mer (Alpes-Maritimes), France

88 left JOAN MIRÓ. *Man with a Pipe.* 1925. Oil on canvas, 57²/₈ × 45 inches. Private collection

89 right JOAN MIRÓ. *Automaton.* 1924. Pen and ink, 18 × 24 inches. Collection Mr. and Mrs. Morton G. Neumann, Chicago

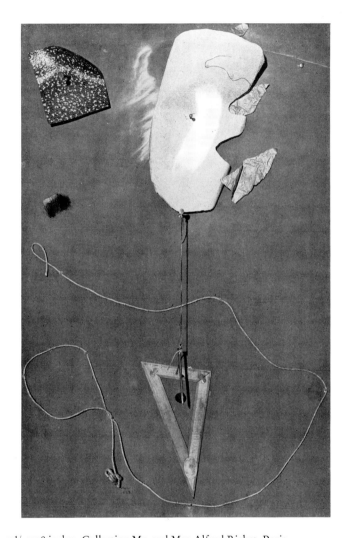

90 left JOAN MIRÓ. *Spanish Dancer*. 1928. Pasted paper and charcoal, 40¹/₈ × 28 inches. Collection Mr. and Mrs. Alfred Richet, Paris

91 right JOAN MIRÓ. *Spanish Dancer*. 1928. Collage of sandpaper, string, and nails, 41³/₄ × 26³/₄ inches. Collection Mr. and Mrs. Morton G. Neumann, Chicago

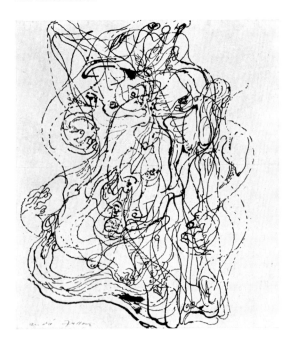

92 ANDRÉ MASSON. *Automatic Drawing.* (1924). Ink, 9^1/$_2$ × 8 inches. Private collection

André Masson: 1924–1929

At the time of André Masson's contact with the Breton circle in the winter of 1923/1924 his painting was unabashedly Analytic Cubist. And as that refined and studied mode of execution left no opening for automatism, for a few years Masson exploited this method only in drawings, the form in which he expressed himself best throughout his career. The automatic drawings (fig. 92) were begun with no subject or compositional distribution in mind. Letting his pen travel rapidly across the paper in a mediumist fashion, he soon found hints of images—anatomical fragments and objects—manifesting themselves within the "abstract" web. Sometimes these clues were slightly detailed by conscious elaborations with the pen, but they were always left in an ambiguous state; at the same time, changes and additions were made to endow the image with a satisfactory aesthetic structure, but always without halting the rapid movement of the pen.

Masson's line quickly took on a very particular character. In contrast to Miró's relaxed and sensuous lyricism, Masson's sudden redirections and frequently convoluted and angular contours, which admitted no revisions, conveyed a sense of overwhelming urgency and conflicting impulses. The seismographic nature of the markings suggested a hand responsive to the most minute variations within the psyche.

Although Miró had been able to find a way of accommodating his easygoing automatism to the possibilities of oil painting by the beginning of 1925, Masson seemed unable to realize his urgent draftsmanship with brush and paint. Nor could he translate his powerful aggressive and erotic impulses into anything like the formal vocabulary he inherited from Analytic Cubism. It was inevitable that his new poetic subject matter should engender changes in the calm architectural scaffolding he had been using; and if he could not make his painting automatic, he could at least change its motifs and morphology. Just as Miró's Synthetic Cubism began in 1924 to assimilate a new fantasy content, and its attendant biomorphism, so the Analytic Cubism of Masson gradually accommodated imagery of a type never contemplated by the originators of the style. The torso in *Woman* (fig. 93) is not resolved in a scaffolding of rectilinear accents but reconstitutes itself as an Earth Mother whose botanical "organs" have become universal symbols of generation. Metamorphosis thus became the informing principle of Masson's new iconography, which fused the image of man with that of the earth, the animal world, and the heavens.

As *The Haunted Castle* illustrates (fig. 94), the winter of 1926/1927 found Masson striving for a way to endow his paintings with the discoveries of automatic drawing. In the center of this picture the Cubist scaffolding has dissolved under the pressure of the meandering line, though it persists in the margins. But painting was unalterably resistant to the rapid and extended linear automatism Masson wanted. Constant reloading of the brush broke the continuity of the line as well as the sequence of psychic impulses, while the drag of the brush prevented the rapid execution that was possible with pen or pencil.

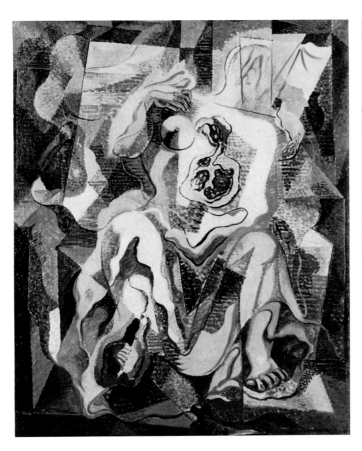

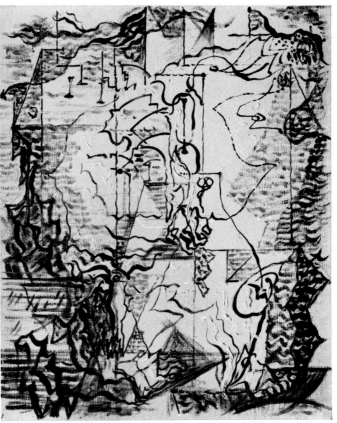

93 ANDRÉ MASSON. *Woman*. 1925. Oil on canvas, 28³/₄ × 23¹/₂ inches.
Collection Dr. and Mrs. Paul Larivière, Montreal

94 ANDRÉ MASSON. *The Haunted Castle*. (1927). Oil on canvas,
18¹/₂ × 15³/₈ inches. Collection Mr. and Mrs. Claude Asch, Strasbourg

Masson's resolution of the problem took the form of the remarkable sand and tube-painted pictures of 1927. In many of these the brush was eliminated almost entirely. Glue was spilled on the raw canvas and "drawn" out over the surface with the fingers. Sand was poured over the surface, and after the stretcher was tilted, remained only in those areas. In pictures such as *Two Death's-Heads* (fig. 95), the process was repeated with different colored sands to produce a relief-like layering. The application of sand was followed in most instances by drawing with paint squeezed from a specially constructed large tube. In *Painting (Figure)* the drawing descants the sand patterns with suggestions of birds and fish that metamorphose into a figure (fig. 96) In *The Villagers* (fig. 97) the linear counterpoint remains marginal, allowing the flat patterns of sand and color to dominate.

The sand and tube-painted pictures represented the high point of Masson's *élan*. But unlike Miró, he seemed not to know where his best possibilities lay, and instead of developing the sand style, he relaxed into a more familiar curvilinear Cubist manner during the final years of the decade.

96 ANDRÉ MASSON. *Painting (Figure)*. (1927). Oil and sand on canvas, 18 × 10¹/₂ inches. Private collection

95 ANDRÉ MASSON. *Two Death's-Heads*. (1927). Oil and sand on canvas, 5⁵/₈ × 9⁵/₈ inches. Collection Mr. and Mrs. E. A. Bergman, Chicago

opposite
97 ANDRÉ MASSON. *The Villagers*. (1927). Oil and sand on canvas, 31⁷/₈ × 25⁵/₈ inches. Private collection

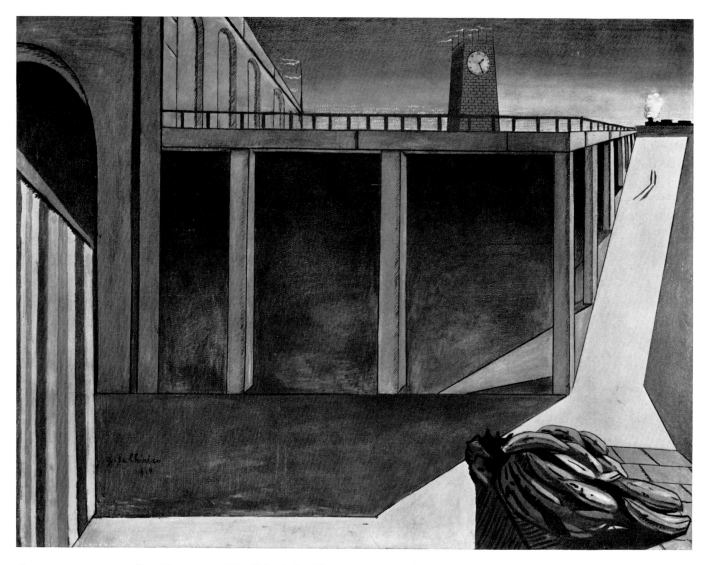

98 GIORGIO DE CHIRICO. *Gare Montparnasse (The Melancholy of Departure).* 1914. Oil on canvas, 55¹/₈ × 72⁵/₈ inches. Collection James Thrall Soby, New Canaan, Connecticut

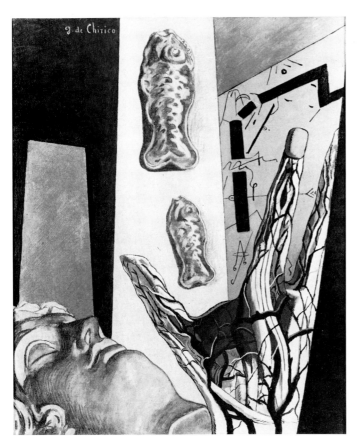

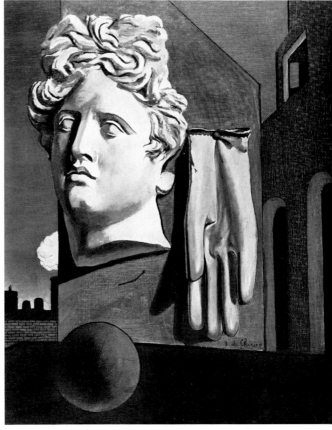

99 GIORGIO DE CHIRICO. *The Span of Black Ladders.* (1914). Oil on canvas, 24¹/₄ × 18⁵/₈ inches. Collection Mr. and Mrs. James W. Alsdorf, Winnetka, Illinois

100 GIORGIO DE CHIRICO. *The Song of Love.* (1914). Oil on canvas, 28³/₄ × 23¹/₂ inches. Private collection

Giorgio de Chirico and Surrealist Illusionism

"Abstract" Surrealism emerged from an iconographic, morphological, and methodological restructuring of Cubism which left almost no immediately recognizable vestiges of the earlier style. But illusionist Surrealism—Magritte, Tanguy, and Dali—was always to manifest its debt to Giorgio de Chirico. So influenced was this trend by both his style and iconographic ordering that de Chirico has frequently been misrepresented as a Surrealist himself, yet his important work terminated in 1917, seven years before the formal establishment of the movement.

De Chirico's mature style appeared *sui generis* in the con-

text of modern painting. It seemed no more related to Cubism than it did to Dada, which was working its way out of formal abstraction in the same years. Seemingly neither modernist art, nor anti-art, it appeared to revert to the illusionism of the Renaissance from which it derived the spatial "theater" it bequeathed to Surrealism. The idealized architecture of de Chirico's streets and piazzas recalled—in Leopardian silence and nostalgia—the Italy of another epoch.

It was with the art of the *quattrocento* that de Chirico felt his closest affinity. As in Piero della Francesca and Uccello, the foreground figures and objects in *The Philosopher's Conquest* (fig. 101), *The Double Dream of Spring* (fig. 103), and *The Disquieting Muses* (fig. 104) occupy

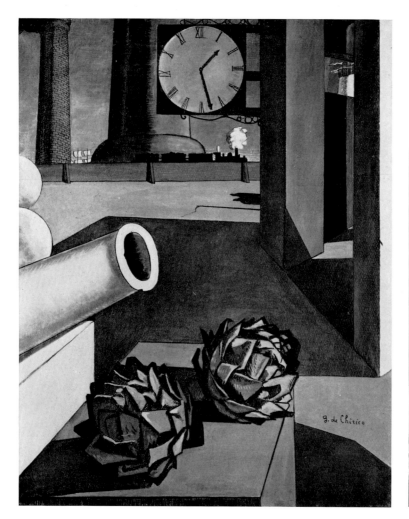

101 left GIORGIO DE CHIRICO. *The Philosopher's Conquest.* (1914). Oil on canvas, 49¹/₂ × 39¹/₄ inches. The Art Institute of Chicago, the Joseph Winterbotham Collection

102 right GIORGIO DE CHIRICO. *The Mystery and Melancholy of a Street.* 1914. Oil on canvas, 34¹/₄ × 28¹/₈ inches. Private collection

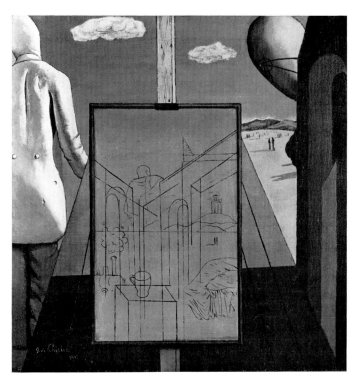

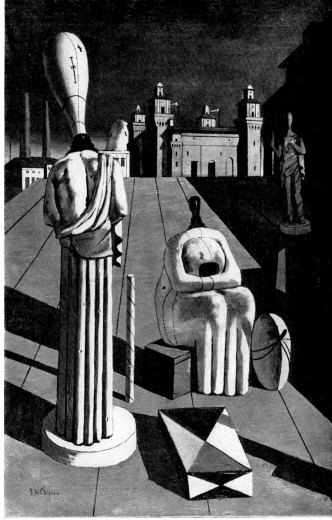

103 left GIORGIO DE CHIRICO. *The Double Dream of Spring.* 1915. Oil on canvas, 22¹/₈ × 21³/₈ inches. The Museum of Modern Art, New York, Gift of James Thrall Soby

104 right GIORGIO DE CHIRICO. *The Disquieting Muses.* (1917). Oil on canvas, 38¹/₄ × 26 inches. Collection Gianni Mattioli, Milan*

a frontal space that is separate from the background which is treated as a foil or backdrop. The High Renaissance continuity of space through the middle ground, as in the mature Raphael, is alien to him, as is its aerial or atmospheric perspective.

But de Chirico's classical world was not recollected in tranquility. The pervasive malaise of his vision ended by denying the ordered, rational structure of experience proposed by fifteenth-century art. And this denial was even more a matter of formal than of literary content.[78] In a style that constitutes as much a parody as an adaptation of Renaissance art, de Chirico revealed, at least by 1913, a more subtle insight into Cubism than did his Futurist compatriots, while his imagery, by "irrationalizing" the cosmos of the *quattrocento*, reflected the unstable mood of the early twentieth century with a vividness equal to theirs.

As against single-point perspective, which reflected the unity of purpose and stability of the Renaissance, the orthogonals of such paintings as *The Mystery and Melancholy of a Street* (fig. 102) and *The Span of Black Ladders* (fig. 99), with their multiple and conflicting vanishing points, project an atmosphere of uncertainty. The space is more dreamlike than real, as are the absolute silence and the white, non-atmospheric "interior" light. This enigmatic light, which recalls that of Henri Rousseau, sometimes casts no shadows, seeming to make the objects it illuminates apparitional; at other times, as in *The Mystery and Melancholy of a Street*, it casts distorted shadows of invisible bodies, suggesting the proximity of menacing presences.

Unlike the monumental painting of the *quattrocento*, in which modeling in the round created the illusion of space-displacing solid forms, de Chirico's shading and shallow, virtually ungraduated modeling deny bulk and render his figures flat and spectral. And though his orthogonals would seem schematically to indicate retreating space, the bland, unmodeled surfaces of the planes they delineate remain paradoxically flat on the surface, as on a screen. All this indicates, as in the boldly designed *Gare Montparnasse* (fig. 98), a greater affinity with Synthetic Cubism than with old-master illusionism.

While Magritte, though sacrificing de Chirico's fluency of touch and semi-transparent *matière*, retained a some-

what comparable standard of abstraction, Tanguy and Dali altered the de Chirico style in a way that put them at a much greater remove from the mainstream of modern painting. Their crystalline surfaces, in which all traces of brushwork and impasto have been suppressed, their modeling in the round, and their atmospheric perspective recall Meissonier more than Piero. Despite de Chirico's parentage of Surrealist illusionism, his own work is finally closer stylistically, though not poetically, to Matisse and Mondrian than to Tanguy and Dali.

De Chirico's undermining of the rational classical world was expressed iconographically through enigmatic combinations of objects, usually autobiographical and often sexual in content. The association of the head of the *Apollo Belvedere*, a surgeon's glove, a ball, and a steam locomotive in the exquisitely colored *Song of Love* (fig. 100) has the simplicity and poignancy of Lautréamont's famous image. We feel that these objects have been retrieved from the edge of memory. Some of them recall de Chirico's childhood in Greece and the world of his engineer father. In *The Philosopher's Conquest* (fig. 101), the juxtaposition of cannon, balls, and artichokes evokes a veiled eroticism that is more usually expressed in de Chirico's paintings by the towers and arcades of his dream architecture.

De Chirico was the first to translate Lautréamont's poetic paradigm into painting; Duchamp's images on glass and compound Readymades came later. While the Surrealists—Magritte excepted—were to use the principle as a springboard for hybrid fantasies and fantastical metamorphoses, de Chirico rarely altered or abstracted the objects he represented. As in dreams, the approach to reality was selective, but the prosaism of dream imagery was maintained. "Yet even if the exterior aspect of the object is respected," Breton observed, "it is evident that this object is no longer cherished for itself, but solely as a function of the signal that it releases . . . [de Chirico] retains only such exterior aspects of reality as propose enigmas or permit the disengagement of omens and tend toward the creation of a purely divinatory art."[79]

The only seemingly "invented" forms we see in de Chirico's paintings are the mannequins, such as the one peering from the corner of *The Double Dream of Spring*

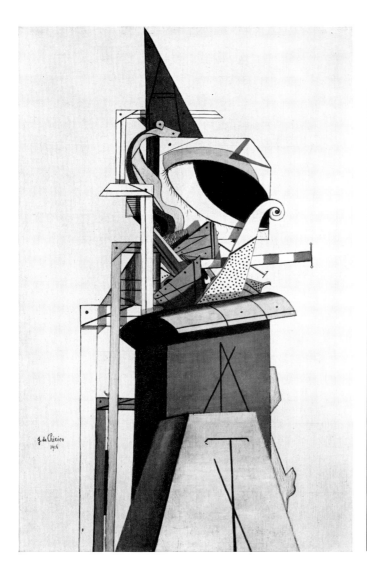

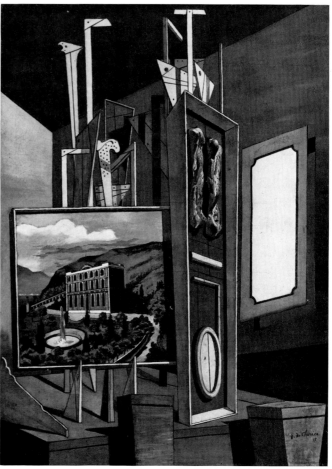

105 GIORGIO DE CHIRICO. *The Jewish Angel.* 1916. Oil on canvas, 26¹/₂ × 17¹/₄ inches. Penrose Collection, London

106 GIORGIO DE CHIRICO. *Grand Metaphysical Interior.* 1917. Oil on canvas, 37³/₄ × 27³/₄ inches. Collection James Thrall Soby, New Canaan, Connecticut

(fig. 103) or the immobile columnar presences in the monumental *Disquieting Muses* (fig. 104). Devoid of features and frequently deprived of limbs, these mannequins are charged with pathos, especially when playing the roles of lovers out of antique literature. But these, too, have a realistic source, insofar as they were partially derived, as probably were Duchamp's *Nine Malic Molds*, from tailor's dummies. Even the strange scaffoldings, which support the giant eye in *The Jewish Angel* (fig. 105) and the boxed pictures in the *Grand Metaphysical Interior* (fig. 106), seem like objects from the phenomenological world. They represent, more or less, translations of abstract Analytic Cubist structures into suggestions of studio carpentry.

In 1917 de Chirico suddenly lost his muse and began his progression toward the kind of meretricious painting that has since been associated with his name. Though Breton became disenchanted with de Chirico's subsequent pictures, he looked back on the painter as a "great sentinel" on the route to be traveled by Surrealism. Lautréamont and de Chirico, wrote Breton, were the "fixed points" that "sufficed to determine our straight line."[80]

Max Ernst: 1921–1929

Max Ernst's paintings of 1921–1924 (figs. 109, 111) formed a link between the de Chirico style and Surrealist illusionism. They combined de Chirico's spatial theater with ideas derived from Ernst's own Dada collages. The fantastical conception of *The Elephant Celebes* (page 84), for example, is collage-engendered, while the three-dimensional modeling of the monster's "trunk" and "body," and its relation to the horizon, go beyond de Chirico in the direction of a consistent illusionism. Translated into *trompe-l'œil* painting and enlarged in size, Ernst's hybrids took on a more intense reality.

This proto-Surrealist phase was realized mostly in Paris, where Ernst went in the summer of 1922; in the history of the avant-garde there, it coincided with the transitional *époque floue*. It terminated with his three-month trip to the Far East in July 1924, which was followed by a virtual lacuna in Ernst's work for about nine months. When he resumed in August 1925, it was in a new and more "abstract" manner.

On his return to Paris, toward the end of 1924, Ernst found avant-garde circles exercised by the appearance of Breton's Surrealist manifesto, which had been issued in October. And he himself tells us that his new automatic manner—based on *frottage* (rubbing)—was developed "under the direct influence of the information concerning the mechanism of inspiration" suggested there.[81] It certainly also reflected his confrontation of the new work of Miró and Masson, who had established their "abstract" Surrealist manners during the previous year.

Ernst gives the following account of the inception of *frottage*:

> . . . I was struck by the obsession imposed upon my excited gaze by the wooden floor, the grain of which had been deepened and exposed by countless scrubbings. I decided to explore the hidden symbolism of this obsession, and to aid my meditative and hallucinatory powers, I derived from the floorboards a series of drawings by dropping pieces of paper on them at random and then rubbing them with black lead. . . . The drawings thus obtained steadily lost the character . . . of the wood, thanks to a series of suggestions and transmutations that occurred to me spontaneously (as in hypnagogic visions), and assumed the aspect of unbelievably clear images probably revealing the original causes of my obsession. . . .
>
> I marveled at the results and, my curiosity awakened, I was led to examine in the same way all sorts of materials that I happened upon: leaves and their veins, the ragged edges of sackcloth, the palette knife markings on a "modern" painting, and so forth. . . .[82]

The rubbing—more inherently accidental than automatic drawing—provided random patterns that Ernst altered in varying degrees as he envisioned Gestalts of fantastic landscapes, animals, and hybrids. Drawings such as *The Ego and His Own* (fig. 112) reveal both an imagination and a sensibility to the aesthetic possibilities of light and dark that rival Redon's.

Ernst soon accommodated this technique of provoking inspiration to the medium of oil painting by scraping paint off prepared canvases while they were lying on materials such as wire mesh, chair caning, and haphazardly coiled twine. The twine might also be dipped in paint and

107 *Exquisite Corpse (Cadavre Exquis)* by Man Ray, Yves Tanguy, Joan Miró, Max Morise. (1928). Pen and ink and crayon, $13^3/8 \times 8^1/2$ inches. Collection Mr. and Mrs. E. A. Bergman, Chicago

108 *Exquisite Corpse (Cadavre Exquis)* by Esteban Francés, Remedios Lissarraga, Oscar Dominguez, Marcel Jean. (1935). Collage of pasted papers, $10^1/2 \times 8$ inches. Collection Marcel Jean, Paris

Exquisite Corpse

Among Surrealist techniques exploiting the mystique of accident was a kind of collective collage of words or images called the cadavre exquis *(exquisite corpse). Based on an old parlor game, it was played by several people, each of whom would write a phrase on a sheet of paper, fold the paper to conceal part of it, and pass it on to the next player for his contribution. The technique got its name from results obtained in an initial playing, "Le cadavre exquis boira le vin nouveau" (The exquisite corpse will drink the young wine). The game was adapted to the possibilities of drawing and even collage by assigning a section of a body to each player, though the Surrealist principle of metaphoric displacement led to images that only vaguely resembled the human form.*

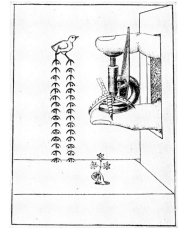

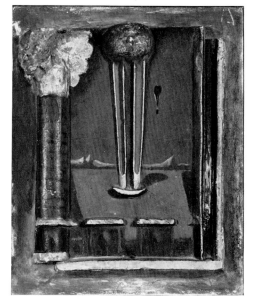

109 above MAX ERNST. *Œdipus Rex*. 1922. Oil on canvas, 36⁵/₈ × 40¹/₄ inches. Private collection*

110 above right MAX ERNST. *The Invention*. (1922). Illustration in Paul Eluard, *Répétitions* (Paris, 1922)*

111 below right MAX ERNST. *Free Balloon*. (c. 1922). Painted tile, 14¹/₄ × 9⁷/₈ inches. Private collection

opposite
MAX ERNST. *The Elephant Celebes*. 1921. Oil on canvas, 49¹/₄ × 42 inches. Penrose Collection, London

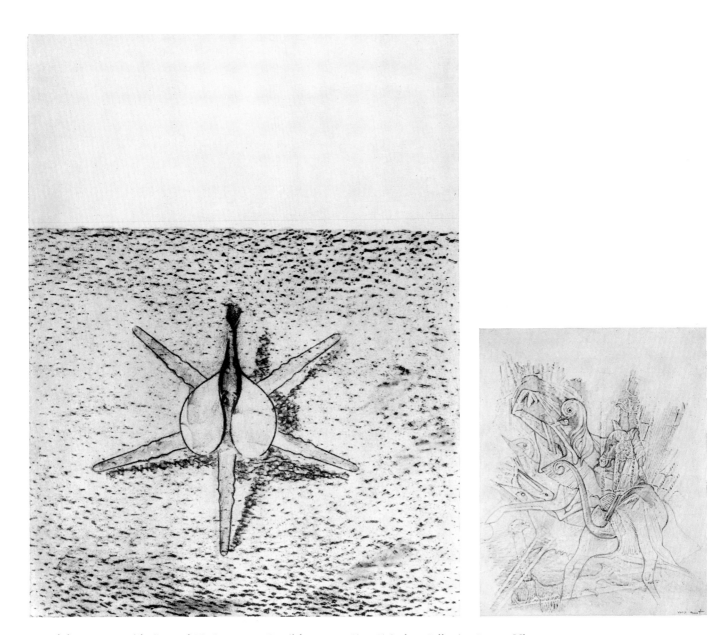

112 left MAX ERNST. *The Ego and His Own*. 1925. Pencil frottage, 10¼ × 7⅞ inches. Collection Arman, Nice

113 right MAX ERNST. *Stallion*. (c. 1925). Pencil frottage, 12 × 10 inches. Collection Mr. and Mrs. Joseph R. Shapiro, Oak Park, Illinois

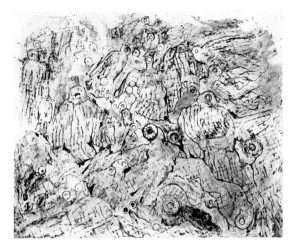

114 left MAX ERNST. *To 100,000 Doves*. (1925). Oil on canvas, 32 × 39¹/₂ inches. Collection Mme Simone Collinet, Paris

115 below MAX ERNST. *Blue and Rose Doves*. (1926). Oil on canvas, 31⁷/₈ × 39³/₈ inches. Kunstmuseum, Düsseldorf

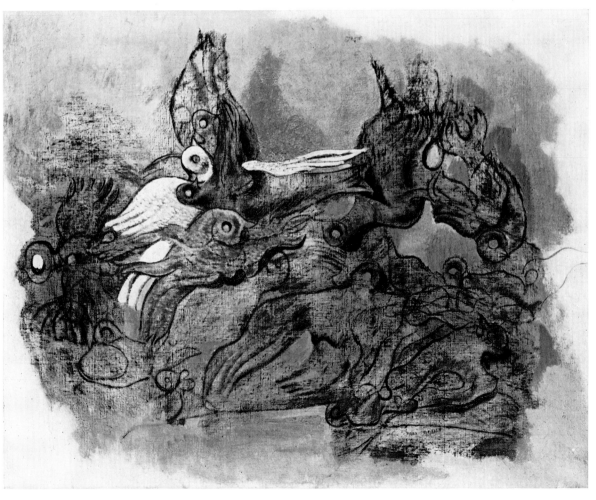

dropped on the face of the canvases, just as wood slats and other materials could be lightly pigmented and "printed" on the surface. The series of which *To 100,000 Doves* (fig. 114) and *Blue and Rose Doves* (fig. 115) are outstanding examples was executed largely by the scraping method. The creamy, seductively textured surface of the former was a new thing for Ernst, and quite opposite in character to the tight, dry handling of his proto-Surrealist pictures. In the mass of painterly cues obtained by scraping, he divined the presence of myriad birds whose heads and bodies he then "materialized" by brushing in some contours and details. The absence of modeling—Ernst preferred to maintain only the delicate value gradations achieved through *frottage*—the fragmentation of forms, the shallow space, and the dissolution of the pattern near the frame all echo the late Analytic Cubism which that same year was undergoing a not unrelated metamorphosis in the hands of Masson. *Blue and Rose Doves* is less crowded in its patterning than *To 100,000 Doves*. Though the lines occasioned by the string *frottage* meander freely over the surface, their pattern is still comfortably adjusted to the frame.

Ernst's obsession with birds, which was celebrated in the Dove series, led him to a hallucinatory identification with them; around 1930 he created an alter ego, a sort of avian *Doppelgänger*, christened Loplop, Superior of the Birds. Loplop's features are only schematically indicated in the "Loplop Introduces" collages of 1932, but elsewhere his elongated, anthropomorphic appearance was not without a curious resemblance to the painter himself.

The years 1925–1928 were the finest and most productive in Ernst's career, and almost all the series he undertook then—the "Forests," "Hordes," "Shell Flowers" among them—were in some way dependent upon *frottage*. In the *Snow Flowers* (fig. 117), the painterly "blossoms" produced by this technique were handsomely set off by the flat grounds on which they were "randomly" spotted. The scene of *Chaste Joseph* (fig. 118) is set in a "woods" derived from a *frottage* of wood planks comparable in effect to those in the Forest series. The patterns of flat color represent a pair of biomorphic bird-personages whose nuptials—a hallucination of standard images such as Raphael's *Sposalizio*—are blessed by an avian high priest, a forerunner of Loplop.

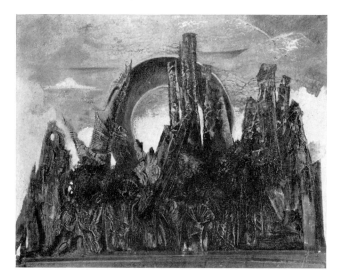

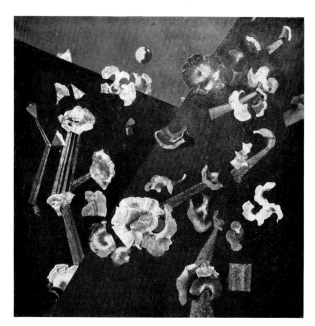

116 above MAX ERNST. *Forest.* (1927). Oil on canvas, 44⁷/₈ × 57¹/₂ inches. Collection Mr. and Mrs. Joseph Slifka, New York

117 below MAX ERNST. *Snow Flowers.* (1927). Oil on canvas, 51⁵/₈ × 51⁵/₈ inches. Collection F. C. Graindorge, Liège

opposite
118 MAX ERNST. *Chaste Joseph.* 1928. Oil on canvas, 63 × 51¹/₄ inches. Collection A. D. Mouradian, Paris

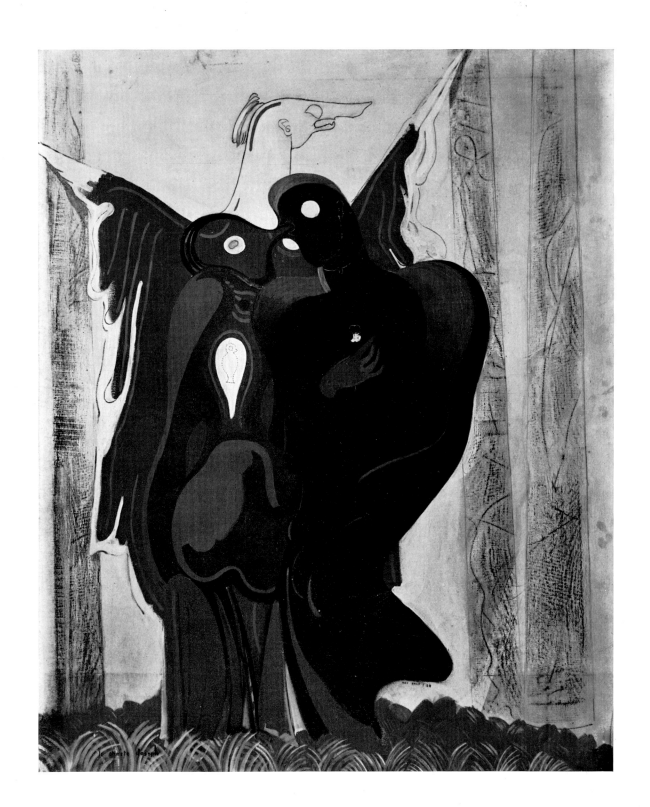

RENÉ MAGRITTE. *The Conqueror.* (1925). Oil on canvas, 25³/₈ × 29⁵/₈ inches. Collection Eric Estorick, London

René Magritte

The first year of Surrealist painting following the publication of the manifesto had witnessed the total dominance of the automatism so emphasized in its text. But late in 1925 the Belgian painter René Magritte, under the influence of de Chirico, renewed "dream image" illusionism, and about a year later Tanguy adapted the biomorphology of Arp and Miró to the same spatial theater. Not until Dali burst onto the scene in 1929, however, did this form of Surrealist painting become dominant.

The style Magritte established in 1925 remained essentially the same to the end of his life.[83] He sought an almost total prosaism in the things he represented; his art contains few of the bizarre beings of Ernst, none of the "paranoid" fantasies of Dali. Rarely—as in *The Conqueror* (page 90)—did he form a figure on the basis of a *trompe-l'œil* of collage; but even then, the integrity of the individual constituents was respected. In his greater closeness to de Chirico,

Magritte distinguishes himself from the other Surrealists by the technical devices—*frottage*—and aesthetic formulation—biomorphism—he eschews.[84] In an attempt to create a purely poetic image, he sought to by-pass modernist painting, though the handsomeness and economy of his compositions recall his apprenticeship as an abstractionist. The originality of his images—though not the measure of their pictorial quality—lies in the secret affinities between dissociated objects revealed by means of Lautréamont's poetic principle.

The paintings produced during the first three years of Magritte's maturity were dark in mood and in color. The cannibalistic violence of *Pleasure* (fig. 119) and the frustrating isolation of *The Lovers* (fig. 120) are more intense than the impersonality, irony, and dead-pan humor his later painting allowed. Overwhelmingly black and brown, they are devoid of the decorative qualities introduced by 1929 in *On the Threshold of Liberty* (fig. 124) and emphasized in recent paintings such as *Arch of Triumph*,

119 RENÉ MAGRITTE. *Pleasure.* (1926). Oil on canvas, 29$^{1/2}$ × 39$^{3/8}$ inches. Collection Gerrit Lansing, New York

120 RENÉ MAGRITTE. *The Lovers.* (1928). Oil on canvas, 21$^{3/8}$ × 28$^{7/8}$ inches. Collection Richard S. Zeisler, New York

121 left ODILON REDON. *Light*. (1893). Lithograph, 15 7/16 × 10 3/4 inches. The Museum of Modern Art, New York, Gift of Victor S. Riesenfeld*

122 below left RENÉ MAGRITTE. *Personal Values*. 1952. Oil on canvas, 31 5/8 × 39 1/2 inches. Collection Jan-Albert Goris, Brussels

123 below right CLAES OLDENBURG. *Colossal Fagend, Dream State*. 1967. Pencil, 30 × 22 inches. Collection Alfred Ordover, New York

the background of which suggests Magritte's assimilation of the decorative "all-over" configurations familiar in abstract painting after World War II.

The cannon that penetrates the room in *On the Threshold of Liberty* recalls de Chirico's symbolism, in which, however, the psychosexual implications seemed less close to the surface of consciousness. The compartments that form the walls of the chamber display some of Magritte's recurrent and more elliptical motifs—forest, sky, façade, paper cutout, flames, sleigh bells, wooden planks. The truncated torso of a woman diagonally opposite the cannon suggests the first metaphoric leap which sets in motion the chain of associations.

In *Personal Values* (fig. 122) the wall of the room is made of sky, and through the technique of scale dissociation, the toilet articles have been rendered Gargantuan. Though anticipated by Redon (fig. 121), this effect was derived directly from results obtained in collage when fragments of images taken from sources with different scales were juxtaposed. Ernst had converted such collage discoveries into *trompe-l'œil* painting in *Œdipus Rex* (fig. 109), while Duchamp's miniaturized French window, *Fresh Widow* (its title suffered a head cold), had represented a translation of the same principle from the world of pictorial illusion to that of objects. Though also inspired by outdoor advertising, Claes Oldenburg's *Giant Fagends* (fig. 125) and, above all, his projected city monuments, mark a recent development of this idea. His *Colossal Fagend, Dream State* (fig. 123), a sketch for such a city monument, gives a Pop Art brashness to the sexual connotations which are usually more veiled in Surrealist symbols.

124 above RENÉ MAGRITTE. *On the Threshold of Liberty*. (1929). Oil on canvas, 44⁷/₈ × 57¹/₂ inches. Museum Boymans-van Beuningen, Rotterdam

125 below CLAES OLDENBURG. *Giant Fagends*. 1967. Stuffed and painted canvas, Formica, and wood, 3 feet high × 8 feet wide × 6 feet 10 inches deep. The Kleiner Foundation, Beverly Hills, California, Courtesy Los Angeles County Museum of Art*

Words and Images

Magritte's *peinture-poésie* has been criticized as the simple translation of literary ideas into images. He replies that in his poetry-in-painting the image is "an idea capable of becoming visible *only* through painting," and that its nature is as inseparable from visualization as a poetic image is from verbalization. He might have added that merely reproducing any three-dimensional object on a delimited flat surface—that is, picturing it—automatically engenders a set of aesthetic rapports that have no necessary relation to the meaning of the object qua object.

If painting distinguishes the image of an object from the object itself, poetry does the same thing with the word for it. Certain of Magritte's pictures pair these *aperçus;* the painted image of the pipe in *The Wind and the Song* (fig. 129) releases different signals than either the word "pipe" or a real pipe. Hence the didactic legend "Ceci n'est pas une pipe" (This is not a pipe) inscribed on the surface of the picture. Elsewhere, as in *The Key of Dreams* (fig. 128), Magritte juxtaposed images of objects and logically unrelated words, suggesting that a "resonance" might exist between their signals.

The preoccupation with the use of words *in* images, and vice versa, was natural for the poet-painters of Dada and Surrealism, and it led to many novel combinations. It was hardly a new issue, however, having been explored as early as the Dark Ages by the Merovingian and Insular illuminators and as recently as by the Cubists. The Dadaists went far beyond the Cubists in composing pictures with letters and words connected syntactically, on occasion extending the texts into whole poems. The Surrealist phase began in 1924 with the illusionist "picture-poem" invented by Max Ernst—a three-dimensional projection of Apollinaire's *Calligrammes* (fig. 130). Here the words wind in and out of perspective space, sometimes creating an architecture of their own, sometimes fusing with the forms to which they refer, as for example, the words "grand amoureux" and the embracing arms of the lover in *Who Is that Very Sick Man* (fig. 131).[85] Miró's picture-poems of the following year reflect the vogue of automatism. The handwriting in his *Oh! One of Those Men Who's Done All That* (fig. 133) provides the rhythm that then arabesques

out over the surface to suggest—but only in a most schematic way—a narrative sexual confrontation. The text of *A Bird Pursues a Bee and "Kisses" It* (fig. 132) goes on to be more specific on a comparable theme; the track of the pursuing bird, who is composed of a collage of feathers, is traced by the unwinding letters of the word "poursuit." Norman Bluhm's spatter-and-drip-accenting of Frank O'Hara's poem *It's Raining* (fig. 134) represents an Abstract Expressionist counterpart of such automatic picture-poems.

Tanguy's picture-letter of January 28, 1933, to Paul Eluard (fig. 126) is another type of invention based on the fusion of words and images. The conceit requires that we imagine a perspective drawing of a letter folded into the morphological patterns of Tanguy's paintings. Some words disappear or are broken off by the projections of the biomorphic "hill town," and "birds" in the form of punctuation marks fly around the margins.

Picasso's association with the Surrealists led him to compose a quantity of automatic poetry which was joined to illustration. *At the End of the Jetty* (fig. 127) is a whimsical Surrealist poem[86] in a spirit typical of Picasso's poetry of the thirties and of his Surrealist play, *Desire Caught by the Tail.* It describes a coprophagous Ubu-esque bourgeois whose face is drawn alongside, his nose projecting into the handwritten text of the poem as though sniffing it.

Breton's contribution to these inter-aesthetic explorations was the poem-object, a miniature relief-assemblage in which various found objects were collaged to a picture surface in juxtaposition with fragments of poetry. In the beribboned *For Jacqueline* (fig. 135) the poem begins with a label that serves both visually and verbally, for the words "Carte resplendissante" on the label must be read with the words written on the accompanying strip of paper in order to arrive at the first line of the poem. The relationship between words and object may also be mimetic, as with the phrase "jardin de la pendule" (garden of the clock) which is coupled with a flower made of clock parts. Breton departed from the poetic in the same way as Magritte did from the plastic, in these efforts, "to combine the resources of poetry and plasticity and speculate on their power of reciprocal exaltation."[87]

126 YVES TANGUY. *Letter to Paul Eluard.* 1933. Pen and ink, 10½ × 7½ inches. The Museum of Modern Art, New York

127 PABLO PICASSO. *At the End of the Jetty.* 1937. Pen and ink, 11¼ × 8¼ inches. Collection Mr. and Mrs. Lee V. Eastman, New York

128 RENÉ MAGRITTE. *The Key of Dreams.* (1930). Oil on canvas, 32 × 23³/₄ inches. Private collection*

129 RENÉ MAGRITTE. *The Wind and the Song.* (1928–1929). Oil on canvas, 23¹/₄ × 31¹/₂ inches. Private collection

LA CRAVATE ET LA MONTRE

130 GUILLAUME APOLLINAIRE. "La Cravate et la Montre," a poem from *Calligrammes: Poèmes de la Paix et la Guerre 1913–1916* (Paris, 1917)*

131 MAX ERNST. *Who Is that Very Sick Man.* (1924). Oil on canvas. Collection Mr. and Mrs. Lennart Erichson, Hillsborough, California

132 JOAN MIRÓ. *A Bird Pursues a Bee and "Kisses" It.* 1927. Oil on canvas, 31⁷/₈ × 39³/₈ inches. Private collection

133 JOAN MIRÓ. *Oh! One of Those Men Who's Done All That.* 1925. Oil on canvas, 51⅛ × 37⅜ inches. Collection Aimé Maeght, Paris

134 NORMAN BLUHM and FRANK O'HARA. *It's Raining.* (1960). Gouache and ink, 48 × 40 inches. Private collection

136 above YVES TANGUY. *Fantômas.* (1925–1926). Oil with collage of cardboard and cotton, 19¹/₂ × 58¹/₂ inches. Private collection

137 right YVES TANGUY. Title unknown (1926). Oil on canvas with string, 36¹/₄ × 25¹/₂ inches. Private collection

Yves Tanguy

Yves Tanguy was the only autodidact among the illusionist Surrealists. Unlike Magritte and Dali who, after art school training, experimented with various forms of Cubism, Tanguy went from the whimsical primitivism of such paintings as *Fantômas* (fig. 136) to the tightly painted academic illusionism of his mature style without ever passing through modernist painting. His characteristic manner crystallized in 1927, and from then until his death in 1955 it underwent no change except for a tightening in execution after 1930, and a gradual intensification of color.

This consistency of style paralleled the persistence of his vision, a "mindscape" resembling desert wasteland or ocean floor which remained with him for life. In the early *A Large Painting Which Is a Landscape* (fig. 138) this world is sparsely populated with forms that are a con-

opposite
135 ANDRÉ BRETON. *For Jacqueline.* 1937. Collage of pasted paper, metal, ribbon, and a leaf, 15¹/₂ × 12 inches. Collection Mr. and Mrs. E. A. Bergman, Chicago

version of Arp's flat biomorphic patterns into three-dimensional illusions a few years before Arp himself was to realize his own personal form-language as sculpture in the round. *The Certitude of the Never Seen* (fig. 139) extends the biomorphism to the contoured frame, which becomes a projecting platform before the picture where minuscule sculptures in the round and their shadows are read continuously with the illusionistic space of the painting itself. The proliferation and enlargement of these biomorphs, which are characteristic of Tanguy's paintings of the thirties, led in the following decade to structures affecting an architectural grandeur. The scaffolding of *Indefinite Divisibility*, for example (fig. 140), suggests the transformation of the monumental construction in de Chirico's *Jewish Angel* (fig. 105) into Tanguy's own form-language; even the elongated shadow it casts has its precedents in the Italian painter's work.

The poetry of Tanguy's mature imagery differs from that of the other illusionist Surrealists, and even from that of most of the "abstract" painters in the group; it is less specifically literary. Though on occasion his forms are anthropomorphic—those of *Through Birds, Through Fire, but Not Through Glass* (fig. 141) recall de Chirico's muses and lovers out of antique literature—they are never particularized with features or anatomical details. Nor can his forms ever be identified as recognizable objects, as can the shapes of Miró and Masson, to say nothing of those of Magritte and Dali. If Tanguy's style is realistic, his visual poetry is abstract.

At its best Tanguy's poetic gift overcame the uninteresting, even slick, facture of his work. The poetry was already remarkable in such early "primitive" works as the collage-painting in which a string tree sprouts from a cart that crushes a Rousseau-esque little girl (fig. 137). In his last years it reached a hallucinatory intensity. The black light and foreboding atmosphere of *Imaginary Numbers* (fig. 143), probably his last painting, suggest a prescience of death. Here the biomorphic forms, which had multiplied over the years to fill the once almost empty spaces, are identified with what may have been their first inspiration, the menhirs and polished boulders of the Brittany coast of Tanguy's childhood.

138 YVES TANGUY. *A Large Painting Which Is a Landscape.* 1927. Oil on canvas, 46 × 35 3/4 inches. Collection Mr. and Mrs. William Mazer, New York

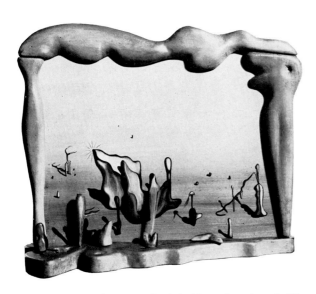

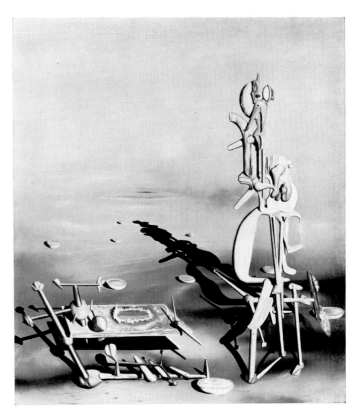

139 YVES TANGUY. *The Certitude of the Never Seen.* (1933). Oil on wood with carved wood frame, 8⁵/₈ inches high × 9⁷/₈ inches wide × 2¹/₂ inches deep. Private collection

140 YVES TANGUY. *Indefinite Divisibility.* 1942. Oil on canvas, 40¹/₈ × 35 inches. Albright-Knox Art Gallery, Buffalo

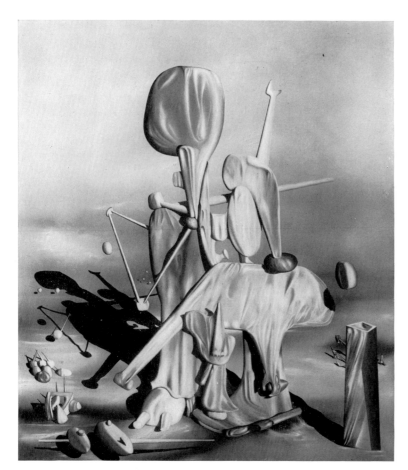

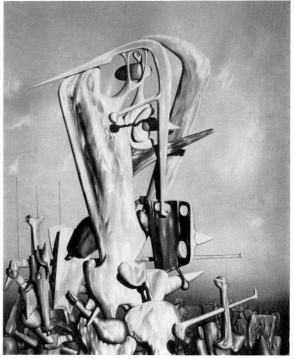

141 left YVES TANGUY. *Through Birds, Through Fire, but Not Through Glass.* 1943. Oil on canvas, 40 × 35 inches. Collection Mr. and Mrs. Donald Winston, Los Angeles

142 right YVES TANGUY. *My Life, White and Black.* 1944. Oil on canvas, 36 × 30 inches. Collection Mr. and Mrs. Jacques Gelman, Mexico City

opposite
143 YVES TANGUY. *Imaginary Numbers.* (1954). Oil on canvas, 39^{1}/$_{8}$ × 32^{1}/$_{8}$ inches. Pierre Matisse Gallery, New York

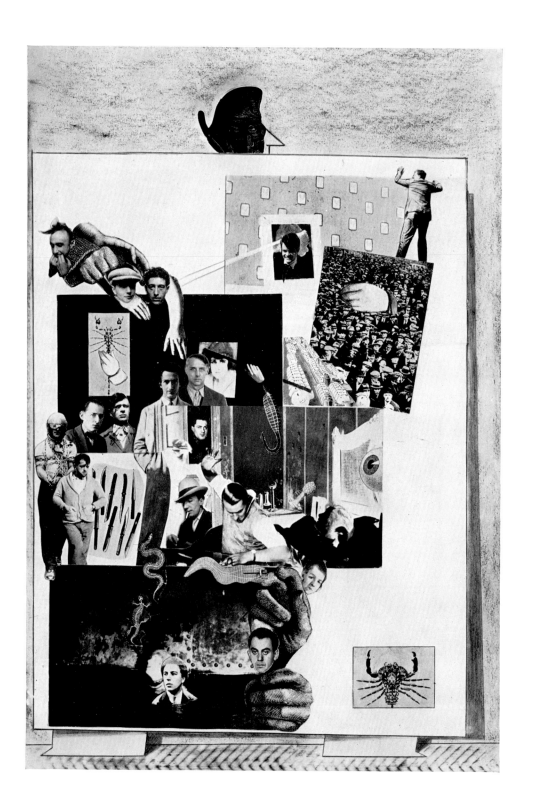

145　SALVADOR DALI. *The Basket of Bread.* 1926. Oil on wood,
12½ × 12½ inches. Collection Mr. and Mrs. A. Reynolds Morse,
Cleveland*

The Surrealism of
the Thirties

opposite
144　MAX ERNST. *Loplop Introduces Members of the Surrealist Group.*
(1930). Collage of pasted photographs and pencil; 19¾ × 13¼ inches. The
Museum of Modern Art, New York. For identification of the individuals
represented see page 194

The year 1929 was one of crisis and redirection for Sur-
realism. According to Breton the movement was intended
to function as the spontaneous expression of affinities be-
tween independent collaborators. But a group that con-
ducted psychological and literary experiments, produced
manifestoes on current issues, published books and maga-
zines, organized "manifestations," and held art exhibitions
could not function with total spontaneity. Organization
and authority were needed, and Breton provided these to
a degree that many considered excessive, with the result
that as issues multiplied so did disagreement and conflict.
One after another the participants in this *"collective*
experience of *individualism"*[88] were forced to choose be-
tween the polar terms of the formula.

What this crisis meant for Surrealist art was reflected in
Masson's departure from the movement and Salvador
Dali's arrival. The initial sovereignty of the "abstract"
Surrealists, already modified by the emergence of Magritte
and Tanguy, now became a memory. For three or four years,
in Breton's view, Dali "incarnated the Surrealist spirit and
his genius made it shine as could only have been done by
one who had in no way participated in the often ungrateful
episodes of its birth."[89]

Breton's second Surrealist manifesto, which appeared in
December 1929 in the last issue of the movement's pioneer

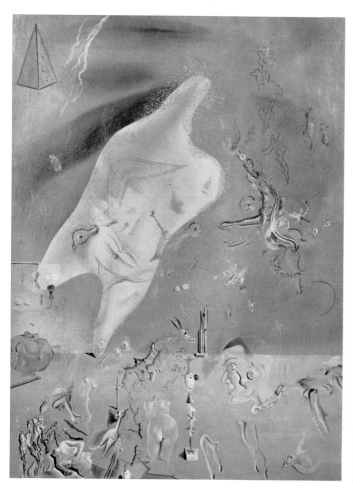

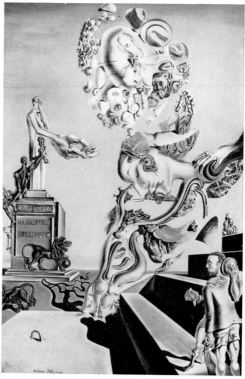

146 SALVADOR DALI. *Senicitas*. 1928. Oil on wood, 25¹/₄ × 18⁷/₈ inches. Private collection

147 SALVADOR DALI. *The Lugubrious Game*. 1929. Oil on wood with collage, 18¹/₈ × 15 inches. Private collection

review *La Révolution Surréaliste*,[90] put the imprimatur on the new direction. Virtually nothing was said about automatism, which had been the central tenet in the original manifesto. Breton conceded that automatic writing and, even more, the recounting of dreams, could still be useful, but he deplored the fact that these techniques had increasingly led to art. The procedures would now have to be restored to their original experimental scientific basis, the purpose of which was the liberation of man through self-knowledge, "free of the artistic alibi."

The relation of Dali's art to this shift in attitude can be properly assessed only if we keep in mind that, at the time, Dali viewed his painting as a kind of anti-art which entirely by-passed "plastic considerations and other *conneries*."[91] Moreover, his impact on the movement can hardly be evaluated in terms of painting alone. For some years Dali kept Surrealist circles in constant effervescence with his "critical" writing, his *gestes* (comparable to the best of Dada in their anarchic humor), his objects, and his poetry. All these activities issued from what Dali called his "paranoiac-critical method," which he defined as "a spontaneous assimilation of irrational knowledge based upon the critical and systematic objectification of delirious phenomena."[92] "I believe," he predicted, "that the moment is near when by a procedure of active paranoiac thought, it will be possible . . . to systematize confusion and contribute to the total discrediting of the world of reality."[93] "It is perhaps with Dali," Breton exclaimed, "that all the great mental windows are opening."[94]

After having mastered the technique of academic painting as a student, Dali experimented—not without success—with various forms of Cubism and collage. Then, in 1926, at the age of twenty-two, he turned to a painstakingly detailed realism that he associated with his great idol Meissonier. But Dali handled the highlights and shadows in a way that haloed his subjects with an apparitional luminosity (fig. 145) that was foreign to Meissonier, and which soon served well in the depiction of fantastic subjects.

The crystallization of Dali's mature style, however, required more than this characteristic facture. Other discoveries had to be made, and the paintings of 1927–1928 document his assimilation of morphological and iconographic

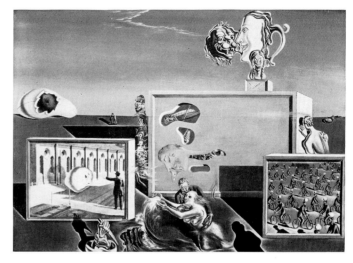

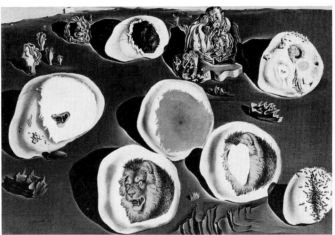

148 above SALVADOR DALI. *Illumined Pleasures.* (1929). Oil on composition board with collage, 9⅜ × 13¾ inches. The Museum of Modern Art, New York, the Sidney and Harriet Janis Collection

149 below SALVADOR DALI. *Accommodations of Desire.* 1929. Oil on wood, 8⅝ × 13¾ inches. Julien Levy Gallery, Inc., Bridgewater, Connecticut

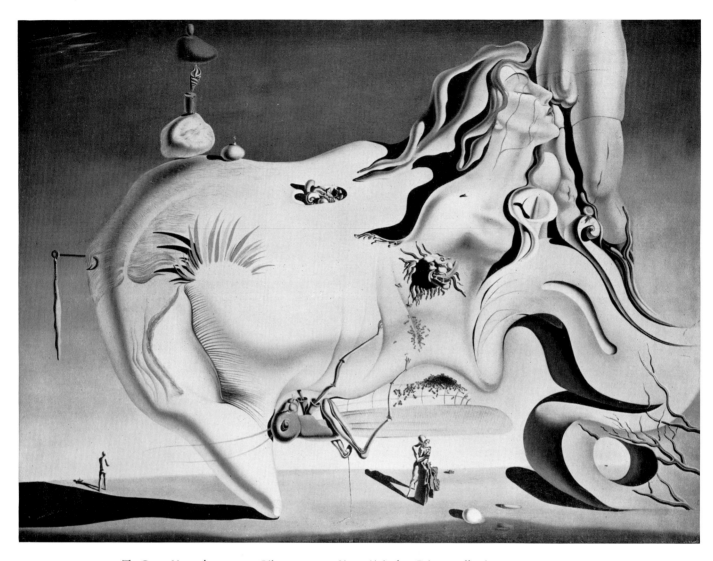

150 SALVADOR DALI. *The Great Masturbator*. 1929. Oil on canvas, 43³/₈ × 59¹/₄ inches. Private collection

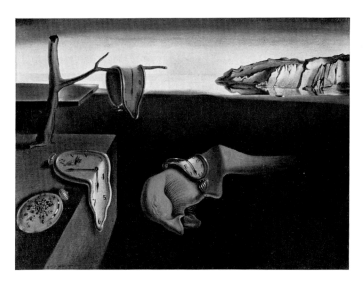

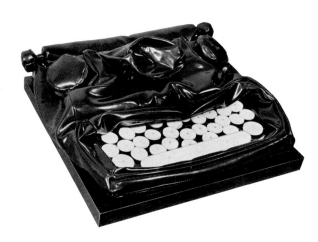

151 SALVADOR DALI. *The Persistence of Memory.* 1931. Oil on canvas, 9¹/₂ × 13 inches. The Museum of Modern Art, New York, Given anonymously

152 CLAES OLDENBURG. *Soft Typewriter.* 1963. Vinyl, kapok, wood, and plexiglass, 8⁷/₈ inches high × 27 inches wide × 25⁵/₈ inches deep. Collection Alan P. Power, Richmond (Surrey), England

ideas from Surrealist art, Tanguy primarily. The landscape ground of his *Senicitas* (fig. 146), for example, is dominated by a large biomorphic torso tentatively modeled with a navel and the musculature of an abdomen; the hairlike motifs surrounding this form, the elongated pyramids and cryptic letters in the upper left corner, and the fluttering transparent ribbons nearby are all derived directly from Tanguy's transitional paintings of 1926 and early 1927. The birds and birds' heads are of a type used by Ernst in the same years, and the little guitar shapes in flat color recall Miró.

The eclectic Surrealism of *Senicitas,* combined with the "magic realism" of the paintings that immediately preceded it, led in 1929 to Dali's first mature works, a series of brilliant small pictures whose hallucinatory intensity he was never to surpass. In some of these, *The Lugubrious Game,* for example (fig. 147), the photographic realism of the painted passages is indistinguishable from those parts of the surface which are actually collaged bits of photographs and color engravings. In equating his painting technique with the verisimilitude and surface finish of photography Dali here brought full circle the "perversion" of collage that was initiated by Ernst (see above, page 50).

Dali maintained the activity of collage, but in disguising even those differentiations of image components still visible in Ernst, he produced, in effect, an anti-collage.

Dali's "paranoiac-critical method" of painting called for the use of a fastidious illusionism to render his hallucinatory visions convincing.

> My whole ambition in the pictorial domain is to materialize the images of concrete irrationality with the most imperialist fury of precision. – In order that the world of the imagination and of concrete irrationality may be as objectively evident, of the same consistency, of the same durability, of the same persuasive, cognoscitive and communicable thickness as that of the exterior world of phenomenal reality. . . . – The illusionism of the most *arriviste* . . . art, the usual paralyzing tricks of *trompe-l'œil,* the most . . . discredited academicism, can all transmute into sublime hierarchies of thought . . .[95]

However much Dali would later insist that this "retrograde technique" (his own term) was suitable for the aesthetic of a high art, he viewed it in his Surrealist days only as a "functional form of thought." The plastic limitations of such academicism are particularly apparent in such

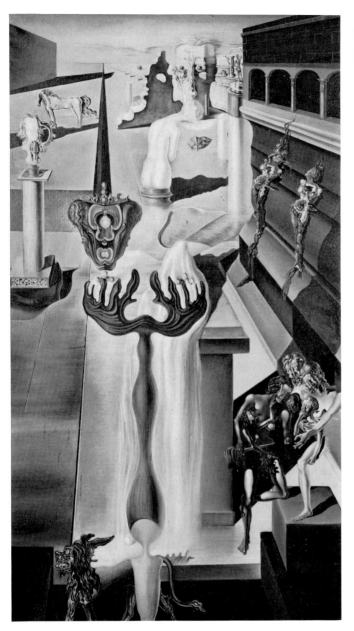

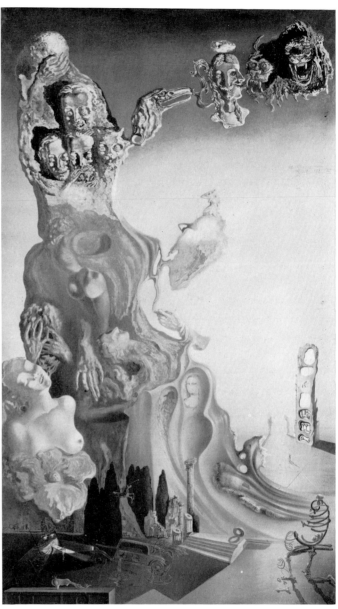

153　SALVADOR DALI. *The Invisible Man.* (1929–1933). Oil on canvas, 54⅞ × 31 inches. Private collection

154　SALVADOR DALI. *Imperial Monument to the Child-Woman* (unfinished). (c. 1929). Oil on canvas, 56 × 32 inches. Private collection

larger pictures as *The Great Masturbator* (fig. 150) where, as in large photographic prints, the eye is dulled by the expanse of shiny, undifferentiated surface. The tiny pictures, *Illumined Pleasures* (fig. 148) or *Accommodations of Desire* (fig. 149), for example, in which Dali achieved an extraordinary concentration of imagery, can be seen virtually as jeweled objects. Their miniature dimensions are ideal for an image projected from the imagination, analogous as they are in size to the "screen" of the mind's eye, which we feel to be located just inside the forehead.[96]

Whereas the imagery of de Chirico, Ernst, and Magritte focused primarily on the familiar, common denominators of human psychology, Dali's iconography dealt with more abnormal, exacerbated states. His obsessions with castration, putrefaction, voyeurism, onanism, coprophilia, and impotence were manifested in a vocabulary that reflected

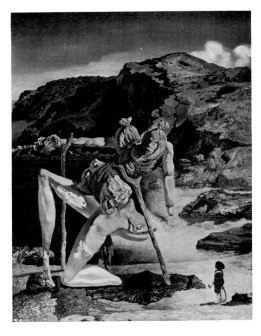

155 SALVADOR DALI. *The Specter of Sex Appeal.* 1934. Oil on wood, 7 × 5 1/2 inches. Private collection

not only an inventory of his own dream imagery but a familiarity with the writing of Krafft-Ebing as well as Freud. Much of his iconography was new to painting, for example, the extraordinary limp watches (fig. 151) and other "soft constructions" that foreshadow Oldenburg's soft machines (fig. 152). But more than is generally realized was assimilated from de Chirico and the pioneer Surrealists. In *Illumined Pleasures* alone, the boxed picture-within-a-picture, the bearded paternal figure and disembodied shadow in the foreground, the tiny scene of the Return of the Prodigal Son and the "cephalic biomorph" with a toupee near the horizon all derive directly or indirectly[97] from paintings by de Chirico, while the colorful totem of birds' heads near the center derives from Ernst, and the painting inside the box on the right recalls Magritte.

The arabesques and surface incrustations of the *Imperial Monument to the Child-Woman* (fig. 154) are notable for their derivation from Art Nouveau, a style that Dali admired at a time when it was not fashionable in avant-garde circles. Alternately gemlike and putrescent, the monument's surface also harks back to the "byzantinism" of Gustave Moreau, a painter much appreciated by the Surrealists; it foreshadows the decalcomania effects in Ernst's work of the early forties.

Notwithstanding Dali's borrowings and his overconscious involvement with psychological theory, the poetry of his early Surrealist imagery is intense and genuinely felt. In the course of the thirties this tended to dissipate. Double images, which made affective metaphors in the earlier pictures—as for example, the Art Nouveau-inspired "vaginal head" in *The Invisible Man* (fig. 153)—were multiplied and took on a forced, cerebral quality, while various "signature" icons, such as the "soft constructions," tended to be thrown together in an increasingly self-conscious manner. This caused some dissatisfaction in Surrealist circles, but had little to do, however, with Dali's banishment from the movement in the latter part of the decade, which was more a matter of personal and political conflicts.

The pioneer years between the two Surrealist manifestoes saw nothing in the way of Surrealist sculpture. The medium did not especially lend itself to the practice of automatism or to the delineation of the irrational perspectives of a fantasy world; its very concreteness, its displacement of finite space, seemed alien to the imagination. Yet the illusionism heralded by Tanguy and Magritte and consummated by Dali had made an aim of concreteness, of endowing the imagined with the same materiality, "the same persuasive, cognoscitive and communicable thickness" as the real. As a logical extension of this principle into three dimensions, Dali created "dream objects," which were soon at the center of the phenomenal proliferation of objects that characterized Surrealist activities throughout the 1930s. In this context, sculpture began to come to the fore as an art capable of endowing fantasy with a material actuality.

The principle that informed Surrealist objects was a poetic one. Although the artists and poets who fabricated the objects undoubtedly made certain decisions that were prompted aesthetically, it was officially understood that the adjustment of components in these assemblages was determined—as in Lautréamont's famous image—only by the efficacy of metaphoric rapports. This, of course, could hardly be maintained for sculpture. Though a combination of found objects could be construed as non-art, the practice of modeling and carving immediately enforced the operation of an aesthetic whose underpinning had to come from somewhere. Just as pioneer Surrealist painting depended on Cubism for its point of departure, so Surrealist sculpture presupposed the art of Picasso, Brancusi, and Lipchitz. Out of these sources, and out of the morphologies and technical devices they themselves had used earlier, Arp, Giacometti, and Ernst produced a body of sculpture that may be defined as Surrealist. Arp's sculpture was predominantly a matter of three-dimensional biomorphism; Giacometti's, a transference of illusionist space into miniature para-illusionist fields of actual space; and Ernst's, a translation and modification of collage to the purpose of sculpture. Common to the work of all three was the same type of fantasy that had governed the subject matter of Surrealist painting.

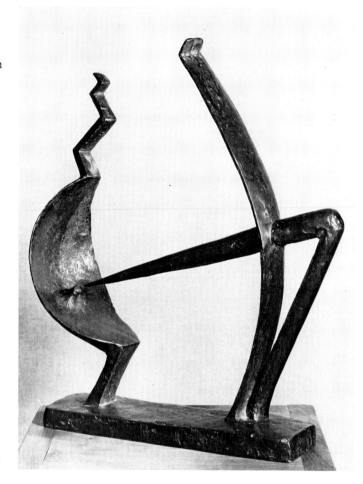

156 ALBERTO GIACOMETTI. *Man and Woman.* (1928–1929). Bronze, 18 1/8 × 15 3/4 inches. Collection Mme Henriette Gomès, Paris

Alberto Giacometti became a formal member of the Sur- realist movement in the winter of 1929/1930 though his friendships among the Surrealists and his familiarity with Surrealist literature were already reflected in his art by 1928. The earliest of his important sculptures, those of 1926–1927, are indebted to Brancusi and have little of the surreal about them. The pinched, low-relief contours of the static *Couple* recall Brancusi's *Kiss*, while the plaquelike narrowness of *Head* reminds us of the *Fish* that Brancusi had just then completed, as well as of the Cycla- dic images that interested both sculptors. Up to 1926 Giacometti had been working from the model; in sculp- tures such as *Head* he worked from memory, which facili- tated the paring away of inessentials in favor of a kind of conceptual essence.

David Sylvester has described Giacometti's transition to Surrealism as a shift from working from memory to work- ing from the imagination.[98] *Man and Woman* (fig. 156), executed in the winter of 1928/1929, already witnesses a move in this direction. The "man" in this sculpture is a taut linear cipher, arched like a bow, from which springs a long, spikelike sex aimed at a tiny hole in the smooth concave torso of the "woman." The theme of sexual aggres- sion explicitly suggests the ambiance of Surrealism and particularly reflects Giacometti's friendship at that time with the "dissident" Surrealists Masson and Leiris.

Three Personages Outdoors (fig. 157), completed at the time of Giacometti's formal adhesion to Surrealism, devel- oped an idea proposed in Lipchitz's "transparencies" but remained true to Giacometti's personal form-language. Its central "figure" also suggests an awareness of Picasso's wire constructions of 1928. From then on Giacometti sought "a kind of skeleton in space. Figures were never for me a compact mass but like a transparent construction."[99] The Picasso constructions may also have played a role in Giacometti's remarkable "cage" sculptures of the next few years. The *Cage* of 1931 (fig. 158) is a box of space crowded with anatomically allusive forms that obstruct, squeeze, and claw one another. In this dialogue between cur- vilinear forms and a rectilinear spatial frame Giacometti anticipated the effects of such sculptures as Seymour Lipton's *Imprisoned Figure* (fig. 159) and Roland Piché's *Sunset and Deposition in a Space Frame* (fig. 160).

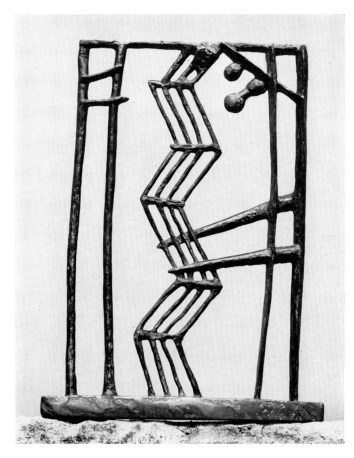

157 ALBERTO GIACOMETTI. *Three Personages Outdoors*. 1930. Bronze, 20¼ × 15 inches. Collection Mrs. Rosalie Thorne McKenna, Stonington, Connecticut

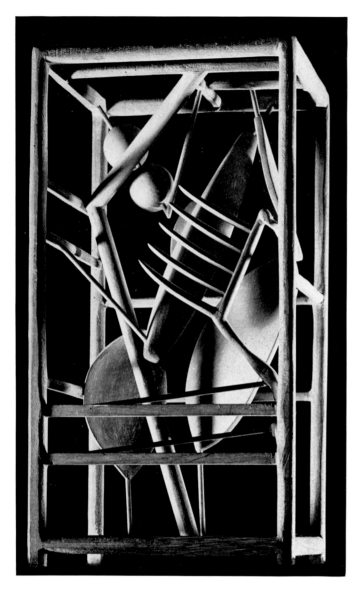

158 ALBERTO GIACOMETTI. *Cage.* (1931). Wood, 19¹/₄ × 10⁵/₈ inches. Moderna Museet, Stockholm

Giacometti's cages hinted at the possibility of a transparent space sculpture that would constitute a plastic counterpart to illusionist pictorial space, an idea that was to be realized in the form of *The Palace at 4 A.M.* (fig. 166). But the realization of this conception required first a demarcated lateral space on which the vertical structure could be erected. *Man, Woman, and Child* (fig. 161) begins to define such a sculptural "ground." It is more articulated in the lateral field of *No More Play* (fig. 162) where the minuscule, rigidly frontal male and female figures stand isolated in a landscape that is punctuated by "lunar" concavities and rectangular tombs, one of which contains a miniature skeleton. The existential loneliness and desolate environment of *No More Play* foreshadow Giacometti's post-World War II city squares and, at a much greater remove, the environment and the cybernetic personages in such sculptures as Ernest Trova's *Venice Landscape* (fig. 165).

Though Degas had broken through the standard confrontation assumed for sculpture in certain of his "Bathers" which are seen satisfactorily only when viewed from above, *No More Play* and comparable works implied a more rigorous exploitation of this new viewpoint. Nevertheless, they were still table-top sculptures raised to a position intermediate between the floor and the spectator's eye by their supports, which thus constituted modified forms of the traditional base or socle. The overcoming, or elimination, of the latter has been one of the persistent problems of modern sculpture, and Giacometti saw the issue through to one of its logical conclusions in the pioneering *Woman with Her Throat Cut* (fig. 164). This free-lying sculpture was the first conceived to splay out on the floor, which is precisely the way Giacometti showed it in his studio. The elements of its vaguely crustacean female anatomy—and hence the reading of its sexually violent iconography—can be apprehended only from above.

Having articulated his para-illusionistic lateral space on the horizontal plaques of *No More Play* and *Point to the Eye,* Giacometti proceeded to raise a three-dimensional vertical architecture on it. The wood scaffolding of *The Palace at 4 A.M.* (fig. 166) is an evolution of the cage idea through and beyond the more highly articulated table-top sculpture. Here we have the final triumph of the

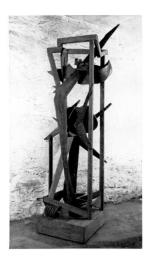

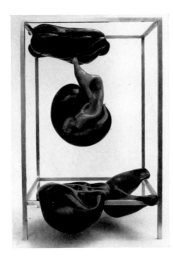

159 left SEYMOUR LIPTON. *Imprisoned Figure.* (1948). Lead and wood, 6 feet 8 inches high. Marlborough-Gerson Gallery, Inc., New York

160 right ROLAND PICHÉ. *Sunset and Deposition in a Space Frame.* (1966). Polyester resin, fiberglass, and aluminum, 20 inches high × 17 inches wide × 14 inches deep. Collection Joseph Bernstein, Metairie, Louisiana

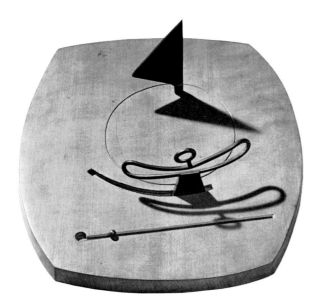

161 ALBERTO GIACOMETTI. *Man, Woman, and Child.* (1931). Wood and metal, 3⅝ inches high × 13¾ inches wide × 9⅞ inches deep. Collection Mme M. Arp-Hagenbach, Basel

artist's aim of achieving a "transparent construction," which had been signaled by *Three Personages Outdoors.* At the same time, it is the work that perhaps best expresses the poetic side of Giacometti; his account of its iconography reads like a Surrealist prose poem.[100]

The Palace at 4 A. M. is such a perfect realization of the possibilities implied in Giacometti's earlier work that it is difficult to imagine him going further in that direction; David Smith, however, in his early Surrealist-influenced sculptures such as *Interior for Exterior* (fig. 167), showed how the skeletal architecture and stylized figures of the *Palace* could be abstracted in the spirit of a metalwork tradition that is indebted to Picasso and González.

Giacometti's figure sculptures of the two years following the *Palace* represented something of a *détente*, and a prophecy of the work that would follow his break with Surrealism. *The Invisible Object* (fig. 163) depicts a female nude adjusted in totemistic immobility to a scaffolding and panel that might have constituted a high-back chair in the *Palace.* The incantatory quality of the gesture with which she holds a "void" that contains the mysterious object of the title foreshadows the semaphoric magic of Giacometti's later sculptures.

Though Arp is best known for his sculpture in the round, he did not turn to it until 1930, at the age of forty-three. This shift engendered no break in style, however, since it simply involved the translation into three dimensions of the poetically allusive biomorphism that he had pioneered in flat reliefs. Arp's development throughout was, as it were, hermetic, motivated by a single-minded search for the most perfect plastic realization of his characteristic morphology and poetry.

Arp's move to Paris and his participation in Surrealism is not especially reflected in the reliefs of the twenties. These were continuous in character with those of the previous decade except that he tended more frequently to set the freely meandering contours within a rectangular frame. Slight variations in materials, as in the string reliefs of the later twenties, such as *Drunken Egg Holder* (fig. 170), provided new linear inflections, but occasioned no change in vocabulary or iconography.

Stabile Head (fig. 168) and a few other freestanding

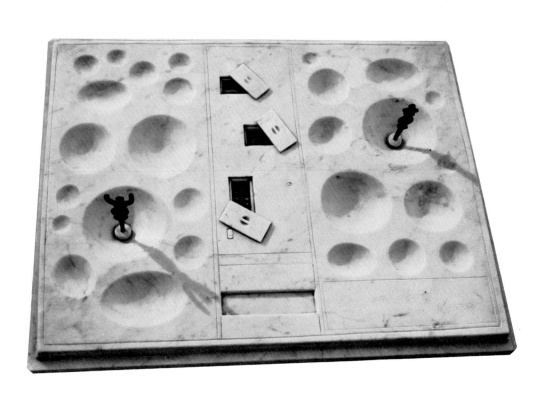

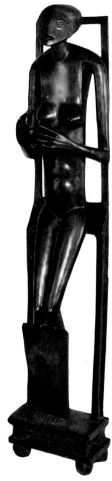

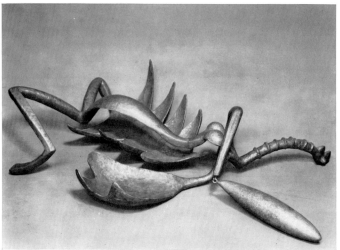

162 above left ALBERTO GIACOMETTI. *No More Play.* (1932). Marble with wood and bronze, 23¼ inches wide × 17¾ inches deep. Collection Mr. and Mrs. Julien Levy, Bridgewater, Connecticut

163 above right ALBERTO GIACOMETTI. *The Invisible Object.* (1934–1935). Bronze, 61 inches high. Collection Mrs. Bertram Smith, New York

164 right ALBERTO GIACOMETTI. *Woman with Her Throat Cut.* 1932. Bronze, 34½ inches long. The Museum of Modern Art, New York

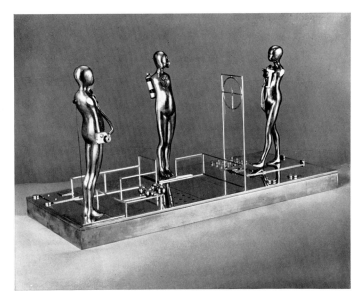

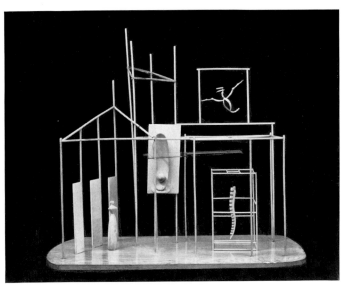

left

165 above ERNEST TROVA. Model for *Venice Landscape.* (1966).
Polished silicone bronze, 14 inches high × 20 inches wide × 12 inches
deep. Pace Gallery, New York

166 below ALBERTO GIACOMETTI. *The Palace at 4 A.M.* (1932–1933).
Construction in wood, glass, wire, and string, 25 inches high × 28¼
inches wide × 15¾ inches deep. The Museum of Modern Art, New York

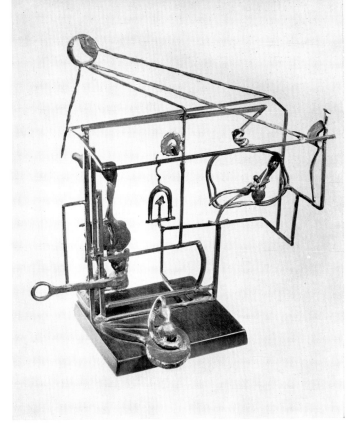

167 right DAVID SMITH. *Interior for Exterior.* (1939). Steel and bronze,
18 inches high × 22 inches wide × 23¼ inches deep. Collection Mr. and
Mrs. Orin Raphael, Oakmont, Pennsylvania

reliefs of the period signal Arp's desire to break away from the plane of the wall, but their flat forms, carpentered from paper stencils, remained essentially two dimensional despite their thickness. Sculpture in the round required a substitution of modeling and carving for the purely draftsmanly contouring Arp had always used; by the end of 1930 he had made this change and realized, in small scale, his first successful three-dimensional works. Some of these early sculptures in the round were carved from wood, such as *Bell and Navels* (fig. 169), which is not without an affinity to Giacometti's sculptures of that time. But wood carving gave way to the use of plaster as Arp increased the complexity and size of his pieces, and from 1933 to 1935, it became the medium of his great series of "Human Concretions" (fig. 171).

"Concretion," wrote Arp in a statement that tells as much about his method as his morphology, "is the result of a process of crystallization: the earth and the stars, the matter of the stone, the plant, the animal, man, all exemplify such a process. Concretion is something that has grown."[101] The idea of "growth" reflects the additive, improvisational manner in which Arp modeled his sculpture, which distinguishes it from the reductionism of Brancusi. Arp is interested less in the purified essence of the motif than in the multiplication of poetic associations. Brancusi's sculptural process is centripetal, paring away to the simplest, most economical forms; Arp's is centrifugal, the work appearing to grow organically from a nucleus. In order to facilitate such an improvisational method, Arp worked almost entirely in clay and plaster. The stone, terra-cotta, or high tension bronze versions of his sculptures were made from these originals; the material chosen was a matter of relative indifference to Arp so long as it was handsome and could be smoothly finished. In fact, except for a unique series of torn-paper collages, this suppression of all traces of facture was a common denominator in his style from its inception.

Whereas some of the artists who were closest to Surrealism experienced difficulty sustaining their work after the movement's demise, Arp, who had never particularly drawn upon its resources, went on to create some of his greatest sculptures in the years after World War II. *Human Lunar Spectral* (fig. 172), perhaps the most monumental

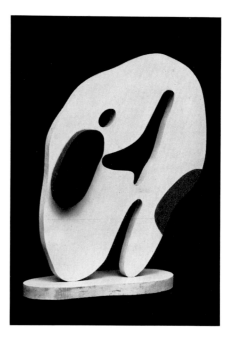

168 JEAN (HANS) ARP. *Stabile Head.* (1926). Painted wood, 24 inches high. Collection P. Janlet, Brussels

169 JEAN (HANS) ARP. *Bell and Navels.* (1931). Painted wood, 10 inches high × 19⅝ inches diameter at base. Estate of the artist

of his works, evokes a form midway between a man and a meteorite. An extraordinary fantasy of a torso, it affirms Arp's place as the last great sculptor in a tradition that reaches back through Brancusi and Rodin to the Greeks. The best sculpture of recent generations has derived from another tradition, begun by Picasso with his collage-constructions. Arp hinted at these possibilities of space-enclosing rather than space-displacing forms in his sinuous *Ptolemy* (fig. 173), but it remained alien to his essentially monolithic sense of sculpture.

Ernst turned to sculpture in 1934 while vacationing in Switzerland with Giacometti. Until then he had devoted virtually no effort to that art, and even since, it has played at best only a sporadic and secondary role in his work.

This is regrettable, for his sculpture of the later thirties and the forties conveys convincingly and directly an imagery that in the painting of these years often appears fussy. Ernst's first sculptures of 1934 were virtually found among the rounded and polished stones of the Swiss mountain streams (fig. 174). Their beautiful, organic shapes needed only slight modification—through low-relief carving or painting—to reveal a hidden content of avian personages and other monsters.

This same bestiary, which inhabited Ernst's darkling "Forest" pictures of the period, also provided the iconography of the plaster sculpture he went on to do in the fall of 1934 and subsequently. One of the most intense of these is *Woman Bird* (fig. 175), a rectangular plaque on which a hallucinated visage has impressed itself as though it were

170 JEAN (HANS) ARP. *Drunken Egg Holder*. (1928). String and oil on canvas, 26 × 21⁵/₈ inches. Collection Mme M. Arp-Hagenbach, Basel

171 JEAN (HANS) ARP. *Human Concretion on a Round Base*. (1935). Bronze, 24³/₈ inches high × 28³/₈ inches wide × 21¹/₄ inches deep. Private collection

172 JEAN (HANS) ARP. *Human Lunar Spectral.* (1950). Marble, 36⅝ inches high. Collection Mr. and Mrs. Nathan Cummings, New York

173 JEAN (HANS) ARP. *Ptolemy.* (1953). Bronze, 40½ inches high × 20⅞ inches wide × 16⅞ inches deep. Collection Mr. and Mrs. William Mazer, New York

a Surrealist Veronica's Handkerchief. Like a sudden irrational thought an aggressively beaked bird extrudes from the forehead to contrast with the transfixed anxiety of the face below.

Despite the fantastic figurations of these Ernst sculptures, they originated in part from casts and impressions in plaster of real objects.[102] *The Table Is Set* (fig. 176) was probably derived from a chance grouping of objects on a table top that was "frozen" by casting, a plastic anticipation of Spoerri's *tableaux-pièges* (fig. 78). The assembling of Ernst's sculptures constituted a three-dimensional counterpart to the method he used in his Dada collages, except that in the sculptures the original objects were more concealed as their forms metamorphosed into his fantastical beings. This automatism reflected a freedom from preconceptions about the nature of sculpture which fostered images of refreshing unfamiliarity; had Ernst's plasters of the thirties and forties not remained uncast and largely unknown they might well have played a role in reviving the then lagging art of sculpture.

175 MAX ERNST. *Woman Bird*. (1934–1935). Bronze, 20³/₄ inches high. Allan Frumkin Gallery, New York

174 MAX ERNST. Untitled. (1934). Painted stone, 5³/₄ inches long. Private collection

176 MAX ERNST. *The Table Is Set*. (1944). Bronze, 11³/₄ inches high × 21¹/₂ inches wide × 21¹/₂ inches deep. Collection D. and J. de Menil, Houston

177 left PABLO PICASSO. *Composition.* 1933. Watercolor and ink, 15³/₄ × 19⁷/₈ inches. Collection Dr. and Mrs. Allan Roos, New York

178 right PABLO PICASSO. *Bull's Head.* 1943. Bronze, after bicycle seat and handlebars, 16¹/₂ inches high × 16¹/₈ inches wide × 5⁷/₈ inches deep. Collection the artist, Mougins (Alpes-Maritimes), France*

Picasso and Surrealism

Between 1926 and 1939 Picasso's art shared a number of features with the work of the Surrealists, but his relation to the movement was equivocal. He was very much a part of the Surrealist scene in Paris, enjoying frequent contact with the painters and close friendship with poets of the movement, particularly Paul Eluard. Never formally a member of the movement—despite Breton's attempts to annex him—he nevertheless participated in most of its exhibitions and lent his support to many of its activities. His affinity with certain aspects of Surrealist fantasy, his involvement with automatic poetry, and his sympathy with the social aims of the movement notwithstanding, Picasso's art was antagonistic to Surrealism since it was almost always set in motion by a motif seen in the real world; the Surrealist vision was discovered, as Breton said, "with the eyes closed." Surrealist techniques always produced different results when employed by Picasso; his joining of a bicycle seat and handlebars to form the *Bull's Head* (fig. 178) was alien to the spirit of the Surrealist *objet-trouvé-aidé* insofar as its metamorphosis was more a question of plasticity than of poetry. Even Picasso's automatic poems

remain apart from Surrealism to the extent that they do not derive from dream imagery. As Breton himself observed, they find their "point of departure in immediate reality."[103]

The most Surrealist of Picasso's images are the compound object-personages depicted in the linear works of 1933 (fig. 177, 182, 237) with their "stuffed" limbs and torsos of furniture and studio detritus, and the dreamlike confrontation of realistic but rationally unrelated figures exemplified by *Minotauromachy.* But he also produced a group of works which, though more abstract in nature, contain fantastical metamorphoses—often biomorphic—that link them to Surrealism. In *The Painter,* for example (fig. 180), an outsize hand has designed a group of figures whose contours unwind in a vertiginous maze; *The Open Window* (fig. 181), more Synthetic Cubist in its over-all structure, contains an isolated pair of giant feet. Picasso's whimsical obsession with enlarged extremities of the body was also a frequent motif in his poetry; two unattached feet complain of chilblains as they wander through his Surrealist play of 1941, *Desire Caught by the Tail.*

The rubbery surreal biomorphs and harder "bone" structures of Picasso's figure paintings of the late twenties and early thirties were brought together in his unique

179 above PABLO PICASSO. *Crucifixion*. 1930. Oil on wood, 20 × 26 inches. Collection the artist, Mougins (Alpes-Maritimes), France*

180 below PABLO PICASSO. *The Painter*. 1930. Oil on wood, 19³/₄ × 25⁵/₈ inches. Collection Dr. and Mrs. Abraham Melamed, Milwaukee

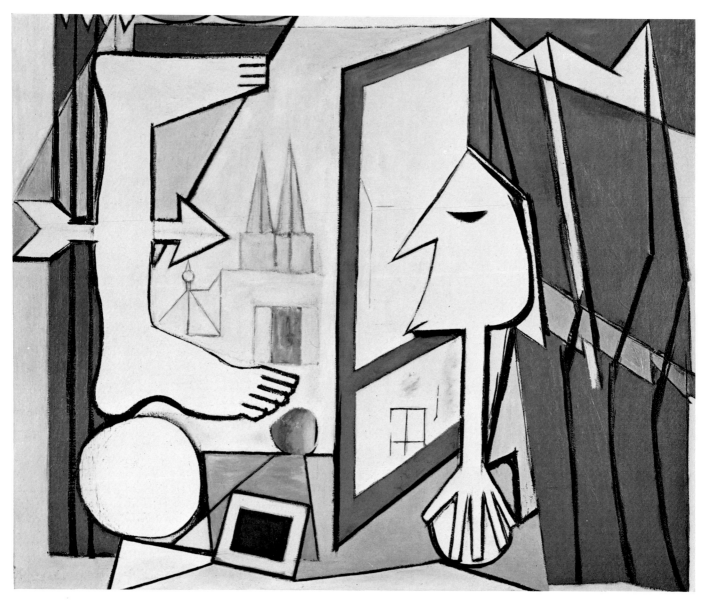

181 PABLO PICASSO. *The Open Window.* 1929. Oil on canvas, 51¹/₄ × 63³/₄ inches. Collection Mrs. Mollie Bostwick, Chicago

opposite
182 right PABLO PICASSO. *Minotaur.* 1933. Pen and ink, 15¹/₂ × 19¹/₂ inches. Private collection

183 far right PABLO PICASSO. *Minotaure.* (1933). Pencil drawing with pasted paper, cloth, and leaves on wood, 19¹/₈ × 16¹/₈ inches. Collection Alexandre P. Rosenberg, New York

Crucifixion of 1930 (fig. 179). In this Surrealist interpretation of the event,[104] most of the monstrously distorted figures are depicted in more or less Synthetic Cubist patterning. But the vinegar-soaked sponge in the upper left and the equestrian Centurion are disconcertingly depicted in a more realistic mode. Certain clues in the composition—the immense sponge opposed to the tiny Centurion—suggest that the event is being pictured from the hallucinated perspective of the man on the cross rather than from the viewpoint of the observer. This renders it antisacramental and outside the historical tradition of Crucifixion iconography, while locating it among the images of violent anguish that are not infrequent in Picasso's art during the Surrealist years. The *Crucifixion*, and the surreal variations on Grünewald's *Isenheim Altar* to which it is related, constitute, along with the agonized Minotaur-corrida images, an important source of the *Guernica*, in which Picasso synthesized stylistic and iconographic ideas from most of the movements in which he had participated.[105]

Picasso had begun to develop his personal version of Greek mythology in the late twenties, and though such imagery is more collective than the esoteric and private symbolisms favored by the Surrealists, his example had a considerable influence on Surrealist painting in the late thirties, particularly that of Masson. These interests were reflected in the title, *Minotaure*, suggested by Georges Bataille and Masson for the de luxe art magazine that became the main Surrealist review of that period. Picasso was invited to design the cover of the first issue and produced a brilliant collage of a minotaur rampant on a field of paper doilies, tin foil, ribbons, and corrugated cardboard (fig. 183). His fascination with this ancient hybrid monster accorded with the growing interest in French intellectual circles in the psychoanalytical interpretation of myth. The labyrinth—the recesses of the mind—contains at its center the Minotaur, symbol of irrational impulses. Theseus, slayer of the beast, thus symbolizes the conscious mind threading its way into its unknown regions and emerging again by virtue of intelligence, that is, self-knowledge—a paradigmatic schema for the Surrealist drama, as indeed, for the process of psychoanalysis.

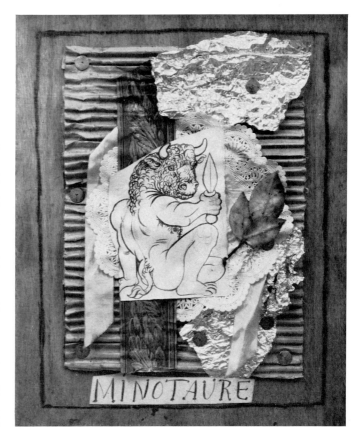

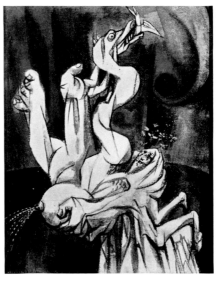

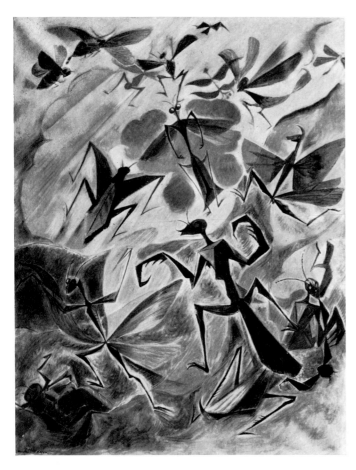

184 left ANDRÉ MASSON. *Summer Divertissement.* (1934). Oil on canvas, 36¼ × 28¾ inches. Private collection

185 right ANDRÉ MASSON. *The Spring.* (1938). Oil on canvas, 18⅛ × 15 inches. Richard Feigen Gallery, Chicago

The Surrealist Pioneers During the Thirties

During the thirties Surrealist art sustained its position as the leading vanguard movement largely through default. Its pioneer years in the previous decade had witnessed a phenomenal variety of stylistic and iconographic inventions; but like many other modern movements, Surrealism could not sustain momentum for more than five or six years. The new adherents of the thirties, such as Brauner, Dominguez, and Delvaux, worked largely within pictorial conceptions that were established in the previous decade and proved incapable of reinforming the movement with its original impetus; their originality was more a matter of novelty—often the creation of new automatic techniques—than of forging new stylistic or iconographic structures.

Even the pioneers generally fared less well in the thirties. Masson's painting, which alternated between the Cubist-inspired shallow space and color patterning of *Summer Divertissement* (fig. 184) and the more sculpturesque effects of *The Spring* (fig. 185), was in constant crisis. Ernst's work underwent a less critical equivocation. His strongest pictures, such as the colorfully striated *Landscape with Tactile Effects* (fig. 186) and the strangely emblematic *Blind Swimmer* (fig. 188), recalled his work of 1925–1928,

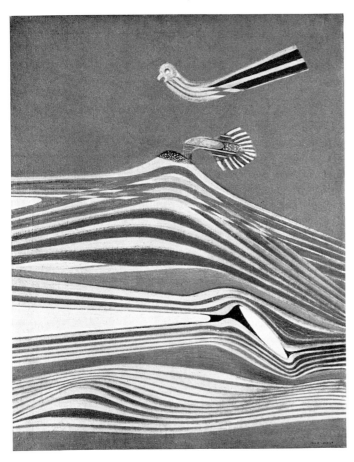

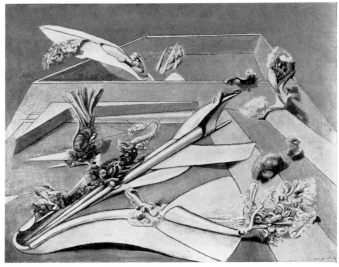

186 left MAX ERNST. *Landscape with Tactile Effects.* (1934–1935). Oil on canvas, 39³/₈ × 33¹/₂ inches. Collection Mr. and Mrs. James Johnson Sweeney, Houston

187 right MAX ERNST. *Garden Airplane Trap.* 1935. Oil on canvas, 21¹/₄ × 29 inches. Collection the artist, Huismes (Indre-et-Loire), France*

but were interspersed with such more dryly painted illusionist series as the "Garden Airplane Trap" (fig. 187).

The turn taken by Surrealism in 1929 was bound to displease Miró. But unlike Masson, who officially broke with the movement for almost a decade, Miró simply drifted somewhat from its milieu, while remaining on good terms with Breton. *Painting*, of 1930 (fig. 191), illustrates the tendency toward greater abstraction and simplification in Miró's art at the time of his disengagement. Its nominal title also reflects his move away from the intricate, poetic iconographies of the 1920s. However, Miró never questioned his ultimate commitment to *peinture-poésie:* "For me a form is never something abstract; it is always a sign of something."[106] When Arp suggested that he join the purist *abstraction-création* group he rejected their approach as "too limited."

With the exception of such series as the quaintly literal collages of 1933 (fig. 190), which were an immediate response to those of Ernst of the year before (fig. 189), much of Miró's work in the thirties involved a synthesizing of his dual manners of the twenties in pictures of even richer color and greater breadth. In the large *Snail Woman Flower Star* (fig. 192) the lettering of the earlier picture-poems achieves a level of consummate ease and decora-

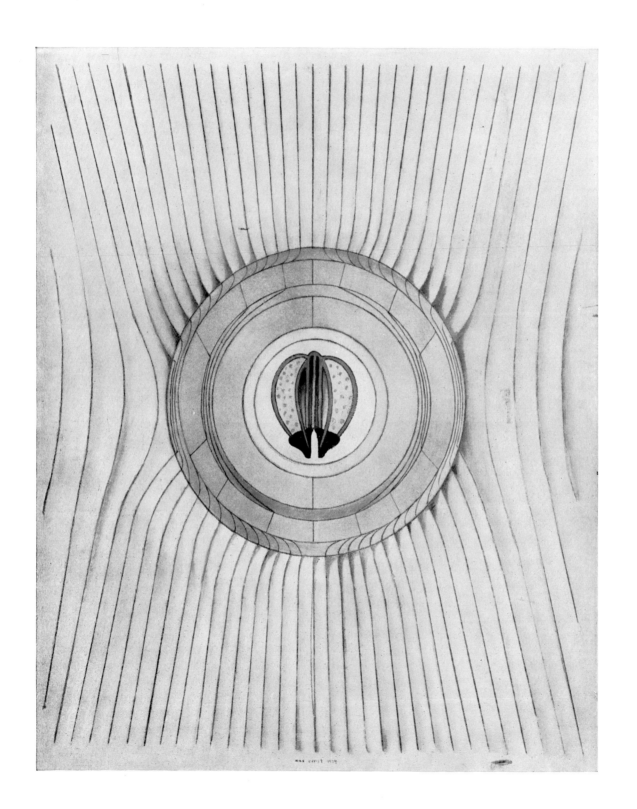

opposite
188 MAX ERNST. *The Blind Swimmer.* 1934. Oil on canvas, 36$^{1}/_{4}$ ×
28$^{7}/_{8}$ inches. Private collection

189 left MAX ERNST. *Loplop Introduces.* 1932. Pasted papers, watercolor, pencil frottage, and photograph, 19$^{5}/_{8}$ × 25$^{3}/_{8}$ inches.
Collection Mr. and Mrs. E. A. Bergman, Chicago

190 right JOAN MIRÓ. *Composition.* (1933). Conté crayon and pasted papers on pastel paper, 42$^{1}/_{2}$ × 28$^{1}/_{2}$ inches.
Collection Mr. and Mrs. E. A. Bergman, Chicago

191 JOAN MIRÓ. *Painting.* 1930. Oil on canvas, 59 × 88⁵/₈ inches. Collection D. and J. de Menil, Houston

tiveness as it winds around motifs of greater morphological and poetic simplicity than had previously been the case. Here, and in the less literal *Animated Forms* of the following year (fig. 193), Miró was able to recapture the spontaneity of his earlier automatic pictures with a breadth and abandon and sumptuousness of color that he has rarely been able to equal.

Despite the gains evident in Miró's best work of the thirties, new pictorial and poetic conceptions occurred to him less frequently. Nevertheless, there were still exceptional departures, such as the stylized realism of the *Self-Portrait* (fig. 194) and *Still Life with Old Shoe.* The intense introspectiveness of the former and the implicit social sympathy of the latter reflected, according to Miró,[107] the immediacy of the Spanish Civil War. This realism was short lived, however, and in the series of women's portraits of late 1938 and 1939, such as *Seated Woman I* (fig. 195), he returned to his personal form-language with a vengeance.

The most remarkable of Miró's late inventions were the small crowded compositions of 1940–1941 generically entitled "Constellations." The evenness in the spotting of forms and distribution of color accents in such pictures as *Acrobatic Dancers* (fig. 196) tended to dissolve the discreteness of the figures and, with it, traditional compositional focus and hierarchy. The more all-over dispersal of the shapes and the animated flicker of the color in the "Constellations" produced an optical experience unprecedented in Miró's work, except for the ornamental and tightly painted *Harlequin's Carnival* of 1924–1925 (fig. 86). They anticipated the all-over patterning familiar in both abstract and figurative painting around 1950.

opposite
192 JOAN MIRÓ. *Snail Woman Flower Star.* (1934). Oil on canvas, 76³/₄ × 67³/₄ inches. Private collection

193 left JOAN MIRÓ. *Animated Forms.* (1935). Oil on canvas, 76¹/₂ × 68 inches. Los Angeles County Museum of Art, the Estate of David E. Bright

194 right JOAN MIRÓ. *Self-Portrait.* 1937–1938. Pencil, crayon, and oil on canvas, 57¹/₂ × 38¹/₄ inches. Collection James Thrall Soby, New Canaan, Connecticut

195 left JOAN MIRÓ. *Seated Woman I.* (1938). Oil on canvas, 63 × 50⁷/8 inches. Collection Miss Peggy Guggenheim, Venice*

196 right JOAN MIRÓ. *Acrobatic Dancers.* (1940). Gouache and oil wash on paper, 18¹/8 × 15 inches. Wadsworth Atheneum, Hartford, the Philip L. Goodwin Collection

197 VICTOR BRAUNER. *Gemini*. 1938. Oil on canvas, 18 × 21³/₈ inches. Collection Mr. and Mrs. Julien Levy, Bridgewater, Connecticut

New Adherents and New Techniques in the Thirties

Victor Brauner was the most talented Surrealist recruit of the middle thirties. His self-proclaimed commitment to the absolute priority of poetic as over and against aesthetic concerns[108] did not, however, turn him into an academic *imagier,* though it did result in certain inconsistencies of style. Despite the manifest influence of Klee and Ernst in much of his imagery, such pictures as *Gemini* (fig. 197) demonstrate that Brauner was able to put a very intense personal stamp on his visions. During World War II Brauner was in hiding and unable to get materials, but this condition was turned into a virtue in a series of pictures made with candle wax. Sometimes these encaustics were incised with a knife or stylus, but on other occasions, as in *Talisman* (fig. 199), the tallow was roughly modeled into graffito-like reliefs. Such pictures of the thirties as the *Object Which Dreams* (fig. 198) had already demonstrated how musically Brauner could use color even as a function of sculpturesque illustration. This gift became even more apparent in the flatter, more decorative manner he used in the two decades prior to his recent death (fig. 200).

198 above VICTOR BRAUNER. *Object Which Dreams*. 1938. Oil on canvas, 31 × 25 inches. Collection Mr. and Mrs. Joseph R. Shapiro, Oak Park, Illinois

200 VICTOR BRAUNER. *Prelude to a Civilization.* 1954. Encaustic, 51¹/₄ × 76³/₄ inches. Collection Mr. and Mrs. Jacques Gelman, Mexico City

opposite

199 VICTOR BRAUNER. *Talisman.* 1943. Wax on wood, 6³/₈ × 10⁷/₈ inches. The Museum of Modern Art, New York, the Sidney and Harriet Janis Collection

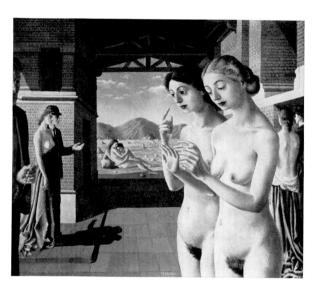

201 PAUL DELVAUX. *Pygmalion*. 1939. Oil on wood, 53^1/$_8$ × 65 inches. Yannick Bruynoghe-Galerie Maya, Brussels

202 PAUL DELVAUX. *Hands*. 1941. Oil on canvas, 43^1/$_4$ × 51^1/$_4$ inches. Collection Richard S. Zeisler, New York

203 PAUL DELVAUX. *Le Train Bleu*. 1946. Oil on canvas, 48 × 96^1/$_8$ inches. Collection Joachim Jean Aberbach, Sands Point, New York

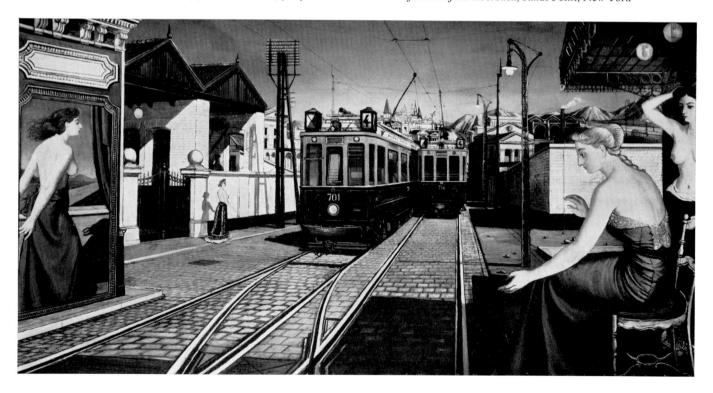

The Belgian painter Paul Delvaux modified the illusionism of de Chirico and Magritte in a more detailed illustrative manner. Women constitute—as in *Hands* (fig. 202)—the core of his visionary world, women in a sexual context both wistful and passive. Their desire is usually voyeuristic and is expressed toward preoccupied savants or, as in *Pygmalion* (fig. 201), epicene youths. The environments of Delvaux's visions vary but tend toward either a Surrealist equivalent of the antique Hellenism of Puvis de Chavannes, or the Flemish counterpart of the Chiricoesque piazza, as in *Le Train Bleu* (fig. 203).

The work of most of the younger Surrealists is best characterized by their inventions of new automatic techniques that rounded out a battery begun earlier with automatic drawing, *frottage*, and the exquisite corpse. Oscar Dominguez was the first to exploit the possibilities of decalcomania. By spreading gouache on a sheet of paper, laying another sheet on top of it, pressing here and there, and then peeling the second sheet off, he produced effects suggesting exotic flora, mineral deposits, spongy growths—a veritable spelunker's dream. The fantasies generated by this technique (fig. 204) recommended it immediately to other Surrealists and, as it was a way of image-making that required no technical ability, it was immediately adopted by the poets as well as the painters. In order to achieve more contoured, defined images, Dominguez and Marcel Jean also experimented with the use of stencils in conjunction with decalcomania (fig. 205), but it was only with Ernst's adaptation of the technique to oil painting in such fantastic landscapes as *Europe After the Rain* (fig. 249) that the poetic possibilities of decalcomania were realized as significant art. Ernst himself later invented another automatic technique that he called "oscillation," which involved gyrating a can of paint with a pinhole in it at the end of a string. The method, which produced accidental linear patterns of the type illustrated by the study for *Surrealism and Painting* (fig. 209), has been mistakenly identified as the origin of Pollock's drip style.[109]

Wolfgang Paalen, whose oil paintings of the late thirties (fig. 206) suggested a fractured, crystalline version of Tanguy's biomorphic illusionism, was the inventor of *fumage* (fig. 207). This involved the evocation of a picture from the burns and smoke trails left by "drawing" with a

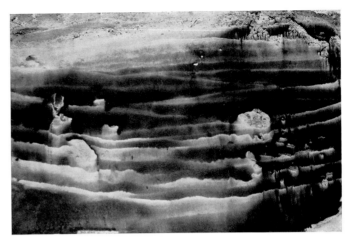

204 above YVES TANGUY. *Decalcomania.* 1936. Gouache, 12 × 19 inches. Collection Marcel Jean, Paris

205 below OSCAR DOMINGUEZ. *Decalcomania.* (1937). Gouache, 6 1/8 × 8 5/8 inches. The Museum of Modern Art, New York, Given anonymously

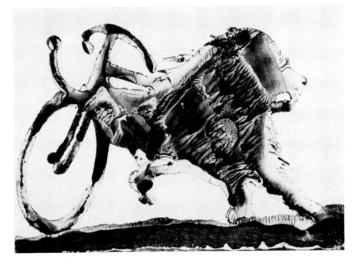

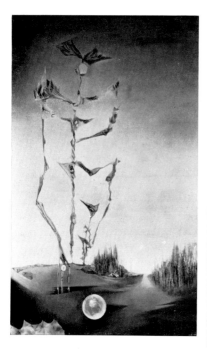

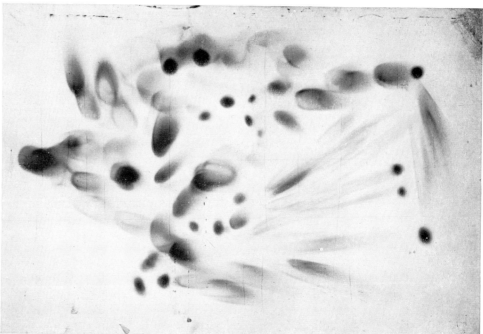

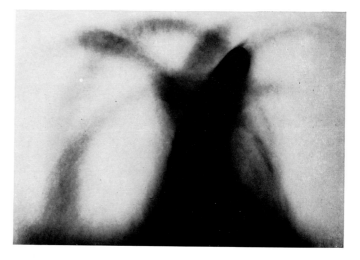

lit candle. Later Yves Klein, in such works as *Mark of Fire* (fig. 208), was to use the possibilities of flame in a more daring and robust manner, in accord with the Abstract Expressionist scale and taste that informed his accidental techniques.

Gordon Onslow-Ford who—with Matta—was the last Surrealist recruit before its wartime exile, invented the technique of *coulage* (pouring). In *Without Bounds* (fig. 210) the ripolin enamel, only partly controlled by the artist's guiding hand, "finds" its own silhouettes. The puddles, organic in contour and rich in Rorschach-like suggestions, create an illusion of continuous metamorphosis, approximating the elusive effects of Thomas Wilfred's Lumia compositions with which the Matta "Inscapes" of that time (see below, page 166) also have close affinities. In some cases, Onslow-Ford gave order to these seemingly "formless" arrangements by superimposing geometrical linear designs on them and interlocking the two systems by peeling away the enamel to reveal different levels according to the geometrical divisions.

206 above left WOLFGANG PAALEN. *Totemic Landscape of My Childhood.* 1937. Oil on canvas, 51 × 32 inches. Grosvenor Gallery, London

207 above right WOLFGANG PAALEN. *Fumage.* (c. 1938). Oil, candle burns, and soot on canvas, 10¹/₂ × 16³/₈ inches. Collection Mr. and Mrs. Julien Levy, Bridgewater, Connecticut

208 below YVES KLEIN. *Mark of Fire.* 1961. Burned paper, 31¹/₂ × 45¹/₂ inches. Alexander Iolas Gallery, New York

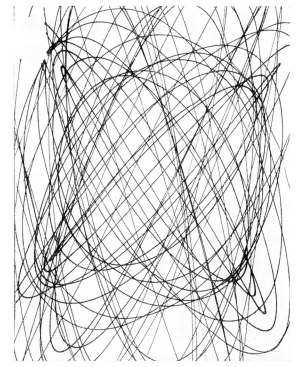

209 above MAX ERNST. Study for *Surrealism and Painting*. 1942. Ink,
24³/₄ × 19⁷/₈ inches. Private collection

210 below GORDON ONSLOW-FORD. *Without Bounds*. 1939. Enamel
paint on canvas, 28³/₄ × 36¹/₄ inches. Collection the artist, Inverness,
California

211 *Exposition Surréaliste d'Objets*. Galerie Charles Ratton, Paris, May 1936. The objects on display, apart from those in the vitrines and the primitive works, are, from left to right: Picasso, *Guitar;* Man Ray, *Boardwalk;* Paalen, *The Exact Hour;* Giacometti, *Suspended Ball;* and Picasso, *Still Life*

212 SALVADOR DALI. *A Tray of Objects*. (1936). Collection Charles Ratton, Paris. Now dismantled

213 above MERET OPPENHEIM. *Fur-Covered Cup, Saucer, and Spoon*. (1936). Fur, cup, saucer, and spoon, cup 4³/₈ inches diameter; saucer 9³/₈ inches diameter; spoon 8 inches long. The Museum of Modern Art, New York

214 below E. L. T. MESENS. *Les Caves du Vatican*. (1936). Construction with tree trunk and silk banner, 6³/₄ × 4³/₄ inches. Collection Charles Ratton, Paris

Surrealist Objects

The Surrealist object was essentially a three-dimensional collage of "found" articles that were chosen for their poetic meaning rather than their possible visual value. Its entirely literary character opened the possibility of its fabrication—or, better, its confection—to poets, critics, and others who stood professionally outside, or on the margins of, the plastic arts. This partially explains the tremendous vogue object-making enjoyed in Surrealist circles during the 1930s.

Duchamp had provided prototypes for Surrealist objects in his *Why Not Sneeze?* (fig. 9) and *Fresh Widow*. But he was primarily concerned with the illustration of ideas, and consequently found it unnecessary to proliferate his objects once the principles they embodied were established. Less restricted by intellectual aims, Man Ray had developed some of Duchamp's possibilities in such objects of the twenties as *Gift* (fig. 38) and *Emak Bakia*. But even though as early as 1923 Breton had called for "the concrete realization and subsequent circulation of numbers of copies of objects perceived only in dreams,"[110] it was

215 left MARCEL JEAN. *Horoscope*. (1937). Painted dressmaker's dummy with plaster ornaments and watch, 28 inches high. Collection the artist, Paris

216 right ROLAND PENROSE. *The Last Voyage of Captain Cook*. (1936–1967). Painted plaster, wood, and wire, 27 inches high × 26 inches wide × 34 inches deep. Collection the artist, London

only with the triumph of illusionism signaled by the emergence of Dali that the stage was set for the efflorescence of the object.

The simplest Surrealist objects did not involve the collage principle. As in Duchamp's Readymades, displacement alone sufficed. But the Surrealists expanded the range of possible choices: *objets trouvés* exhibited by Dali, for example, included a plaster cast of a foot, a woman's shoe, a pair of chocolate gloves wrapped in tin foil, a pornographic toy, and a loaf of bread in the form of a ribbon bow (fig. 212). The exhibition of Surrealist objects held at the Galerie Charles Ratton in Paris in 1936 (fig. 211) even included natural objects such as evocatively shaped stones and carnivorous plants.

Among the more sophisticated Surrealist objects were those which, like Meret Oppenheim's classic *Fur-Covered Cup, Saucer, and Spoon* (fig. 213), confused the texture of one article with the form of another; here the fur, which might provoke pleasant tactile sensations on a coat, becomes disconcerting in conjunction with objects of oral use. Marcel Jean's *Horoscope* (fig. 215) was a dressmaker's dummy, reminiscent of de Chirico's, the surface of

217 left SALVADOR DALI. *The Venus de Milo of the Drawers*. (1936). Painted bronze, 39⅜ inches high. Galerie du Dragon, Paris

218 center RENÉ MAGRITTE. *Bottle*. (1959). Painted glass bottle, 11¾ inches high. Collection Harry Torczyner, New York

219 right LAWRENCE VAIL. *Bottle*. (1944). Painted bottle with pasted paper, cork stopper with eyeglass frames, brush, and cloth, 16¼ inches high. Collection Miss Yvonne Hagen, New York

which was painted to suggest a contour map, a geographical interpretation of the female body that was carried further in Roland Penrose's *Last Voyage of Captain Cook* (fig. 216), where an ancient Venus was caged by a simplified version of an armillary sphere.

Though a painter of very limited gifts, Oscar Dominguez was one of the most original of the object makers. *Conversion of Energy* (fig. 220)—also known as *Le Tireur* because it was constructed around a plaster cast of the famous Hellenistic *Thorn Puller*—is Dominguez's most beautiful and intricate Surrealist object. We see the boy's

headless, truncated torso through a jaggedly broken pane of glass that bears a troubling, guillotine-like relationship to the figure behind it. Dominguez's *Armchair* (fig. 221), a wheelbarrow upholstered in red satin, was so popular with collectors that numerous replicas were made; it also seems to have provided a cue for Christo's *Package on Wheelbarrow* (fig. 35).

The illusionist Surrealists naturally found it easy to realize their fantasies in object form. Magritte's *Bottle* (fig. 218), a Freudian female "receptacle" painted as a nude, and Dali's *Venus de Milo of the Drawers* (fig. 217), the female

body objectified as bedroom furniture, were both ideas adapted from paintings. Because of his more abstract form language, Tanguy was the exception among the illusionists. His activity as an object maker was limited and, as in *From the Other Side of the Bridge* (fig. 224), his objects constituted more plastic inventions than composites of real objects. For much the same reasons, Miró and Masson made little in the way of objects. Their constructions and sculptures, though often incorporating real objects, nevertheless remained true to their respective form languages (fig. 223). Even Miró's *Poetic Object* (fig. 222), a rare instance in which he collaged such real articles as a stuffed parrot, a derby, and a map, is informed by an aesthetic—epitomized in its carved wooden centerpiece—alien to the pure Surrealist object. This aesthetic conviction is also evident in some of Giacometti's works, such as *Caught Hand* (fig. 225), that were nominally held to be objects. An aggressive counterpart of Picabia's machines, this contraption is as fully informed by the aesthetic of sculpture as were Picabia's machines by that of painting.

Picasso's object-sculptures, like much of his sculpture proper, rarely got beyond the stage of drawings. The extraordinary personage with a cobbler's-last foot, a hat sporting a dancing doll, and an appendage of toy airplanes was an exception. But even this has been dismantled,[111] though it is fortunately perserved in a Brassaï photograph (fig. 238). Most of Picasso's images of hybrid Surrealist objects involved the combination of stuffed "limbs," furni-

left
220 above OSCAR DOMINGUEZ. *Conversion of Energy (Le Tireur).* (1935). Painted plaster, objects, and glass, 18⁷/₈ × 12¹/₄ inches. Collection Charles Ratton, Paris

221 below OSCAR DOMINGUEZ. *Armchair.* (1937). Wheelbarrow upholstered with satin. Whereabouts unknown. Gown by Lucien Lelong. Photograph by Man Ray

opposite
224 right YVES TANGUY. *From the Other Side of the Bridge.* (1936). Painted wood and stuffed cloth, 19 inches long × 8³/₄ inches wide × 5³/₄ inches high. Collection Mr. and Mrs. Morton G. Neumann, Chicago

225 far right ALBERTO GIACOMETTI. *Caught Hand.* (1932). Wood and metal, 23 inches long. Kunsthaus, Zurich

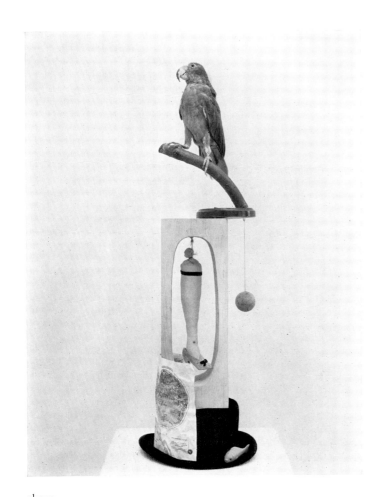

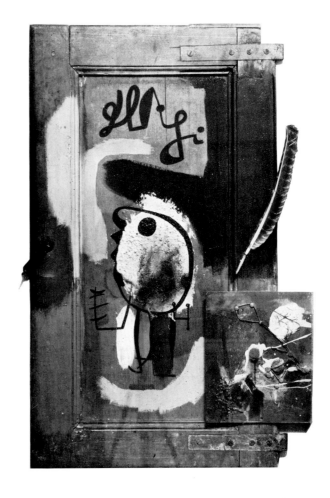

above

222 left JOAN MIRÓ. *Poetic Object.* (1936). Construction of hollowed wooden post, stuffed parrot on wooden stand, hat, and map, 31⁷/₈ inches high × 11⁷/₈ inches wide × 10¹/₄ inches deep. The Museum of Modern Art, New York, Gift of Mr. and Mrs. Pierre Matisse

223 right JOAN MIRÓ. *Object.* (1931). Painted wood with feather and metal, 44⁷/₈ × 28³/₄ inches. Private collection

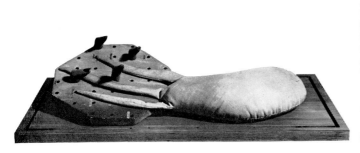

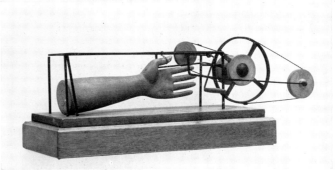

ture, and studio detritus mentioned above. Like the ambiguously sexed personage that dumbfounds the model in one of the last prints of "The Sculptor's Studio" (fig. 237), these constructions were so complicated in conception that Picasso evidently did not wish to expend the energy necessary to realize them in actuality.

Though Joseph Cornell never joined the Surrealist movement, he worked in the thirties and forties at the edge of its orbit. Related on one side to the American tradition of an art that celebrated memorabilia—the *trompe-l'oeil* painting of Harnett and Peto—his style and iconography are unthinkable without Surrealism. It was Max Ernst's poetic concept of the collage, recapitulated in Cornell's *Schooner* of 1931 (fig. 226), that constituted his point of departure. From there he moved easily into the Surrealist object, even to those (fig. 227) which, like Giacometti's and Dali's "Objects of Symbolic Function," incorporated the possibility of motion.

Sometimes the resources of the object were wed to an interest in automatic poetry. The *Mémoires de Madame la Marquise de la Rochejaquelin* (fig. 228) is a glass-covered box containing a series of lines of French text laminated to glass. These are cushioned by colored sand and may be shaken so that they form themselves into constantly renewable accidental poems.

Cornell is mostly associated with the kind of box that translates the Surrealist object into a kind of stage space. Often, as in the marvelous *Pantry Ballet for Jacques Offenbach* (fig. 229), where a corps de ballet of red plastic fish is posed against a drop-scene of shelving paper and toy silverware props, this quite literally becomes a miniature theater, with a proscenium fringed with paper doily "curtains." While such boxes recall the toy stages with which Cornell played as a child, it is probable that their more immediate prototypes were the "boxes" in such paintings as Dali's *Illumined Pleasures* (fig. 148), which were themselves suggested by earlier ones in de Chirico (fig. 106). In effect, Cornell was re-creating in a combination of real three-dimensional space and scenic illusion precisely that spatial "theater" which had originated in de Chirico and been kept alive by illusionist Surrealism. His boxes surely exercised some influence on those of Arman, whose

opposite

226 top JOSEPH CORNELL. Untitled (*Schooner*). 1931. Collage,
4¹/₂ × 5³/₄ inches. Private collection, Courtesy Pasadena Art Museum,
California

227 center JOSEPH CORNELL. Untitled. Undated. Construction with
iron rod, string, rubber ball, and leather-covered book on wooden base,
18¹/₄ inches high × 11³/₄ inches wide × 8¹/₂ inches deep. Private collection

228 bottom JOSEPH CORNELL. *Mémoires de Madame la Marquise de
la Rochejaquelein.* 1943. Cardboard box with pasted papers, sand, glass,
and rhinestones, 2 inches high × 4¹/₄ inches diameter. Private collection

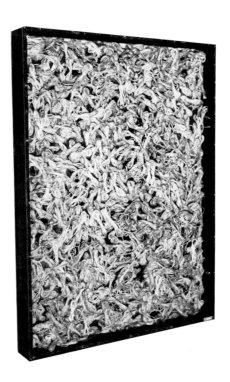

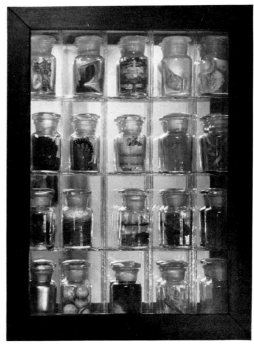

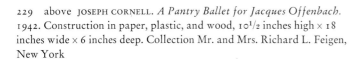

229 above JOSEPH CORNELL. *A Pantry Ballet for Jacques Offenbach.*
1942. Construction in paper, plastic, and wood, 10¹/₂ inches high × 18
inches wide × 6 inches deep. Collection Mr. and Mrs. Richard L. Feigen,
New York

right

230 above ARMAN. *Fortune Smiles on the Daring Ones.* (1962).
Threads in wooden box, 40⁵/₈ × 31¹/₈ inches. Collection Dr. R. Matthys-
Colle, Ghent, Belgium

231 below JOSEPH CORNELL. *Pharmacy.* (1943). Construction in wood
and glass, 15¹/₄ inches high × 12 inches wide × 3¹/₈ inches deep.
Collection Mrs. Marcel Duchamp, New York

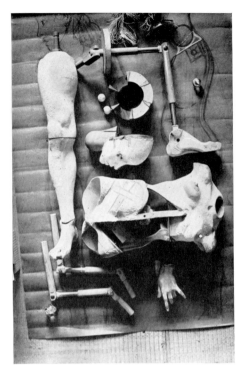

236 HANS BELLMER. *The Machine-Gunneress.* (1937). Wood, metal, and papier-mâché, 23⅝ inches high. Private collection

opposite
232–235 HANS BELLMER. *La Poupée.* (1936). Wood, metal, and papier-mâché, 70⅞ inches long. Private collection

Abstract Expressionist accumulation of swirling threads (fig. 230) also realizes suggestions inherent in Duchamp's string-labyrinth installation of the 1942 Surrealist exhibition (fig. 252) within the language of Pollock's all-over linear style. Some of Cornell's own later boxes, such as *Pharmacy* (fig. 231), reflect an awareness of these new compositional formulations.

In 1936, the very year of the *Exposition Surréaliste d'Objets* held at the Galerie Charles Ratton, a Berlin artist named Hans Bellmer visited Paris and joined the Surrealists. His strange "dolls" had been conceived earlier, but their development suggested a quasi-Expressionist counterpart to Surrealist objects, particularly those that included clothes dummies or the type of mannequins that were to play such a central role in the great Surrealist exhibition of 1938. Bellmer's work was known to Paris artists from photographs that had appeared in the December 1934 issue of *Minotaure* under the title "*Poupée. Variations sur le montage d'une mineure articulée*" (*Poupée. Variations on the Assembling of an Articulated Minor*). These showed his female mannequin, *La Poupée* (figs. 232–235), in various stages of construction, from the wood-and-metal skeleton to the realistic shell of plaster and papier-mâché. A system of ball joints permitted the body to be dismantled and reassembled in all sorts of confused combinations. The photographs showed the doll in truncated, fragmentary form, as though violently torn apart. The dismountable wigs, clothes, and glass eyes made it appreciated as an ideal fetish-object in the Freudian sense. Though the *poupée* in her various reincarnations, such as the aggressive machine-gunneress (fig. 236), has been his lifetime obsession, Bellmer has also developed his erotic theme of the hallucinatory confusion of limbs in a number of extraordinary if unpublishable drawings of pubescent girls.

From the first exhibition of Surrealist art at the Galerie Pierre in 1925 through that of the Surrealist objects at the Ratton gallery in 1936 the installations had been straightforward and informative. But late in 1937 it was decided to stage a major Surrealist exhibition in which the objects—many of them large and freestanding—and the paintings would meld in a total Environment that would

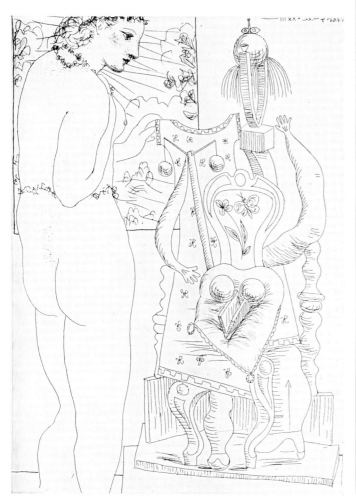

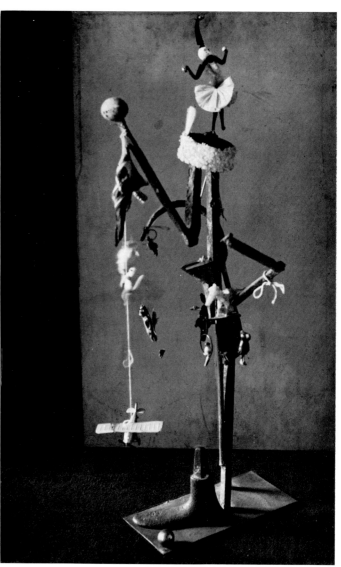

237 PABLO PICASSO. *Nude and Sculpture.* 1933. Etching, 10¹/₂ × 7⁵/₈ inches. The Museum of Modern Art, New York

238 PABLO PICASSO. *Woman.* (1930–1932). Iron, with cobbler's last, toy airplanes, doll, and string, 31⁷/₈ inches high. Now dismantled

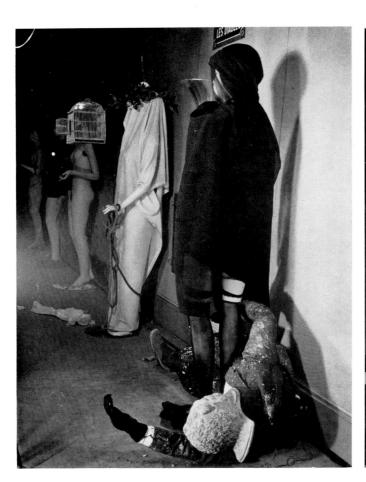

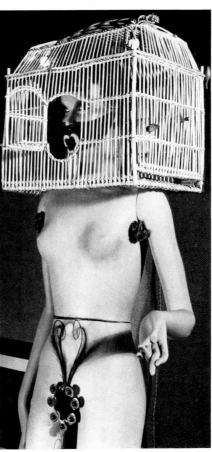

239 *Exposition Internationale du Surréalisme*. Galerie Beaux-Arts, Paris, January–February 1938. "Surrealist street," with mannequins by André Masson, Kurt Seligmann, and Max Ernst

240 ANDRÉ MASSON. Mannequin at *Exposition Internationale du Surréalisme*, Paris, 1938

provide a theatrical experience for the spectator as he wove his way through the exhibition.

It was, of course, hardly a new idea. The Cologne Dada exhibition of 1920, for example, had been installed in the back room of a café that visitors could reach only by going through a public urinal. At the opening of the exhibition a young girl in a first communion dress recited obscene-sounding poems, and Ernst invited the visitors to destroy one of his wooden objects to which he had chained an ax for their convenience. But the Surrealist exhibition that opened in January 1938 in the Galerie Beaux-Arts was a more elaborate undertaking. The lobby was dominated by Dali's *Rainy Taxi* (fig. 241), a discarded vehicle inside of which a complicated system of tubing produced a localized rainstorm that drenched two dummies, a driver with a shark's head representing Columbus and a distracted female passenger seated among heads of lettuce and live crawling snails.

The lobby led into a "Surrealist street" (fig. 239) decorated with whimsically titled blue-and-white Paris street signs, and lined with female mannequins composed and dressed by Ernst, Arp, Tanguy, Man Ray, Duchamp, Dali, Miró, and others. One of the most admired was Masson's (fig. 240), the head of which was enclosed in a bird cage, the mouth gagged by a black velvet band decorated with a pansy; beyond that it was adorned with nothing but a G string made of glass eyes. The lobby led into the large central hall (fig. 242), which was designed by Duchamp, who had accepted the task of overseeing the entire operation. He hung 1,200 coal sacks from the ceiling and covered the floor with dead leaves and moss, which gave way at one point to a lily pond surrounded by ferns and reeds. Near this stood a sumptuous double bed, above which hung Masson's *Death of Ophelia*, echoing the implications of the pond and empty bed. The opening of the exhibition was a kind of Happening: coffee roasters permeated the atmosphere with "Perfumes of Brazil," German marching songs came over the loudspeakers, and, at the suggestion of Dali, a dancer named Helen Vanel improvised "The Unconsummated Act" around the pond (fig. 243).

Architecture, even more than sculpture, was an art alien to the aims and practices of Surrealism. To be sure,

Breton was fascinated by the fantastic "palace" that had been constructed by the postman Ferdinand Cheval in southern France between 1879 and 1912. But this involved none of the collective and materialistic implications of architecture, which are so far from the spirit of Surrealism. Nevertheless, the Environment at the Galerie Beaux-Arts did lead Matta Echaurren to speculate on the possibility of a Surrealist architecture. A few months after the opening, Matta, formerly a student in the atelier of Le Corbusier and a recent adherent to Surrealism, published in *Minotaure* a project for a hallucinatory apartment (fig. 244). An "iconic-psychologic" column passed through the different floors, which were decorated with soft, inflated-rubber furniture in the biomorphic shapes that Matta had just begun to employ in paintings. The vertiginous intersecting spaces were separated by pliable walls that would theoretically alter to reflect the inhabitant's anxieties. Later Frederick Kiesler, who designed Peggy Guggenheim's Art of This Century gallery in 1942 with curving walls and wooden biomorphic furniture (fig. 254), and who installed much of the 1947 Surrealist exhibition at the Galerie Maeght, brought Surrealist architecture closer to possible realization with the more advanced projects for The Endless House (fig. 245). This conception, some aspects of which dated from the twenties, emerged in fully developed form as a succession of biomorphic shell-walls articulating a space that could flow continuously or be sectioned off for privacy. By way of this essentially sculpturesque conceit, the beamless, columnless, concrete structure suggested in a more thoroughgoing way than Matta's project a translation of the fundamental Surrealist morphology into architecture.

The 1938 exhibition at the Galerie Beaux-Arts was the last such major Surrealist event before the outbreak of World War II. With the fall of France some Surrealists went into hiding; others, like Miró and Arp, gained the comparative safety of the countries of their citizenship; but the largest number, including Ernst, Masson, Tanguy, Dali, Matta, and Breton himself, took refuge in the United States where the movement experienced its brilliant final phase.

241 SALVADOR DALI. *Rainy Taxi*, at *Exposition Internationale du Surréalisme*, Paris, 1938

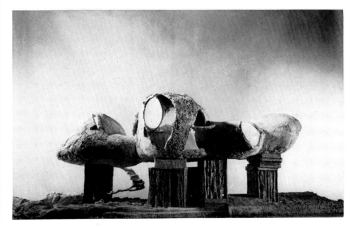

243 Helen Vanel dancing "The Unconsummated Act" by the pond at *Exposition Internationale du Surréalisme*, Paris, 1938

244 above MATTA (ECHAURREN). *Project for an Apartment.* (1938). Collage. Whereabouts unknown, reproduced from *Minotaure* (Paris), Spring 1938

245 below FREDERICK KIESLER. Model for The Endless House. (1958–1959). Cement, 42 inches high × 72 inches long. Collection Mrs. Frederick Kiesler, New York

242 View of the pond at *Exposition Internationale du Surréalisme*, Paris, 1938. Works of art, from left to right: Paalen, Title unknown; Roland Penrose, *The Real Woman*; Masson, *The Death of Ophelia*; Marcel Jean, *Horoscope*

247 ANDRÉ MASSON. *Torrential Self-Portrait.* (1945). Ink, 18⁷/8 × 24 inches. Private collection

Surrealism in Exile and After

opposite
246 Artists in Exile, photograph taken on the occasion of an exhibition at Pierre Matisse Gallery, New York, March 1942. From left to right, first row: Matta Echaurren, Ossip Zadkine, Yves Tanguy, Max Ernst, Marc Chagall, Fernand Léger; second row: André Breton, Piet Mondrian, André Masson, Amédée Ozenfant, Jacques Lipchitz, Pavel Tchelitchew, Kurt Seligmann, Eugene Berman

By 1942, New York and its environs had become the focal point of Surrealist activity. The painters constituted the nucleus of a historically unparalleled group of "artists in exile" which included, among others, Marc Chagall, Fernand Léger, Jacques Lipchitz, and Piet Mondrian (fig. 246). But the community life of Paris could not be re-created in New York, and the exiled artists found it difficult to maintain contact with each other. For the Surrealists, the Julien Levy and Pierre Matisse galleries, where many of them exhibited, became important meeting places. Peggy Guggenheim's gallery, Art of This Century (fig. 254), was an important point of contact between the European and American painters presenting—in the context of its fundamentally Surrealist orientation—many of the first one-man shows of the pioneers of the new American painting. The attitude of The Museum of Modern Art was encouraging; Alfred H. Barr, Jr., the director at the time, had always been interested in Surrealism. In 1936 he organized the pioneering exhibition *Fantastic Art, Dada, Surrealism,* at which time he obtained many Surrealist works for the Museum's permanent collection. He and James Thrall Soby maintained close contact with the members of the movement; in 1935 Soby had published *After Picasso,* the first American book primarily devoted to Surrealism.

The magazines *View* and *VVV* were also foci of Surrealist activity. From the special Surrealist issue of Octo-

ber-November 1941 edited by Nicolas Calas, *View* was almost entirely in the service of the movement, devoting special numbers to the work of Duchamp, Ernst, and Tanguy. *VVV*, which was modeled on *Minotaure* in content though not in format, was put out by David Hare with Breton, Ernst, and, later, Duchamp, as advisors. It served as a forum for the exchange of ideas between the European expatriates and avant-garde American writers and poets; along with major texts by Breton, among them the "Prolegomena to a Third Manifesto of Surrealism or Else," it published others by such Americans as Robert Motherwell, Harold Rosenberg, and Lionel Abel.

Only one group exhibition was staged during the exile period. It was held in the old Reid mansion on Madison Avenue in October 1942. In addition to the expected European painters, it contained work by Calder, Motherwell, Baziotes, and Hare. Duchamp designed the installation (fig. 252), which consisted of a maze of string, an Ariadne's thread beyond which the pictures hung like secrets at the heart of the labyrinth; the spatial effects suggested there, along with ideas derived from the contour lines of the mathematical objects at the Poincaré Institut in Paris, were later explored by Matta in such paintings as *Onyx of Electra* (fig. 253) and *Xpace and the Ego* (fig. 261). Duchamp also designed the catalogue of the exhibition whose title, *First Papers of Surrealism*, was an allusion to the "first papers" of immigrants to the United States.

Of the pioneer Surrealists who spent the war years in America only Masson experienced a major change in style, though Ernst and Tanguy both produced stronger work here than they had during the later thirties in Europe.

248 KURT SELIGMANN. *Star Eater.* (1947). Oil on canvas, 46 × 35 inches. Collection Mrs. Ruth White, New York

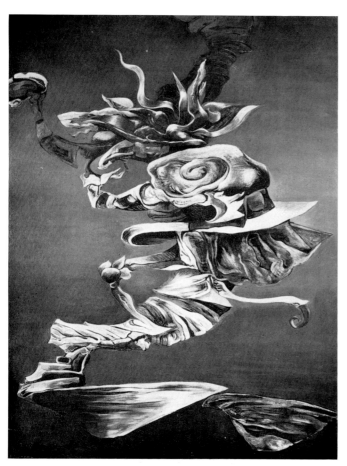

opposite

249 above MAX ERNST. *Europe After the Rain.* 1940–1942. Oil on canvas, 21⁵/₈ × 58¹/₄ inches. Wadsworth Atheneum, Hartford, the Ella Gallup Sumner and Mary Catlin Sumner Collection

250 below MAX ERNST. *Vox Angelica.* 1943. Oil on canvas, 60¹/₈ × 80¹/₈ inches. Collection Mr. and Mrs. Julien Levy, Bridgewater, Connecticut

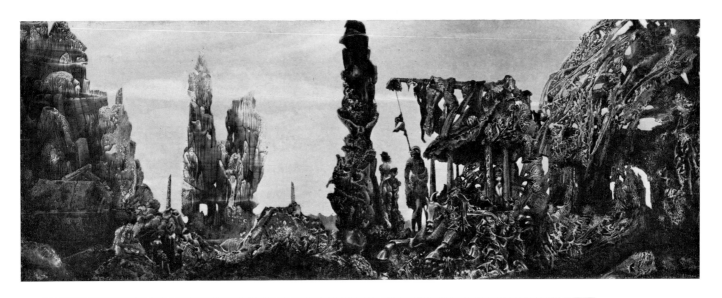

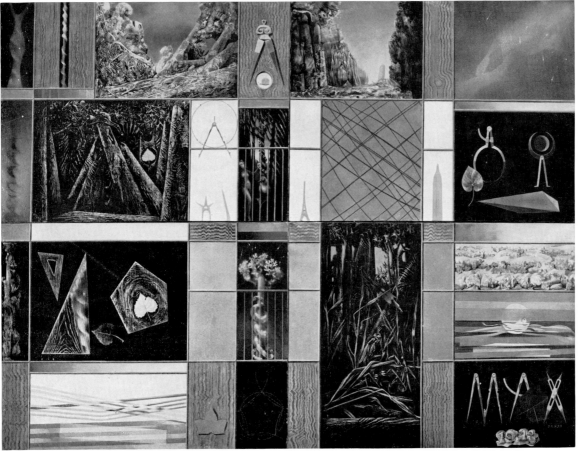

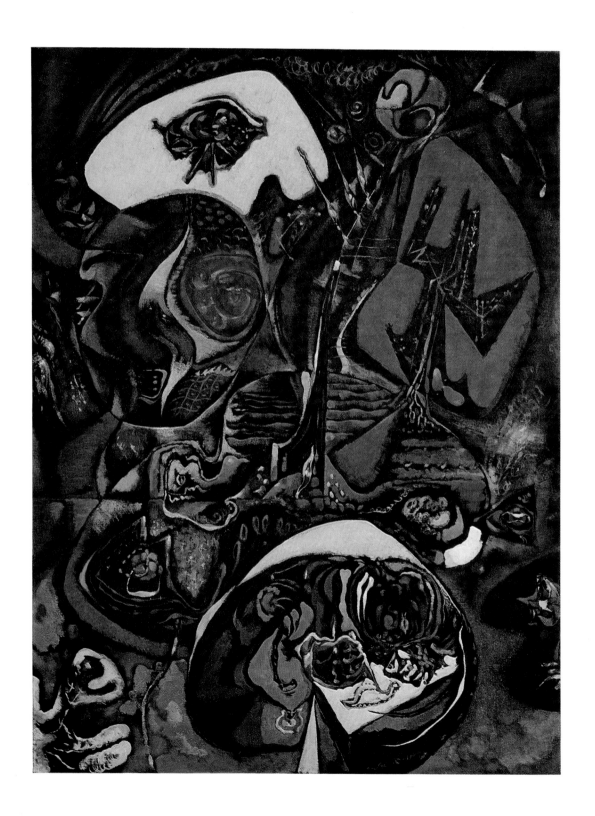

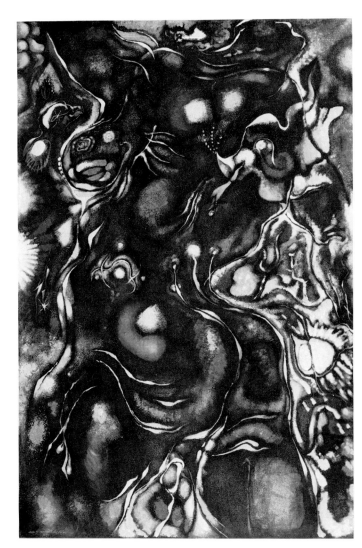

251 ANDRÉ MASSON. *Antille*. (1943). Oil and tempera on canvas, 49⅝ × 33½ inches. Collection Peter B. Bensinger, Chicago

opposite
ANDRÉ MASSON. *Meditation of the Painter*. (1943). Oil and tempera on canvas, 52 × 40 inches. Collection Richard S. Zeisler, New York

Ernst's first paintings in America, such as *Europe After the Rain* (fig. 249), were derived from the decalcomania grounds laid down while he was still in Europe. In the decalcomania illusions of mineral and organic deposits Ernst divined monsters and landscapes that he then elucidated with the brush. He also worked in a variety of older manners and newly invented ones; *Vox Angelica* (fig. 250) is a kind of catalogue of these, containing along with panels of decalcomania, *frottage* "Forests," and "Striated Landscapes," a panel in linear patterns achieved by the technique of oscillation (see above, pages 139, 141).

Much of Masson's work in the late thirties was fussy and too specifically literary, but he found inspiration in the Connecticut landscape of his exile. It drew him back to the more botanical and biological fantasies that had marked his earliest years as a Surrealist. He dropped his sculpturesque style of the late thirties in favor of the flatter, more "abstract" patterning we see in *The Meditation of the Painter* (page 162), a beautifully composed fantasy of organisms on and under the earth. Like most of the paintings of 1942–1944, *The Meditation of the Painter* was executed slowly, with tender concern for the subtleties of texture and brushwork. In the drawings, however, automatism still prevailed. The brilliant self-portrait (fig. 247) was made in a few minutes. The patternings that emerged in such spontaneously realized drawings as *Invention of the Labyrinth* (fig. 255) became the bases for the more slowly gestated and intricately organized paintings of the period.

The luminous coloring of *Antille* (fig. 251) reflected Masson's stay in the Caribbean on his way to New York. One night some time after his arrival here, he awakened troubled by a dream he could not recall. Following the chain of his associations, he executed a series of rapid drawings—strange birds, exotic flora and fauna, sexual organs—which eventually led to the central image of the dream: the torso of a voluptuous Negro woman whom he had glimpsed during his stay in the Antilles. All these "associational" images were synthesized in *Antille*, where they are disposed in relation to the twisting purple-brown body of the woman. Her perspiration is suggested by the reflections of the sand mixed in the pigment, a typically surreal use of a substance that was employed by the Cubists for abstract textural purposes.

163

254 above Art of This Century, New York, October 1942. Surrealist
gallery designed by Frederick Kiesler. On chair at left, Giacometti's
Woman with Her Throat Cut

255 right ANDRÉ MASSON. *Invention of the Labyrinth.* (1942). Ink,
23¹/₄ × 18³/₈ inches. Private collection

opposite
252 above Installation view of exhibition *First Papers of Surrealism*,
held at 451 Madison Avenue, New York, October–November 1942.
Hanging by André Breton, twine by Marcel Duchamp

253 below MATTA (ECHAURREN). *The Onyx of Electra.* (1944). Oil on
canvas, 50¹/₈ × 72 inches. Collection Mr. and Mrs. E. A. Bergman,
Chicago

The very first oils of Chilean-born Matta, painted in 1938, marked him as an independent and unusual talent. But while the character of his style was set in Paris during this first year of work, it was only with his arrival in America in 1939 that his painting began to take on the brilliance and range that put it at the center of Surrealist art during World War II. Matta's was the last major pictorial statement entirely definable within the co-ordinates of Surrealism. Though Gorky became a Surrealist painter in many ways—catapulted in that direction by Miró and Matta—his mature style can be fully comprehended only in the light of his long apprenticeship to the European modernist tradition, Picasso especially, and, later, to the influence of Kandinsky. This is not true of Matta, whose stylistic sources—Tanguy and, to a lesser extent, Duchamp—were entirely within the Surrealist tradition.

Inscape (fig. 256), painted shortly before his departure for America, illustrates the type of biomorphic fantasy landscape, a kind of soft-focus Tanguy, that dominated Matta's painting from its inception through 1942. As the title implies, it is a landscape "discovered" within the self, a morphological projection of a psychological state.[112] The image was induced improvisationally, the landscape defining itself as the work progressed. Matta worked rapidly, partly with rags; clusters of pigment might be spread thin into washes suggesting membranous hills, or left alone as highlights suggesting rocks. *The Earth Is a Man* (fig. 258) is the brilliant synthesis of these amorphous landscapes. The sun, partly eclipsed by a disintegrating red planet, illuminates a primordial landscape of apocalyptic splendor, and everywhere the forms are engulfed in endless metamorphoses, passing through what appear to be vaporous liquid and crystalline states in a kind of "futurism of the organic."[113]

256 above MATTA (ECHAURREN). *Inscape (Psychological Morphology No. 104).* (1939). Oil on canvas, $28\frac{7}{8} \times 36\frac{3}{8}$ inches. Collection Gordon Onslow-Ford, Inverness, California

257 below MATTA (ECHAURREN). *Here Sir Fire, Eat.* (1942). Oil on canvas, 56×44 inches. Collection James Thrall Soby, New Canaan, Connecticut

258 MATTA (ECHAURREN). *The Earth Is a Man.* (1942). Oil on canvas, 6 feet ¹/₄ inch × 8 feet. Collection Mr. and Mrs. Joseph R. Shapiro, Oak Park, Illinois

259 above MATTA (ECHAURREN). *To Escape the Absolute.* (1944). Oil on canvas, 38×50 inches. Collection Mr. and Mrs. Joseph Slifka, New York

260 left MATTA (ECHAURREN). *Splitting the Ergo.* (1946). Oil on canvas, 6 feet 4⁷/₈ inches × 8 feet 3¹/₄ inches. Collection Mr. and Mrs. Burton Tremaine, Meriden, Connecticut

261 MATTA (ECHAURREN). *Xpace and the Ego*. (1945). Oil on canvas, 6 feet 9 inches × 15 feet. Private collection

By the end of 1942 Matta had already begun, as in *Here Sir Fire, Eat* (fig. 257), to renounce the use of a horizon line in favor of looser, more tenuous arrangements of small galactic forms in deep perspective space, a vision that matured two years later in such pictures as *To Escape the Absolute* (fig. 259). Here the allusion to interstellar space is intended to suggest simultaneously the cosmos and the recesses of the mind. To create this "painterly" equivalent of the linear space of de Chirico, Matta availed himself of all the techniques of old-master illusionism. But he went far beyond de Chirico in his atomization of the coherent, unified, and systematic space of the older art. As the eye tries to find its way through the penumbra, it slips into unexpected byways, is sucked into whirlpools of space, or is frustrated by opaque planes that block its passage—a symbolic drama of the mind's journey into its own unconscious.

Toward the end of 1944 the deep space of such dark pictures as *To Escape the Absolute* gave way to a shallower space that depended more on draftsmanly than atmospheric devices. In the taut and intricately wired *Onyx of Electra* (fig. 253) gemlike clusters of pigment function as nodes or terminals for nervous linear circuits. These space-contouring webs created a vertiginous environment which in *Xpace and the Ego* (fig. 261) and other pictures of the following year became peopled with monstrous personages. At their most literal, these bizarre anthropomorphs, which became increasingly sculpturesque in their modeling as Matta proceeded, recalled the monsters of Ernst, Giacometti's *Invisible Object* (the original plaster of which Matta owned), and the aggressive mannequins in Masson's drawings of 1939–1941. At their more mechanical, they reflected Matta's fascination with Duchamp's machinist pictures of 1912, from whose cinematic effects he derived the spun, splayed, and shuffled planes of such pictures as *Splitting the Ergo* (fig. 260). *Xpace and the Ego*, fifteen feet wide, was one of the first of the giant canvases that became virtually standard in Matta's exhibitions from 1946 onward. The painters of the New York School arrived at this format only in 1950, but in an abstract, anti-illusionistic style alien to Matta's wide-screen theater.

262 WIFREDO LAM. *Eggue Orissi, l'Herbe des Dieux.* 1944. Oil on canvas, 71$^{1}/_{2}$ × 49 inches. The Reader's Digest Association, Pleasantville, New York.

opposite

263 above WIFREDO LAM. *Song of the Osmosis.* (1945). Oil on canvas, 49$^{1}/_{2}$ × 60$^{3}/_{8}$ inches. Collection Joseph Cantor, Carmel, Indiana

264 below WIFREDO LAM. *The Antillean Parade.* 1945. Oil on canvas, 49$^{1}/_{2}$ × 43$^{1}/_{2}$ inches. Collection Joseph Cantor, Carmel, Indiana

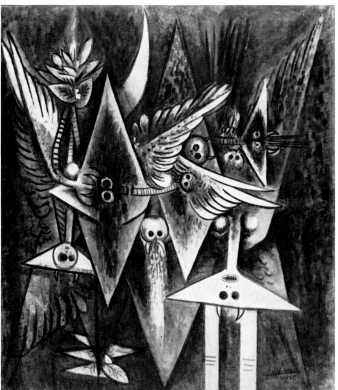

Wifredo Lam was the first Surrealist to make primitive and ethnic sources central to his art. Though we see iconographic traces of such magical imagery from time to time in the work of Ernst, it counted for surprisingly little among the Surrealist painters in general. This, despite the fact that many Surrealists were avid collectors of primitive art, which appealed to them especially because it stood outside an aesthetic tradition. Such pictures as Lam's *Antillean Parade* (fig. 264) contain a fusion of influences as diverse as Haitian voodoo figures and African masks. From the penumbra of bamboo and palm frond forests that form Lam's primal landscapes, emerge hybrid personages whose presences seem to be discovered in the very defining of the flora (fig. 262). Picasso was one of the earliest and continuous influences on Lam, and many of his forests reflect the shallow space and hybrid primitive iconography of *Les Demoiselles d'Avignon,* but the facture is less aggressive, attaining sometimes, as in *Song of the Osmosis* (fig. 263), a transparency and delicacy that rather recalls Cézanne's watercolors.

Arshile Gorky was the last important artist to be associated with Surrealism. Breton became interested in him in 1943, and two years later devoted the concluding section of the new edition of his *Le Surréalisme et la peinture* to Gorky.[114] By then he was considered a full-fledged member of the movement. Though Gorky explored the possibilities of automatism and wrung from biomorphism a particular pathos, he was more deeply committed by affinity and by training than even Miró to the mainstream of European painting, as represented by Picasso and Matisse. The Surrealists, by and large, disdained the medium, as their various techniques for by-passing it suggest. Gorky delighted in oil painting and nursed from its possibilities a range of effects that place him second to none as a manipulator of the brush.

The extraordinary painterly sensibility of Gorky's best work was achieved through a long apprenticeship. Years of paraphrasing Cézanne, Picasso, and Matisse, and then in the later thirties and early forties, Miró and Matta, allowed Gorky to select and retain from their styles what was viable for him. But even as he passed into his maturity in the winter of 1942/1943 he was still anxious to learn,

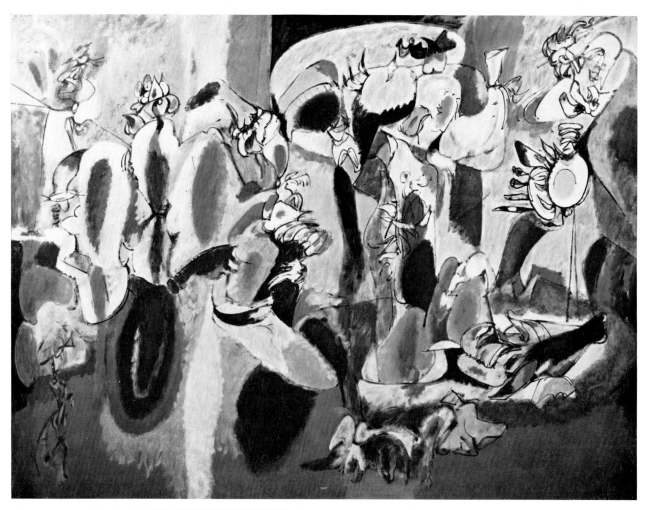

265 above ARSHILE GORKY. *The Liver Is the Cock's Comb*. 1944. Oil on canvas, 6 feet 1 inch × 8 feet 2¹/₂ inches. Albright-Knox Art Gallery, Buffalo

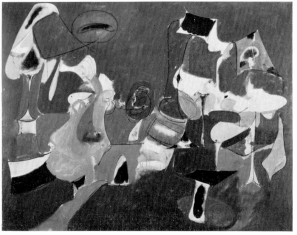

266 left ARSHILE GORKY. *Soft Night*. 1947. Oil on canvas, 38 × 50 inches. Collection Mrs. John C. Franklin, Greenwich, Connecticut

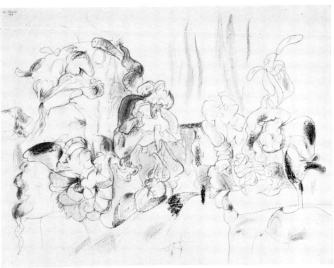

267 MATTA (ECHAURREN). *Landscape.* 1940. Pencil and crayon, 14³/₄ × 21¹/₂ inches. Collection Mr. and Mrs. E. A. Bergman, Chicago

268 ARSHILE GORKY. *Landscape.* 1943. Pencil and crayon, 20¹/₄ × 27³/₈ inches. Collection Mr. and Mrs. Walter Bareiss, Munich

and still unwilling to narrow himself to a single tradition, as his assimilations at that time from Kandinsky's works of 1910–1914 testify. By the following year his modesty and openness to the art of other painters, whom he selected with infallible instinct, emerged in pictures that communicated Gorky's personal poetry with an overwhelming orchestral sumptuousness. *The Liver Is the Cock's Comb* (fig. 265) synthesizes the pictorial language of Kandinsky, the biomorphism of Miró, and the automatist "Inscapes" of Matta, but goes beyond them all in painterly richness.[115]

Gorky's focus upon sexuality is an important aspect of his attachment to Surrealism. Each painter in the movement handled the erotic in a manner consistent with his art as a whole. In Miró's work, for example, sex is almost always playful and whimsical; in Dali's, it is associated with voyeurism. But the two artists who gave the erotic the crucial role of catalyst to the creative powers were Masson and Matta. Both understood the sexual paroxysm as the moment of the fusion of contraries: the conscious and unconscious, mind and body, the self and the "other," and, hence, the moment of the liberation of the imagination. In Masson, sexuality has a robust quality; it seems to galvanize his automatism and bind all sorts of hybrid

themes with its energy. In Matta, on the other hand, after the lyricism of the "Inscapes," it acquired an aggressive and self-conscious character. The "poetry of sex," which Gorky's friend and biographer Ethel Schwabacher has called "his myth,"[116] dominated the iconography of *The Liver Is the Cock's Comb*. It ranges from the quite literal male and female genitalia at center left of the picture to more ambiguous, schematic allusions of the type used by Miró and Masson. But the sumptuous affirmation of the sexual in *The Liver Is the Cock's Comb* was not to endure; following the tenor of Gorky's personal life, it soon gave way to an eroticism marked by anxiety, nervous tension, and masochism.

During the winter of 1944/1945, Gorky's interest in spontaneity carried him beyond the "Improvisations" of Kandinsky to the technique of automatism. Such pictures as *One Year the Milkweed* (fig. 269) and *The Leaf of the Artichoke Is an Owl* (fig. 270) show him nearer to Surrealism than he had yet been, or was ever to be afterward, and mark precisely the time of his greatest personal closeness to Breton and to Matta. The rapid drawing, the loose brushwork that encouraged the spilling and dripping of the liquid paint, departed from Matta's automatism of

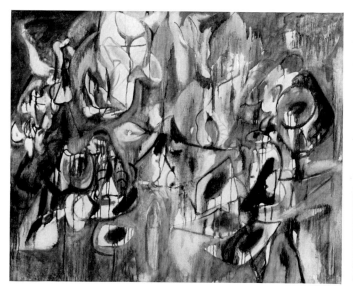

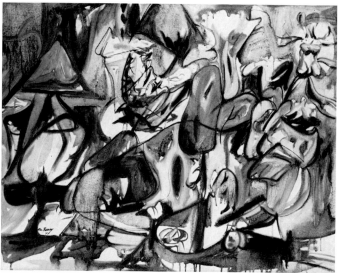

269 ARSHILE GORKY. *One Year the Milkweed*. 1944. Oil on canvas, 37 × 47¹⁄₄ inches. Collection Mrs. Agnes Gorky Phillips, London

270 ARSHILE GORKY. *The Leaf of the Artichoke Is an Owl*. 1944. Oil on canvas, 28 × 36 inches. Collection Mrs. Ethel K. Schwabacher, New York

1938–1942 and went beyond it. It was only natural that Breton should have encouraged Gorky in this excursion. Julien Levy, Gorky's dealer at the time, speaks of this as "liberation." For Gorky, "automatism was a redemption." Surrealism, he continues, helped Gorky "both to bring himself to the surface and dig himself deep in his work," so that "his most secret doodling could be very central."[117]

Gorky's most automatic and loosely painted works were not all of high quality. In view of the chance aspects and the rapid execution involved, they could not be endowed with the loving nuancing that his more studied earlier approach had permitted, and it is not surprising that some of the compositions even got away from him. But in subsequent pictures, such as the exquisite *Diary of a Seducer* (fig. 271), Gorky retained from his automatic phase the diaphanous washes and ease of execution, which he joined to passages of excruciatingly delicate and fluent drawing and shading. As in the case of *The Liver Is the Cock's Comb* and many other pictures, the composition of *The Diary of a Seducer* implies a bisecting horizontal above and below which the forms cluster; behind the troubled eroticism suggested by the darkling ambiance and attenuated organic forms are hints of the landscape origin from which

this horizontal remains. Breton himself singled out Gorky as the "only Surrealist . . . in direct contact with nature, placing himself *before her* to paint."[118] But this commitment to a starting point in nature suggests that despite the fantastical morphological changes that he imposed on his image of nature, Gorky's instincts were fundamentally alien to Surrealism.

In 1947 Gorky's art reflected the unbelievable string of tragedies that were to lead to his suicide the following year: a fire that destroyed his studio and much of his work, cancer, sexual impotence, and a broken neck from an auto accident. For a year his biomorphic forms had already been marked by extremes of pathos and aggression. The profiles of his new shapes suggested emotions that were being exacerbated, literally drawn out almost beyond the point of endurance. In the center right of *Betrothal II*, for example (fig. 272), the contours of a shape are pinched together and drawn upward like a nerve being pulled, until, just before snapping, they resolve into another plane—itself painfully attenuated.

Gorky's mature career belonged to a period of transition in the avant-garde; it extended from 1942 through 1947 and

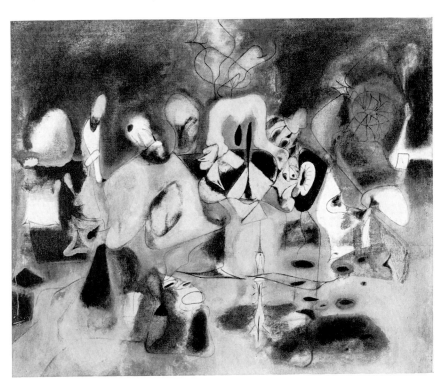

271 above ARSHILE GORKY. *The Diary of a Seducer*. 1945. Oil on canvas, 50 × 62 inches. Collection Mr. and Mrs. William A. M. Burden, New York

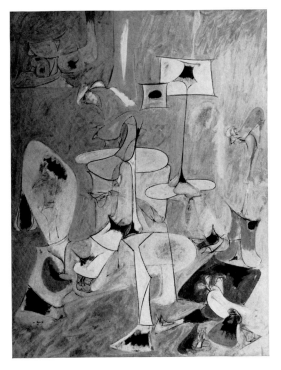

272 left ARSHILE GORKY. *The Betrothal II*. 1947. Oil on canvas, 50³/4 × 38 inches. Whitney Museum of American Art, New York

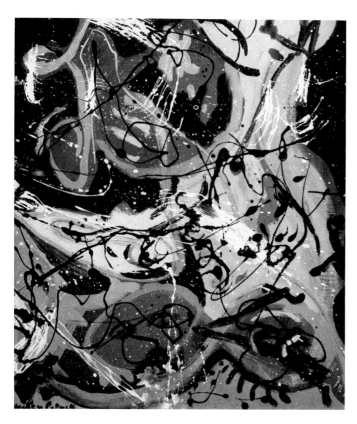

273 JACKSON POLLOCK. Untitled abstraction. 1943. Oil and enamel paint on canvas, 25 × 22 inches. Joseph H. Hirshhorn Collection, New York

thus corresponded simultaneously to the last phase of Surrealism and to the early work of the artists who would later emerge as innovators of the new American painting. The international Surrealist exhibition at the Galerie Maeght in 1947 sounded the death knell of the Surrealist movement. That same year Jackson Pollock's work—the consolidation of his revolutionary "drip" style—announced a new phase in the history of art. From then until the end of the decade the work of many other American painters would pass from a "surrealizing" phase to more daring and individual manners. The return of Breton and most of the Surrealist painters to France helped to create an atmosphere in America that was conducive to originality. Their presence here had been germinal, but the period of symbiosis was over. By 1950 a number of American painters had made significant breakthroughs, and various counterpart styles—*tachisme* or *l'informel*—were even being established in Europe.

In Paris, Breton, whose entourage now contained virtually none of the pioneer Surrealists, tried heroically to regain his position of leadership in the avant-garde. But in contrast to the Surrealist exhibitions of the 1920s and 1930s, as well as that of 1942 in New York, the 1947 exhibition at the Galerie Maeght had the atmosphere of a historical retrospective; little of the recent work shown was of the first order. It received enormous attention in Paris and enjoyed great publicity, but this interest was inspired more by curiosity than by any real urge to participate in or support Surrealism. Current French art was left untouched by the show. This is not surprising; Surrealism appeared clearly beside the point to such new leaders of the French literary, philosophical, and even political scene as Sartre and Camus. Their positions enjoyed the sense of pertinence that stemmed from their involvement with the Resistance while the Surrealists were in exile.[119]

Breton also attempted to revive the failing movement by putting out two new reviews, *Médium* and *Le Surréalisme Même*, but far from testifying to its vitality they offered perhaps the best evidence that Surrealism was no longer capable of inspiring or attracting to it men of genius. Except for an occasional contribution by one of the earlier Surrealists, generally something from the pre-1939 period, both the writing and the works of art reproduced

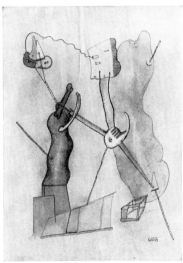

274　above WOLS (ALFRED OTTO WOLFGANG SCHULZ). *Whales in Water Flowers.* (1937). Oil on paper, 10⅝ × 13¾ inches. Galerie Europe, Paris

275　below WOLS (ALFRED OTTO WOLFGANG SCHULZ). *Electric Contact.* (1938). Gouache, 12⅜ × 9¼ inches. Galerie Europe, Paris

in these magazines were of an unrelieved mediocrity.

After 1947, Breton occasionally arranged large exhibitions of Surrealist painting, but these were of interest only to the extent that they were retrospective. The most interesting European painters to utilize ideas derived from Surrealism—Wols and Michaux, for example—had developed outside the confines of the movement, which was more than ever defined by Breton's personal likes and dislikes. In a show Breton organized in December 1959 at the Galerie Cordier, he was reduced to including Jasper Johns's *Target with Plaster Casts* (fig. 30), an excellent but not particularly Surrealist work, in order to create a sense of up-to-dateness. The best of Surrealism had long since been absorbed into the mainstream of modern art and literature, where it enjoys an immortality far more substantial than any that could be conferred on it by Breton's attempts to keep the movement alive by fiat.

The early transitional period of American painting, which corresponded to that of Gorky's maturity, had seen the assimilation of Surrealist ideas from Miró and, to a lesser extent, Masson and Ernst, into a pictorial context dominated by the influence of Picasso. Though Baziotes, Motherwell, and Hare participated in the 1942 New York Surrealist exhibition, the Americans generally remained at some distance from the movement, a distance that allowed each one to filter Surrealism according to his temperament. While "abstract" Surrealism provided a still workable morphology—biomorphism—and a methodology—automatism—illusionist Surrealism was entirely by-passed.

Pollock's development offers a paradigm of the relationship of Surrealism to American art of the forties. The myth-oriented iconography of his work of the early forties, like that of Rothko, Gottlieb, and others, paralleled that of the late phase of Surrealist *peinture-poésie* and his form-language was influenced by Miró and Masson (though his Cubist substructure and bravura execution reflected a more profound commitment to Picasso than to anyone else). But what Pollock really took from Surrealism was an idea—automatism—rather than a manner.[120] Already in the untitled abstraction of 1943 (fig. 273) his desire to liberate himself from the restrictions of traditional facture and the mannerisms they entailed had led him to drip liquid paint

and to draw with a stick rather than a brush. Spilling and dripping as such was hardly a novel idea, but Pollock was the first to use it consistently in order to facilitate extended spontaneous drawing.

Pollock used automatism as a means of getting the picture started, and, like the Surrealists, believed that this method would give freer rein to the unconscious. The increasing velocity of his execution from 1943 onward led to an atomization of the picture surface that permitted him to invest it with a continuous rhythm, his characteristic "pneuma." By the winter of 1946/1947 the scale and richness of this rhythm had necessitated the adoption of the drip technique in a consistent manner; the totemic presences of Pollock's earlier work disappeared under the ensuing labyrinthine web. This "classic" style of Pollock constituted a kind of apotheosis of automatism, and of the constructive possibilities of chance and accident. His painting not only went beyond the wildest speculations of Surrealism in the extent of its automatism, but in its move toward pure abstraction, was alien to the Surrealist conception of picture-making. Nevertheless, as Pollock relaxed his drip style in the black-and-white paintings of 1951, fragments of anatomies—some monstrous and deformed, others more literal—surfaced again, as if the fearful presences in his work of the early forties had remained as informing spirits beneath the fabric of the "all-over" pictures.

The second World War and the emigration of so many leading painters had broken the continuity of European painting, with the result that the progression epitomized in Pollock's work took place later in Europe and had less thrust and originality. There, the development of the *informel* in the work of such painters as Wols and Michaux failed to lead to such radical conclusions as those proposed by the art of their American counterparts. In the 1930s Wols had been strongly influenced by Surrealism, as illustrated by the Tanguyesque *Electric Contact* (fig. 275) and *Whales in Water Flowers* (fig. 274), which unmistakenly derives from Ernst's "Dove" series. In the years following World War II, Wols's automatism became more marked, largely under the impact of Klee. Then, in the years just before his tragic death, he pushed his miniaturist improvisation into larger size in a series of oil paintings some of which retained vague suggestions of his earlier fantasy per-

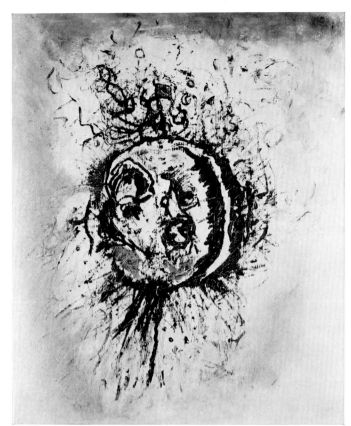

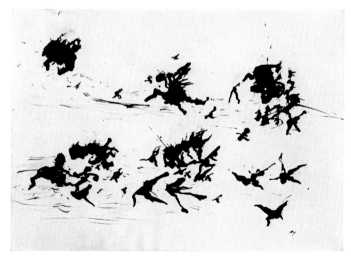

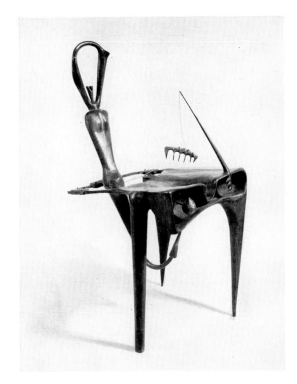 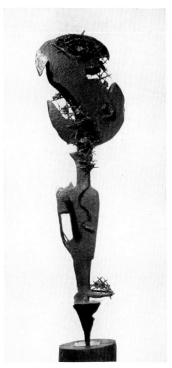 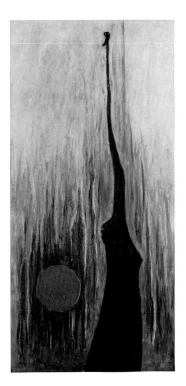

278 left DAVID HARE. *Magician's Game.* (1944). Bronze, 43 inches high × 33 inches long. Collection the artist, New York

279 center HERBERT FERBER. *He Is Not a Man.* (1950). Lead and brass, 72 inches high. Collection Mark Rothko, New York

280 right CLYFFORD STILL. *Jamais.* 1944. Oil on canvas, 65 × 31 1/2 inches. Collection Miss Peggy Guggenheim, Venice*

opposite
276 above WOLS (ALFRED OTTO WOLFGANG SCHULZ). *Anxious Face.*
(1946). Oil on canvas, 25 × 20 1/2 inches. Collection Mr. and Mrs. Morton
G. Neumann, Chicago

277 below HENRI MICHAUX. Untitled. (c. 1956). Ink, 29 × 41 inches.
Collection Mrs. Ruth Moskin Fineshriber, New York

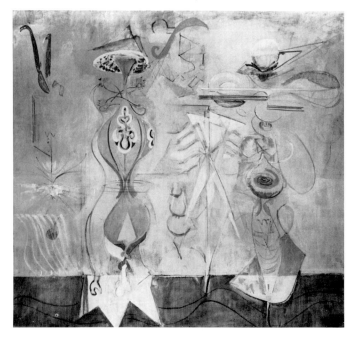

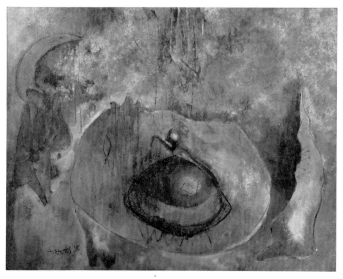

281 above MARK ROTHKO. *Slow Swirl by the Edge of the Sea.* (1944). Oil on canvas, 6 feet 3 inches × 7 feet ½ inch. Collection the artist, New York

282 below THEODOROS STAMOS. *Sacrifice.* 1948. Oil on composition board, 36 × 48 inches. Collection the artist, New York

sonages (fig. 276), while others passed over into total abstraction. Michaux, too, moved from the figurative context demonstrated by the hallucinated *Head* to "randomly" blotted and splashed drawings—influenced by Pollock's 1951 black-and-white paintings—where the patterning, nominally abstract, nevertheless retains a Rorschach-like allusiveness (fig. 277).

In its surrealizing phase of the early and mid-forties, American painting often exploited biomorphism. Theodoros Stamos wrought from it an image of primordial beings (fig. 282), whose sculptural counterpart is suggested in Herbert Ferber's *He Is Not a Man* (fig. 279); Baziotes subsequently endowed a comparable vision with a diaphanous quality reminiscent of Redon. The biomorphism of Barnett Newman's *Pagan Void* was exceptional in his imagery, which, in such visionary pictures as *Genetic Moment* (fig. 284), suggested distant affinities with Ernst's wood-*frottage* "Forests." It was, however, a fundamental constituent in the exquisite monsters of Mark Rothko; in his *Slow Swirl by the Edge of the Sea* (fig. 281) the biomorphism is attenuated by automatic drawing of an elegance comparable to the best of Surrealism at that time.

During the fifties, when their mature styles were making their mark, many American artists were reluctant to exhibit their earlier surrealizing works, and a whole generation has grown up hardly aware of their existence. Today, we are able to see how much originality these pictures contain despite debts to Surrealism, and how often—as was already the case with Gorky—even the borrowed stylistic formulations contained a greater depth and quality than did their prototypes.

The reaction of the pioneer American painters in the late forties against the mythic, biomorphic, and poetic images of their own work, and against the Surrealist ambiance that influenced it, was a stringent one. Having been to some extent overimpressed by the Surrealists as the embodiment of the great European avant-garde, the Americans now regarded them largely as idols with clay feet. Only Miró, who had not been in America during the war, and, to some extent, Masson were excepted from the widespread contumely. By 1950 this reaction appeared to be complete. Except in the case of Pollock's automatism, the mature styles of the Abstract Expressionist painters seemed to

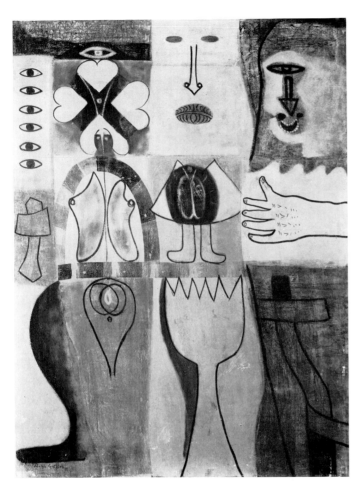

283 ADOLPH GOTTLIEB. *Oracle*. 1947. Oil on canvas, 60 × 44 inches. Collection Mr. and Mrs. Albert A. List, New York*

284 BARNETT NEWMAN. *Genetic Moment*. (1947). Oil on canvas, 38 × 28 inches. Collection Mrs. Annalee Newman, New York

285 left ALFONSO OSSORIO. *Sea Change*. 1951. Ink, wax, and watercolor, 30 × 22 inches. Collection the artist, East Hampton, New York

286 right GEORGE COHEN. *Hermes*. (1957). Oil, cloth, and sandpaper on canvas, 46 × 36 inches. Collection Mr. and Mrs. Joseph R. Shapiro, Oak Park, Illinois

reject out of hand everything that Surrealism stood for.

But at the same time they produced a kind of abstraction markedly different from that to which Cubism and Fauvism alone might have been expected to lead. These movements had already lost their momentum in Europe in the 1930s, and the American practitioners of Cubism and abstraction in that decade found themselves at a dead end. Only a new spirit could have freed them; the American painters' experience of Surrealism in the early and middle forties enabled them to "open up" the language they had inherited from Cubism and Fauvism, and thus preserve what was still viable in those styles. And while it is true that they expunged the quasi-literary imagery that had earlier related their paintings to Surrealism, the visionary spirit of their wholly abstract art retained much of Surrealism's concern with poetry albeit in a less obvious form. The poetic content of the mature art of Pollock, Rothko, Newman, Still, Motherwell, and Gottlieb (to say nothing

of some sculptors) does as much to set them apart from Picasso, Matisse, and Mondrian as do differences in technique or structure.

The debt to Surrealism in the mature work of the first-generation Americans was only implicit; their revival of the main line of European abstraction, which had faltered about the time of World War I, was explicit. And thus it appeared by 1955 as if the entire Dada-Surrealist adventure was a kind of anti-modernist reaction situated parenthetically between the great abstract movements prior to World War I and after World War II. But the force of this conviction has been compromised by a subsequent reaction in favor of Dada—and to a much lesser extent Surrealism—on the part of many younger artists who have matured since 1955.[121] Yet even the artists who seemed most neo-Dadaist, such as Johns and Rauschenberg, by no means accepted Dadaist positions integrally. When Johns and Rauschenberg posed Duchamp's questions they came up

 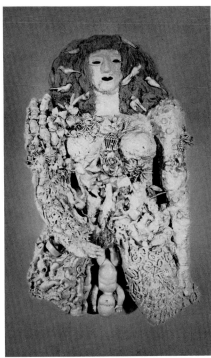 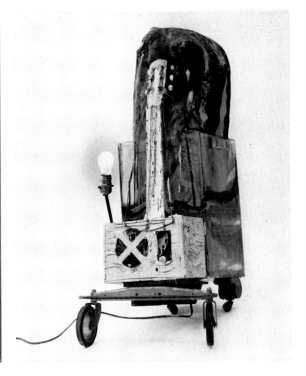

287 left BERNARD SCHULTZE. *Mannequin-Migof.* (1967). Painted polyester resin, 70½ inches high × 28¾ inches wide × 23⅝ inches deep. London Arts Incorporated, Detroit

288 center NIKI DE SAINT PHALLE. *Ghea.* (1964). Construction in papier-mâché with painted toys, mounted on wood, 70⅞ × 43⅜ inches. Alexander Iolas Gallery, New York

289 right EDWARD KIENHOLZ. *Ida Franger.* 1960. Construction with cloth, metal, plastic, light bulb, and stuffed bird, 34 inches high × 17 inches wide × 22 inches deep. Collection the artist, Los Angeles

290 VALERIO ADAMI. *Henri Matisse Painting the Model.* (1966). Synthetic polymer paint on canvas, 31⁷/₈ × 39³/₈ inches.
Collection Professor Alik Cavaliere, Milan

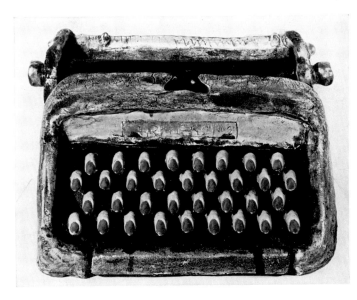

with quite different answers. In place of an intellectually oriented nihilism toward art, they responded with a sensuous affirmation of painting, the inflection of which moreover depended—Rauschenberg's facture, for example—on the very Abstract Expressionism whose tenets they were against on other levels. Johns's *Target with Plaster Casts* (fig. 30) has affinities with such Picabia targets as *Optophone* (fig. 29) and with Dali's *objet-trouvé* plaster cast of a foot (fig. 212). But while such motifs retain their poetic ambiguities in Johns's piece, their anti-art implications are dissolved by the refined aestheticism of his style. By the same token the mannequin-based constructions of Bernard Schultze and Niki de Saint Phalle differ characteristically from their Surrealist predecessors. The charred and torn textures into which the flesh of Schultze's *Mannequin-Migof* resolves (fig. 287), and the vermicular encrustation of toy dolls on the skin of Niki de Saint Phalle's earth goddess *Ghea* (fig. 288), presuppose the language of Abstract Expressionism despite their more evident commitment to a tradition of poetic representation.

Since 1950 there has been no such thing as Dadaist or Surrealist art properly speaking. What was vital in those movements has been so assimilated into the cumulative vocabulary of art that much of what is done today is touched by it in one way or another. The selection of works in the Heritage section of the exhibition suggests some of the many kinds of stylistic and iconographic fusions this assimilation has made possible. Sometimes, as for example, in Klapheck's sewing machine, *Intriguing Woman* (fig. 291), the debt is iconographic only. This "machine charmer," as Breton, who devoted his last catalogue preface to Klapheck, called him, accomplishes his effects through the medium of "hard-edge" painting. This same style, modified by Lichtenstein's Pop Art cartoon pictures, becomes a function of another kind of equation in Adami's *Henri Matisse Painting the Model* (fig. 290), based upon a famous photograph of Matisse at work. Here the derivative element is biomorphic fantasy. With each new stylistic wave the vestiges of Dada and Surrealist ideas become further attenuated and diffused. Today they are taken up by younger artists less from their original sources than from the modified forms in which they have appeared in the art of the two decades since the second World War.

291 above KONRAD KLAPHECK. *Intriguing Woman.* (1964). Oil on canvas, 39³/₈×43³/₈ inches. Collection Mr. and Mrs. Julien Levy, Bridgewater, Connecticut

292 below ROBERT ARNESON. *Typewriter.* (1965). Painted and glazed ceramic, 12 inches wide × 10 inches deep. Allan Stone Gallery, New York

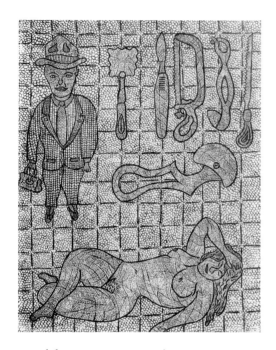

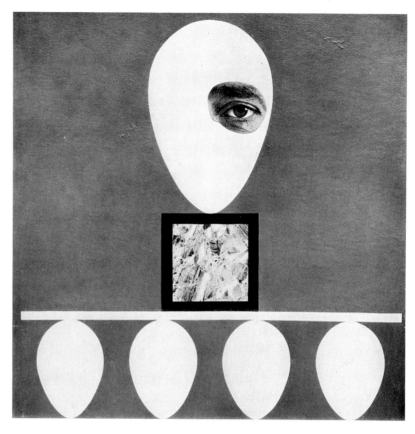

293 left WILLIAM N. COPLEY. *Il Est Minuit Docteur.* 1961. Oil on canvas, 32 × 25¹/₂ inches. Collection the artist, New York

294 right CLARENCE CARTER. *Borne in Triumph.* 1965. Synthetic polymer paint on canvas, 44 × 44 inches. New Jersey State Museum, Trenton

Notes

The reader will find that in the case of translated material there may be differences between the version presented here and the English source to which he is directed. The author has taken the liberty of modifying translations in the interest of clarity and greater accuracy, but prefers, for the convenience of students, to indicate where material is readily available in English.

1 During his Dada period André Breton summarized this view—which he maintained throughout the Surrealist years—as follows: "It would be an error to consider art as an end. The doctrine of art for art's sake . . . seems senseless to me. We know that poetry must lead somewhere" ("Les Chants de Maldoror"); ". . . painting, for example, should not have for its end the pleasure of the eyes . . . I persist in believing that a picture or sculpture . . . is justifiable only insofar as it is capable of advancing our abstract knowledge properly so-called (*notre connaissance proprement dite*)" ("Distances"); both reprinted in André Breton, *Les Pas perdus* (Paris, 1924), pp. 80, 174.

2 Tristan Tzara, Introduction, in Georges Hugnet, *L'Aventure Dada* (Paris, 1957), p. 7.

3 Cited in Maurice Nadeau, *The History of Surrealism*, translated by Richard Howard (New York, 1965), p. 110.

4 "Phare de *La Mariée*," *Minotaure* (Paris), Winter 1935, p. 45; English translation, "Lighthouse of the Bride," in Robert Lebel, *Marcel Duchamp*, translated by George Heard Hamilton (New York, 1959), p. 88.

5 "Conférence sur Dada," delivered at the Weimar Congress of 1922, published in *Merz* (Hanover), January 1924, pp. 68–70; English translation, "Lecture on Dada," in Robert Motherwell (ed.), *The Dada Painters and Poets* (New York, 1951), pp. 246–51.

6 "De plus en plus je m'éloignais de l'esthétique," reprinted in Arp, *On My Way: Poetry and Essays 1912–1947* (New York, 1948), p. 91.

7 Paris Dadaists considered the aimless murder carried out by Lafcadio in André Gide's *Les Caves du Vatican* (1914) to be the literary prototype of the *geste gratuit*, the act that breaks the chain of "logical" causality.

8 *Second Manifeste du Surréalisme* (Paris, 1930), p. 12.

9 "Manifesto of mr. aa the anti-philosopher" (1920?); English translation in Motherwell (ed.), *op. cit.*, p. 85.

10 See below, pages 27 and 31, and note 36.

11 Richard Huelsenbeck, *En avant Dada: Die Geschichte des Dadaismus* (Hanover, 1920), p. 33; English translation in Motherwell (ed.), *op. cit.*, p. 43.

12 Tzara, Introduction, *op. cit.*, p. 7.

13 See "Entretien," in Michel Sanouillet (ed.), *Marchand du sel, Ecrits de Marcel Duchamp* (Paris, 1958), p. 159, the authorized French translation of a conversation between Marcel Duchamp and James Johnson Sweeney filmed in 1955 and shown as part of the *Wisdom* series on NBC-TV, January 1956.

14 Quoted in "Eleven Europeans in America," James Johnson Sweeney (ed.), *The Museum of Modern Art Bulletin* (New York), vol. 13, no. 4/5, 1946, p. 20.

15 *Ibid.*

16 *Ibid.* (italics mine).

17 See "Entretien," *op. cit.*, pp. 153–54.

18 When the letters of the title are pronounced quickly in French they form the sentence, "Elle a chaud au cul" (She has hot pants).

19 "A point that I want very much to establish is, that the choice of these Readymades was never dictated

by an aesthetic delectation. The choice was based on a reaction of visual *indifference*, with at the same time a total absence of good or bad taste, in fact, a complete anesthesia" (statement at *The Art of Assemblage: A Symposium*, The Museum of Modern Art, New York, October 19, 1961).

20 Motherwell (ed.), *op. cit.*, p. xvii.

21 Discussing "minimal" sculpture, Clement Greenberg observes ("Recentness of Sculpture," in Maurice Tuchman [ed.], *American Sculpture of the Sixties,* Los Angeles County Museum of Art, April 28–June 25, 1967, p. 25): "The look of machinery is shunned now because it does not go far enough towards the look of non-art, which is presumably an 'inert' look that offers the eye a minimum of 'interesting' incident—unlike the machine look, which is arty by comparison (and when I think of Tinguely I would agree with this)."

22 Breton, "Phare de *La Mariée*," *op. cit.*, p. 48; "Lighthouse of the Bride," *op. cit.*, p. 92.

23 See Breton, *ibid.;* Katherine S. Dreier and Matta Echaurren, *Duchamp's Glass: An Analytical Reflection* (New York, 1944); Harriet and Sidney Janis, "Marcel Duchamp, Anti-Artist," *View* (New York), March 1945, pp. 18 ff.; Michel Carrouges, "Franz Kafka et Marcel Duchamp," in his *Les Machines célibataires* (Paris, 1954), pp. 27–59; Jean Reboul, "Machines célibataires, schizophrénie et lune noire," *Journal Intérieur du Cercle d'Etudes Métaphysiques* (Toulon), May 1954; Lebel, *op. cit.*, pp. 65–75; Lawrence D. Steefel, Jr., "The Position of *La Mariée mise à nu . . .* in the Stylistic and Iconographic Development of the Art of Marcel Duchamp," unpublished Ph.D. dissertation, Princeton University, 1960; Arturo Schwarz, *The Large Glass and Related Works* (Milan, 1967).

24 For phrases quoted in this paragraph, see Duchamp's notes in the *Green Box*; see also *The Bride Stripped Bare by Her Bachelors, Even; A Typographic Version by Richard Hamilton of Marcel Duchamp's Green Box*, translated by George Heard Hamilton (New York, 1960).

25 Observation by Suzi Bloch, cited in Barbara Rose, *A New Aesthetic*, catalogue of an exhibition at The Washington Gallery of Modern Art, May 6–June 25, 1967, p. 12.

26 Lebel, *op. cit.*, p. 68.

27 Quoted in Marcel Jean, *The History of Surrealist Painting*, translated by Simon Watson Taylor (New York, 1960), p. 59.

28 *Anemic Cinema*, his motion picture of 1926, was a resolution of this problem.

29 Clement Greenberg sees this same point being made by modernist painting in general, and particularly by the styles of American avant-garde painters such as Barnett Newman (cf., "Louis and Noland," *Art International* [Zurich], May 25, 1960, pp. 26–29) and Jackson Pollock ("Jackson Pollock: Inspiration, Vision, Intuitive Decision," *Vogue* [New York], April 1, 1967, pp. 158 ff).

30 Quoted in Philip Pearlstein, "The Symbolic Language of Francis Picabia," *Arts* (New York), January 1956, p. 39.

31 "Cubism by a Cubist," preface to the catalogue of his exhibition at Alfred Stieglitz's Little Gallery of the Photo-Secession ("291"), New York, March 17–April 5, 1913; reprinted in Frederick James Gregg (ed.), *For and Against: Views on the International Exhibition Held in New York and Chicago* (New York: Association of American Painters and Sculptors, Inc., 1913), p. 46.

32 This view of the painter is whimsically portrayed in Chardin's *Monkey Painter* in the Louvre; for an excellent discussion of the artist as the ape of nature, cf. H. W. Janson, *Apes and Ape Lore* (London, 1952), pp. 287 ff. Attention given in recent years to the "paintings" of chimpanzees suggests that the painter can never get the monkey off his back. When realistic, he was held to be "the ape of nature"; now abstract, he is described in terms of the nature of the ape.

33 Conversation with Pierre Soulages in Paris in 1950, repeated to the author.

34 Gabrielle Buffet-Picabia, *Aires abstraites* (Geneva, 1957), p. 33; Philip Pearlstein, *op. cit.*, pp. 37–43; and *idem*, "The Paintings of Francis Picabia, 1908–1930," unpublished Master's thesis, Institute of Fine Arts, New York University, 1955, where Pearlstein observes that the title, *Edtaonisl*, is an alternation of the letters of "étoil[e]" and "dans[e]," a reference to the "star dancer" Mlle Napierkowska.

35 Although the date of 1913 has generally been accepted for this painting, recent evidence indicates that 1914 is probably more justifiable; see William A. Camfield, "The Machinist Style of Francis Picabia," *Art Bulletin* (New York), September–December 1966, p. 313 note 25.

36 *Ibid.*, pp. 309–22. Camfield provides some of the models on which Picabia's object-portraits were based.
Picabia's drawings are traditionally held, following the formula of his wife, Gabrielle Buffet-Picabia, to have been made "with no attempt at aesthetic expression. They are distinguished from catalogue representations only by their isolation and by the intentions with which they are charged" ("Some Memories of Pre-Dada: Picabia and Duchamp," in Motherwell [ed.], *op. cit.*, p. 258). But a comparison of the drawings and their models betrays instantly the modernist— specifically the Cubist—underpinning of the style.

37 Henri Bergson, *Le Rire* (Paris, 1900); English translation, *Laughter: An Essay on the Meaning of the Comic*, translated by Cloudesley Brereton and Fred Rothwell (New York, 1911).

38 Gabrielle Buffet-Picabia, *Aires . . .*, *op. cit.*, p. 35.

39 "M'amenez-y" (bring me there) is a substitution for the correct "Amenez-y-moi"; it is also a play on the word "amnésie." For a discussion in English of the verbal Readymade, see Jean, *op. cit.*, p. 86.

40 When the Cabaret Voltaire was founded no one thought in terms of a movement, programmatic or otherwise. But during its first few months, a collective social and artistic outlook began to take hold, and on April 11, 1916, about eight weeks after the opening of the Cabaret, Ball noted in his diary that a Voltaire Society was being planned to co-ordinate the increasingly varied activities sponsored by the Cabaret's founders. An entry one week later indicated that Ball's suggestion to use the word "Dada" in connection with the forthcoming issue of the Cabaret's projected magazine had been accepted by the group. These two entries provide us with our most accurate limits for the discovery of the word "Dada." Its first appearance in any public document was in the review *Cabaret Voltaire*, which appeared the following June.
Tzara has always claimed discovery of the word— "I found the word Dada by accident in the Larousse dictionary"—and he is widely credited with the discovery by writers on the subject. Georges Hugnet states: "Tristan Tzara gave a name to this delicious malaise: DADA" ("Dada," *The Bulletin of The Museum of Modern Art* [New York], November-December, 1936, p. 3). Georges Ribemont-Dessaignes, himself a Parisian Dadaist ("Histoire de Dada," *La Nouvelle Revue Française* [Paris], June 1931, p. 868), and art historian Jean Cassou ("Tristan Tzara et l'humanisme poétique," *Labyrinthe* [Paris], November 15, 1945, p. 2) both support this attribution. Unfortunately, these critics lean heavily on a statement by Arp in an issue of the review *Dada* titled *Dada Intirol Augrandair* (Open-Air Dada in Tirol), published when Tzara, Arp, Ernst, and Breton were vacationing in the Tirol in the summer of 1921. Breton and Picabia had raised the question of whether Tzara was really the one who had discovered the magic name, and word had been spreading in Paris that it was Arp, not Tzara, who had found it. Under pressure from Tzara, Arp wrote a disavowal, which began: "I hereby declare that Tristan Tzara discovered the word Dada on February 8, 1916, at six o'clock in the afternoon; I was present with my twelve children when Tzara for the first time uttered this word which filled us so justifiably with enthusiasm. This took place at the Café de la Terrasse in Zurich, and I was wearing a brioche in my left nostril." Ribemont-Dessaignes reports (*Déja Jadis* [Paris, 1958], p. 12) that "someone" (most likely Breton, who was anxious to discredit Tzara) told him that afterward,

in the corridor outside the room in which he had made his "deposition," Arp remarked: "I found myself under an obligation to make this declaration, but in reality it is I who . . ." In 1949, Arp affirmed to Robert Motherwell that his account was, of course, a Dada joke, as he "would have supposed it sufficiently evident from its fantastic tone" (Motherwell [ed.], *op. cit.*, p. xxxi). Its humorous nature notwithstanding, Arp's deposition has not only supported Tzara's claim to having found the word but also provided historians with an erroneous date for the event, February 8, 1916, weeks before Huelsenbeck's arrival in Zurich, and, as we have deduced from Ball's diary, more than two months before the actual discovery. This error was unfortunately perpetuated by Georges Hugnet in his essay cited above, which was subsequently included in the revised and enlarged edition of *Fantastic Art, Dada, Surrealism*, published by The Museum of Modern Art in 1937, long the standard work on the movement, as well as in David Gascoyne's *A Short Survey of Surrealism* (London, 1935).

Although Eugene Jolas attributed the discovery of the word to Hugo Ball, the latter never made such a claim. On the contrary, a letter he wrote to Richard Huelsenbeck in November 1926 strongly points to Huelsenbeck as the discoverer: "You would then have the last word on the matter, *as you had the first*" (italics mine). Huelsenbeck has long insisted on this distinction, and on numerous occasions has recounted his version of the finding of "Dada." In *En avant Dada* (*op. cit.*, p. 4), Huelsenbeck reports: "The word 'Dada' was accidentally discovered by Hugo Ball and myself in a German-French dictionary as we were looking for a name for Madame Le Roy, the chanteuse at our Cabaret." In "Dada Lives" (*Transition* [Paris], Fall 1936, p. 78; also Motherwell [ed.], *op. cit.*, p. 280), he recounts the details:

I was standing behind Ball looking into the dictionary. Ball's finger pointed to the first letter of each word descending the page. Suddenly I cried halt. I was struck by a word I had never heard before, the word "Dada."

"Dada," Ball read, and added: "It is a children's word meaning hobbyhorse." At that moment I understood what advantages the word held for us.

41 *Die Flucht aus der Zeit* (Munich and Leipzig, 1927), entry for May 24, 1916.

42 Described to the author by Jean Arp in Meudon during the spring of 1959.

43 "Dadakonzil," in Peter Schifferli (ed.), *Die Geburt des Dada. Dichtung und Chronik der Gründer* (Zurich, 1957), pp. 9–10.

44 See the author's "Toward a Critical Framework, 3. A Post-Cubist Morphology," *Artforum* (Los Angeles), September 1966, pp. 46 ff.

45 Georges Hugnet, "L'Esprit dada dans la peinture," *Cahiers d'Art* (Paris), vol. 7, no. 1/2, 1932, p. 62; English translation, "The Dada Spirit in Painting," in Motherwell (ed.), *op. cit.*, p. 134.

46 Conversation with the author in Meudon in the spring of 1959.

47 Klee was a pioneer in automatic drawing, one of the facets of his art which particularly recommended him to the Surrealists, on whom he had a considerable influence. Though hardly known in France at the time, Klee was championed by the Surrealists. He is one of the few modern painters mentioned in the Surrealist manifesto and, despite the fact that he was not then, and never would become, a member of the movement, his work figured in the first exhibition of Surrealist painting at the Galerie Pierre, Paris, 1925.

48 Huelsenbeck, *op. cit.*, p. 35; Motherwell (ed.), *op. cit.*, p. 44.

49 "Ready money," the pseudonym of Alfred Grünewald, a banker's son and talented collagist (fig. 62), who was primarily concerned with radical politics.

50 "Au-delà de la peinture," *Cahiers d'Art* (Paris), vol. 11, no. 6/7, 1936, pp. 169–72; English translation in *Beyond Painting* (New York, 1948), p. 14.

51 *Ibid.*, p. 164; English translation, p. 13.

52 For a discussion of the variety of Ernst's collage techniques, see Lucy Lippard, "Dada into Surrealism," *Artforum* (Los Angeles), September 1966, pp. 10–15.

53 Kurt Schwitters, "Merz," *Der Ararat* (Munich), vol. 2, no. 1, 1921, pp. 5, 6; English translation in Motherwell (ed.), *op. cit.*, pp. 59, 60.

54 "Kurt Schwitters Katalog," *Merz 20* (Hanover) March 1927, pp. 99–100; quoted in Werner Schmalenbach, "Kurt Schwitters," *Art International* (Zurich), September 1960, p. 58; and in *Retrospective Kurt Schwitters*, Marlborough-Gerson Gallery, New York, May-June 1965, p. 9.

55 The extreme to which Schwitters could carry his love for the small is demonstrated by the collage he made in 1920 which has so kindly been lent to the exhibition by Dr. Lotti Steinitz-Sears, the daughter of Kate Steinitz. Called *The Smallest Merz Picture in the World*, it measures $1^7/8 \times 1^1/8$ inches, and was made by Schwitters as a birthday present for Ilse Steinitz's dollhouse. According to the present owner she bought it from her sister for two pfennigs, but instead of hanging it in her own dollhouse, preserved it in a matchbox; the collage and the matchbox were eventually put into another box with an inlay design by Schwitters, thus becoming, in Kate Steinitz's words, "doppelt verschwittert." (This information has been taken from the typescript Kate Steinitz has made available of her forthcoming publication: *Kurt Schwitters: A Portrait from Life; with "Collision," a Science-Fiction Opera Libretto in Banalities by Kurt Schwitters and Kate Trauman Steinitz, and Other Writings*. Translated from the German by Robert Bartlett Haas. Introduction by John Coplans and Walter Hopps. Berkeley and Los Angeles: University of California Press [1968].)

56 Schwitters, "Merz," *op. cit.*, p. 7; Motherwell (ed.), *op. cit.*, p. 62.

57 Inspired at the outset by Tzara, the Letterists, led by Isidore Isou and Maurice Lemaître, were primarily concerned with the formation of a poetry and theater based purely on the sound of individual letters—as opposed to the nonsense syllables favored by most Dada phoneticists—but they also produced a variegated, though uneven, body of plastic art. Lemaître's *Document on a Woman of My Life* (fig. 68) typically contains letters of an invented alphabet that cryptically spell out an autobiographical message. Their shapes are counterpointed by superimposed Latin letters—formed from different positionings of a female nude. These ensembles, which the Letterists call "hypergraphism," i.e., superwriting, are intended to fuse—as had Klee on occasion—both the abstract and the representational possibilities of letters.

58 In addition to this Hanover *Merzbau*, Schwitters built two others. In 1937 he began a second one in Lysaker, outside Oslo, Norway, which was destroyed by fire in 1951. With the help of a grant from The Museum of Modern Art, New York, in 1945, he began his third, in England, in a barn in Little Langdale, near Ambleside, which was left unfinished at his death in 1948.

59 Kate Steinitz, "The Merzbau of Kurt Schwitters," unpublished manuscript quoted in William C. Seitz, *The Art of Assemblage* (New York, 1961), p. 50.

60 Quoted in Alan Solomon, *Robert Rauschenberg*, catalogue of an exhibition at The Jewish Museum, New York, March 31–May 12, 1963, p. 11.

There is of course no "gap" between art and life; the gap is between new forms of art and the expansion of the definition of art to include them. Everything that is not finally defined as art remains "life." The anti-art of the Dadaists seemed to them to be outside art; it was simply outside the definition that prevailed then. Even the Readymades (see above, pages 17–19) can be defined as art. When they first began, Environments, Happenings, and other hybrid forms in which Rauschenberg participated made some claim to being outside "art" while not being "life," but they strike us today as comprehensible within an expanded definition of a wordless theater. For a discussion of the relation of recent "minimal" sculpture to the idea of theater, see Michael Fried, "Art and Objecthood," *Artforum* (Los Angeles), Summer 1967, pp. 12–23.

61 Schwitters, "Merz," *op. cit.*, p. 7; Motherwell (ed.), *op. cit.*, pp. 62–63.

62 *Ibid.*, pp. 8–9; pp. 62–63.

63 Clement Greenberg, "Modernist Painting," *Arts Year-book 4* (New York), 1961, pp. 103–8.

64 Tzara, Introduction, *op. cit.*, p. 7.

65 See the author's "Jackson Pollock and the Modern Tradition, I. The Myths and The Paintings," *Artforum* (Los Angeles), February 1967, pp. 15–16, and p. 22 note 24.

66 See Barbara Rose, "An Interview with Robert Motherwell," *Artforum* (Los Angeles), September 1965, pp. 33–37. See also "Concerning the Beginnings of the New York School: 1939–1943. An Interview with Peter Busa and Matta, Conducted by Sidney Simon in Minneapolis in December 1966," *Art International* (Zurich), Summer 1967, pp. 17–20; and "Concerning the Beginnings of the New York School: 1939–1943. An Interview with Robert Motherwell Conducted by Sidney Simon in New York in January 1967," *ibid.*, pp. 20–23.

67 According to Breton, the first appearance in print of the word "surrealism" was as the subtitle ("a surrealist drama") of Apollinaire's *Les Mamelles de Tirésias*, (The Breasts of Tiresias), which had its première on June 24, 1917, under the sponsorship of Pierre Albert-Birot and his review *Sic*. Actually, as William S. Lieberman has pointed out ("Picasso and the Ballet," *Dance Index* [New York], November-December 1946, p. 265), the word had appeared in print a month earlier, in a short text written by Apollinaire for the program of Diaghilev's production of the Satie-Massine-Picasso ballet *Parade*. Cocteau had called *Parade* a "realist ballet," implying that the primarily Cubist décor and costumes, the disjointed scenario, and the unexpected character of Satie's music and Massine's choreography had combined to illuminate an artistic truth more "real" than that conveyed by conventional realism. In his brief program text Apollinaire went further, seeing in the product of this unique collaboration "a kind of *sur-réalisme*" which would become "the point of departure for a series of manifestations of [the] New Spirit that, finding today an occasion to show itself, shall not fail

to captivate the elite, and promises to transform arts and manners into universal joy. For common sense wants them to be at least on a level with scientific and industrial progress" (Program for *Parade*, May 1917, reprinted in Guillaume Apollinaire, *Chroniques d'art* [Paris, 1960], pp. 426–27; English translation, Lieberman, *op. cit.*, pp. 268–69).

68 "Entrée des médiums," reprinted in *Les Pas perdus*, *op. cit.*, p. 149.

68 a *Manifeste du Surréalisme* (Paris, 1924), p. 42.

69 *Ibid.*, pp. 23–24.

70 Cf. Pierre Naville, "Beaux-Arts," *La Révolution Surréaliste* (Paris), April 15, 1925, p. 27: "Everyone knows there is no *surrealist painting*; neither the lines of the pencil abandoned to the accident of gesture, nor the image retracing the images of the dream nor imaginative fantasies, of course, can be so described" (English translation in Nadeau, *op. cit.*, p. 108).

71 Though "abstract" is a handy word to distinguish the surrealism of Miró and Masson from the illusionism of Magritte and Dali, the process it normally describes—and the etymology of the word itself—are, in fact, alien to all Surrealist art (see next paragraph). For this reason I have placed the word in quotation marks.

72 The Surrealists "rehabilitated" many of the writers Dada had scorned. Their essential attachment was to the Romantic-Symbolist tradition, particularly the writers of *romans noirs* and all the others who celebrated the marvelous and bizarre. Baudelaire, Gérard de Nerval, Aloysius Bertrand were the literary old masters. Rimbaud (who had been rejected by Dada), Alfred Jarry (who had not been), and Lautréamont ("discovered" by Breton in the pre-Dada stage of *Littérature*) became the immediate literary progenitors of the movement. The German Romantics attracted special interest, and the poets in the circle around Breton all read Novalis' *Hymns to the Night* and the *Contes bizarres* of Achim von Arnim, both of which left traces on later Surrealist literature and the imagery of Surrealist paintings. The "last of the great poets" in the literary tradition that Breton was bent on resusci-

tating was Guillaume Apollinaire, and it was no accident that the term "surrealist" was his invention. It will be recalled that Jacques Vaché—with typically Dadaist nihilism—had dismissed Apollinaire, suspecting him of "patching up Romanticism with telephone wire" (*Lettres de guerre* [Paris, 1919], p. 18; English translation in Motherwell [ed.], *op. cit.*, p. 69). To Vaché, for whom all art was "foolishness," Apollinaire's aesthetics were clearly no more than the most recent phase of a vestigial kind of poetry that traced its development back to Baudelaire. Despite his great admiration for Vaché, Breton could reject neither Apollinaire nor the tradition that lay behind him. In accepting Apollinaire, who had "no fear of art," Breton marked his break with the literary nihilism to which Dada had at least paid lip service.

73 Cited in James Johnson Sweeney, "Joan Miró: Comment and Interview," *Partisan Review* (New York), February 1948, p. 209.

74 Conversation between Miró and Masson in 1924; recounted to the author by Masson.

75 See the author's "Toward a Critical Framework, 3. A Post-Cubist Morphology," *op. cit.*

76 Sweeney, *op. cit.*, p. 212.

77 *Le Surréalisme et la peinture* (Paris, 1928), p. 62.

78 See the author's "Toward a Critical Framework, 2. Giorgio de Chirico," *Artforum* (Los Angeles), September 1966, pp. 41–45.

79 *L'Art magique* (Paris, 1957), p. 42.

80 *Le Surréalisme et la peinture, op. cit.*, p. 30

81 "Comment on force l'inspiration," *Le Surréalisme au Service de la Révolution* (Paris), May 1933, p. 45; English translation, "Inspiration to Order," in *Beyond Painting*, op. cit., p. 24.

82 "Au-delà de la peinture," *op. cit.*, pp. 152–54; English translation, p. 7.

83 The only exception to Magritte's stylistic continuity is a series of loosely painted Impressionistic versions of his typical subject matter painted during the first years of World War II.

84 The rare instances of Magritte's use of biomorphism—such pictures as *The Acrobat's Ideas* (1928) and *Surprises and the Ocean* (c. 1929–1930)—all date from his earliest years as a Surrealist.

85 *Qui est ce grand malade dont parlent les fous*
Qui est ce grand amoureux dont chantent les frères
Un papillon sur lequel s'étalent des trous
Un enfant reçu à Paris et partout ailleurs
Une oreille prêtée un ventriloque sans air
Si non un chevalier sans cadeaux et sans peur

Who is that very sick man of whom the fools speak
Who is that great lover of whom the brothers sing
A butterfly on which holes spread
A child received in Paris and everywhere else
An ear lent, a ventriloquist without air
If not a knight without presents and without fear
(English translation in John Russell, *Max Ernst* [Cologne, 1966], p. 340).

86 *Au bout de la jetée promenade*
derrière le casino le monsieur
si correctement habillé si gentiment
déculotté mangeant son
cornet de frittes d'étrons
crache gracieusement
les noyaux des
olives à la gueule
de la mer
enfilant ses
prières à la corde
du drapeau qui grille
au bout du gros mot
qui illumine la scène
la musique cache son
museau dans l'arène
et découe
son effroi
du cadre de guêpes
jambes écartées
l'éventail fond
sa cire sur
l'ancre

At the end of the jetty promenade
behind the casino
the gentleman so correctly dressed
with his pants so nicely down
eating his cone of fried turds
gracefully spits
olive pits
into the maw
of the sea
threading his
prayers on the cord
of the flag
that roasts at the end of the curse
which lights up the scene
the music hides
his muzzle in the arena
and unfastens
his fear
of the frame of wasps
legs spread-eagled
the fan drips
wax
on the anchor

87 "Du Poème-objet," *Le Surréalisme et la peinture*,
 2nd edition (New York, 1945), p. 178.

88 Georges Charbonnier in conversation with André
 Masson; see André Masson, *Entretiens avec Georges
 Charbonnier* (Paris, 1958), p. 127.

89 *Entretiens 1913–1952* (Paris, 1952), p. 159.

90 The integral publication of the second manifesto in
 book form dates from 1930. The replacement at that
 time of *La Révolution Surréaliste* with a new review,
 Le Surréalisme au Service de la Révolution, also
 signaled the movement's change of direction. While
 the title of the earlier organ had argued a "Surrealist
 revolution," that of the latter envisioned Surrealism
 in the service of the revolution, i.e., the Communist
 revolution. However, attempts at a common front
 with the Communists proved impossible and, despite
 the defections of Aragon and others, Breton success-
 fully dissociated the movement from the Party. The

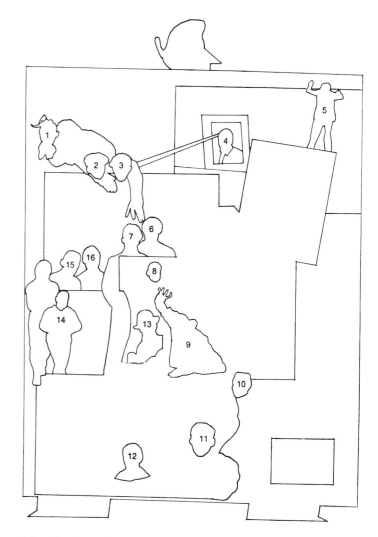

Identification of individuals represented in Max Ernst's
Loplop Introduces Members of the Surrealist Group,
figure 144, page 106:
1. Yves Tanguy; 2. Louis Aragon; 3. Alberto Giacometti;
4. René Crevel; 5. Georges Sadoul; 6. Max Ernst;
7. Salvador Dali; 8. André Thirion; 9. René Char;
10. Maxine Alexandre; 11. Man Ray; 12. André Breton;
13. Paul Eluard; 14. Luis Buñuel; 15. Benjamin Péret;
16. Tristan Tzara.

alternative was the total sacrifice of its ideals and values in the face of Communist discipline; see Nadeau, *op. cit.*, pp. 154–82.

91 "L'Ane pourri," *Le Surréalisme au Service de la Révolution* (Paris), vol. 1, no. 1, 1930, p. 12.

92 The definition given here is my resolution of two slightly differing texts, the first cited in Breton, "Le Cas Dali," *Le Surréalisme et la peinture*, 2nd edition, *op. cit.*, p. 145, and the second cited in Nadeau, *op. cit.*, p. 184.

93 "L'Ane pourri," *op. cit.*, p. 9.

94 In the text to the catalogue of Dali's exhibition at the Galerie Goemans, Paris, November 20–December 5, 1929; English translation, "The First Dali Exhibition," in André Breton, *What Is Surrealism?*, translated by David Gascoyne (London, 1936), pp. 27–30.

95 *Conquest of the Irrational*, translated by David Gascoyne (New York, 1935), p. 12.

96 It was Professor Meyer Schapiro who, in a discussion of the work of Paul Klee, brought to my attention the location and size of the "screen" of the imagination.

97 For a discussion of the descent of the bearded figure from de Chirico via Max Ernst's *Revolution by Night,* see the chapter on Salvador Dali in the author's *Dada and Surrealist Art* to be published in 1968 by Harry N. Abrams, Inc.

98 In a lecture, *"No More Play": Giacometti and Surrealism,* given at the Institute of Fine Arts, New York University, March 3, 1967.

99 Letter to Pierre Matisse, 1947, published in *Exhibition of Sculptures, Paintings, Drawings*, Pierre Matisse Gallery, New York, January 19–February 14, 1948; reproduced in facsimile with translation, in Peter Selz (ed.), *Alberto Giacometti* (New York, 1965), pp. 14–29.

100 "This object took shape little by little in the late summer of 1932; it revealed itself to me slowly, the various parts taking their exact form and their precise place within the whole. By autumn it had attained such reality that its actual execution in space took no more than one day.

"It is related without any doubt to a period in my life that had come to an end a year before, when for six whole months, hour after hour was passed in the company of a woman who, concentrating all life in herself, magically transformed my every moment. We used to construct a fantastic palace at night—days and nights had the same color, as if everything happened just before daybreak; throughout the whole time I never saw the sun—a very fragile palace of matchsticks. At the slightest false move a whole section of this tiny construction would collapse. We would always begin it over again.

"I don't know why it came to be inhabited by a spinal column in a cage—the spinal column this woman sold me one of the very first nights I met her on the street—and by one of the skeleton birds that she saw the very night before the morning in which our life together collapsed—the skeleton birds that fluttered amid cries of wonder at four o'clock in the morning very high above the pool of clear, green water where extremely fine, white skeletons of fish floated in the great unroofed hall. In the middle there rises the scaffolding of a tower, perhaps unfinished or, since its top has collapsed, perhaps also broken. On the other side there appeared the statue of a woman, in which I recognized my mother, just as she appears in my earliest memories. The mystery of her long black dress touching the floor troubled me; it seemed to me like a part of her body, and aroused in me a feeling of fear and confusion. All the rest has vanished, and escaped my attention. This figure stands out against the curtain that is repeated three times, the very curtain I saw when I opened my eyes for the first time. . . .

"I can't say anything about the red object in front of the board; I identify it with myself" (*Minotaure* [Paris], December 1933, p. 46; English translation in Selz [ed.], *op. cit.*, p. 44).

101 Cited in Carola Giedion-Welcker, *Jean Arp* (New York, 1957), p. xxvii.

102 See Lucy Lippard, "The Sculpture," in Sam Hunter (ed.), *Max Ernst: Sculpture and Recent Painting,*

catalogue of an exhibition at The Jewish Museum, New York, March 3–April 17, 1966, *passim*.

103 "Picasso poète," *Cahiers d'Art* (Paris), vol. 10, nos. 7–10, 1935, p. 187.

104 For an extended iconographic and formal analysis of this picture, see the chapter "Picasso and Surrealism" in the author's *Dada and Surrealist Art* to be published in 1968 by Harry N. Abrams, Inc.

105 For a discussion of the *Guernica* in terms of these sources, see *ibid.*

106 Sweeney, "Joan Miró . . .," *op. cit.*, p. 208.

107 *Ibid.*, p. 210.

108 Cf. Sarane Alexandrian, *Victor Brauner: l'Illuminateur* (Paris, 1954), p. 66.

109 See the author's "Jackson Pollock and the Modern Tradition, VI. An Aspect of Automatism," *Artforum* (Los Angeles), May 1967, pp. 30–31.

110 *Entretiens 1913–1952, op. cit.*, p. 161.

111 The metal skeleton, minus the found objects (among them, the cobbler's last), was exhibited in *Hommage à Pablo Picasso*, Petit Palais, Paris, November 1966–February 1967, cat. no. 231; in *Picasso*, The Tate Gallery, London, June 9–August 13, 1967, cat no. 28; in *The Sculpture of Picasso*, The Museum of Modern Art, New York, October 9, 1967–January 1, 1968, p. 66, cat. no. 29.

112 Matta subtitled all works of 1938–1940 "Psychological Morphology," and numbered them as such. Later he referred generically to the fantasy landscapes of 1938–1943 as "Inscapes."

113 Meyer Schapiro, Introduction, in Ethel K. Schwabacher, *Arshile Gorky* (New York, 1957), p. 13.

114 *Le Surréalisme et la peinture*, 2nd edition, *op. cit.*, pp. 196–99.

115 For an extended discussion of this work see the author's "Arshile Gorky, Surrealism, and the New American Painting," *Art International* (Zurich), February 1963, pp. 33–34.

116 Schwabacher, *op. cit.*, p. 19.

117 Foreword, in William C. Seitz, *Arshile Gorky: Paintings, Drawings, Studies* (New York, 1961), p. 8.

118 *Le Surréalisme et la peinture*, 2nd edition, *op. cit.*, p. 198.

119 Tzara delivered a lecture at the Sorbonne in April 1947 in which he challenged the Surrealists to justify their absence from France during the war, and scorned the review *VVV* for having continued to fashion Surrealist games but never once mentioning the Occupation; Sartre (in *Les Temps Modernes* [Paris], May 1947, p. 1429), declared that when the moment for action came, the Surrealists were incapable of action; Camus, who engaged in brief debate with Breton (in *Arts* [Paris], November 16 and 23, 1951), criticized the movement for its nihilism. For a discussion of the atmosphere Breton encountered on his return to France from America, see Clifford Browder, *André Breton: Arbiter of Surrealism* (Paris, 1967), pp. 41 ff.

120 Pollock's relationship to Surrealist methods has been discussed many times; see, for example, the interview between Robert Motherwell and Sidney Simon, *op. cit.*, pp. 21–23, and the author's "Jackson Pollock and the Modern Tradition, VI. An Aspect of Automatism," *op. cit.*, pp. 28–33. Pollock's experimentation with automatic poetry has been specifically noted by Francis V. O'Connor, *Jackson Pollock* (New York, 1967), p. 26.

121 This is not to suggest that the younger generation did not express its reaction to the poetic abstraction of the "first generation" in other forms; anti-painterly, hard-edge, "cool" abstraction proved another option.

Chronology

Compiled by Irene Gordon

1913

NEW YORK

January. Francis Picabia arrives in New York in connection with the Armory Show.

February 17–March 15. Armory of the Sixty-Ninth Infantry. *International Exhibition of Modern Art*. Duchamp's *Portrait of Chess Players* (1911), *The King and Queen Surrounded by Swift Nudes* (1912), and *Nude Descending a Staircase, No. 2* (1912) attract much attention and controversy. Picabia exhibits Cubist-inspired works, *Dances at Spring* and *Procession, Seville* (both 1912).

March 17–April 5. Little Gallery of the Photo-Secession (291 Fifth Avenue). *Picabia Exhibition*. Picabia shows a series of watercolors at Alfred Stieglitz's gallery "291," where Matisse, Picasso, Cézanne, Rousseau, Marin, Weber, Dove, and Hartley had already been introduced to America. The preface Picabia writes for his exhibition appears in *Camera Work* (April–July), a magazine published by Stieglitz from 1903 to 1917 in which much avant-garde work is reproduced.
Soon after the exhibition closes Picabia returns to Paris.

NEW JERSEY

Spring. Man Ray joins artists' and intellectuals' colony in Ridgefield. Meets Alfred Kreymborg and Max Eastman.

PARIS

On his return to Paris, Picabia paints large canvases—*Edtaonisl, Udnie,* and (probably the following year) *Je revois en souvenir ma chère Udnie (I See Again in Memory My Dear Udnie).*

Duchamp paints *Chocolate Grinder I* which marks the break with the canvases of 1912 and establishes the basis of the *Large Glass*. Renounces oil painting, secures a minor post in the Bibliothèque Ste.-Geneviève, makes his first Readymade, *Bicycle Wheel*.

The "American" boxer-poet Arthur Cravan (Fabian Avenarius Lloyd) continues to publish his polemical review *Maintenant,* the first issue of which appeared in April 1912.

De Chirico continues series of metaphysical Italian piazzas; exhibits three paintings in the Salon des Indépendants, four in the Salon d'Automne.

August. Max Ernst, who lives in Cologne, visits Paris.

September. Apollinaire publishes "L'Antitradizione futurista," in *Lacerba* (Florence); *Alcools* and *Les Peintres cubistes* also published this year.

November. Picasso's earliest Cubist constructions are reproduced for the first time, in *Les Soirées de Paris*.

SWITZERLAND

Hans (Jean) Arp, living in Weggis, has drawings reproduced in *Der Sturm* (Berlin); is also co-author with L. H. Neitzel of a book on new French painting *(Neue französische Malerei)* published in Leipzig.

BERLIN

September–November. Der Sturm. *Erster deutscher Herbstsalon*. Exhibition includes, among others, Picabia, Arp, Ernst, Klee, Chagall, and the Futurists. Marinetti gives two lectures during the course of the exhibition.

1914

NEW YORK

November 3–December 8. Little Gallery of the Photo-Secession (291). *Negro Art*. An exhibition of African wood carvings, reported in *Camera Work* as "the first time in the history of exhibitions, either in this country or elsewhere, that Negro statuary was shown solely from the point of view of art."

PARIS

Cravan's review of the Salon des Indépendants, which he publishes as an issue of *Maintenant* (March–April), constitutes

an attack on modern art and some of its practitioners. He is challenged to a duel by Apollinaire and is taken to court by Sonia Delaunay, which results in a sentence of eight days in jail and a fine of one franc.

Picabia, though a Cuban national, allows himself to be drafted into the French army.

Arp arrives for a stay, during which he meets Cravan, Apollinaire, Delaunay, Modigliani, and Picasso; his style changes under the impact of Cubism.

André Breton "discovers" the Gustave Moreau museum.

ZURICH

Hugo Ball, German poet and pacifist, and his wife Emmy Hennings arrive from Germany.

COLOGNE

Arp and Max Ernst meet at the Deutscher Werkbund exhibition (May–October).

1915

NEW YORK

March. The periodical *291*, edited by Paul Haviland and Marius de Zayas, begins to appear, under Stieglitz's auspices.

June. Picabia, on his way to an army mission, arrives in New York and stays for several months; publishes in *291* a series of "object portraits" which present Stieglitz as a camera, Picabia himself as an auto horn, and the young American girl in a state of nudity as a spark plug. He also executes a series of "machine pictures."

Duchamp arrives in New York. Visits artists' colony in Ridgefield, New Jersey, where he meets Man Ray. Begins *The Bride Stripped Bare by Her Bachelors, Even (the Large Glass),* which he will leave incomplete in 1923.

De Zayas publishes *African Negro Art: Its Influence on Modern Art.*

September. Picabia leaves New York for Panama.

PARIS

March. The fifth, and last, number of Cravan's *Maintenant* appears.

ZURICH

Arp, Tristan Tzara, Marcel Janco settle in Zurich. Arp begins collaboration with his future wife, Sophie Taeuber.

November. Galerie Tanner. Joint exhibition of Arp, Otto van Rees, and Mme van Rees. Arp shows precisely executed rectilinear collages and writes a preface to the catalogue.

FERRARA

July. De Chirico returns to Italy from Paris. He does military service at Ferrara, where he meets Carlo Carrà.

1916

NEW YORK

Man Ray makes collages called "Revolving Doors" (1916–1917); paints *The Rope Dancer Accompanies Herself with Her Shadows.*

The home of the poet Walter C. Arensberg is a meeting place for avant-garde artists and intellectuals such as Duchamp, Man Ray, Marius de Zayas.

PARIS

January. Pierre Albert-Birot begins to publish the review *Sic,* which soon shows Dadaist tendencies.

NANTES

Jacques Vaché and André Breton meet. Breton is an orderly in an army mental clinic, where he becomes interested in psychiatry.

ZURICH

February 5. Opening of the Cabaret Voltaire, founded by Hugo Ball.

February 26. Richard Huelsenbeck arrives from Berlin.

March 30. Gala night at Cabaret Voltaire during which Huelsenbeck, Janco, and Tzara (aided by the researches of the Futurists, and Henri Martin Barzun and Fernand Divoire) recite a simultaneous poem of their own creation.

April. The word "Dada" discovered.

June. Publication of the first, and only, issue of *Cabaret Voltaire.* The preface, written by Ball in May, uses the word "Dada" publicly for the first time. Contributors include,

among others, Apollinaire, Arp, Cendrars, Huelsenbeck, Kandinsky, Marinetti, Modigliani, Picasso, Tzara.

July. First publication under the Dada imprint: Tzara's *La première Aventure céleste de M. Antipyrine* (The First Celestial Adventure of Mr. Fire Extinguisher), with color woodcuts by Janco.

July 14. Salle zur Waag. First Dada Soirée. An evening of music, dances, manifestations, poetry readings, costumes, masks, paintings. Tzara reads the first Dada manifesto.

Hugo Ball composes "Lautgedichte" (sound poems).

September. Huelsenbeck's *Phantastische Gebete* (Fantastic Prayers) published under the Dada imprint, with woodcuts by Arp.

October. Huelsenbeck's *Schaleben Schalomai Schalamezomai* published under the Dada imprint, with drawings by Arp.

Arp confirms his biomorphic style, begun the previous year, in wood reliefs *(Forest, Portrait of Tzara)* and "automatic" drawings. Begins collages "arranged according to the laws of chance."

[COLOGNE]

Max Ernst, serving as an artillery engineer in the German army, makes occasional small paintings.

BERLIN

January. Der Sturm. Max Ernst's first exhibition.

MADRID

April 23. Arthur Cravan knocked out by Jack Johnson in a boxing match.

BARCELONA

August. Picabia settles in Barcelona where he finds Marie Laurencin, Albert Gleizes, Arthur Cravan.

1917

NEW YORK

April. Picabia arrives from Barcelona where, in the first months of the year, he had published nos. 1–4 of his review *391*.

April 10–May 6. Grand Central Palace. *First Annual Exhibition of the Society of Independent Artists*. Picabia exhibits *Physical Culture* and *Music Is Like Painting*. Duchamp sends a urinal (Readymade) titled *Fountain* and signed "R. Mutt"; its rejection leads to his resignation from the jury. His Readymades are shown in the lobby of the Bourgeois Gallery.

Arthur Cravan arrives drunk at the Independents exhibition where he is to deliver a lecture. He curses the smartly dressed audience and begins to undress, but is stopped by police.

April–May. Beatrice Wood publishes, Man Ray and Duchamp edit, and H. P. Roché and Arensberg contribute to the two issues of *The Blind Man* (dealing mainly with the Independents controversy) and the one issue of *Rongwrong*.

June–August. Picabia publishes nos. 5, 6, 7 of *391*.

PARIS

May. Théâtre du Châtelet. First performance of Erik Satie's ballet, *Parade,* with scenario by Cocteau, choreography by Massine, décor and costumes by Picasso. The program contains an article by Apollinaire in which the earliest reference to "sur-réalisme" appears.

June 24. Première of Apollinaire's *Mamèlles de Tirésias* (The Breasts of Tiresias), subtitled "a surrealist drama." Jacques Vaché, dressed as an English officer, brandishes a gun during the intermission and causes a riot.

Friendship of Breton, Philippe Soupault, and Louis Aragon. Breton sees a copy of *Dada 1* at the home of Apollinaire, although the Zurich magazines remain virtually unknown in Paris until 1919.

October. Picabia arrives from New York via Barcelona.

ZURICH

January–February. Galerie Corray. Dada Exhibition. Includes Arp, Janco, Hans Richter, Negro art; Tzara delivers three lectures: on Cubism, on the old and new art, and on the art of the present.

March 17. Galerie Dada (formerly the Galerie Corray) opens, with exhibition of Campendonk, Kandinsky, Klee, and others.

March 23. Galerie Dada. Grand opening ceremonies. Dance, music, and poetry program, dances by Sophie Taeuber, costumes by Arp.

July. Publication of *Dada 1*, which succeeds the review *Cabaret Voltaire*. *Dada 1* and *Dada 2* (December) include contributions by Arp, de Chirico *(The Evil Genius of a King)*, Janco, Kandinsky, and Klee.

Marcel Janco makes painted reliefs, masks, constructions; does an oil painting of the Cabaret Voltaire.

Augusto Giacometti joins the Dadaists, makes abstract paintings and a Dada machine from clockparts.

BERLIN

January. Huelsenbeck returns to Berlin from Zurich. In May he publishes "Der neue Mensch" in the magazine *Die Neue Jugend*, preparing the way for Dada.

BARCELONA

Miró meets Picabia, Laurencin, and Max Jacob.

1918
NEW YORK

Duchamp paints his last picture, *Tu m'*, a frieze-shaped canvas slightly over ten feet wide, for Katherine Dreier's library.

Man Ray begins his "Aerographs," executed with an air gun.

MEXICO

Arthur Cravan is seen for the last time in a small town on the Mexican coast.

PARIS

November 9. Apollinaire dies. Memorial statements by Tzara and Picabia published in *Dada 3* (December).

Friendship of Breton, Paul Eluard, and Jean Paulhan is formed. They, as well as Aragon, Soupault, and Georges Ribemont-Dessaignes, see Dada periodicals in Paris and become interested in the movement.

Breton begins correspondence with de Chirico.

ZURICH

July 23. Salle zur Meise. *Soirée Tristan Tzara.*

December. Tzara's "Manifeste Dada 1918" is published in *Dada 3*.

BASEL

An artists' club, Das Neue Leben, is founded. Arp, Augusto Giacometti, and Janco are among its charter members.

LAUSANNE

February. Picabia arrives, stays in Gstaad. He meets Tzara and Arp, participates in *Dada 3*.

BERLIN

Huelsenbeck founds a new branch of Dada.

April. Club Dada is founded. First meeting April 12, at which Huelsenbeck reads a manifesto signed by Tzara, Franz Jung, George Grosz, Janco, Huelsenbeck, Gerhard Preiss, Raoul Hausmann, and Walter Mehring. One issue of a revue, *Club Dada,* published, edited by Mehring, Huelsenbeck, Jung, and Hausmann.

June. Kurt Schwitters seeks out Herwarth Walden to examine the possibility of exhibiting at Der Sturm gallery. Meets Arp, which leads to a close association with the Zurich Dadaists.

Hausmann and others develop new typography on the basis of Futurist compositions; makes "letterist" sound poems (working with individual letters instead of inventing words as had Ball and others); invents a form of photo-montage that is actually photo-collage.

COLOGNE

Max Ernst is discharged from the army; meets Baargeld (Alfred Grünewald).

1919
PARIS

March. First issue of *Littérature*, edited by Aragon, Breton, and Soupault.

April. *Littérature* publishes (continuing in the May issue) Breton's "discovery" of the *Poésies* of the nineteenth-century poet Isidore Ducasse (the "comte de Lautréamont"), the sole copy of which belongs to the Bibliothèque Nationale. Paul Valery and André Gide are among *Littérature*'s heroes.

July. Duchamp arrives, stays with Picabia. They establish contact with the Dada group then meeting at the Café Certà. Duchamp adds a beard and mustache to a reproduction of the *Mona Lisa*, titles it *L.H.O.O.Q.*

Littérature publishes (continuing in the August and September issues) the letters of Jacques Vaché.

October. *Littérature* publishes (continuing in the November and December issues) "Les Champs magnétiques," by Breton and Soupault, later described by Breton as "incontestably the first Surrealist work (in no way Dada) since it is the fruit of the first systematic applications of automatic writing."

NANTES

January. Jacques Vaché commits suicide.

ZURICH

January. Kunsthaus. *Das neue Leben.* Exhibition includes Arp, Augusto Giacometti, Janco, Picabia, and others. Tzara delivers lecture, *L'Art abstrait* (Abstract Art); Janco, *Sur l'Art abstrait et ses buts* (Abstract Art and Its Aims).

February. Picabia publishes no. 8 of *391.*

April 9. Saal zur Kaufleuten. *8. Dada-Soirée.* Program promises manifestoes, lectures, compositions, dance, simultaneous poems; lists, among others, Tristan Tzara's *Le Fièvre du mâle,* described as a simultaneous poem performed by 20 persons; Hans Arp's *Wolkenpumpe;* Suzanne Perottet playing compositions of Arnold Schönberg.

May. *Dada 4–5* appears with cover title *Anthologie Dada;* contains drawings by Picabia, woodcuts by Arp, reproductions of paintings by Augusto Giacometti, Kandinsky, Klee, and Richter.

Sophie Taeuber makes "Dada heads" from hat molds.

November. Publication of *Der Zeltweg,* magazine edited by Tzara, Otto Flake, and Walter Serner, cover design by Arp.

BERLIN

January. Der Sturm. Schwitters shares group exhibition with Paul Klee and Johannes Molzahn.

February 6. Manifesto *Dadaisten gegen Weimar* appears, signed by Baader, Hausmann, Tzara, George Grosz, Janco, Arp, Huelsenbeck, and others.

June. Hausmann founds review *Der Dada* (three issues, 1919–1920).

COLOGNE

Ernst and Baargeld found the Dada conspiracy of the Rhineland, whose address is W/3 West Stupidia.

Ernst publishes a portfolio of eight lithographs influenced by Carrà and de Chirico entitled *Fiat Modes: Pereat Ars* (Let There Be Fashion: Down with Art).

HANOVER

Kurt Schwitters makes his first *Merz* collages, books, and poems; publishes *Anna Blume,* a poem formed by "collaging" the clichés of bourgeois sentimental language.

1920

NEW YORK

Duchamp, who has returned from Paris, Katherine Dreier, and Man Ray found the Société Anonyme, which is in effect the first museum of modern art in New York. Duchamp decides to change from "anti-artist" to "engineer," a shift in identity that is signaled by the adoption of the pseudonym Rrose Sélavy and photographs of Duchamp as a woman by Man Ray. His first machine is the *Rotary Glass Plate,* made, with the aid of Man Ray, of glass plates turned by a motor.

PARIS

January. Tzara, "awaited like a Messiah," arrives in Paris.

January 23. Palais des Fêtes. *Premier Vendredi de Littérature.* The first Friday soirée organized by *Littérature,* which serves as an introduction of the Dada manifestation into Paris. The program lists a talk by André Salmon, poems by or read by Max Jacob, Aragon, Breton, Eluard, Cocteau, Tzara, among others; a display of paintings by de Chirico, Juan Gris, Léger, sculpture by Jacques Lipchitz. Under the title "Poème," Tzara reads a newspaper article while Eluard and a friend of Breton's hammer on bells; Breton presents a Picabia drawing in chalk on a blackboard which he erases as the drawing appears.

February. Dada manifestations are held at the Salon des Indépendants, Club du Faubourg, and the Université Populaire du Faubourg St.-Antoine.

Dada 6 appears as *Bulletin Dada,* declares itself anti-pictorial and anti-literary; includes poems by Picabia, Tzara,

Breton, Aragon, and others, which had been recited at the January soirée.

March. *Dada 7* is published as *Dadaphone*; cover by Picabia, texts by Tzara, Picabia, Soupault, Eluard, Ribemont-Dessaignes, Breton, Aragon, and others.

March 27. Maison de l'Œuvre. *Manifestation Dada.* Comprised of manifestoes read by 38 lecturers, farces, music, and short plays, among them Tzara's *La première Aventure céleste de M. antipyrine,* and Breton reading in total darkness Picabia's "Manifeste cannibale."

April. Picabia publishes the first of two issues of a new review, *Cannibale,* which includes his collage-picture *Portrait of Cézanne,* in which the artist is represented by a stuffed monkey.

May. *Littérature* publishes the 23 Dada manifestoes that were read at the February manifestations. The magazine now puts itself completely in the service of Dada.

May 26. Salle Gaveau. *Festival Dada.* Program lists *Le Célèbre illusioniste* by Ribemont-Dessaignes, during which colored balloons with the names of famous people are released; and Tzara's *La deuxième Aventure de monsieur Aa l'antipyrine.* The program also announces that "all the Dadaists will have their hair cut on stage."

August. *Nouvelle Revue Française* contains Breton's "Pour Dada."

BERLIN

With Raoul Hausmann, the brothers Herzfelde, Johannes Baader, and Hannah Höch, Huelsenbeck guides Berlin Dada toward a more radical political consciousness than it has elsewhere. George Grosz contributes to antibourgeois, antireligious, antipatriotic Dada magazines.

February. Huelsenbeck, Hausmann, and Baader organize a Dada tour that begins in Leipzig (Zentraltheater, February 24), and includes Teplitz-Schönau (February 26), Prague (Commodities Exchange, March 1; Mozarteum, March 2), and Karlsbad (March 5). In Prague—where the Czechs are opposed to them because they are Germans, the Germans consider them Bolsheviks, and the Socialists denounce them as reactionaries—the atmosphere of violence built up against

them by weeks of publicity causes Baader to desert the tour.

April. Der Sturm. First one-man show of Schwitters.

June. Kunsthandlung Dr. Otto Burchard. *Erste Internationale Dada-Messe.* First international Dada fair brings together 174 Dada objects and works of art.

Dada Almanach, the last important German Dada publication, appears, edited by Huelsenbeck.

Arp visits Berlin, meets El Lissitzky, Schwitters, and the Dadaists.

COLOGNE

February. Publication of *Die Schammade (Dadameter),* edited by Ernst, cover by Arp, contributions by Aragon, Baargeld, Breton, Huelsenbeck, and others.

April. Brauhaus Winter. *Dada-Vorfrühling: Gemälde, Skulpturen, Zeichnungen, Fluidoskeptrik, Vulgärdilettantismus.* Participants are Arp, Baargeld, and Ernst. Entrance to exhibition is through a public urinal; Ernst supplies a hatchet with one object so that the public may destroy it; a young girl in first communion dress recites obscene poetry. Police close the exhibition, but it reopens in May when it appears that the work judged most shocking by the police is Dürer's engraving *Adam and Eve.*

Ernst collaborates with Arp, and also with Baargeld, on a series of collages that they call "Fatagaga" (FAbrication de TAbleaux GArantis GAzométriques [Manufacture of Pictures Guaranteed To Be Gasometric]).

BRUSSELS

René Magritte has his first exhibition, which he shares with P. Flouquet, at the Centre de l'Art. Meets E. L. T. Mesens.

1921

NEW YORK

Man Ray invents his "Rayographs"; makes Dada objects, such as *Gift.*

April. Publication of *New York Dada,* edited by Duchamp and Man Ray.

July. Man Ray leaves for Paris.

PARIS

April 14. *Excursions & Visites Dada. 1ère Visite: Eglise Saint Julien le Pauvre.* The first, and only, of a series of derisive Dada visits to various places "to remedy the incompetence of suspect guides and cicerones."

May 3–June 3. Au Sans Pareil. *Exposition Dada Max Ernst.* First Paris exhibition of Ernst's collages, opening is staged as a Dada demonstration.

May 13. Salle des Société Savantes. *Mise en Accusation et Jugement de M. Maurice Barrès par Dada* (Trial and Sentencing of M. Maurice Barrès by Dada). Breton is presiding judge at the "trial" of the writer Maurice Barrès, indicted by the Dadaists for "crimes against the security of the spirit." Picabia disapproves and does not take part; Tzara, too, is critical but participates as one of the "witnesses" against Barrès, who is represented by a life-size mannequin.

June 6–30. Galerie Montaigne. *Salon Dada, Exposition Internationale.* End of season Dada exhibition and series of demonstrations. Catalogue, which lists 81 works, contains contributions from poets and artists including, among others, Arp, Aragon, Eluard, Péret, Man Ray, Tzara. Soupault's entry in the exhibition is a mirror entitled *Portrait of an Unknown*; slips of paper with numbers (28–31) take the place of the works Duchamp refused to send. Tzara's *Le Cœur à gaz* (The Gas-Operated Heart) given for the first time. The last major Dada show.

July. Having renounced Dada in published statements, Picabia turns violently against his former colleagues; publishes a special number of *391—Le Pilhaou-Thibaou—*in which he denies that Tzara invented the word "Dada."

Man Ray arrives; Duchamp introduces him to the Dadaists.

August. Last issue of series 1 of *Littérature* is devoted to the Barrès trial held in May.

December 3–31. Librairie Six. *Exposition Dada, Man Ray.* A retrospective exhibition of 35 works dating 1914–1921. Catalogue notes by Aragon, Arp, Eluard, Ernst, Man Ray, Ribemont-Dessaignes, Soupault, and Tzara.

COLOGNE

Ernst makes proto-Surrealist paintings (*The Elephant Celebes*)

that merge collage imagery of the previous years with elements of Chiricoesque style. Makes his first entirely illusionistic collage of old engravings.

PRAGUE

September 1. Commodities Exchange. Anti-Dada and *Merz* soirée organized by Schwitters and Hausmann which consists of poetry readings by both men. Schwitters hears Hausmann's phonetic poem *fmsbw* for the first time, which has a profound effect on him.

TIROL

September. Arp, Ernst, and Tzara vacationing together in Tarrenz-bei-Imst publish *Dada Intirol Augrandair,* the last important Dada publication; includes Arp's fantasy on the origin of the word "Dada," which is later seriously used to support Tzara's claim to the discovery of the word.

Breton, on his honeymoon, joins the Dadaists and, except for a brief excursion to Vienna to have an interview with Freud, remains through October when he and Eluard return to Paris by way of Cologne where they visit Ernst.

1922

PARIS

January–April. During the winter months Breton attempts to organize a Congrès de Paris (Congress of Paris), a Congrès International pour la Détermination des Directives et la Défense de l'Esprit Moderne (International Congress for the Determination of Directives and for the Defense of the Modern Spirit). The Organizing Committee includes Georges Auric, Delaunay, Léger, Ozenfant, Paulhan, and Roger Vitrac. Tzara refuses to participate, for which he is attacked by Breton who declares that Tzara is not the father of Dada and accuses him of having usurped credit for the Dada manifesto of 1918 from Serner, whom he alleges to be the author. In a meeting at the Closerie des Lilas (February 17) Breton is called to account for the character of his attacks on Tzara, and the forty-five persons present pass a resolution withdrawing their confidence from the Organizing Committee. In April Tzara edits a pamphlet, *Le Cœur à barbe* (The Bearded Heart). These last events virtually mark the end of the Dada movement.

March. Publication of the first issue of the new series of *Littérature*, now edited by Breton, which moves away from Dadaism toward what will become Surrealism.

Man Ray publishes *Les Champs délicieux*, an album of 12 Rayographs, preface by Tzara.

Masson in Paris; signs contract with Kahnweiler. Friendship with Miró, the poets Armand Salacrou, Georges Limbour, Michel Leiris. Miró and Masson have adjoining studios at 45 Rue Blomet.

ST.-RAPHAEL

Picabia publishes sole issue of review, *La Pomme de Pins* (The Pine Cone), dated February 25, in which he attacks the Congress of Paris and most of the Dadaists.

COLOGNE

Arp and Sophie Taeuber marry.

HANOVER

Schwitters organizes lectures for Tzara in Hanover, Jena, and Weimar.

BERLIN

Grosz breaks with the Dadaists.

WEIMAR

October. *Kongress der Konstruktivisten* (Congress of the Constructivists). Led by Theo van Doesburg, includes Tzara and Arp against the will of more purist members. Among others participating are El Lissitzky, Richter, Moholy-Nagy.

BARCELONA

November 18–December 8. Galeries Dalmau. *Exposition Francis Picabia*. Breton and Picabia journey to Barcelona for the opening of the exhibition; catalogue preface by Breton. Breton also delivers a lecture on modern art.

BRUSSELS

Magritte is introduced to the work of de Chirico through a reproduction of *The Song of Love*.

1923

NEW YORK

Duchamp definitively "incompletes" *The Bride Stripped Bare by Her Bachelors, Even* (the *Large Glass*).

PARIS

July 7. Théâtre Michel. *Soirée du "Cœur à barbe"* (Soirée of the Bearded Heart). Among the performances scheduled are films by Richter and Man Ray, music by Satie, Auric, Stravinsky, and Milhaud, and a performance of Tzara's *Cœur à gaz*. Breton, Aragon, Péret, and Eluard provoke a full-scale riot. Breton later accuses Tzara of being responsible for the police action brought against them.

Breton and his circle dispute the use of the term "surrealism" with Ivan Goll and Paul Dermée, who had also adopted it from Apollinaire.

Summer. Breton and Picasso meet.

Eluard visits the de Chirico exhibition at the second Rome Biennale, purchases a number of new pictures which, on Eluard's return to Paris, are severely criticized by Breton. Rapid disenchantment of the Surrealists with de Chirico ensues.

Tanguy's accidental discovery of an early de Chirico painting in the window of Paul Guillaume's gallery crystallizes his desire to become a painter.

Masson meets Breton and makes first automatic drawings (winter 1923/1924), and semi-Cubist paintings influenced by Picasso, Gris, and Derain.

Toward the end of the year Miró begins his transition from Cubism to Surrealism.

HANOVER

Schwitters publishes the first issues of the review *Merz*: first number (January) is subtitled *Holland-Dada*; second (April) contains "Manifest Proletkunst" signed by Theo van Doesburg, Schwitters, Arp, Tzara; third consists of a portfolio of 6 lithographs by Schwitters; fourth (July) is subtitled *Banalitäten;* fifth is another portfolio, *7 Arpaden*, containing 7 lithographs by Arp; sixth (October) is subtitled *Imitatoren*.

December 30. Hausmann and Schwitters give a *Merzmatinee* during which one of the presentations consists of Hausmann and Schwitters standing on a darkened stage, Hausmann holding the switch to an electric light while Schwitters recites

one of his poems. After every other line Hausmann turns on the light, revealing himself in a grotesque pose. Thus, during the 20 lines of the poem there is an alternation between noisy darkness and silent light.

1924
PARIS

The Café Cyrano in the Place Blanche, near the home of Breton in the Rue Fontaine, is an important meeting place for the Surrealists. Evening gatherings take place at Breton's home, and at the studios of Miró and Masson in the Rue Blomet.

Aragon's *Une Vague de rêves* summarizes the experiments in hypnosis begun two years earlier.

Miró joins the Surrealists and is introduced to Arp's work.

February. Galerie Simon. First one-man exhibition of Masson. Fantasy elements are breaking through Cubist structures. Meets Eluard, Aragon; joins the Surrealists.

July. Ernst sails for the Far East, meets Paul and Gala Eluard in Saigon; returns to Paris in the fall.

October. Ivan Goll publishes the only issue of the review *Surréalisme*.

Breton publishes *Manifeste du surréalisme* in which Surrealism is defined primarily in terms of automatism.

Anatole France dies and the Surrealists publish a pamphlet entitled *Un Cadavre* attacking him. They are in turn viciously attacked in the newspapers.

Bureau de Recherches Surréalistes (Bureau of Surrealist Research) is opened in the Rue de Grenelle; distributes the *papillons surréalistes*.

Picabia now turns against the Surrealist group and lampoons them in the final issue of *391*.

December. Rolf de Maré's Ballets Suédois stages Picabia's Dada ballet *Relâche*, with music by Satie. During the intermission, *Entr'acte*, a film made by Picabia and René Clair, is shown; Satie's score is first music written especially for a film.

Founding of the review *La Révolution Surréaliste;* editors, Pierre Naville and Benjamin Péret; motto, "We must work toward a new declaration of the rights of man." First issue includes accounts of dreams by de Chirico and Breton, automatic texts, illustrations by Ernst, Masson, Man Ray, and Picasso.

1925
PARIS

January 15. The second issue of *La Révolution Surréaliste* publishes responses to the question posed in the December issue: "Le Suicide est-il une solution?" (Is suicide a solution?)

April 15. Third issue of *La Révolution Surréaliste* contains collective addresses to the Pope ("The confessional, O Pope, is not you but us"), the Dalai Lama, Buddhist schools, rectors of European universities, and directors of insane asylums. It is in this issue that Naville declares "there is no such thing as Surrealist painting."

June 12–27. Galerie Pierre. *Exposition Joan Miró*. First exhibition of Miró's Surrealist painting, catalogue text by Péret.

Tanguy and Prévert join the Surrealists, having been introduced into the Breton circle late in the previous year. Marcel Duhamel shares a house in the Rue du Château with them, which becomes a center of Surrealist activity.

Beginning of the collective drawing and poem on folded paper called *cadavre exquis* (exquisite corpse).

Arp returns to Paris, takes studio near Miró and Ernst in the Rue Tourlaque in Montmartre; he begins to participate in the Surrealist group.

Duchamp makes *Rotating Demisphere*, which anticipates the "Rotoreliefs" of 1934; begins to devote himself increasingly to chess.

August. Ernst begins to develop *frottage* (rubbing), an automatic technique first used in drawing, then adapted to painting.

October 21–November 14. Galerie Vavin-Raspail. *39 Aquarelles de Paul Klee*. First one-man show of Klee in Paris; catalogue includes introduction by Aragon, poem by Eluard.

November 14–25. Galerie Pierre. *Exposition, La Peinture Surréaliste*. First group exhibition of Surrealist painting includes Arp, de Chirico, Ernst, Klee, Masson, Miró, Picasso, Man Ray, Pierre Roy; catalogue text by Breton and Desnos. Though Klee's name is mentioned in the Surrealist manifesto, he never actively participates in the movement. He is subsequently championed by the Surrealists but arouses little interest otherwise in France.

1925–1927

BERLIN

Schwitters exhibits at Der Sturm gallery.

HANOVER

Merz no. 13 consists of a phonograph record, "Lautsonate." The "Golden Grotto" section of *Merzbau* is completed.

BRUSSELS

March. Magritte and Mesens publish the sole issue of *Oesophage*, which includes contributions by many leading Dadaists.

Magritte begins to paint his first mature works.

1926

NEW YORK

Duchamp's *Large Glass* is broken on its return from an exhibition of modern art at The Brooklyn Museum.

PARIS

March 26–April 10. Galerie Surréaliste. *Tableaux de Man Ray et Objets des Iles.* Opening exhibition of the Surrealist gallery in the Rue Jacques-Callot is a retrospective of paintings and objects by Man Ray, and primitive sculptures of the Pacific Islands from the collections of Breton, Eluard, Aragon, and others.

Miró and Ernst are attacked by certain Surrealists for collaborating on the décor of Constant Lambert's *Roméo et Juliette* for Diaghilev's Ballets Russes. Collaborating with such an organization is viewed as inimical to the subversive ideal of Surrealism. The opening of the ballet (May 4) is broken up by a Surrealist demonstration, but Miró and Ernst return to grace shortly afterward.

Naville writes "La Révolution et les intellectuels. Que peuvent faire les surréalistes?" (Revolution and the Intellectuals. What Can the Surrealists Do?); in September, Breton replies in a pamphlet, *Légitime Défense.* Naville crisis ensues; he leaves the Surrealist group to become coeditor of the Communist magazine *Clarté.* In November, Artaud and Soupault are expelled from the Surrealist group for "recognizing value in purely literary activity."

Arp settles in the Parisian suburb of Meudon. *La Révolution Surréaliste* (June) reproduces his new work.

Tanguy paints pictures that combine landscapes and figures with collage-in-*trompe l'oeil* elements suggested by Ernst's paintings of 1921–1924.

Picasso reflects first influence of Surrealism.

Man Ray publishes *Revolving Doors, 1916–1917,* a series of abstract collages he had made in New York. He, Duchamp, and Marc Allégret make the film *Anemic Cinema.*

BRUSSELS

October. Aragon acts as intermediary in bringing about official contact between the Paris Surrealists and the Surrealist group founded by Magritte and Mesens, which also includes Louis Scutenaire, Paul Nougé, and Camille Goemans.

MADRID

Dali paints *The Basket of Bread* in detailed but visionary realism. Begins to exhibit in Madrid and Barcelona; is permanently expelled from the Madrid School of Fine Arts.

1927

PARIS

January. Ernst visits Megève, where he begins series of "Hordes." Returns to Paris in February. Continues the "Forests"; other new series are "Shell Flowers" and "Monuments to the Birds."

Breton publishes *Introduction au discours sur le peu de réalité,* probably written in 1924, in which he raises the question of "Surrealist objects."

Aragon, Breton, and Eluard publish *Lautréamont envers et contre tout.*

Masson makes his first sand paintings; by "automatically" spreading glue on the raw canvas and pouring sand on the glue areas, he counterpoints the patterns that result by drawing directly with paint squeezed from a specially constructed tube.

Man Ray makes the film *Emak Bakia.*

Tanguy paints pictures that establish the biomorphism which remains characteristic of his art.

May 26–June 15. Galerie Surréaliste. *Yves Tanguy et Objets*

d'Amérique. First one-man exhibition of Tanguy, catalogue preface by Breton.

Alberto Giacometti moves to studio on the Rue Hippolyte-Maindron, where he will live until his death in 1966.

August. Magritte moves to Perreux-sur-Marne, near Paris (where he remains until 1930) and joins the Surrealist milieu.

October. The only issue of *La Révolution Surréaliste* published during the year contains the French translation of "Hands Off Love," a defense of Charlie Chaplin that had appeared in the September issue of *Transition;* protests official recognition of Rimbaud; reproduces for the first time *cadavre exquis* drawings. The issue also contains the conclusion of Breton's study, "Le Surréalisme et la peinture."

CANNES
Picasso begins sculpturally shading his biomorphic forms; first use of the Minotaur motif.

[COLOGNE]
Baargeld is killed in an avalanche while climbing in the Alps.

MUNICH
Hugo Ball publishes *Die Flucht aus der Zeit,* his diary of the Dada period.

BRUSSELS
April 23–May 3. Galerie Le Centaur. *Exposition Magritte.* First one-man show of Magritte, who had been able to devote himself entirely to painting the previous year thanks to the gallery's aid.

MADRID
Dali, having become interested in Surrealism largely through its publications, begins to work in a new and Surrealist-influenced manner.

LONDON
Two "Sound Poems" by Schwitters published in *Ray* no. 2.

1928
PARIS
February 15–March 1. Galerie Surréaliste. *Œuvres Anciennes*

de Georges de Chirico. Retrospective exhibition, catalogue preface by Aragon.

March. Sole issue of *La Révolution Surréaliste* published during the year contains the questionnaire-discussion of researches in sexuality.

Breton publishes his Surrealist "anti-novel" *Nadja.*

Publication of Breton's *Le Surréalisme et la peinture,* composed of the essays on Picasso, Miró, Braque, de Chirico, Ernst, Man Ray, and Masson which had appeared in successive issues of *La Révolution Surréaliste,* augmented by texts on Tanguy and Arp. The de Chirico text testifies to a final break with the artist.

April 2–15. Au Sacre du Printemps. *Exposition Surréaliste.* Group exhibition includes Arp, de Chirico, Ernst, Georges Malkine, Masson, Miró, Picabia, Roy, Tanguy.

May 1–15. Galerie Georges Bernheim. Miró exhibition.

Desnos and Man Ray make the film *L'Etoile de Mer.*

Masson, abandoning sand painting, reverts to a more Cubist style.

Ernst continues monumental pictures on the theme of Birds, Flowers, and Forests.

Giacometti sculpts from memory, influenced by Brancusi and Lipchitz; friendship with Masson, Leiris, and the "dissident" Surrealists (Queneau, Limbour, Desnos, Prévert), knows Miró.

On various trips to Paris, Dali meets Picasso, Miró, and the Surrealists. He and Luis Buñuel make the film *Un Chien Andalou,* which is shown privately at the Cinéma au Vieux-Columbier.

December 1–15. Galerie Georges Bernheim. *Max Ernst, Ses Oiseaux, Ses Fleurs Nouvelles, Ses Forêts Volantes, Ses Malédictions, Son Satanas.* Catalogue text by Crevel.

HOLLAND
Spring. Miró visits Holland, paints three "Dutch Interiors."

1929
PARIS
April. Georges Bataille founds the review *Documents;* Desnos, Leiris, and Prévert collaborate. Concerned with painting of

all epochs, ethnography and archaeology, it anticipates the character of the later *Minotaure*. Picasso, Léger, Miró, Arp, Masson, Braque, Brancusi, Klee, Giacometti, and Lipchitz are among the contemporary artists whose work is represented.

Man Ray makes film *Les Mystères du Château de Dé* at the home of the vicomte de Noailles.

Miró drifts from the Surrealist milieu but does not break with Breton; makes "imaginary" portraits, highly abstract collages with sandpaper.

Giacometti officially joins the Surrealist circle.

Picasso makes his "bone" paintings.

Masson disengages from the Surrealist movement, dubs himself "dissident" Surrealist.

Ernst's collage-novel, *La Femme 100 Têtes,* published.

Autumn. Dali moves to Paris; he, Buñuel, and René Char join the Surrealists.

October 1–December 23. Studio 28. First public showing of *Un Chien Andalou.*

November 20–December 5. Galerie Goemans. *Dali.* First one-man exhibition in Paris, catalogue essay by Breton.

December. In the last issue of *La Révolution Surréaliste,* Breton publishes the "Second Manifeste du surréalisme," calling it a "recall to principles," a "purification of Surrealism." The list of Surrealist "precursors" is drastically revised: Baudelaire, Rimbaud, Poe, and de Sade are rejected; fourteenth-century alchemists such as Nicolas Flamel are celebrated. Automatism is not mentioned. Former Surrealists Artaud, Vitrac, Limbour, Masson, and Soupault are castigated.

BRUSSELS

June. Special issue of the Belgian magazine *Variétés* is subtitled "Le Surréalisme en 1929," contains articles by leading Belgian and Parisian Surrealists, photographs by Man Ray, exquisite corpses made in collaboration by Miró, Max Morise, Man Ray, and Tanguy, reproductions of work by Magritte, Picabia, Arp, Ernst, and Tanguy.

1930
PARIS

Under the title *Un Cadavre* (which had earlier served for the Surrealist attack on Anatole France), dissident Surrealists violently attack Breton; Leiris, Queneau, Desnos, and Prévert are joined by independents Bataille and Ribemont-Dessaignes. Breton is described as a "flic" (cop), "false curé," "false friend," "false Revolutionary," "false Communist." In a new publication of the second manifesto, Breton interpolates a reply to these attacks.

Breton finds activity in a Communist cell (Gasworks) incompatible with Surrealism, searches for a formula of co-operation between the two movements.

March. Galerie Goemans. *Exposition de Collages.* Catalogue contains important preface by Aragon, "La Peinture au défi."

Ernst begins new collage and painting series, "Loplop présente"; second collage-novel published, *Rêve d'une petite fille qui voulut entrer au Carmel.*

After false starts in 1929, Arp makes first small sculptures in the round; begins "torn papers." Joins Seuphor's Circle and Square group, as does Schwitters.

July. First issue of *Le Surréalisme au Service de la Révolution,* a new review succeeding *La Révolution Surréaliste,* which is founded under the direction of Breton; includes a statement of solidarity with Breton signed by, among others. Aragon, Buñuel, Dali, Eluard, Ernst, Péret, Tanguy, and Tzara.

November 28–December 3. *L'Age d'Or,* film made by Buñuel and Dali, is shown at Studio 28. After a few showings it provokes a violent rightist riot, ink is thrown at the screen, seats are destroyed, and the Surrealist paintings exhibited in the entrance hall (Dali, Ernst, Miró, Tanguy) are damaged and destroyed. The film is banned by the police.

Victor Brauner arrives from Bucharest.

KHARKOV

Aragon attends the Second International Congress of Revolutionary Writers; delivers a *mea culpa* denouncing many Surrealist views, signs a letter to the International Writers' Union which attacks the second Surrealist manifesto, idealism, and Freudianism and Trotskyism as forms of idealism, and pro-

claims acceptance of Communist discipline. Writes the poem *Front rouge* (Red Front), returns to France a Communist convert but does not break with Surrealism.

1931
HARTFORD, CONNECTICUT

November. Wadsworth Atheneum. *Newer Super-Realism.* First important Surrealist exhibition in the United States; 50 works, including de Chirico, Dali, Ernst, Masson, Miró, Picasso.

PARIS

Arp and Giacometti are in close contact.

December. *Le Surréalisme au Service de la Révolution* publishes Dali's "Objets à fonctionnement symbolique," and his "Visage paranoïaque," the first of a series of "double images" he will produce through the 1930s. Issue also reproduces one of Clovis Trouille's anticlerical pictures.

1932
NEW YORK

January 9–29. Julien Levy Gallery. *Surrealist Group Show.* Exhibition previously shown at the Wadsworth Atheneum.

PARIS

January. As a result of the publication of his *Front rouge* (Red Front), Aragon is charged by the government with provoking military disobedience and inciting to murder. Breton and others circulate a petition that is signed by some 300 intellectuals; Gide and Romain Rolland are among those who refuse to sign, maintaining that true revolutionaries bear the responsibility for their work, whatever the risks. Breton publishes a tract intended to be a defense of Aragon, which Aragon, however, disavows. In March, Aragon formally breaks with the Surrealists, who publish a pamphlet criticizing him.

Breton publishes *Les Vases communicants,* in which he attempts to prove that there is no contradiction between Marx and Freud.

Giacometti has first one-man show at the Galerie Pierre Colle.

Arp joins "abstraction-création" group.

Picasso makes drawings after Grünewald's Isenheim *Crucifixion.*

HANOVER

Schwitters publishes last issue of *Merz* (no. 24), which contains "Ursonate"; joins "abstraction-création" group.

1933
PARIS

May. The last issue of *Le Surréalisme au Service de la Révolution* marks the temporary end of official Surrealist reviews.

The review *Minotaure* is founded under the direction of Albert Skira and E. Tériade. With no. 3-4 (December) it becomes a preponderantly Surrealist-oriented publication. The main collaborators are Breton, Dali, Eluard, Maurice Heine, Pierre Mabille, and Péret.

For refusing to condemn a letter he had published in *Le Surréalisme au Service de la Révolution* in which Ferdinand Alquié criticized the Russian film *The Road to Life,* Breton is expelled from the newly founded Association des Ecrivains et Artistes Révolutionnaires.

Publication of Marcel Raymond's *De Baudelaire au surréalisme.*

Victor Brauner is introduced to the Surrealists by Tanguy.

June 7–18. Galerie Pierre Colle. *Exposition Surréaliste.* Works by Duchamp, Ernst, Eluard, Giacometti, Marcel Jean, Dali, Magritte, Miró, Picasso, Man Ray, Tanguy, and others. Dali proposes a catalogue preface (used immediately afterward for his one-man show at the same gallery, June 19–29) which contemptuously dismisses Cézanne as "un peintre très sale" and praises Meissonier.

Masson paints the décor for *Les Présages* (Ballets Russe de Monte Carlo), his first work for the theater.

Surrealist group show at the Salon des Surindépendants includes Arp, Brauner, Dali, Ernst, Giacometti, Valentine Hugo, Magritte, Miró, Oppenheim, Man Ray, Tanguy, Trouille. Kandinsky, recently arrived in Paris, participates as guest of honor.

December. Trial of Violette Nozières, who murdered her parents, is commemorated by the Surrealists in a booklet of

poems and drawings by Arp, Brauner, Breton, Dali, Eluard, etc., cover by Man Ray, published by Editions Nicolas Flamel.

NORWAY

Schwitters moves temporarily to Norway, where he spends increasing amounts of time.

1934

NEW YORK

November. Dali makes first trip to the United States.

November 21–December 10. Julien Levy Gallery. *Paintings by Salvador Dali.*

December. Julien Levy Gallery. *Abstract Sculpture by Alberto Giacometti.* First one-man show of Giacometti in the United States.

PITTSBURGH

Dali's painting *Enigmatic Elements in a Landscape* awarded honorable mention at the Carnegie International.

PARIS

January. Dali is officially censured by the Surrealists for his interest in Nazism and his Hitlerian fantasies, but continues to participate in the Surrealists' exhibitions.

Breton publishes (in Brussels) *Qu'est-ce que le surréalisme?,* illustrated by Magritte.

Publication of *Petite Anthologie poétique du surréalisme,* with important critical introduction by Georges Hugnet.

Ernst spends summer with Giacometti in Maloja (Switzerland), begins relief sculpture on stones; returns to Paris and during the winter months makes plasters of major pieces. Publishes his third collage novel, *Une Semaine de bonté.*

Matta begins to study architecture in the office of Le Corbusier.

Toward the end of the year Oscar Dominguez joins the Surrealists.

December. Galerie Pierre. First exhibition of Victor Brauner in Paris, catalogue preface by Breton. Shortly afterward Brauner returns to his native Bucharest.

Minotaure (no. 6) publishes photographs of Hans Bellmer's first *poupée* in various arrangements.

SPAIN

Masson lives in Catalonian fishing village.

1935

NEW YORK

January 10–February 9. Pierre Matisse Gallery. *Joan Miró 1933–1934.*

January 11. The Museum of Modern Art. Salvador Dali gives an illustrated lecture, *Surrealist Painting: Paranoiac Images,* translated from the French by Julien Levy.

Masson has exhibition at Pierre Matisse Gallery.

Arshile Gorky joins the WPA Federal Art Project and begins work on murals for Newark Airport.

Dali's *Conquest of the Irrational* published by Julien Levy.

Publication of James Thrall Soby, *After Picasso,* first American book primarily devoted to Surrealism.

PARIS

June. A week before the opening of the Congrès des Ecrivains pour la Défense de la Culture, an international congress of writers that aims at furthering Franco-Soviet cultural relations, Breton slaps Ilya Ehrenburg for having published remarks hostile to Surrealism. As a result Breton is not permitted to address the congress, which leads to Crevel's suicide. In the *Bulletin International du Surréalisme* published in August in Brussels the Surrealists denounce both the congress and the Soviet Union.

Breton creates first "poem-objects," compositions in which he combines poetry and the plastic arts.

Picasso abandons himself to writing poetry; his first poems are Surrealist in character and derive from the technique of automatic writing.

Giacometti returns to painting and to working from the model. He is officially expelled from the Surrealist group; later he disowns his early work.

Duchamp's Rotoreliefs are published; he presents them at the Concours Lépine, an annual show for inventors.

Wolfgang Paalen joins the Surrealists.

Dominguez discovers the technique of decalcomania.

LONDON

David Gascoyne publishes *A Short Survey of Surrealism,* the first book in English devoted entirely to Surrealism.

1936

NEW YORK

Duchamp repairs the *Large Glass.*

Julien Levy publishes *Surrealism,* an anthology.

December 9, 1936–January 17, 1937. The Museum of Modern Art. *Fantastic Art, Dada, Surrealism.* Exhibition directed by Alfred H. Barr, Jr., accompanied by an extensively illustrated catalogue, provokes popular controversy.

PARIS

May 22–29. Galerie Charles Ratton. *Exposition Surréaliste d'Objets.* In addition to Surrealist objects, exhibition includes natural objects, interpreted natural objects, perturbed objects, found objects, mathematical objects, Readymades, etc. Special issue of *Cahiers d'Art* on the object includes an essay by Breton, "Crise de l'objet" (The Crisis of the Object).

June. *Minotaure* (no. 8) publishes decalcomanias by Breton, Dominguez, Hugnet, Marcel Jean, and Yves Tanguy.

Surrealists attack the Moscow trials.

BRUSSELS

Paul Delvaux is introduced to the work of de Chirico, Dali, and Magritte by E. L. T. Mesens and Claude Spaak; associates with Belgian Surrealists; evolves mature style.

LONDON

June 11–July 4. New Burlington Galleries. *International Surrealist Exhibition.* Catalogue text by Breton, introduction by Herbert Read, exhibition includes some 60 artists from 14 nations; in addition to the official Surrealist artists, exhibition also includes works by Brancusi, Klee, Picasso, Henry Moore; in addition to Surrealist objects, there are Oceanic objects, African and American objects, photographs of objects from the British Museum, familiar objects, found objects, natural objects interpreted; children's drawings.

Publication of *Surrealism,* edited and with an introduction by Herbert Read, with contributions by Breton, Eluard, Hugnet.

1937

PARIS

Masson returns from Spain, reconciles with Breton, and participates in Surrealist reviews.

Breton opens Galerie Gradiva, a Surrealist gallery on the Rue de Seine, named after the heroine in a story by the German writer Wilhelm Jensen, which had been analyzed by Freud. The glass door, cut out in the silhouette of a couple, is by Duchamp.

Breton publishes *L'Amour fou.*

Miró briefly returns to painting in a realistic vein.

September 22–26. Performance of Alfred Jarry's *Ubu enchaîné* by the company of Sylvain Itkine at the Comédie des Champs-Elysées. Sets by Max Ernst; program pays homage to Jarry with a series of Surrealist texts and illustrations by Magritte, Miró, Paalen, Picasso.

Paalen invents the technique of *fumage,* in which patterns are achieved by passing a candle flame swiftly across a freshly painted surface.

Esteban Francés and Kurt Seligmann join the Surrealist circle.

Matta makes first drawings; joins the Surrealists. Meets Gordon Onslow-Ford who is so impressed with Matta's drawings that he decides to become a painter.

Antonin Artaud institutionalized.

December. Breton takes over editorial direction of *Minotaure.*

NORWAY

Schwitters settles outside Oslo; begins work on second *Merzbau* (destroyed February 1951).

1938

MEXICO

February. Breton, on a lecture tour, stays at the house of Diego Rivera where he meets Rivera's other guest, Leon Trotsky.

July. Breton and Trotsky collaborate on the manifesto *Pour un art révolutionnaire indépendant* (Toward an Independent Revolutionary Art), although at Trotsky's request Rivera's signature replaces his own.

PARIS

January-February. Galerie Beaux-Arts. *Exposition Internationale du Surréalisme*. Organized by Breton and Eluard, general supervision by Duchamp, technical advisers Dali and Ernst, lighting by Man Ray, "waters and brushwood" by Paalen. Catalogue, accompanied by a *Dictionnaire abrégé du surréalisme* compiled by Breton, Eluard, and others, lists 60 artists from 14 countries exhibiting 229 entries, announces: "Ceiling covered with 1,200 sacks of coal, revolving doors, Mazda lamps, echoes, odors from Brazil, and the rest in keeping."

Publication of the complete works of Lautréamont, illustrated by Brauner, Dominguez, Ernst, Magritte, Man Ray, Masson, Matta, Miró, Paalen, Seligmann, Tanguy.

Gordon Onslow-Ford joins the Surrealists.

Matta begins his first oils, a series of "psychological morphologies," or "Inscapes."

Bellmer arrives from Berlin; forms friendship with Eluard and Tanguy, in contact with Arp, Breton, Duchamp, Ernst, Man Ray.

Cuban-born Wifredo Lam arrives after living in Spain for 14 years, becomes close friends with Picasso and Dominguez, has exhibition at the Galerie Pierre.

August. Breton returns from Mexico, breaks permanently with Eluard over Stalinism. Ernst leaves the Surrealist group on behalf of Eluard, Hugnet is expelled.

LONDON

April. First issue of the Surrealist-oriented *London Bulletin* (published by the London Gallery), under the direction of Mesens.

1939

NEW YORK

Wifredo Lam paintings shown at the Perls Gallery.

March 15–16. Dali creates two display windows for Bonwit Teller called *Day (Narcissus)* and *Night (Sleep)*. The store alters one, and in the agitation that follows as Dali struggles with a fur-lined bathtub, he crashes through the plate-glass window.

June. Opening at the World's Fair of Dali's *Dream of Venus*, a Surrealist exhibit in which "liquid ladies" float through the water against a background of ruined Pompeii among an undulating piano, an exploding giraffe, botanical typewriters, etc., occasionally milking a cow, while Venus lies on a couch thirty-six feet long dreaming the dreams of all mankind. The "Rainy Taxi" of the 1938 Paris exhibition is re-created.

Matta arrives.

November. Tanguy arrives, joins Kay Sage.

December 6–31. Julien Levy Gallery. *Exhibition of Objects by Joseph Cornell*. Catalogue text by Parker Tyler.

MEXICO

September. Paalen arrives.

FRANCE

Breton and Péret drafted as war breaks out. Breton assumes a medical post with a pilots school at Poitiers.

Onslow-Ford invents *coulage*.

September. Still a German citizen, Ernst is interned as an enemy alien. At a concentration camp in Les Milles (near Aix-en-Provence), with Bellmer, he experiments with decalcomania. He is liberated at Christmas as a result of Eluard's efforts. At his studio in St.-Martin-d'Ardeche he uses the technique of decalcomania to begin some large canvases.

LONDON

July 19. Dali, brought to visit Freud by Stefan Zweig, makes a sketch of Freud and maintains that Freud's cranium is reminiscent of a snail. The next day Freud writes to Zweig: "... until now I have been inclined to regard the Surrealists, who have apparently adopted me as their patron saint, as complete fools.... That young Spaniard, with his candid fanatical eyes and his undeniable technical mastery, has changed my estimate. It would indeed be very interesting to investigate analytically how he came to create that picture."

1940

NEW YORK

April 16–May 7. Julien Levy Gallery. *Matta.* First exhibition in New York; "catalogue," in form of a newssheet, contains article by Nicolas Calas, quote by André Breton, and a "news story" concerning Julien Levy, Parker Tyler, Calas, and Matta himself.

August. Man Ray arrives, then drives crosscountry to settle in California.
Tanguy and Kay Sage marry.

September. Publication of the first issue of the magazine *View,* founded by Charles Henri Ford.

MEXICO CITY

January–February. Galería de Arte Mexicano. *Exposición Internacional del Surrealismo.* Exhibition organized by Breton, Paalen, and the poet César Moro.

FRANCE

January. Miró at Varengeville-sur-Mer; begins a series of gouaches known collectively as "Constellations." At the fall of France returns to Spain, settles in Palma (Majorca).

Arp flees to Grasse.

August. Breton, demobilized, proceeds to Marseilles where he, among many others, is given refuge by the American Committee of Aid to Intellectuals, directed by Varian Fry. Daily meetings of numerous Surrealists, among them Masson, Lam, and Ernst who arrives after having been released from reinternment.

SWITZERLAND

Brauner takes refuge in an Alpine village, where he remains till the end of the war; devises a new encaustic method to compensate for shortage of painting material.

NORWAY

April. Schwitters flees north after German invasion.

SCOTLAND

June. Schwitters arrives with his son, is interned in various camps for the next 17 months but continues to work intensively.

1941

MARTINIQUE

Breton, Lam, Masson, and Claude Lévi-Strauss arrive on a refugee ship. Lam goes on to Santo Domingo, the others to New York.

NEW YORK

July. Ernst arrives in New York via Lisbon. At the end of the year marries Peggy Guggenheim.

Breton breaks again with Dali, dubs him "Avida Dollars."

Publication of George Lemaître, *From Cubism to Surrealism in French Literature.*

Robert Motherwell meets the Surrealists in exile, studies engraving briefly with Kurt Seligmann, is particularly friendly with Matta.

October-November. *View* devotes a special number to the Surrealist movement.

November 19–January 11, 1942. The Museum of Modern Art. *2 Exhibitions: Paintings, Drawings, Prints—Joan Miró, Salvador Dali.* Dali catalogue by James Thrall Soby is the first comprehensive study of the artist in English; Miró catalogue by James Johnson Sweeney.

PARIS

Picasso writes Surrealist play, *Desire Caught by the Tail.*

LONDON

Schwitters is released from internment, settles in London, earns his living painting portraits.

1942

NEW YORK

March 3–28. Pierre Matisse Gallery. *Artists in Exile.* Exhibition of fourteen artists who have come to America to live and work includes Eugene Berman, Breton, Chagall, Ernst, Léger, Lipchitz, Masson, Matta, Mondrian, Ozenfant, Seligmann, Tanguy, Tchelitchew, and Zadkine. Catalogue essays by James Thrall Soby and Nicolas Calas.

April. Special issue of *View* dedicated to Max Ernst.

Ernst develops technique of "oscillation."

May. Special issue of *View* dedicated to Yves Tanguy.

June. Publication of first issue of *VVV*, a Surrealist-oriented review founded and edited by David Hare, with Breton and Ernst as editorial advisers. Cover by Ernst, introductory note by Lionel Abel, "It is Time To Pick the Iron Rose"; articles by Breton ("Prolegomena to a Third Manifesto of Surrealism or Else"), Kiesler, Lévi-Strauss, Motherwell, Harold Rosenberg.

Dali publishes his autobiography, *The Secret Life of Salvador Dali.*

The Motherwells, Baziotes, and Pollocks make "automatic" poems.

October 14–November 7. 451 Madison Avenue. *First Papers of Surrealism.* Exhibition sponsored by the Coordinating Council of French Relief Societies. Twine webbing installation by Duchamp; participants include Arp, Bellmer, Brauner, Calder, Chagall, Duchamp, Ernst, Francés, Giacometti, Frida Kahlo, Kiesler, Klee, Lam, Matta, Magritte, Miró, Masson, Moore, Richard Oelze, Onslow-Ford, Picasso, Seligmann, and Tanguy. Motherwell, Hare, Baziotes, Jimmy Ernst are among the young Americans shown.

October. Peggy Guggenheim opens her gallery Art of This Century, designed by Frederick Kiesler, which serves as a museum for her private collection and a gallery for temporary exhibitions.

NEW HAVEN

December 10. Breton gives a lecture, *Situation du surréalisme entre les deux guerres,* to the students at Yale University (published in *VVV,* March 1943).

SWITZERLAND

Arp and his wife Sophie Taeuber take refuge from the war.

1943
NEW YORK

March. Publication of *VVV: Almanac for 1943.* Cover by Duchamp.

Baziotes, Motherwell, and Pollock invited to participate in a collage exhibition at Art of This Century.

November 9–27. Art of This Century. *Jackson Pollock: Paintings and Drawings.* First one-man exhibition; catalogue note by James Johnson Sweeney.

ZURICH

January. Sophie Taeuber-Arp dies.

HANOVER

Schwitters' house containing the first *Merzbau* destroyed in an air raid.

1944
NEW YORK

February. Last issue of *VVV.* Cover by Matta; also includes reproduction of Duchamp's *George Washington,* a collage of painted gauze, gold stars, and blue paper, which was commissioned by *Vogue* for a July 4 cover but not used.

Arshile Gorky meets Breton, with whom he forms a warm friendship despite the fact that neither man speaks the other's language.

Hans Richter begins to make the film *Dreams That Money Can Buy,* to which Alexander Calder, Duchamp, Ernst, Fernand Léger, and Man Ray contribute.

Ernst spends summer on Long Island working primarily on sculpture.

October 3–21. Art of This Century. *Paintings and Drawings by Baziotes.* First one-man exhibition.

October 24–November 11. Art of this Century. *Robert Motherwell: Paintings, Papiers Collés, Drawings.* First one-man exhibition; catalogue preface by James Johnson Sweeney.

November. Publication of Sidney Janis, *Abstract & Surrealist Art in America.*

1945
NEW YORK

January 9–February 4. Art of This Century. *Mark Rothko: Paintings.*

March. Julien Levy Gallery. *Arshile Gorky.* Catalogue foreword by Breton, "The Eye-Spring: Arshile Gorky."

March. Special issue of *View* devoted to Duchamp, includes

articles by Breton, James Thrall Soby, Harriet and Sidney Janis, Robert Desnos, Gabrielle Buffet.

Publication of second, enlarged edition of Breton's *Le Surréalisme et la peinture.*

UNITED STATES

Summer. Breton makes a long journey through the West where he visits ghost cities of the Gold Rush period, observes rites on Hopi and Zuni Indian reservations in New Mexico and Arizona.

HAITI

December. Breton arrives for a lecture tour during which he meets Wifredo Lam. Through Mabille, now the French cultural attaché, he witnesses voodoo ceremonies.

PARIS

Brauner returns; accidentally settles in the same building in which Henri Rousseau had had his studio.

November. Masson returns.

Publication of first volume of Maurice Nadeau, *Histoire du surréalisme.*

ENGLAND

Schwitters settles in the Lake District, near Ambleside (Westmorland), where, helped by a grant from The Museum of Modern Art, New York, he begins his third *Merzbau,* at Cylinders Farm, Little Langdale.

1946

NEW YORK

January 2–19. Kootz Gallery. *Robert Motherwell: Paintings, Collages, Drawings.* First exhibition at the gallery with which he will have a long association.

January. A fire in Gorky's studio in an old barn in Sherman, Connecticut, destroys about 27 paintings, including 15 canvases painted during the previous year, which were to have been exhibited in April.

February. Gorky undergoes operation for cancer.

February 2–March 12. Art of This Century. *Clyfford Still.* First one-man show in New York.

February 12–March 2. Samuel M. Kootz Gallery. *William Baziotes.* First exhibition at gallery with which he will have a long association.

April 1–20. Mortimer Brandt Gallery (Contemporary Section directed by Betty Parsons). *Paintings by Stamos.*

April 22–May 4. Mortimer Brandt Gallery (Contemporary Section). *Mark Rothko: Exhibition of Watercolors.*

Late in the year Pollock begins to paint his all-over "drip" canvases.

HAITI

January. Breton's first lecture on Surrealism leads to a general strike and four days of rioting, which oblige the dictator-president to flee the country.

PARIS

Spring. Breton returns; finds an atmosphere hostile to Surrealism, in which men of the Resistance are the heroes and leaders.

Artaud is released from sanatorium. His return is celebrated at the Théâtre Sarah Bernhardt; speech by Breton.

Publication by Galerie Louise Leiris (and Curt Valentin in New York) of *Bestiaire,* introductory text by Georges Duthuit, 12 lithographs and 10 drawings by Masson.

Arp returns to Meudon from Basel. Publication of first complete collection of his poems in French, *Le Siège de l'air: Poèmes 1915–1945.*

November. Théâtre Marigny. Opening of Jean-Louis Barrault's production of *Hamlet,* translation by André Gide, costumes and settings by Masson.

1947

NEW YORK

February. Miró arrives in the United States to paint a mural commissioned for the Gourmet Restaurant of the Terrace Hilton Hotel in Cincinnati; works on the mural in a studio on East 119th Street.

April 14–26. Betty Parsons Gallery. *Clyfford Still: Recent Paintings.*

1947

Spring. Peggy Guggenheim closes Art of This Century and returns to Europe.

October. Miró's finished mural exhibited at The Museum of Modern Art.

Publication of Anna Balakian, *Literary Origins of Surrealism.*

CHICAGO
November 6–January 11, 1948. The Art Institute of Chicago. *The Fifty-Eighth Annual Exhibition of American Painting and Sculpture: Abstract and Surrealist American Art.*

PARIS
April. In a lecture at the Sorbonne entitled *Le Surréalisme et l'après-guerre,* Tzara condemns Surrealism in the name of *art engagé* and rallies his audience to Communism. The lecture is violently interrupted by Breton who leads members of the audience out of the hall.

May. In an article in *Les Temps Modernes,* Jean-Paul Sartre declares that Surrealist revolt is basically abstract, metaphysical, and ineffective, and that the Surrealists were incapable of action when the moment came.

June. Publication of *Rupture inaugurale,* a collective declaration in which the Surrealists answer Sartre's charges.

July–August. Galerie Maeght. *Exposition Internationale du Surréalisme.* Last major group show of the movement, organized by Breton and Duchamp, installation supervised by Kiesler. Catalogue, *Le Surréalisme en 1947,* lists 87 artists representing 24 countries, among whom are Arp, Bellmer, Brauner, Calder, Enrico Donati, Duchamp, Ernst, Giacometti, Gorky, Jacques Hérold, Kiesler, Lam, Matta, Miró, Isamu Noguchi, Penrose, Picabia, Man Ray, Richier, Riopelle, Kay Sage, Serpan, Tanguy. Among the unrealized plans: the exhibition of "surrealists despite themselves," which would have included work by Arcimboldo, Blake, Bosch, Henri Rousseau, and of "those who have ceased to gravitate in the movement's orbit," such as Dali, Dominguez, Masson, Picasso.

Selected Bibliography

This bibliography has been compiled with the needs of the student in mind, and what might be available in general libraries. The first section consists of a number of bibliographies for the use of the more specialized reader.

I BIBLIOGRAPHIES

1 THE ART INSTITUTE OF CHICAGO. *Surrealism and Its Affinities: The Mary Reynolds Collection.* 1956.

2 H. MATARASSO LIBRAIRIE. *Surréalisme: Poésie et art contemporains.* Paris, 1949.

3 MOTHERWELL, ROBERT, ed. *The Dada Painters and Poets: An Anthology.* New York: Wittenborn, Schultz, 1951.
 Contains a critical bibliography by Bernard Karpel. – Also includes such basic documents as: Richard Huelsenbeck, "En avant Dada: A History of Dadaism," pp. 21–47; Tristan Tzara, "Seven Dada Manifestoes," pp. 73–98; Albert Gleizes, "The Dada Case," pp. 297–303; and two inserted broadsides: Richard Huelsenbeck, "Dada Manifesto 1949," and Tristan Tzara, "An Introduction to Dada."

4 LIBRAIRIE NICAISE. *Cubism, futurism, dada, surréalisme.* Paris, 1960.
 Complemented by a further publication by Librairie Nicaise, *Poésie-prose, peintres, graveurs de notre temps, éditions rares, révues.* Paris, 1964.

II BOOKS, ANTHOLOGIES, SPECIAL ISSUES OF PERIODICALS, ARTICLES

DADA

BALL, HUGO. See bibl. 56.

BARR, ALFRED, H., JR. See bibl. 81.

5 BAUR, JOHN. "The Machine and the Subconscious: Dada in America," *Revolution and Tradition in American Art.* Cambridge, Mass.: Harvard University Press, 1951, pp. 23–33.
 Originally published in *Magazine of Art* (New York), October 1951.

6 BUFFET-PICABIA, GABRIELLE. *Aires abstraites.* Geneva: Pierre Cailler, 1957.
 See also bibl. 30.

CRAVAN, ARTHUR. See bibl. 65.

7 GLEIZES, ALBERT. "L'Affaire Dada," *Action* (Paris), April 1920, pp. 26–32.
 For English translation, see bibl. 3.

8 HAUSMANN, RAOUL. *Courrier dada.* Paris: Le Terrain Vague, 1958.
 Includes a bio-bibliography.
 See also bibl. 58, 60.

9 HUELSENBECK, RICHARD. *En avant Dada; Die Geschichte des Dadaismus.* Hanover: Paul Steegemann, 1920.
 For English translation, see bibl. 3.
 See also bibl. 3, 14, 58, 61, 91, 108.

10 HUGNET, GEORGES. *L'Aventure dada (1916–1922).* Paris: Galerie de l'Institut, 1957.
 See also bibl. 30, 81.

LIPPARD, LUCY R. See bibl. 18.

11 RIBEMONT-DESSAIGNES, GEORGES. *Déja Jadis; Ou du Mouvement dada à l'espace abstrait.* Paris: René Julliard, 1958.

12 RICHTER, HANS. *Dada, Art and Anti-Art.* New York: McGraw Hill, 1965.

13 SANOUILLET, MICHEL. *Dada à Paris.* Paris: Jean-Jacques Pauvert, 1965.
 See also bibl. 74, 117.

14 SCHIFFERLI, PETER, ed. *Die Geburt des Dada: Dichtung und Chronik der Gründer*. Zurich: Verlag der Arche, 1957.
Includes contributions by Arp, Huelsenbeck, Tzara. – Documentary section reprinted in Peter Schifferli, ed., *Als Dada Begann*. Zurich: Verlag Sanssouci, 1957.

TZARA, TRISTAN. See bibl. 3.

15 ———. *Sept Manifestes dada*. Paris: Jean Budry, 1924.
For English translation, see bibl. 3.
See also bibl. 14, 59, 91, 153.

16 VERKAUF, WILLY, ed. *Dada: Monograph of a Movement*. New York: George Wittenborn, 1957.
Texts in English, German, and French.

SURREALISM

17 ALQUIÉ, FERDINAND. *The Philosophy of Surrealism*. Ann Arbor: University of Michigan Press, 1965.
Translated from the French by Bernard Waldrop. Paris: Flammarion, 1956.

ARAGON, LOUIS. See bibl. 63, 78.

18 *Artforum* (Los Angeles), September 1966.
Special issue devoted to Surrealism: Max Kozloff, "Surrealist Painting Re-examined," pp. 5–9; Lucy R. Lippard, "Dada into Surrealism," pp. 10–15; Ronald Hunt, "The Picabia/Breton Axis," pp. 16–20; Robert Rosenblum, "Picasso as Surrealist," pp. 21–25; Toby Mussman, "The Surrealist Film," pp. 26–31; Roger Shattuck, "On René Magritte," pp. 32–35; William Rubin, "Toward a Critical Framework," pp. 36–55; Whitney Halstead, "The Hodes Collection," pp. 56–59; Kurt von Meier, "Surrealism and Architecture," pp. 60–65; Sidney Tillim, "Surrealism as Art," pp. 66–71; Annette Michelson, "Breton's Esthetics," pp. 72–77; Nicolas Calas, "A Perspective," pp. 78–79; Nicolas Slonimsky, "Music and Surrealism," pp. 80–85; Jerrold Lanes, "Surrealist Theory and Practice in France and America," pp. 86–87.

19 BALAKIAN, ANNA. *Literary Origins of Surrealism*. New York: King's Crown Press, 1947; New York University Press, 1966.

20 ———. "Is Surrealism a Humanism?" *Arts and Sciences* (New York), June 14, 1965, pp. 1–7.

BARR, ALFRED H., JR. See bibl. 81.

21 BRETON, ANDRÉ. *Manifeste du surréalisme*. Paris: Editions du Sagittaire, 1924.

22 ———. *Second Manifeste du surréalisme*. Paris: Editions Kra, 1930.

23 ———. *Les Manifestes du surréalisme, suivis de prolégomènes à un troisième manifeste du surréalisme ou non*. Paris: Editions du Sagittaire, 1946.

24 ———. *Les Manifestes du surréalisme, suivis de prolégomènes à un troisième manifeste du surréalisme ou non, du surréalisme en ses œuvres vives, et d'éphémérides surréalistes*. Paris: Editions du Sagittaire, 1955.

25 ———. *Les Pas perdus*. Paris: Gallimard, 1924.

26 ———. *La Situation du surréalisme entre les deux guerres*. Paris: Editions de la Revue Fontaine, 1945.

27 ———. *Le Surréalisme et la peinture*. Paris: Gallimard, 1928; 2nd edition, New York and Paris: Brentano's, 1945; 3rd edition, additional essays, revised and corrected, Paris: Gallimard, 1966.

28 ———. *What is Surrealism?* London: Faber & Faber, 1936. Translated from the French by David Gascoyne. Brussels: René Henriquez, 1934.
———, ELUARD, PAUL, *et al. Dictionnaire abrégé du surréalisme*. See bibl. 84.

29 ——— and PÉRET, BENJAMIN. *Almanach surréaliste du demi-siècle*. Paris: Editions du Sagittaire, 1950.
See also bibl. 30, 38, 46, 49, 63, 69, 72, 73, 80, 84, 85, 86, 88, 90, 96, 153.

30 *Cahiers d'Art* (Paris), no. 1-2, 1936.
Special issue devoted to the object, includes: André Breton, "Crise de l'objet," pp. 21–26; Georges Hugnet, "L'Œil de l'aiguille," p. 27; Paul Eluard, "L'Habitude des tropiques," p. 29; Gabrielle Buffet, "Cœurs volants," pp. 34–43; Claude Cahun, "Prenez garde aux objets domestiques," pp. 45–48; Salvador Dali, "Honneur à l'objet!" pp. 53–56; Marcel Jean, "Arrivée de la belle époque," p. 60; Hans Bellmer, untitled, p. 66.

CAHUN, CLAUDE. See bibl. 30.

31 CALAS, NICOLAS. "Surrealist Intentions," *Trans/formation* (New York), 1950, pp. 48–52.
See also bibl. 18.

32 CHARBONNIER, GEORGES. *Le Monologue du peintre.* 2 vols. Paris: René Julliard, 1952, 1960.

> Conversations with artists: vol. 1 includes Max Ernst, Joan Miró, Francis Picabia, Alberto Giacometti, André Masson; vol. 2 includes Salvador Dali.

33 COMFORT, ALEX and BAYLISS, JOHN, eds. *New Road.* London: The Grey Walls Press, 1943.

DAVIES, HUGH SYKES. See bibl. 46.

34 DUPLESSIS, YVES. *Surrealism.* New York: Walker & Company, 1962.

> Translated from the French by Paul Capon. Paris: Presses Universitaires de France, 1950.

ELUARD, PAUL. See bibl. 30, 46, 84, 153.

35 FOWLIE, WALLACE. *Age of Surrealism.* New York: The Swallow Press and William Morrow, 1950.

36 GASCOYNE, DAVID. *A Short Survey of Surrealism.* London: Cobden-Sanderson, 1935.

> See also bibl. 80, 82.

37 GAUSS, CHARLES. "Theoretical Backgrounds of Surrealism," *Journal of Aesthetics and Art Criticism* (New York), Fall 1943, pp. 37–44.

38 GUGGENHEIM, PEGGY, ed. *Art of This Century: Objects, Drawings, Photographs, Paintings, Sculpture, Collages, 1910 to 1942.* New York: Art of This Century, 1942.

> Includes: André Breton, "Genesis and Perspective of Surrealism"; Arp, "Abstract Art, Concrete Art."

HALSTEAD, WHITNEY. See bibl. 18.

HUGNET, GEORGES. See bibl. 46, 81.

39 JANIS, SIDNEY. *Abstract & Surrealist Art in America.* New York: Reynal & Hitchcock, 1944.

> See also bibl. 87.

40 JEAN, MARCEL. *The History of Surrealist Painting.* New York: Grove Press, 1960; reprinted 1967.

> With the collaboration of Arpad Mezei. Translated from the French by Simon Watson Taylor. Paris: Editions de Seuil, 1959.

> See also bibl. 30.

KOZLOFF, MAX. See bibl. 18.

LANES, JERROLD. See bibl. 18.

41 LEVY, JULIEN. *Surrealism.* New York: The Black Sun Press, 1936.

> Excerpts from the writings of twentieth-century Surrealists and precursors of Surrealism; list of Surrealist exhibitions in the United States 1930–1936; bibliography.

See also bibl. 92, 99, 140.

LIPPARD, LUCY R. See bibl. 18.

MACAGY, JERMAYNE. See bibl. 92.

MEIER, KURT VON. See bibl. 18.

MESENS. E. L. T. See bibl. 64, 83, 145.

MICHELSON, ANNETTE. See bibl. 18.

MUSSMAN, TOBY. See bibl. 18.

NACENTA, RAYMOND. See bibl. 97.

42 NADEAU, MAURICE. *History of Surrealism.* New York: Macmillan, 1965.

> Introduction by Roger Shattuck. Translation from the French by Richard Howard. Paris: Club des Editeurs, 1958. – An abridgement and revision of *Histoire du surréalisme.* 2 vols. Paris: Editions du Seuil, 1945, 1948. Vol. 1 contains the history of the movement, as well as documents and excerpts from original publications mentioned in the course of the text, and bibliography of Surrealist publications; vol. 2, *Documents surréalistes,* contains material in vol. 1 as well as additional documents. – The 1958 and 1965 editions do not contain the documentary portions of vol. 1 and include only a selection of material from vol. 2.

43 PEYRE, HENRI. "The Significance of Surrealism," *Yale French Studies* (New Haven), Fall-Winter 1948, pp. 34–49.

44 PIERRE, JOSÉ. *Le Surréalisme.* Lausanne: Editions Rencontre, 1966.

45 RAYMOND, MARCEL. *From Baudelaire to Surrealism.* New York: Wittenborn, Schultz, 1950.

> Translated from the French. Rev. ed., Paris: José Corti, 1947.

46 READ, HERBERT, ed. *Surrealism.* London: Faber & Faber, 1936.

Herbert Read, Introduction, pp. 19–91; André Breton, "Limits not Frontiers of Surrealism," pp. 95–116; Hugh Sykes Davies, "Surrealism at This Time and Place," p. 119–68; Paul Eluard, "Poetic Evidence," pp. 171–83; Georges Hugnet, "1870–1936," pp. 187–251.
See also bibl. 80, 82, 92.

RUBIN, WILLIAM. See bibl. 18.

47 SOBY, JAMES THRALL. *After Picasso.* New York: Dodd, Mead, 1935.

SLONIMSKY, NICOLAS. See bibl. 18.

48 SWEENEY, JAMES JOHNSON, ed. "Eleven Europeans in America," *The Museum of Modern Art Bulletin* (New York), September 1946, pp. 1–39.
Includes interviews with André Masson, Kurt Seligmann, Max Ernst, Marcel Duchamp, Yves Tanguy.

49 *This Quarter* (Paris), September 1932.
Special Surrealist issue, guest editor André Breton.

TILLIM, SIDNEY. See bibl. 18.

50 *Variétés* (Brussels), June 1929.
Special issue entitled "Le Surréalisme en 1929."

51 WALDBERG, PATRICK. *Surrealism.* Lausanne: Skira, 1965. Translated from the French by Stuart Gilbert. Lausanne: Skira, 1962.

52 ———. *Surrealism.* New York: McGraw-Hill, 1965.
See also bibl. 97.

III DADA AND SURREALIST BULLETINS AND PERIODICALS

* Indicates that the publication is available in The Museum of Modern Art Library.

53 * *Bleu* (Mantua), January 1921.
Edited by J. Evola, Cina Cantarelli, and Aldo Fiozzi.

54 * *The Blind Man* (New York), April, May 1917.
Edited by Marcel Duchamp, with editorial participation by Man Ray.

55 *Bulletin International du Surréalisme.* 1935–1936.
Published irregularly by Surrealist groups in various countries, title and text in French and language of origin: (Prague), April 1935; (Santa Cruz de Tenerife), October 1935; (Brussels), August 20, 1935; (London), September 1936.

56 * *Cabaret Voltaire* (Zurich), June 1916.
Edited by Hugo Ball.

57 * *Cannibale* (Paris), April 25, May 25, 1920.
Edited by Francis Picabia.

58 * *Club Dada* (Berlin), 1918.
Edited by Richard Huelsenbeck, Franz Jung, and Raoul Hausmann.

59 * *Dada* (Zurich and Paris), July 1917–March 1920.
Edited by Tristan Tzara. *Dada 4-5* cover title is *Anthologie Dada; Dada 6* cover title is *Bulletin Dada; Dada 7* cover title is *Dadaphone.*

60 * *Der Dada* (Berlin), 1919–1920.
Edited by Raoul Hausmann, George Grosz, John Heartfield.

61 *Dada Almanach* (Berlin), 1920
Edited by Richard Huelsenbeck. Published in facsimile edition, New York: Something Else Press, 1966.

62 *Documents* (Paris), 1929–1930.
Edited by Georges Bataille.

63 * *Littérature* (Paris), March 1919–June 1924.
Edited by Louis Aragon, André Breton, Philippe Soupault.

64 * *London Bulletin* (London), April 1938–June 1940.
Edited by E. L. T. Mesens. Includes catalogues of Surrealist one-man exhibitions at London Gallery.

65 * *Maintenant* (Paris), April 1912–March-April 1915.
Edited by Arthur Cravan. Published in facsimile edition, Paris: Erik C. Losfeld, 1957.

66 * *Merz* (Hanover), 1923–1932.
Edited by Kurt Schwitters.

67 * *Minotaure* (Paris), 1933–1939.
Edited by Albert Skira and E. Tériade.

68 * *New York Dada* (New York), April 1921.
Edited by Marcel Duchamp, with editorial participation by Man Ray.

69　* *La Révolution Surréaliste* (Paris), December 1, 1924–December 15, 1929.
　　Edited by Pierre Naville, Benjamin Péret, André Breton.

70　* *Rongwrong* (New York), 1917.
　　Edited by Marcel Duchamp.

71　* *Die Schammade* (Cologne), February 1920.
　　Edited by Max Ernst.

72　* *Le Surréalisme au Service de la Révolution* (Paris), 1930–1933.
　　Edited by André Breton.

73　* *Le Surréalisme, Même* (Paris), 1956–1959.
　　Edited by André Breton.

74　* *391* (Barcelona, New York, Zurich, Paris), 1917–1923.
　　Edited by Francis Picabia. Published in reduced facsimile, ed. Michel Sanouillet, Paris: Le Terrain Vague, 1960.

75　* *VVV* (New York), June 1942–February 1944.
　　Edited by David Hare.

IV EXHIBITION CATALOGUES
(not including individual artists)
arranged chronologically

76　COLOGNE. BRAUHAUS WINTER. *Dada-Vorfrühling: Gemälde, Skulpturen, Zeichnungen, Fluidoskeptrik, Vulgärdilettantismus.* April, May 1920.

77　BERLIN. KUNSTHANDLUNG DR. OTTO BURCHARD. *Erste Internationale Dada-Messe.* June 5–August 25, 1920.

78　PARIS. GALERIE GOEMANS. *Exposition de Collages.* 1930.
　　Contains: Louis Aragon, "La Peinture au défi."

79　PARIS. GALERIE CHARLES RATTON. *Exposition Surréaliste d'Objets.* May 22–29, 1936.

80　LONDON. NEW BURLINGTON GALLERIES. *The International Surrealist Exhibition.* June 11–July 4, 1936.
　　Preface by André Breton, translated by David Gascoyne. Introduction by Herbert Read.

81　NEW YORK. THE MUSEUM OF MODERN ART. *Fantastic Art, Dada, Surrealism.* December 7, 1936–January 17, 1937.
　　Catalogue edited by Alfred H. Barr, Jr. 1st ed., 1936; 2nd ed., 1937 includes essays by Georges Hugnet, "Dada," pp. 15–34, and "In the Light of Surrealism," pp. 35–52.

82　LONDON. LONDON GALLERY. *Surrealist Objects & Poems.* 1937.
　　Herbert Read, Foreword; David Gascoyne, "Three Poems."

83　BRUSSELS. PALAIS DES BEAUX-ARTS. *Trois Peintures Surréalistes: René Magritte, Man Ray, Yves Tanguy.* December 11–22, 1937.
　　Presented by E. L. T. Mesens.

84　PARIS. GALERIE BEAUX-ARTS. *Exposition Internationale du Surréalisme.* January–February 1938.
　　Organized by André Breton and Paul Eluard, general supervision by Marcel Duchamp, technical advisers Salvador Dali and Max Ernst, lighting by Man Ray. Catalogue contains "Dictionnaire abrégé du surréalisme," compiled by Breton, Eluard, and others.

85　MEXICO CITY. GALÉRIA DE ARTE MEXICANO. *Exposición Internacional del Surrealismo.* January–February 1940.
　　Organized by André Breton, Wolfgang Paalen, and César Moro.

86　NEW YORK. [Coordinating Council of French Relief Societies.] *First Papers of Surrealism.* October 14–November 7, 1942.
　　Exhibition held at the Reid Mansion, 451 Madison Avenue. Hanging by André Breton, webbing installation by Marcel Duchamp.

87　SAN FRANCISCO MUSEUM OF ART. *Abstract and Surrealist Art in the United States.* 1944.
　　Works of art selected by Sidney Janis. Cincinnati Art Museum, February 8–March 12; Denver Art Museum, March 26–April 23; Seattle Art Museum, May 7–June 10; Santa Barbara Museum of Art, June–July; San Francisco Museum of Art, July.

88　PARIS. GALERIE MAEGHT. *Exposition Internationale du Surréalisme: Le Surréalisme en 1947.* July–August 1947.
　　Organized by André Breton and Marcel Duchamp.

89　THE ART INSTITUTE OF CHICAGO. *The Fifty-Eighth Annual Exhibition of American Painting and Sculpture: Abstract*

and Surrealist American Art. November 6, 1947–January 11, 1948.

Organized by Frederick A. Sweet and Katherine Kuh; catalogue texts: Daniel Catton Rich, Foreword; Frederick A. Sweet, "The First Forty Years"; Katherine Kuh, "The Present."

90 PARIS. GALERIE NINA DAUSSET. *Le Cadavre Exquis, son Exaltation.* October 7–30, 1948.

Essay by André Breton.

91 NEW YORK. SIDNEY JANIS GALLERY. *Dada 1916–1923.* April 15–May 9, 1953.

Catalogue (a large sheet, originally distributed as a crumpled ball of paper) designed by Marcel Duchamp, contains original statements by Tristan Tzara, Jean Arp, Richard Huelsenbeck, and Jacques-Henry Lévesque.

92 HOUSTON. CONTEMPORARY ARTS MUSEUM. *The Disquieting Muse: Surrealism.* January 9–February 16, 1958.

Contains excerpts from Herbert Read's *Surrealism and the Romantic Principle;* Jermayne MacAgy, "History is Made at Night"; Julien Levy, "The Disquieting Muse."

93 DÜSSELDORF. KUNSTHALLE. *Dada: Dokumente einer Bewegung.* September 5–October 19, 1958.

Texts in German, French, Dutch, and English. – Exhibition also shown: Amsterdam, Stedelijk Museum, December 23, 1958–February 2, 1959.

94 THE ARTS CLUB OF CHICAGO. *Surrealism Then and Now.* October 1–30, 1958.

95 PARIS. GALERIE DANIEL CORDIER. *Exposition Internationale du Surréalisme.* December 15, 1959–February 29, 1960.

On the theme of eroticism.

96 NEW YORK. D'ARCY GALLERIES. *Surrealist Intrusion in the Enchanters' Domain.* November 28, 1960–January 14, 1961.

Directed by André Breton and Marcel Duchamp.

97 PARIS. GALERIE CHARPENTIER. *Le Surréalisme: Sources, Histoire, Affinités.* 1964.

Texts by Raymond Nacenta and Patrick Waldberg.

98 SÃO PAULO. VIII BIENAL. *Surrealismo e Arte Fantástica.* 1965.

Organized by Felix Labisse.

99 SANTA BARBARA. ART GALLERY OF THE UNIVERSITY OF CALIFORNIA. *Surrealism, a State of Mind, 1924–1965.* February 26–March 27, 1966.

Note by Mrs. Ala Story; Introduction by Julien Levy.

100 SANTA BARBARA MUSEUM OF ART. *Harbingers of Surrealism.* February 26–March 27, 1966.

Foreword by William J. Hesthal.

101 MILAN. GALLERIA SCHWARZ. *Cinquant' Anni a Dada: Dada in Italia 1916–1966.* June 24–September 30, 1966.

Texts in Italian, French, and English. Essays by Lino Montagna, Arturo Schwarz, and Daniela Palazzoli.

102 STOCKHOLM. MODERNA MUSEET. *Dada.* February 3–March 27, 1966.

Organized by K. G. Hultén.

103 ZURICH. KUNSTHAUS. *Dada. Ausstellung zum 50-jährigen Jubiläum.* October 8–November 17, 1966.

Texts in German and French. Extensive chronology, biographies of the artists. Also shown: Paris, Musée National d'Art Moderne, November 30, 1966–January 30, 1967.

104 BERN. KUNSTHALLE. *Phantastische Kunst — Surrealismus.* October 21–December 4, 1966.

V INDIVIDUAL ARTISTS

Artist's writings and interviews (arranged chronologically); works about the artist; exhibition catalogues (arranged chronologically).

ARP, Jean (Hans)

105 *On My Way: Poetry and Essays, 1912–1947.* (The Documents of Modern Art.) New York: Wittenborn, Schultz, 1948.

Contains bibliography.
See also bibl. 14, 38, 91, 108.

106 CATHELIN, JEAN. *Arp.* Paris: Le Musée de Poche, 1959.

107 GIEDION-WELCKER, CAROLA. *Jean Arp.* New York: Harry N. Abrams, 1957.

Translated from the German by Norbert Guterman.

108 NEW YORK. THE MUSEUM OF MODERN ART. *Arp.* 1958. James Thrall Soby, ed. Articles by Jean (Hans) Arp,

Richard Huelsenbeck, Robert Melville, and Carola Giedion-Welcker. – Published on the occasion of an exhibition at the Museum, October 6–November 30, 1958.

BELLMER, Hans. See bibl. 30.

de CHIRICO, Giorgio

109 *Hebdomeros*. New York: Four Seasons Book Society, 1966. 1966.
Translated, with an introduction, by James A. Hodkinson. Originally published Paris: Editions du Carrefour, 1929.
See also bibl. 110.

110 NEW YORK. THE MUSEUM OF MODERN ART. *Giorgio de Chirico*. 1955.
Text by James Thrall Soby. Includes writings by the artist, bibliography. – Published on the occasion of an exhibition at the Museum, September 8–October 30, 1955.

DALI, Salvador

111 *La Femme visible*. Paris: Editions Surréalistes, 1930.

112 "The Stinking Ass," *This Quarter* (Paris), Summer 1932, pp. 49–54.
Translation of "L'Ane pourri," *Le Surréalisme au Service de la Révolution* (Paris), July 1930, pp. 9–12.

113 *Conquest of the Irrational*. New York: Julien Levy, 1935.
Translated from the French by David Gascoyne.
See also bibl. 30, 32.

114 DESCHARNES, ROBERT. *The World of Salvador Dali*. New York: Harper & Row, 1962.

115 NEW YORK. THE MUSEUM OF MODERN ART. *Salvador Dali: Paintings, Drawings, Prints*. 1941; rev. ed. 1946.
Text by James Thrall Soby. Includes chronology, list of exhibitions, lists of films and ballets on which Dali collaborated, jewelry, bibliography. – Published on the occasion of an exhibition at the Museum, November 19, 1941–January 11, 1942.

116 NEW YORK. GALLERY OF MODERN ART. *Salvador Dali. 1910–1965, with The Reynolds Morse Collection*. 1965.
Published on the occasion of an exhibition at the Gallery, December 18, 1965–February 28, 1966.
See also bibl. 84.

DUCHAMP, Marcel

117 *Marchand du sel; Ecrits de Marcel Duchamp*. Michel Sanouillet, ed. Paris: Le Terrain Vague, 1958.
Contains bibliography.

118 "Marcel Duchamp," in James Nelson, ed. *Wisdom: Conversations with the Elder Wise Men of Our Day*. New York: W. W. Norton, 1958, pp. 89–99.
Transcription of a conversation between Duchamp and James Johnson Sweeney shown on NBC-TV, January 1956.

119 *The Bride Stripped Bare by Her Bachelors, Even: A Typographic Version by Richard Hamilton of Marcel Duchamp's Green Box*. (The Documents of Modern Art.) New York: George Wittenborn, 1960.
First complete translation, by George Heard Hamilton, of Duchamp's *Boîte verte; Ou, la Mariée mise à nu par ses célibataires même*. Paris: Editions Rrose Sélavy, 1934.
See also bibl. 48, 153.

120 HAMILTON, RICHARD. "Duchamp," *Art International* (Zurich), January 1964, pp. 22–28.

121 LEBEL, ROBERT. *Marcel Duchamp*. New York: Grove Press, 1959.
Translated from the French by George Heard Hamilton. – Catalogue raisonné, bibliography.

122 RUBIN, WILLIAM. "Reflections on Marcel Duchamp," *Art International* (Zurich), November 1960, pp. 49–53.

123 PASADENA ART MUSEUM. *Marcel Duchamp*. October 8–November 3, 1963.
Largest comprehensive exhibition of Duchamp's life-work to date.

124 NEW YORK. CORDIER & EKSTROM. *Not Seen and/or Less Seen of/by Marcel Duchamp/Rrose Selavy: 1909–64*. January 14–February 13, 1965.
Foreword and catalogue by Richard Hamilton. – Exhibition of the Mary Sisler collection.

125 LONDON. ARTS COUNCIL OF GREAT BRITAIN. *The Almost Complete Works of Marcel Duchamp*. At the Tate Gallery, June 18–July 31, 1966.

First major retrospective exhibition to be held in Europe.
See also bibl. 54, 68, 70, 84, 86, 88, 91, 96.

ERNST, Max

126 *Beyond Painting and Other Writings by the Artist and His Friends.* (The Documents of Modern Art.) New York: Wittenborn, Schultz, 1948.
Bibliography by Bernard Karpel.
See also bibl. 32, 48.

LIPPARD, LUCY R. See bibl. 18, 131.

127 RUBIN, WILLIAM. "Max Ernst," *Art International* (Zurich), May 1, 1961, pp. 31–37.

128 RUSSELL, JOHN. *Max Ernst.* New York: Harry N. Abrams, 1967.

129 WALDBERG, PATRICK. *Max Ernst.* Paris: Jean-Jacques Pauvert, 1958.

130 NEW YORK. THE MUSEUM OF MODERN ART. *Max Ernst.* 1961.
William S. Lieberman, ed. Includes "An Informal Life of M. E. (as told by himself to a young friend)"; a selection from Ernst's writings revised and augmented by the artist for this publication; bibliography. – Published on the occasion of an exhibition at the Museum, March 1– May 7, 1961.

131 NEW YORK. THE JEWISH MUSEUM. *Max Ernst: Sculpture and Recent Painting.* 1966.
Sam Hunter, ed. Includes: Lucy R. Lippard, "The Sculpture," pp. 37–52; John Russell, "Recent Book Illustration," pp. 55–56. – Published on the occasion of an exhibition at the Museum, March 3–April 17, 1966.
See also bibl. 71, 84.

GIACOMETTI, Alberto

132 "1+1=3," *Trans/formation* (New York), 1952, pp. 165–67. Translated from the French. Originally published *Minotaure* (Paris), December 1933, p. 46.

133 *Alberto Giacometti, Schriften, Fotos, Zeichnungen / Essais, photos, dessins.* Ernst Scheidegger, ed. Zurich: Peter Schifferli, 1958.
See also bibl. 32, 136.

134 BUCARELLI, PALMA. *Giacometti.* Rome: Editalia, 1962.

135 DUPIN, JACQUES. *Alberto Giacometti.* Paris: Maeght, 1962. Published also in an edition with an interleaved English translation by John Ashbery.

136 NEW YORK. THE MUSEUM OF MODERN ART. *Alberto Giacometti.* 1965.
Introduction by Peter Selz. Includes chronology compiled by Irene Gordon; letter from the artist to Pierre Matisse, 1947; bibliography. – Published on the occasion of an exhibition at the Museum, June 7–October 10, 1965. Exhibition also shown: The Art Institute of Chicago, November 5–December 12, 1965; Los Angeles County Museum of Art, January 11–February 20, 1966; San Francisco Museum of Art, March 10–April 24.

GORKY, Arshile

137 ROSENBERG, HAROLD. *Arshile Gorky: The Man, the Time, the Idea.* New York: Horizon Press, 1962.

138 RUBIN, WILLIAM, "Arshile Gorky, Surrealism, and the New American Painting," *Art International* (Zurich), February 1963, pp. 27–38.

139 SCHWABACHER, ETHEL. *Arshile Gorky.* New York: Macmillan for the Whitney Museum of American Art, 1957. Preface by Lloyd Goodrich; Introduction by Meyer Schapiro.

140 NEW YORK. THE MUSEUM OF MODERN ART. *Arshile Gorky: Paintings, Drawings, Studies.* 1962.
By William C. Seitz; Foreword by Julien Levy. – Published on the occasion of an exhibition at the Museum, December 17, 1962–February 12, 1963. Also shown: The Washington Gallery of Modern Art, March 12–April 14, 1963.

GROSZ, George

141 *A Little Yes and a Big No, the Autobiography of George Grosz.* New York: The Dial Press, 1946.

142 BITTNER, HERBERT, ed. *George Grosz.* New York: Arts, Inc., 1960.
Grosz, "On My Drawings" (1944); Introduction by Ruth Berenson and Norbert Muhlen; bibliography.
See also bibl. 60.

KIESLER, Frederick

143 "Design-Correlation," *VVV* (New York), March 1943, pp. 76–80.

144 *Inside the Endless House; Art, People, and Architecture: A Journal.* New York: Simon and Schuster, 1964.

MAGRITTE, René

145 "Word vs Image," in New York. Sidney Janis Gallery. *René Magritte.* March 1–20, 1954.
 Translation from the French by E. L. T. Mesens of "Les Mots et les images," *La Révolution Surréaliste* (Paris), December 15, 1929, pp. 32–33.

146 Scutenaire, Louis. *Magritte.* Brussels: Editions Librairie Sélection, 1947.

 Shattuck, Roger. See bibl. 18.

147 Waldberg, Patrick. *René Magritte.* Brussels: André De Rache, 1965.
 Translated from the French by Austryn Wainhouse.

148 New York. The Museum of Modern Art. *René Magritte.* 1966.
 Text by James Thrall Soby, bibliography. – Published on the occasion of an exhibition at the Museum, December 13, 1965–February 27, 1966. Also shown: Rose Art Museum, Brandeis University, Waltham, Massachusetts, April 3–May 1; The Art Institute of Chicago, May 30–July 3; Pasadena Art Museum, August 1–September 4; University Art Museum, University of California, Berkeley, October 1–November 1, 1966.
 See also bibl. 83.

MAN RAY

149 *Self-Portrait.* Boston: Little, Brown, 1963.
 See also bibl. 152, 153.

150 Belz, Carl. "Man Ray and New York Dada," *Art Journal* (New York), Spring 1964, pp. 207–13.
 See also bibl. 153.

151 London. Institute of Contemporary Arts. *Works of Man Ray.* March 31–April 25, 1959.

152 Milan. Galleria Schwarz. *Man Ray: Objects of My Affection.* March 14–April 3, 1964.
 Texts by Man Ray and Tristan Tzara.

153 Los Angeles County Museum of Art, Lytton Gallery. *Man Ray.* October 27–December 25, 1966.
 Texts by Jules Langsner and Man Ray; section titled "Man Ray's Friends on Man Ray" includes writings by Paul Eluard, Marcel Duchamp, André Breton, Tristan Tzara, Hans Richter; Carl I. Belz, "The Film Poetry of Man Ray."
 See also bibl. 54, 68, 83, 84.

MASSON, André

154 *Entretiens avec Georges Charbonnier.* Paris: René Julliard, 1958.

155 Hahn, Otto. *Masson.* New York: Harry N. Abrams, 1965.
 Translation from the French by Robert Erich Wolf.

156 Juin, Hubert. *André Masson.* Paris: Le Musée de Poche, 1963.

157 Leiris, Michel and Limbour, Georges. *André Masson and His Universe.* Geneva and Paris: Editions des Trois Collines/London: Horizon, 1947.
 Includes texts in French, with some translated into English by Douglas Cooper.

158 Rubin, William. "Notes on Masson and Pollock," *Arts* (New York), November 1959, pp. 36–43.
 See also bibl. 32, 48.

MATTA (Sebastian Antonio Matta Echaurren)

159 "Hellucinations," in Ernst, Max. *Beyond Painting . . .* (The Documents of Modern Art.) New York: Wittenborn, Schultz, 1948, pp. 193–94.

160 New York. The Museum of Modern Art. *Matta.* 1957.
 Text by William Rubin. – Published on the occasion of an exhibition at the Museum, September 10–October 20, 1957.

MIRÓ, Joan

161 Sweeney, James Johnson. "Joan Miró: Comment and Interview," *Partisan Review* (New York), February 1948, pp. 206–12.

162 *Joan Miró: Gesammelte Schriften.* Ernst Scheidegger, ed. Zurich: Verlag der Arche, 1957.
 See also bibl. 32.

163 DUPIN, JACQUES. *Miró.* New York: Harry N. Abrams, 1962.
Translated from the French by Norbert Guterman. – Catalogue raisonné, bibliography.

164 GREENBERG, CLEMENT. *Joan Miró.* New York: Quadrangle Press, 1948.

165 LASSAIGNE, JACQUES. *Miró: Biographical and Critical Study.* Geneva: Skira, 1963.
Translated from the French by Stuart Gilbert.

166 MOTHERWELL, ROBERT. "The Significance of Miró," *Art News* (New York), May 1959, pp. 32–33.

167 NEW YORK. THE MUSEUM OF MODERN ART. *Joan Miró.* 1941.
Essay by James Johnson Sweeney. – Published on the occasion of an exhibition at the Museum, November 19, 1941–January 11, 1942.

168 NEW YORK. THE MUSEUM OF MODERN ART. *Joan Miró.* 1959.
Essay by James Thrall Soby; bibliography. – Published on the occasion of an exhibition at the Museum, March 18–May 10, 1959.

169 LONDON. ARTS COUNCIL OF GREAT BRITAIN. *Miró.* At the Tate Gallery, August 27–October 11, 1964.
Text by Roland Penrose. – Also shown: Zurich, Kunsthaus, October 31–December 6.

PAALEN, Wolfgang. See bibl. 85.

PICABIA, Francis

170 *Poèmes et dessins de la fille née sans mère.* Lausanne: Imprimeries Réunis, 1918.

171 *Dits. Aphorismes réunis par Poupard-Lieussou.* Paris: Le Terrain Vague, 1960.
See also bibl. 32, 57, 74.

172 BUFFET-PICABIA, GABRIELLE. "Picabia, l'inventeur," *L'Œil* (Paris), June 1956, pp. 30–35, 46–47.

173 CAMFIELD, WILLIAM. "The Machinist Style of Francis Picabia," *Art Bulletin* (New York), September-December 1966, pp. 309–22.
HUNT, RONALD. See bibl. 18.

174 PEARLSTEIN, PHILIP. "The Symbolic Language of Francis Picabia," *Arts* (New York), January 1956, pp. 37–43.

175 SANOUILLET, MICHEL. *Picabia.* Paris: Les Editions du Temps, 1964.
Contains bibliography by Poupard-Lieussou; chronology.

176 NEWCASTLE. UNIVERSITY OF NEWCASTLE UPON TYNE, HATTON GALLERY. *Francis Picabia.* March 1964.
Introduction by Ronald Hunt. – Exhibition also shown at London, Institute of Contemporary Arts, April 1964.

PICASSO, Pablo

177 *Desire Caught by the Tail.* New York: Citadel Press, 1962.
Translated from the French by Bernard Frechtman. Originally published Paris: Gallimard, 1945.

178 BARR, ALFRED. H., JR. *Picasso: 50 Years of His Art.* New York: The Museum of Modern Art, 1946.
Bibliography by Dorothy Simmons.

179 BOECK, WILHELM and SABARTÉS, JAIME. *Picasso.* New York: Harry N. Abrams, 1955.

180 PENROSE, ROLAND. *Picasso: His Life and Work.* New York: Harper & Row, 1958.

181 ROSENBLUM, ROBERT. "Picasso as a Surrealist," in ART GALLERY OF TORONTO. *Picasso and Man.* 1964.
Reprinted in bibl. 18.

182 NEW YORK. THE MUSEUM OF MODERN ART. *The Sculpture of Picasso.* 1967.
Essay by Roland Penrose; chronology by Alicia Legg; bibliography. – Published on the occasion of an exhibition at the Museum, October 9, 1967–January 1, 1968.

SCHWITTERS, Kurt

183 *Memoiren Anna Blumes in Bleie.* Freiburg: Walter Heinrich, 1922.
See also bibl. 66, 187.

184 SCHMALENBACH, WERNER. *Kurt Schwitters.* Cologne: Verlag DuMont Schauberg, 1967.

185 STEINITZ, KATE. *Kurt Schwitters: A Portrait from Life.* Berkeley and Los Angeles: University of California Press, [1968].

186 THEMERSON, STEFAN. *Kurt Schwitters in England*. London: Gaberbocchus Press, 1958.

187 LONDON. MARLBOROUGH FINE ART LIMITED. *Schwitters*. March–April 1963.
 Includes Ernst Schwitters, "One Never Knows"; statements by the artist; biographical notes by Hans Bolliger.

188 NEW YORK. MARLBOROUGH-GERSON. *Kurt Schwitters*. May–June 1965.
 Texts by Werner Schmalenbach and Kate Steinitz; biographical notes by Hans Bolliger.

SELIGMANN, Kurt. See bibl. 48.

TANGUY, Yves
 See bibl. 48.

189 BRETON, ANDRÉ. *Yves Tanguy*. New York: Pierre Matisse, 1946.
 Text in French and English; English translation by Bravig Imbs.

190 TANGUY, KAY SAGE, ed. *Yves Tanguy: A Summary of His Works*. New York: Pierre Matisse, 1963.
 Includes an illustrated bibliography by Poupard-Lieussou and Bernard Karpel.

191 NEW YORK. THE MUSEUM OF MODERN ART. *Yves Tanguy*. 1955.
 Text by James Thrall Soby; bibliography. – Published on the occasion of an exhibition at the Museum, September 7–October 30, 1955.
 See also bibl. 83.

VI AFTER DADA AND SURREALISM

192 ALLOWAY, LAWRENCE. "The Biomorphic Forties," *Artforum* (Los Angeles), September 1965, pp. 18–22.
 See also bibl. 198.

193 *Artforum* (Los Angeles), September 1965.
 Special issue on the New York School.

194 GOOSSEN, EUGENE C. "The Philosophic Line of Barnett Newman," *Art News* (New York), June 1957, pp. 30–31.

195 KAPROW, ALLAN. *Assemblage, Environments & Happenings*. New York: Harry N. Abrams, 1966.

196 KIRBY, MICHAEL. *Happenings*. New York: Dutton, 1965.
 An illustrated anthology.

197 LIPPARD, LUCY R. "Eccentric Abstraction," *Art International* (Zurich), November 1966, pp. 28, 34–40.

198 ———. *Pop Art*. New York: Praeger, 1966.
 With contributions by Lawrence Alloway, Nancy Marmer, and Nicolas Calas.

199 MEYERS, J. B. "The Impact of Surrealism on the New York School," *Evergreen Review* (New York), March-April 1960, pp. 75–85.

200 RUBIN, WILLIAM. "Adolph Gottlieb," *Art International* (Zurich), no. 3-4, 1959, pp. 34–37.

201 ———. "Jackson Pollock and the Modern Tradition, III. Cubism and the Later Evolution of the All-Over Style," *Artforum* (Los Angeles), April 1967, pp. 18–31.

202 [SIMON, SIDNEY]. "Concerning the Beginnings of the New York School: 1939–1943. An Interview with Peter Busa and Matta, Conducted by Sidney Simon in Minneapolis in December 1966," *Art International* (Zurich), Summer 1967, pp. 17–20.

203 ———. "Concerning the Beginnings of the New York School: 1939–1943. An Interview with Robert Motherwell, Conducted by Sidney Simon in New York in January 1967," *ibid.*, pp. 20–23.

204 SOBY, JAMES THRALL. "Some Younger American Painters," *Contemporary Painting*. New York: The Museum of Modern Art, 1948, pp. 69–84.

205 NEW YORK. THE MUSEUM OF MODERN ART. *New Images of Man*. 1959.
 Edited by Peter Selz. – Published on the occasion of an exhibition at the Museum, September 9–November 29, 1959. Also shown: Baltimore Museum of Art, January 9–February 7, 1960.

206 NEW YORK. THE MUSEUM OF MODERN ART. *The Art of Assemblage*. 1961.
 By William C. Seitz. – Published on the occasion of an exhibition at the Museum, October 2–November 12, 1961. Also shown: Dallas Museum of Contemporary Arts, January 9–February 11, 1962; San Francisco Museum of Art, March 5–April 15.

Catalogue of the Exhibition

Dimensions are given in feet and inches, height preceding width. A date is enclosed in parentheses when it does not appear on the work of art. The notation (NY), (LA), or (C) indicates that the respective works will be shown only in New York, Los Angeles, or Chicago.

ADAMI, Valerio. Italian, born Bologna, 1935; lives in Milan

1 *Henri Matisse Painting the Model.* (1966). Synthetic polymer paint on canvas, 35¹/8 × 45⁵/8 inches. Collection Professor Alik Cavaliere, Milan. *Ill. p. 184*

ARMAN (Fernandez). French, born Nice, 1928; lives in Nice and New York

2 *Fortune Smiles on the Daring Ones.* (1962). Threads in wooden box, 40⁵/8 × 31¹/8 inches. Collection Dr. R. Matthys-Colle, Ghent, Belgium. *Ill. p. 149*

3 *Cold Petting.* (1967). Polyester resin and mannequin hands, 35 inches high × 14³/8 inches wide × 9⁵/8 inches deep. Sidney Janis Gallery, New York

ARNESON, Robert. American, born Benicia, California, 1930; lives in Davis, California

4 *Typewriter.* (1965). Painted and glazed ceramic, 12 inches wide × 10 inches deep. Allan Stone Gallery, New York. *Ill. p. 185*

ARP, Jean (Hans). French, born Strasbourg, 1887; died Basel, 1966

5 *Automatic Drawing.* 1916. Brush and ink on gray paper, 16³/4 × 21¹/4 inches. The Museum of Modern Art, New York, Given anonymously. (NY). *Ill. p. 40*

6 *Portrait of Tzara.* (1916). Painted wood relief, 19¹/2 × 18¹/2 inches. Estate of the artist. *Ill. p. 39*

7 *Collage with Squares Arranged According to the Laws of Chance.* (c. 1917). Collage of colored papers, 12³/4 × 10⁵/8 inches. Collection P. G. Bruguière, Issy-les-Moulineaux, France. *Ill. p. 41*

8 *Enak's Tears (Terrestrial Forms).* (1917). Painted wood relief, 33¹/2 × 23⁵/8 inches. Collection F. C. Graindorge, Liège. *Ill. p. 39*

9 *Egg Board.* (1922). Painted wood relief, 29³/4 × 39¹/8 inches. Collection F. C. Graindorge, Liège. *Ill. p. 40*

10 *Stabile Head.* (1926). Painted wood, 24 inches high. Collection P. Janlet, Brussels. *Ill. p. 120*

11 *Drunken Egg Holder.* (1928). String and oil on canvas, 26 × 21⁵/8 inches. Collection Mme M. Arp-Hagenbach, Basel. *Ill. p. 121*

12 *Bell and Navels.* (1931). Painted wood, 10 inches high × 19⁵/8 inches diameter at base. Estate of the artist. *Ill. p. 120*

13 *Relief After Torn Papers.* (1933). Painted plaster, 10¹/4 × 17³/8 inches. Private collection

14 *Human Concretion on a Round Base.* (1935). Bronze, 24³/8 inches high × 28³/8 inches wide × 21¹/4 inches deep. Private collection. *Ill. p. 121*

15 *According to the Laws of Chance (Periods and Commas).* (1943). Painted wood relief, 43¹/4 × 55¹/8 inches. Kunstmuseum, Basel, Depositum der Emanuel Hoffmann-Stiftung

16 *Human Lunar Spectral.* (1950). Marble, 36⁵/8 inches high. Collection Mr. and Mrs. Nathan Cummings, New York. (NY). *Ill. p. 122*

17 *Ptolemy.* (1953). Bronze, 40¹/2 inches high × 20⁷/8 inches wide × 16⁷/8 inches deep. Collection Mr. and Mrs. William Mazer, New York. *Ill. p. 122*

ARTAUD, Antonin. French, born Marseilles, 1896; died Paris, 1948

18 *Minotaur.* (1946). Colored pencil, 25³/8 × 19³/4 inches. Collection Dr. and Mrs. M. Zara, Paris

BAADER, Johannes. German, born Stuttgart, 1876; died in Bavaria, 1955

19 *The Author in His Home.* (c. 1920). Collage of pasted photographs on book page, 8½ × 5¾ inches. The Museum of Modern Art, New York, Abby Aldrich Rockefeller Fund

20 *Collage a.* (1920–1922). Collage of pasted papers, 13⅞ × 19⅞ inches. Musée National d'Art Moderne, Paris. *Ill. p. 44*

BAARGELD (Alfred Grünewald). German, born Cologne; died in the Tirol, 1927

21 *The Human Eye and a Fish, the Latter Petrified.* 1920. Pen and ink with collage, 12¼ × 9⅜ inches. The Museum of Modern Art, New York, Purchase. *Ill. p. 49*

22 *The Red King.* 1920. Pen and ink on wallpaper, 19⅜ × 15¼ inches. The Museum of Modern Art, New York, Purchase

BAZIOTES, William. American, born Pittsburgh, 1912; died New York, 1963

23 *Mirror Figure.* (1948). Oil on canvas, 30 × 24 inches. Collection Mr. and Mrs. Gordon B. Washburn, New York

BELLMER, Hans. German, born Katowice, Poland, 1902; lives in Paris

24 *La Poupée.* (1936). Wood, metal, and papier-mâché, 70⅞ inches long. Private collection. *Ill p. 150*

25 *La Poupée.* (1936, cast 1965). Painted aluminum, 17 × 8⅝ inches. Galerie F. Petit, Paris

26 *The Machine-Gunneress.* (1937). Wood, metal, and papier-mâché, 23⅝ inches high. Private collection. *Ill. p. 151*

BIASI, Guido. Italian, born Naples, 1933; lives in Paris

27 *Magic Cupboard.* (1961). Painted wood construction, 22⅛ × 17¾ inches. Collection Richard Dreyfus, Basel

BLUHM, Norman. American, born Chicago, 1920; lives in New York

28 *It's Raining* (poem by Frank O'Hara). (1960). Gouache and ink, 48 × 40 inches. Private collection. *Ill. p. 99*

BRAUNER, Victor. Romanian, born Piatra-Neamt, 1903; died Paris, 1966

29 *Gemini.* 1938. Oil on canvas, 18 × 21⅜ inches. Collection Mr. and Mrs. Julien Levy, Bridgewater, Connecticut. *Ill. p. 136*

30 *Object Which Dreams.* 1938. Oil on canvas, 31 × 25 inches. Collection Mr. and Mrs. Joseph R. Shapiro, Oak Park, Illinois. *Ill. p. 136*

31 *Talisman.* 1943. Wax on wood, 6⅜ × 10⅞ inches. The Museum of Modern Art, New York, the Sidney and Harriet Janis Collection. (NY). *Ill. p. 136*

32 *Prelude to a Civilization.* 1954. Encaustic, 51¼ × 76¾ inches. Collection Mr. and Mrs. Jacques Gelman, Mexico City. *Ill. p. 137*

BRETON, André. French, born Tinchebray (Orne), 1896; died Paris, 1966

33 *Decalcomania.* (1936). Gouache, 10 × 13 inches. Collection Marcel Jean, Paris

34 *For Jacqueline.* 1937. Collage of pasted paper, metal, ribbon, and a leaf, 15½ × 12 inches. Collection Mr. and Mrs. E. A. Bergman, Chicago. *Ill. p. 100*

CALDER, Alexander. American, born Philadelphia, 1898; lives in Saché (Indre-et-Loire), France, and Roxbury, Connecticut

35 *Eiffel Tower.* (1943). Painted metal and wire, 40 inches high × 17 inches wide × 65 inches deep. Collection Mr. and Mrs. Jennings Lang, Beverly Hills, California

CARTER, Clarence. American, born Portsmouth, Ohio, 1904; lives in Milford, New Jersey

36 *Borne in Triumph.* 1965. Synthetic polymer paint on canvas, 44 × 44 inches. New Jersey State Museum, Trenton. *Ill. p. 186*

de CHIRICO, Giorgio. Italian, born Volo, Greece, 1888; lives in Rome

37 *Gare Montparnasse (The Melancholy of Departure).* 1914. Oil on canvas, 55⅛ × 72⅝ inches. Collection James Thrall Soby, New Canaan, Connecticut. (NY). *Ill. p. 76*

38 *The Mystery and Melancholy of a Street.* 1914. Oil on canvas, 34¼ × 28⅛ inches. Private collection. *Ill. p. 78*

39 *The Philosopher's Conquest.* (1914). Oil on canvas, 49½ × 39¼ inches. The Art Institute of Chicago, the Joseph Winterbotham Collection. *Ill. p. 78*

40 *The Song of Love.* (1914). Oil on canvas, 28¾ × 23½ inches. Private collection. *Ill. p. 77*

41 *The Span of Black Ladders.* (1914). Oil on canvas, 24¼ × 18⅝ inches. Collection Mr. and Mrs. James W. Alsdorf, Winnetka, Illinois. *Ill. p. 77*

42 *The Double Dream of Spring.* 1915. Oil on canvas, 22⅛ × 21⅜ inches. The Museum of Modern Art, New York, Gift of James Thrall Soby. *Ill. p. 79*

43 *The Jewish Angel.* 1916. Oil on canvas, 26½ × 17¼ inches. Penrose Collection, London. *Ill. p. 81*

44 *Grand Metaphysical Interior.* 1917. Oil on canvas, 37¾ × 27¾ inches. Collection James Thrall Soby, New Canaan, Connecticut. (NY). *Ill. p. 81*

CHRISTO (Javacheff). Bulgarian, born Gabrovo, 1935; lives in New York

45 *Package on Wheelbarrow.* 1963. Cloth, rope, wood, and metal, 35 inches high × 60 inches long × 23 inches wide. Collection the artist, New York. *Ill. p. 32*

46 *Lower Manhattan Packed Buildings.* 1964–1966. Collage of photographs and pasted paper, 20½ × 29½ inches. Collection Mr. and Mrs. Horace H. Solomon, New York. *Ill. p. 33*

CITROEN, Paul. Dutch, born Berlin, 1896; lives in Amsterdam

47 *Metropolis.* (1923). Collage of photographs, prints, and post cards, 30 × 23 inches. Prentenkabinet, Rijksuniversiteit, Leiden, The Netherlands. (NY). *Ill. p. 45*

COHEN, George. American, born Chicago, 1919; lives in Evanston, Illinois

48 *Hermes.* (1957). Oil, cloth, and sandpaper on canvas, 46 × 36 inches. Collection Mr. and Mrs. Joseph R. Shapiro, Oak Park, Illinois. *Ill. p. 182*

COPLEY, William N. American, born New York, 1919; lives in New York

49 *Il Est Minuit Docteur.* 1961. Oil on canvas, 32 × 25½ inches. Collection the artist, New York. *Ill. p. 186*

CORNELL, Joseph. American, born New York, 1903; lives in Flushing, New York

50 Untitled *(Schooner).* 1931. Collage, 4½ × 5¾ inches. Private collection, Courtesy Pasadena Art Museum, California. *Ill. p. 148*

51 Untitled. Undated. Construction with iron rod, string, rubber ball, and leather-covered book on wooden base, 18¼ inches high × 11¾ inches wide × 8½ inches deep. Private collection. *Ill. p. 148*

52 *Egypt.* Undated. Cardboard box with pasted papers, and rolls of paper tied with thread, 2 inches high × 4¼ inches diameter. Private collection

53 *A Pantry Ballet for Jacques Offenbach.* 1942. Construction in paper, plastic, and wood, 10½ inches high × 18 inches wide × 6 inches deep. Collection Mr. and Mrs. Richard L. Feigen, New York. (NY). *Ill. p. 149*

54 *Mémoires de Madame la Marquise de la Rochejaquelein.* 1943. Cardboard box with pasted papers, sand, glass, and rhinestones, 2 inches high × 4¼ inches diameter. Private collection. *Ill. p. 148*

55 *Pharmacy.* (1943). Construction in wood and glass, 15¼ inches high × 12 inches wide × 3⅛ inches deep. Collection Mrs. Marcel Duchamp, New York. (NY). *Ill. p. 149*

56 *1909.* Undated. Collage with coin and stamp, oil and pencil on composition board, 12 × 9 inches. Private collection

DALI, Salvador. Spanish, born Figueiras, 1904; lives in Cadaqués and New York

57 *Senicitas.* 1928. Oil on wood, 25¼ × 18⅞ inches. Private collection. *Ill. p. 108*

58 *Accommodations of Desire.* 1929. Oil on wood, 8⅝ × 13¾ inches. Julien Levy Gallery, Inc., Bridgewater, Connecticut. *Ill. p. 109*

59 *The Great Masturbator.* 1929. Oil on canvas, 43⅜ × 59¼ inches. Private collection. *Ill. p. 110*

60 *Illumined Pleasures.* (1929). Oil on composition board with collage, 9³/₈ × 13³/₄ inches. The Museum of Modern Art, New York, the Sidney and Harriet Janis Collection. (NY). *Ill. p. 109*

61 *Imperial Monument to the Child-Woman* (unfinished). (c. 1929). Oil on canvas, 56 × 32 inches. Private collection. *Ill. p. 112*

62 *The Lugubrious Game.* 1929. Oil on wood with collage, 18¹/₈ × 15 inches. Private collection. (NY). *Ill. p. 108*

63 *The Invisible Man.* (1929–1933). Oil on canvas, 54⁷/₈ × 31 inches. Private collection. *Ill. p. 112*

64 *The Persistence of Memory.* 1931. Oil on canvas, 9¹/₂ × 13 inches. The Museum of Modern Art, New York, Given anonymously. (LA, C). *Ill. p. 111*

65 *The Specter of Sex Appeal.* 1934. Oil on wood, 7 × 5¹/₂ inches. Private collection. *Ill. p. 113*

66 *Six Objects* (all that is left of a tray of objects). (1936). Erotic group, 2³/₄ × 2³/₈ inches; paperweight, 3¹/₂ inches diameter; stone foot, 9¹/₈ inches long; foil-covered gloves, 7¹/₈ inches long; plaster foot, 10⁵/₈ inches long; cardboard matchbook, 2 inches long. Collection Charles Ratton, Paris. *Ill. of original work p. 143*

67 *The Venus de Milo of the Drawers.* (1936). Painted bronze, 39³/₈ inches high. Galerie du Dragon, Paris. *Ill. p. 145*

DELVAUX, Paul. Belgian, born Antheit, 1897; lives in Brussels

68 *Pygmalion.* 1939. Oil on wood, 53¹/₈ × 65 inches. Yannick Bruynoghe-Galerie Maya, Brussels. *Ill. p. 138*

69 *Hands.* 1941. Oil on canvas, 43¹/₄ × 51¹/₄ inches. Collection Richard S. Zeisler, New York. *Ill. p. 138*

70 *Le Train Bleu.* 1946. Oil on canvas, 48 × 96¹/₈ inches. Collection Joachim Jean Aberbach, Sands Point, New York. *Ill. p. 138*

DIX, Otto. German, born Unterhaus (near Gera), 1891; lives in Boden See

71 *Dada Self-Portrait.* (1920). Chinese ink on cardboard, 9⁵/₈ × 12¹/₈ inches. Collection Adolf Dörries, Braunschweig, Germany

DOMINGUEZ, Oscar. Spanish, born Tenerife (Canary Islands), 1906; died Paris, 1957

72 *Conversion of Energy (Le Tireur).* (1935). Painted plaster, objects, and glass, 18⁷/₈ × 12¹/₄ inches. Collection Charles Ratton, Paris. *Ill. p. 146*

73 *Ouverture.* (1936). Zinc, with sardine can keys and alarm clock, 6 inches high × 10¹/₂ inches wide × 6¹/₂ inches deep. Collection Marcel Jean, Paris

74 *Decalcomania.* (1937). Gouache, 6¹/₈ × 8⁵/₈ inches. The Museum of Modern Art, New York, Given anonymously. *Ill. p. 139*

DUBUFFET, Jean. French, born Le Havre, 1901; lives in Paris

75 *The Magician.* 1954. Slag and roots, 43¹/₂ inches high. Collection N. Richard Miller, Philadelphia. (NY)

DUCHAMP, Marcel. American, born Blainville (Seine-Maritime), France, 1887; lives in New York

76 *The Bride.* 1912. Oil on canvas, 35¹/₈ × 21³/₄ inches. Philadelphia Museum of Art, the Louise and Walter Arensberg Collection. (NY, C). *Ill. p. 14*

77 *The Passage from Virgin to Bride.* 1912. Oil on canvas, 23³/₈ × 21¹/₄ inches. The Museum of Modern Art, New York, Purchase. *Ill. p. 13*

78 *Bicycle Wheel.* (Original 1913, lost; replica 1964). Bicycle wheel on wooden stool, 49⁷/₈ inches high. Galleria Schwarz, Milan. *Ill. of different replica p. 15*

79 *Chocolate Grinder, No. 1.* 1913. Oil on canvas, 24³/₄ × 25⁵/₈ inches. Philadelphia Museum of Art, the Louise and Walter Arensberg Collection. (NY, C). *Ill. p. 14*

80 *Bottlerack.* (Original 1914, lost; replica 1964). Galvanized iron, 25 inches high × 17 inches diameter. Galleria Schwarz, Milan. *Ill. of original p. 16*

81 *Nine Malic Molds.* (1914–1915). Oil, lead wire, and foil on glass, 26 × 41 inches. Collection Mrs. Marcel Duchamp, New York. (NY). *Ill. p. 20*

82 *The Bride Stripped Bare by Her Bachelors, Even* (the *Large Glass*). (Original 1915–1923; replica 1966). Oil, lead wire, and foil, dust and varnish on glass, 8 feet 11 inches × 5 feet 7 inches. Private collection. *Ill. of original p. 18*

83 *Traveler's Folding Item.* (1917; replica 1964). Typewriter cover, 9 inches high × 17 inches wide × 12 inches deep. Galleria Schwarz, Milan

84 *Tu m'.* 1918. Oil and graphite on canvas, with bottle-washing brush, safety pins, nut and bolt, 27½ inches × 10 feet 2¾ inches. Yale University Art Gallery, New Haven, Bequest of Katherine S. Dreier. (NY). *Ill. p. 20*

85 *Fresh Widow.* 1920. Miniature French window, wood frame and eight panes of glass covered with leather, 30½ × 17⅝ inches. The Museum of Modern Art, New York, Katherine S. Dreier Bequest. (NY)

86 *Rotary Glass Plate (Precision Optics).* (1920). Motorized construction; painted glass and metal, 73 inches high × 48 inches wide × 40 inches deep. Yale University Art Gallery, New Haven, Collection Société Anonyme. (NY). *Ill. p. 21*

87 *Why Not Sneeze?* (Original 1921; replica 1964). Painted metal cage, marble cubes, thermometer, and cuttlebone, 4⅞ inches high × 8¾ inches wide × 6⅜ inches deep. Galleria Schwarz, Milan. *Ill. of different replica p. 16*

88 *Rotoreliefs (Optical Disks).* (1935). Six cardboard disks printed on both sides, each 7⅞ inches diameter. Private collection. *Ill. of one disk from a different set p. 21*

ERNST, Max. French, born Brühl (near Cologne), Germany, 1891; lives in Huismes (Indre-et-Loire), France

89 *Bird.* (c. 1916–1920). Wood, 40⅛ inches high × 8¼ inches wide × 11⅞ inches deep. Private collection. *Ill. p. 49*

90 *Fruit of a Long Experience.* 1919. Painted wood and metal, 18 × 15 inches. Penrose Collection, London. *Ill. p. 48*

91 *Démonstration Hydrométrique à Tuer par la Température.* (1920). Collage of pasted papers, 9½ × 6¾ inches. Galerie Jacques Tronche, Paris. *Ill. p. 50*

92 *Stratified Rocks.* (1920). Anatomical engraving altered with gouache and pencil, 6 × 8⅛ inches. The Museum of Modern Art, New York, Purchase. *Ill. p. 51*

93 *The Elephant Celebes.* 1921. Oil on canvas, 49¼ × 42 inches. Penrose Collection, London. *Ill. p. 84*

94 *Free Balloon.* (c. 1922). Painted tile, 14¼ × 9⅞ inches. Private collection. *Ill. p. 85*

95 *Who Is That Very Sick Man.* (1924). Oil on canvas, 25⅝ × 19¾ inches. Collection Mr. and Mrs. Lennart G. Erickson, Hillsborough, California. (NY). *Ill. p. 97*

96 *The Ego and His Own.* 1925. Pencil frottage, 10¼ × 7⅞ inches. Collection Arman, Nice. *Ill. p. 86*

97 *Stallion.* (c. 1925). Pencil frottage, 12 × 10 inches. Collection Mr. and Mrs. Joseph R. Shapiro, Oak Park, Illinois. *Ill. p. 86*

98 *To 100,000 Doves.* (1925). Oil on canvas, 32 × 39½ inches. Collection Mme Simone Collinet, Paris. *Ill. p. 87*

99 *Blue and Rose Doves.* (1926). Oil on canvas, 31⅞ × 39⅜ inches. Kunstmuseum, Düsseldorf. (NY). *Ill. p. 87*

100 *Forest.* (1927). Oil on canvas, 44⅞ × 57½ inches. Collection Mr. and Mrs. Joseph Slifka, New York. (LA, C). *Ill. p. 88*

101 *Snow Flowers.* (1927). Oil on canvas, 51⅝ × 51⅝ inches. Collection F. C. Graindorge, Liège. *Ill. p. 88*

102 *Chaste Joseph.* 1928. Oil on canvas, 63 × 51¼ inches. Collection A. D. Mouradian, Paris. *Ill. p. 89*

103 *Loplop Introduces Members of the Surrealist Group.* (1930). Collage of pasted photographs and pencil, 19¾ × 13¼ inches. The Museum of Modern Art, New York, Purchase. *Ill. p. 106*

104 *Loplop Introduces.* 1932. Pasted papers, watercolor, pencil frottage, and photograph, 19⅝ × 25⅜ inches. Collection Mr. and Mrs. E. A. Bergman, Chicago. *Ill. p. 131*

105 *The Blind Swimmer.* 1934. Oil on canvas, 36¼ × 28⅞ inches. Private collection. *Ill. p. 130*

106 Untitled. (1934). Painted stone, 5¾ inches long. Private collection. *Ill. p. 123*

107 *Landscape with Tactile Effects.* (1934–1935). Oil on canvas, 39⅜ × 33½ inches. Collection Mr. and Mrs. James Johnson Sweeney, Houston. (NY). *Ill. p. 129*

108 *Woman Bird.* (1934–1935). Bronze, 20¾ inches high. Allan Frumkin Gallery, New York. *Ill. p. 123*

109 *Landscape with Grain of Wheat.* (1935). Oil on canvas, 25⅝ × 31⅞ inches. Collection Mr. and Mrs. Joseph Slifka, New York. (LA, C)

110 *Europe After the Rain*. 1940–1942. Oil on canvas, 21⁵/₈ × 58¹/₄ inches. Wadsworth Atheneum, Hartford, the Ella Gallup Sumner and Mary Catlin Sumner Collection. *Ill. p. 161*

111 Study for *Surrealism and Painting*. 1942. Ink, 24³/₄ × 19³/₈ inches. Private collection. *Ill. p. 141*

112 *Vox Angelica*. 1943. Oil on canvas, 60¹/₈ × 80¹/₈ inches. Collection Mr. and Mrs. Julien Levy, Bridgewater, Connecticut. *Ill. p. 161*

113 *The Table Is Set*. (1944). Bronze, 11³/₄ inches high × 21¹/₂ inches wide × 21¹/₂ inches deep. Collection D. and J. de Menil, Houston. *Ill. p. 123*

114 *A Microbe Seen Through a Temperament*. (1964). Wood and metal, 9 feet 1¹/₄ inches high. Alexander Iolas Gallery, New York

EVOLA, Julius. Italian, born Rome, 1898; lives in Rome

115 *Dada Landscape*. (1920–1921). Oil on canvas, 38¹/₄ × 29⁷/₈ inches. Collection Arturo Schwarz, Milan

EXQUISITE CORPSES (*Cadavres Exquis*)

116 André Breton, Yves Tanguy, Max Morise, Marcel Duhamel. (1926). Colored pencil, 10⁵/₈ × 8¹/₄ inches. Collection F. C. Graindorge, Liège

117 Man Ray, Yves Tanguy, Joan Miró, Max Morise. (1928). Pen and ink and crayon, 13³/₈ × 8¹/₂ inches. Collection Mr. and Mrs. E. A. Bergman, Chicago. *Ill. p. 83*

118 Esteban Francés, Remedios Lissarraga, Oscar Dominguez, Marcel Jean. (1935). Collage of pasted papers, 10¹/₂ × 8 inches. Collection Marcel Jean, Paris. *Ill. p. 83*

FERBER, Herbert. American, born New York, 1906; lives in New York

119 *He Is Not a Man*. (1950). Lead and brass, 72 inches high. Collection Mark Rothko, New York. *Ill. p. 179*

FRANCÉS, Esteban. American, born Port-Bou, Spain, 1914; lives in New York and Mallorca

120 *War*. (1946). Gouache, 18¹/₂ × 24¹/₂ inches. Collection Harry Torczyner, New York

GIACOMETTI, Alberto. Swiss, born Stampa, 1901; died Chur, 1966

121 *The Couple*. (1926). Bronze, 23¹/₂ inches high. Collection Mr. and Mrs. Joseph Slifka, New York

122 *Man and Woman*. (1928–1929). Bronze, 18¹/₈ × 15³/₄ inches. Collection Mme Henriette Gomès, Paris. *Ill. p. 114*

123 *Reclining Woman Who Dreams*. (1929). Painted bronze, 9³/₈ inches high × 16⁵/₈ inches long × 5⁵/₈ inches deep. Joseph H. Hirshhorn Collection, New York

124 *Three Personages Outdoors*. 1930. Bronze, 20¹/₄ × 15 inches. Collection Mrs. Rosalie Thorne McKenna, Stonington, Connecticut. *Ill. p. 115*

125 *Cage*. (1931). Wood, 19¹/₄ × 10⁵/₈ inches. Moderna Museet, Stockholm. *Ill. p. 116*

126 *Man, Woman, and Child*. (1931). Wood and metal, 3⁵/₈ inches high × 13³/₄ inches wide × 9⁷/₈ inches deep. Collection Mme M. Arp-Hagenbach, Basel. *Ill. p. 117*

127 *Caught Hand*. (1932). Wood and metal, 23 inches long. Kunsthaus, Zurich. *Ill. p. 147*

128 *No More Play*. (1932). Marble with wood and bronze, 23¹/₄ inches wide × 17³/₄ inches deep. Collection Mr. and Mrs. Julien Levy, Bridgewater, Connecticut. *Ill. p. 118*

129 *Woman with Her Throat Cut*. 1932. Bronze, 34¹/₂ inches long. The Museum of Modern Art, New York, Purchase. *Ill. p. 118*

130 *The Palace at 4 A.M.* (1932–1933). Construction in wood, glass, wire, and string, 25 inches high × 28¹/₄ inches wide × 15³/₄ inches deep. The Museum of Modern Art, New York, Purchase. (NY). *Ill. p. 119*

131 *The Invisible Object*. (1934–1935). Bronze, 61 inches high. City Art Museum of Saint Louis. (C); Collection Mrs. Bertram Smith, New York. (NY). *Ill. p. 118*

GIACOMETTI, Augusto. Swiss, born Stampa, 1877; died Zurich, 1947

132 *Summer Night*. 1917. Oil on canvas, 26¹/₂ × 25⁵/₈ inches. The Museum of Modern Art, New York

133 *Painting*. 1920. Oil on canvas, 41³/₈ × 41³/₈ inches. Collection Dr. G. Schaufelberger, Würenlos, Switzerland. *Ill. p. 38*

GORKY, Arshile. American, born Khorkom Vari Haiyotz Dzor, Armenia, 1904; died Sherman, Connecticut, 1948

134 *Drawing*. 1943. Pencil and crayon, 18¹/₂ × 23¹/₂ inches. Collection Mr. and Mrs. Seymour Propp, New York. (NY, LA)

135 *Landscape*. 1943. Pencil and crayon, 20¹/₄ × 27³/₈ inches. Collection Mr. and Mrs. Walter Bareiss, Munich. *Ill. p. 173*

136 *The Leaf of the Artichoke Is an Owl*. 1944. Oil on canvas, 28 × 36 inches. Collection Mrs. Ethel K. Schwabacher, New York. *Ill. p. 174*

137 *The Liver Is the Cock's Comb*. 1944. Oil on canvas, 6 feet 1 inch × 8 feet 2¹/₂ inches. Albright-Knox Art Gallery, Buffalo. (NY, C). *Ill. p. 172*

138 *One Year the Milkweed*. 1944. Oil on canvas, 37 × 47¹/₄ inches. Collection Mrs. Agnes Gorky Phillips, London. *Ill. p. 174*

139 *The Diary of a Seducer*. 1945. Oil on canvas, 50 × 62 inches. Collection Mr. and Mrs. William A. M. Burden, New York. (NY). *Ill. p. 175*

140 *The Betrothal II*. 1947. Oil on canvas, 50³/₄ × 38 inches. Whitney Museum of American Art, New York. *Ill. p. 175*

141 *Soft Night*. 1947. Oil on canvas, 38 × 50 inches. Collection Mrs. John C. Franklin, Greenwich, Connecticut. *Ill. p. 172*

GOTTLIEB, Adolph. American, born New York, 1903; lives in New York

142 *The Rape of Persephone*. (c. 1940–1941). Oil on canvas, 32 × 25 inches. Collection Mrs. Annalee Newman, New York

GROSZ, George. American, born Berlin, 1893; died Berlin, 1959

143 *Fit for Active Service*. (1916–1917). Pen and brush and India ink, 20 × 14³/₈ inches. The Museum of Modern Art, New York, Purchase. *Ill. p. 46*

144 *Oppositions*. (c. 1917). Chinese ink on vellum, 23¹/₄ × 18¹/₄ inches. Graphische Sammlung, Staatsgalerie, Stuttgart

145 *The Little Woman-Slayer*. 1918. Oil on canvas, 26 × 26 inches. Collection Mr. and Mrs. Richard L. Feigen, New York

146 *Remember Uncle August, the Unhappy Inventor*. (1919). Oil on canvas, with cut-and-pasted magazine advertisements and buttons, 19¹/₄ × 15⁵/₈ inches. Collection Mr. and Mrs. Bernard J. Reis, New York. *Ill. p. 46*

147 Untitled. 1919. Watercolor, 19¹/₄ × 13⁵/₈ inches. Collection Mr. and Mrs. Richard L. Feigen, New York. *Ill. p. 46*

HARE, David. American, born New York, 1917; lives in New York

148 *Magician's Game*. (1944). Bronze, 43 inches high × 33 inches long. Collection the artist, New York. *Ill. p. 179*

HAUSMANN, Raoul. Austrian, born Vienna, 1886; lives in Limoges, France

149 *Tatlin at Home*. 1920. Collage of pasted papers and gouache, 16¹/₈ × 11 inches. Moderna Museet, Stockholm. *Ill. p. 42*

HÖCH, Hannah. German, born Gotha, 1889; lives in Berlin

150 *Cut with the Kitchen Knife*. (1919). Collage of pasted papers, 44⁷/₈ × 35¹/₂ inches. Nationalgalerie, Staatliche Museen, Berlin. *Ill. p. 43*

151 *High Finance*. 1923. Collage of pasted papers, 14¹/₈ × 12¹/₄ inches. Collection Robert Hughes, London

JANCO, Marcel. Israeli, born Bucharest, 1895; lives in Tel Aviv

152 *Wood Relief*. 1917. Wood (after a plaster original entitled *White on White*), 32⁵/₈ × 26 inches. Private collection. *Ill. p. 37*

153 *Mask*. (1919). Paper, cardboard, twine, gouache, and pastel, 17³/₄ × 8⁵/₈ inches. Musée National d'Art Moderne, Paris. *Ill. p. 37*

JEAN, Marcel. French, born La Charité-sur-Loire, 1900; lives in Paris

154 *Decalcomania*. 1936. Gouache, 19¹/₂ × 13 inches. Collection the artist, Paris

155 *Flottage* (poem by Jean Arp). 1936. Gouache, 19 × 25¹/₂ inches. Collection the artist, Paris

156 *Specter of the Gardenia.* 1936. Plaster covered with cloth, zippers, and strip of film, 10¹/₂ inches high. Collection the artist, Paris

157 *Horoscope.* (1937). Painted dressmaker's dummy with plaster ornaments and watch, 28 inches high. Collection the artist, Paris. *Ill. p. 144*

JENKINS, Paul. American, born Kansas City, Missouri, 1923; lives in New York and Paris

158 *Baptiste.* 1954. Oil on canvas, 36 × 29 inches. Collection Mrs. Ruth Moskin Fineshriber, New York

JOHNS, Jasper. American, born Allendale, South Carolina, 1930; lives in New York

159 *Target with Four Faces.* (1955). Encaustic on newspaper over canvas, surmounted by four plaster casts, 29³/₄ inches high × 26 inches wide × 3¹/₂ inches deep. The Museum of Modern Art, New York, Gift of Mr. and Mrs. Robert C. Scull. (LA, C)

160 *Target with Plaster Casts.* 1955. Encaustic and collage on canvas with plaster casts, 51 × 44 inches. Collection Mr. and Mrs. Leo Castelli, New York. (NY). *Ill. p. 29*

161 *Light Bulb.* (1960). Bronze, 4¹/₄ inches high × 6 inches wide × 4 inches deep. Collection Mr. and Mrs. Leo Castelli, New York. *Ill. p. 21*

KIENHOLZ, Edward. American, born Fairfield, Washington, 1927; lives in Los Angeles

162 *Ida Franger.* 1960. Construction with cloth, metal, plastic, light bulb, and stuffed bird, 34 inches high × 17 inches wide × 22 inches deep. Collection the artist, Los Angeles. *Ill. p. 183*

KIESLER, Frederick. American, born Vienna, 1896; died New York, 1965

163 *Homage to Tanguy—Three-Plan-Plan (t).* 1947. Gouache, wash, brush, pen and ink, 14³/₄ × 19⁷/₈ inches. The Museum of Modern Art, New York, Kay Sage Tanguy Bequest

164 Model for The Endless House. (1958–1959). Cement, 42 inches high × 72 inches long. Collection Mrs. Frederick Kiesler, New York. *Ill. p. 157*

KLAPHECK, Konrad. German, born Düsseldorf, 1935; lives in Düsseldorf

165 *Intriguing Woman.* (1964). Oil on canvas, 39³/₈ × 43³/₈ inches. Collection Mr. and Mrs. Julien Levy, Bridgewater, Connecticut. *Ill. p. 185*

KLEIN, Yves. French, born Nice, 1928; died Paris, 1962

166 *Mark of Fire.* 1961. Burned paper, 31¹/₂ × 45¹/₂ inches. Alexander Iolas Gallery, New York. *Ill. p. 140*

LAM, Wifredo. Cuban, born Sagua la Grande, 1902; lives in Savona, Italy

167 *Eggue Orissi, l'Herbe des Dieux.* 1944. Oil on canvas, 71¹/₂ × 49 inches. The Reader's Digest Association, Pleasantville, New York. *Ill. p. 170*

168 *The Antillean Parade.* 1945. Oil on canvas, 49¹/₂ × 43¹/₂ inches. Collection Joseph Cantor, Carmel, Indiana. *Ill. p. 171*

169 *Fugue and Form.* (1945). Oil on canvas, 56¹/₄ × 47¹/₄ inches. Collection Joseph Cantor, Carmel, Indiana

170 *Song of the Osmosis.* (1945). Oil on canvas, 49¹/₂ × 60³/₈ inches. Collection Joseph Cantor, Carmel, Indiana. *Ill. p. 171*

LEMAÎTRE, Maurice. French, born Paris, 1926; lives in Paris

171 *Document on a Woman of My Life.* 1966. Oil and pasted photographs on canvas, mounted on plywood, 44⁷/₈ × 63³/₄ inches. Collection the artist, Paris. *Ill. p. 55*

LIPTON, Seymour. American, born New York, 1903; lives in New York

172 *Imprisoned Figure.* (1948). Lead and wood, 6 feet 8 inches high. Marlborough-Gerson Gallery, Inc., New York. (NY). *Ill. p. 117*

MAGRITTE, René. Belgian, born Lessines, 1898; died Brussels, 1967

173 *The Conqueror.* (1925). Oil on canvas, 25³/₈ × 29⁵/₈ inches. Collection Eric Estorick, London. *Ill. p. 90*

174 *Pleasure.* (1926). Oil on canvas, 29¹/₂ × 39³/₈ inches. Collection Gerrit Lansing, New York. *Ill. p. 91*

175 *The Reveries of a Solitary Promenader.* (1926). Collage of pasted papers, 21¹/₂ × 15¹/₄ inches. Collection Mr. and Mrs. Joseph R. Shapiro, Oak Park, Illinois

176 *The Lovers.* (1928). Oil on canvas, 21³/₈ × 28⁷/₈ inches. Collection Richard S. Zeisler, New York. *Ill. p. 91*

177 *The Wind and the Song.* (1928–1929). Oil on canvas, 23¹/₄ × 31¹/₂ inches. Private collection. *Ill. p. 96*

178 *On the Threshold of Liberty.* (1929). Oil on canvas, 44⁷/₈ × 57¹/₂ inches. Museum Boymans-van Beuningen, Rotterdam. *Ill. p. 93*

179 *Delusion of Grandeur.* (1948). Oil on canvas, 39 × 32 inches. Joseph H. Hirshhorn Collection, New York

180 *Personal Values.* 1952. Oil on canvas, 31⁵/₈ × 39¹/₂ inches. Collection Jan-Albert Goris, Brussels. *Ill. p. 92*

181 *Bottle.* (1959). Painted glass bottle, 11³/₄ inches high. Collection Harry Torczyner, New York. *Ill. p. 145*

182 *Arch of Triumph.* (1962). Oil on canvas, 51¹/₄ × 65 inches. Collection Harry Torczyner, New York. (NY)

MAN RAY. American, born Philadelphia, 1890; lives in Paris

183 *The Rope Dancer Accompanies Herself with Her Shadows.* 1916. Oil on canvas, 52 × 73³/₈ inches. The Museum of Modern Art, New York, Gift of G. David Thompson. *Ill. p. 30*

184 *Boardwalk.* 1917. Oil on wood with furniture knobs and wire, 25¹/₂ × 28 inches. Collection Mlle Gloria de Herrera, Paris

185 *The Rope Dancer Accompanies Herself with Her Shadows.* 1918. Airbrush, pen and ink, 13³/₈ × 17³/₈ inches. Collection Mr. and Mrs. Morton G. Neumann, Chicago. *Ill. p. 31*

186 *Aerograph.* 1919. Airbrush and watercolor, 29¹/₂ × 23¹/₂ inches. Cordier & Ekstrom, Inc., New York. *Ill. p. 32*

187 *Preconception of Violetta.* 1919. Airbrush, 19³/₄ × 23⁵/₈ inches. Private collection

188 *The Enigma of Isidore Ducasse.* (Original 1920, no longer extant; replica 1967). Cloth and rope over sewing machine, 16 inches high × 18³/₄ inches wide × 11⁵/₈ inches deep. The Museum of Modern Art, New York, Study Collection. *Ill. of original p. 32*

189 *Le Violon d'Ingres.* 1921. Photograph, 19 × 14³/₄ inches. Collection Mr. and Mrs. Melvin Jacobs, New York

190 *Emak Bakia.* Original 1926; replica 1962. Cello fingerboard and scroll with gray hair, 29¹/₄ inches high × 5³/₄ inches wide × 10³/₄ inches deep. The Museum of Modern Art, New York, Kay Sage Tanguy Fund

191 *Rayograph.* (1927). Photogram, 12 × 10 inches. The Museum of Modern Art, New York, Abby Aldrich Rockefeller Fund. *Ill. p. 36*

192 *André Breton.* (1931). Photograph, 11¹/₂ × 8³/₄ inches. The Museum of Modern Art, New York, Gift of James Thrall Soby. *Ill. p. 63*

193 *What We All Need.* 1935. Clay pipe with glass bubble, 3¹/₈ inches high × 8⁵/₈ inches long. Collection Charles Ratton, Paris

194 *Portrait of the Marquis de Sade.* 1936. Pen and ink, 14 × 10 inches. Collection Mr. and Mrs. Joseph R. Shapiro, Oak Park, Illinois. *Ill. p. 35*

MASSON, André. French, born Balagny (Oise), 1896; lives in Paris

195 *Automatic Drawing.* (1924). Ink, 9¹/₂ × 8 inches. Private collection. *Ill. p. 72*

196 *Woman.* 1925. Oil on canvas, 28³/₄ × 23¹/₂ inches. Collection Dr. and Mrs. Paul Larivière, Montreal. *Ill. p. 73*

197 *The Haunted Castle.* (1927). Oil on canvas, 18¹/₂ × 15³/₈ inches. Collection Mr. and Mrs. Claude Asch, Strasbourg. *Ill. p. 73*

198 *Painting (Figure).* (1927). Oil and sand on canvas, 18 × 10¹/₂ inches. Private collection. *Ill. p. 74*

199 *Two Death's-Heads.* (1927). Oil and sand on canvas, 5⁵/₈ × 9⁵/₈ inches. Collection Mr. and Mrs. E. A. Bergman, Chicago. *Ill. p. 74*

200 *The Villagers.* (1927). Oil and sand on canvas, 31⁷/₈ × 25⁵/₈ inches. Private collection. *Ill. p. 75*

201 *Celestial Couples.* (1932). Ink and wash, 13 × 18¹/₈ inches. Collection Mr. and Mrs. Frank Stella, New York

202 *Summer Divertissement.* (1934). Oil on canvas, 36¹/₄ × 28³/₄ inches. Private collection. *Ill. p. 128*

203 *Celestial Sign*. 1938. Ink, 25³/₄×19³/₄ inches. Private collection

204 *The Spring*. (1938). Oil on canvas, 18¹/₈×15 inches. Richard Feigen Gallery, Chicago. *Ill. p. 128*

205 *Invention of the Labyrinth*. (1942). Ink, 23¹/₄×18³/₈ inches. Private collection. *Ill. p. 165*

206 *Antille*. (1943). Oil and tempera on canvas, 49⁵/₈×33¹/₂ inches. Collection Peter B. Bensinger, Chicago. *Ill. p. 163*

207 *Meditation of the Painter*. (1943). Oil and tempera on canvas, 52×40 inches. Collection Richard S. Zeisler, New York. *Ill. p. 162*

208 *Multiplication*. (1943). Ink, 10⁵/₈×8¹/₄ inches. Private collection

209 *The Auguring Sibyl*. (1944). Oil and sand on canvas, 31×38 inches. Private collection

210 *Bison on the Brink of a Chasm*. (1944). Ink, 31¹/₄×22⁵/₈ inches. Joseph H. Hirshhorn Collection, New York

211 *Torrential Self-Portrait*. (1945). Ink, 18⁷/₈×24 inches. Private collection. *Ill. p. 159*

MATTA (Sebastian Antonio Matta Echaurren). Chilean, born Santiago, 1912; lives in Paris

212 *Inscape (Psychological Morphology No. 104)*. (1939). Oil on canvas, 28⁷/₈×36³/₈ inches. Collection Gordon Onslow-Ford, Inverness, California. *Ill. p. 166*

213 *Landscape*. 1940. Pencil and crayon, 14³/₄×21¹/₂ inches. Collection Mr. and Mrs. E. A. Bergman, Chicago. *Ill. p. 173*

214 *The Earth Is a Man*. (1942). Oil on canvas, 6 feet ¹/₄ inch× 8 feet. Collection Mr. and Mrs. Joseph R. Shapiro, Oak Park, Illinois. (NY, C). *Ill. p. 167*

215 *Here Sir Fire, Eat*. (1942). Oil on canvas, 56×44 inches. Collection James Thrall Soby, New Canaan, Connecticut. *Ill. p. 166*

216 *The Onyx of Electra*. (1944). Oil on canvas, 50¹/₈×72 inches. Collection Mr. and Mrs. E. A. Bergman, Chicago. *Ill. p. 164*

217 *To Escape the Absolute*. (1944). Oil on canvas, 38×50 inches. Collection Mr. and Mrs. Joseph Slifka, New York. *Ill. p. 168*

218 *Xpace and the Ego*. (1945). Oil on canvas, 6 feet 9 inches× 15 feet. Private collection. *Ill. p. 169*

219 *Splitting the Ergo*. (1946). Oil on canvas, 6 feet 4⁷/₈ inches× 8 feet 3¹/₄ inches. Collection Mr. and Mrs. Burton Tremaine, Meriden, Connecticut. (NY, C). *Ill. p. 168*

MESENS, E. L. T. Belgian, born Brussels, 1903; lives in London

220 *Les Caves du Vatican*. (1936). Construction with tree trunk and silk banner, 6³/₄×4³/₄ inches. Collection Charles Ratton, Paris. *Ill. p. 143*

MICHAUX, Henri. French, born Namur, Belgium, 1899; lives in Paris

221 *Head*. (c. 1948). Watercolor, 18×12 inches. Collection Mrs. Ruth Moskin Fineshriber, New York

222 *Untitled*. (c. 1956). Ink, 29×41 inches. Collection Mrs. Ruth Moskin Fineshriber, New York. *Ill. p. 178*

MIRÓ, Joan. Spanish, born Montroig, 1893; lives in Palma de Mallorca

223 *The Tilled Field*. 1923–1924. Oil on canvas, 26×37 inches. Collection Mr. and Mrs. Henry Clifford, Radnor, Pennsylvania. (NY). *Ill. p. 66*

224 *Automaton*. 1924. Pen and ink, 18×24 inches. Collection Mr. and Mrs. Morton G. Neumann, Chicago. *Ill. p. 70*

225 *The Harlequin's Carnival*. 1924–1925. Oil on canvas, 25¹/₄×35⁷/₈ inches. Albright-Knox Art Gallery, Buffalo. (NY, C). *Ill. p. 68*

226 *The Birth of the World*. 1925. Oil on canvas, 8 feet ¹/₂ inch× 6 feet 4³/₄ inches. Collection René Gaffé, Cagnes-sur-Mer (Alpes-Maritimes), France. (NY). *Ill. p. 69*

227 *The Gendarme*. 1925. Oil on canvas, 8 feet 1³/₄ inches× 6 feet 4⁷/₈ inches. Collection Mrs. Ernest Zeisler, Chicago. (NY). *Ill. p. 67*

228 *Man with a Pipe*. 1925. Oil on canvas, 57³/₈×45 inches. Private collection. (NY). *Ill. p. 70*

229 *Oh! One of Those Men Who's Done All That*. 1925. Oil on canvas, 51¹/₈×37³/₈ inches. Collection Aimé Maeght, Paris. *Ill. p. 99*

230 *Hand Catching a Bird*. 1926. Oil on canvas, 36¼ × 28¾ inches. Collection Vicomtesse de Noailles, Paris. *Ill. p. 67*

231 *A Bird Pursues a Bee and "Kisses" It*. 1927. Oil on canvas, 31⅞ × 39⅜ inches. Private collection. (NY). *Ill. p. 98*

232 *Circus Horse*. 1927. Oil on canvas, 6 feet 4¾ inches × 9 feet 2¼ inches. Pierre Matisse Gallery, New York. (LA, C)

233 *Landscape with Rooster*. 1927. Oil on burlap, 51¼ × 77 inches. Collection Mr. and Mrs. John Gilbert Dean, North Scituate, Rhode Island. *Ill. p. 65*

234 *Painting*. 1927. Oil on canvas, 38¼ × 51¼ inches. Private collection

235 *Spanish Dancer*. 1928. Pasted paper and charcoal, 40⅛ × 28 inches. Collection Mr. and Mrs. Alfred Richet, Paris. *Ill. p. 71*

236 *Spanish Dancer*. 1928. Collage of sandpaper, string, and nails, 41¾ × 26¾ inches. Collection Mr. and Mrs. Morton G. Neumann, Chicago. (C). *Ill. p. 71*

237 *Collage*. (1929). Ink and pasted papers, 28⅜ × 41 inches. Collection P. G. Bruguière, Issy-les-Moulineaux, France

238 *Painting*. 1930. Oil on canvas, 59 × 88⅝ inches. Collection D. and J. de Menil, Houston. *Ill. p. 132*

239 *Object*. (1931). Painted wood with feather and metal, 44⅞ × 28¾ inches. Private collection. *Ill. p. 147*

240 *Composition*. (1933). Conté crayon and pasted papers on pastel paper, 42½ × 28½ inches. Collection Mr. and Mrs. E. A. Bergman, Chicago. *Ill. p. 131*

241 *Snail Woman Flower Star*. (1934). Oil on canvas, 76¾ × 67¾ inches. Private collection. *Ill. p. 133*

242 *Animated Forms*. (1935). Oil on canvas, 76½ × 68 inches. Los Angeles County Museum of Art, the Estate of David E. Bright. *Ill. p. 134*

243 *Poetic Object*. (1936). Construction of hollowed wooden post, stuffed parrot on wooden stand, hat, and map, 31⅞ inches high × 11⅞ inches wide × 10¼ inches deep. The Museum of Modern Art, New York, Gift of Mr. and Mrs. Pierre Matisse. *Ill. p. 147*

244 *Still Life with Old Shoe*. (1937). Oil on canvas, 32 × 46 inches. Collection James Thrall Soby, New Canaan, Connecticut. (NY)

245 *Self-Portrait*. 1937–1938. Pencil, crayon, and oil on canvas, 57½ × 38¼ inches. Collection James Thrall Soby, New Canaan, Connecticut. (NY). *Ill. p. 134*

246 *Acrobatic Dancers*. (1940). Gouache and oil wash on paper, 18⅛ × 15 inches. Wadsworth Atheneum, Hartford, the Philip L. Goodwin Collection. *Ill. p. 135*

MOPP, Maximilian (Max Oppenheimer). American, born Vienna, 1885; died New York, 1954

247 *The World War*. (1916). Oil on canvas, 21 × 17⅝ inches. The Museum of Modern Art, New York, Given anonymously

NEWMAN, Barnett. American, born New York, 1905; lives in New York

248 *Pagan Void*. 1946. Oil on canvas, 33 × 38 inches. Collection Mrs. Annalee Newman, New York

249 *Genetic Moment*. (1947). Oil on canvas, 38 × 28 inches. Collection Mrs. Annalee Newman, New York. *Ill. p. 181*

OLDENBURG, Claes. American, born Stockholm, 1929; lives in New York

250 *Soft Typewriter*. 1963. Vinyl, kapok, wood, and plexiglass, 8⅞ inches high × 27 inches wide × 25⅝ inches deep. Collection Alan P. Power, Richmond (Surrey), England. *Ill. p. 111*

251 *Colossal Fagend, Dream State*. 1967. Pencil, 30 × 22 inches. Collection Alfred Ordover, New York. *Ill. p. 92*

252 *Fagends, Medium Scale*. 1967. Canvas, urethane foam, synthetic plaster, synthetic polymer paint, Formica, and wood, 56 inches wide × 56 inches deep × 28 inches high. Private collection

ONSLOW-FORD, Gordon. American, born Wendover, England, 1912; lives in Inverness, California

253 *Without Bounds*. 1939. Enamel paint on canvas, 28¾ × 36¼ inches. Collection the artist, Inverness, California. *Ill. p. 141*

OPPENHEIM, Meret. Swiss, born Berlin, 1913; lives in Hünisbach (Thun), Switzerland

254 *Fur-Covered Cup, Saucer, and Spoon*. (1936). Fur, cup, saucer, and spoon, cup 4⅜ inches diameter; saucer 9⅜

inches diameter; spoon 8 inches long. The Museum of Modern Art, New York, Purchase. *Ill. p. 143*

255 *My Nurse.* (Original 1936; replica 1967). Shoes, paper frills, and string on metal platter, 12⅝ inches long × 5½ inches high. Moderna Museet, Stockholm

OSSORIO, Alfonso. American, born Manila, Philippines, 1916; lives in East Hampton, New York

256 *Sea Change.* 1951. Ink, wax, and watercolor, 30 × 22 inches. Collection the artist, East Hampton, New York. *Ill. p. 182*

PAALEN, Wolfgang. Austrian, born Vienna, 1905; died Mexico, 1959

257 *Totemic Landscape of My Childhood.* 1937. Oil on canvas, 51 × 32 inches. Grosvenor Gallery, London. *Ill. p. 140*

258 *Fumage.* (c. 1938). Oil, candle burns, and soot on canvas, 10½ × 16⅜ inches. Collection Mr. and Mrs. Julien Levy, Bridgewater, Connecticut. *Ill. p. 140*

PENROSE, Roland. British, born London, 1900; lives in London

259 *The Last Voyage of Captain Cook.* (1936–1967). Painted plaster, wood, and wire, 27 inches high × 26 inches wide × 34 inches deep. Collection the artist, London. *Ill. p. 144*

PICABIA, Francis. French, born Paris, 1879; died Paris, 1953

260 *Edtaonisl.* 1913. Oil on canvas, 9 feet 10¾ inches × 9 feet 10⅜ inches. The Art Institute of Chicago, Gift of Mr. and Mrs. Armand Phillip Bartos. (NY, C). *Ill. p. 24*

261 *I See Again in Memory My Dear Udnie.* (1914). Oil on canvas, 8 feet 2½ inches × 6 feet 6¼ inches. The Museum of Modern Art, New York, Hillman Periodicals Fund. (LA). *Ill. p. 25*

262 *Paroxyme de la Douleur.* 1915. Oil on cardboard, 31½ × 31½ inches. Collection Mme Simone Collinet, Paris. *Ill. p. 26*

263 *Machine Tournez Vite.* (c. 1916–1917). Gouache, 19¼ × 12⅝ inches. Galleria Schwarz, Milan. *Ill. p. 34*

264 *Centimeters.* (1918). Oil on canvas, with centimeter tape, paper matches, and cardboard matchbox covers, 22 × 15⅜ inches. Galleria Schwarz, Milan

265 *Réveil Matin.* 1919. Tempera on cardboard, 13 × 10⅛ inches. Galleria Schwarz, Milan. *Ill. p. 37*

266 *M'Amenez-y.* (1919–1920). Oil on cardboard, 56⅛ × 40½ inches. Estate of Jean (Hans) Arp. *Ill. p. 28*

267 *The Match Woman II.* 1920. Oil on canvas, with pasted matchsticks, hair pins, zippers, and coins, 35½ × 28⅜ inches. Collection Mme Simone Collinet, Paris. *Ill. p. 26*

268 *Culotte Tournante.* (1922). Watercolor, 28⅜ × 23⅝ inches. Collection Mme Simone Collinet, Paris. *Ill. p. 28*

269 *Optophone.* (c. 1922). Watercolor, 28⅜ × 23⅝ inches. Collection André Napier, Neuilly-sur-Seine, France. *Ill. p. 29*

PICASSO, Pablo. Spanish, born Málaga, 1881; lives in Mougins (Alpes-Maritimes), France

270 *The Open Window.* 1929. Oil on canvas, 51¼ × 63¾ inches. Collection Mrs. Mollie Bostwick, Chicago. (NY). *Ill. p. 126*

271 *The Painter.* 1930. Oil on wood, 19¾ × 25⅝ inches. Collection Dr. and Mrs. Abraham Melamed, Milwaukee. *Ill. p. 125*

272 *The Beach.* 1933. Watercolor, 15¾ × 20⅛ inches. Collection Dr. and Mrs. Allan Roos, New York

273 *Composition.* 1933. Watercolor and ink, 15¾ × 19⅞ inches. Collection Dr. and Mrs. Allan Roos, New York. *Ill. p. 124*

274 *Minotaur.* 1933. Pen and ink, 15½ × 19½ inches. Private collection. *Ill. p. 127*

275 *Minotaure* (design for a magazine cover). (1933). Pencil drawing with pasted paper, cloth, and leaves on wood, 19⅛ × 16⅛ inches. Collection Alexandre P. Rosenberg, New York. *Ill. p. 127*

276 *Nude and Sculpture.* 1933. Etching, 10½ × 7⅝ inches. The Museum of Modern Art, New York, Purchase. *Ill. p. 152*

277 *Two Figures on the Beach.* 1933. Pen and ink, 15¾ × 20 inches. The Museum of Modern Art, New York, Purchase

278 *April Fool.* (1936). Pen and ink, 9¾ × 13¾ inches. Penrose Collection, London

279 *At the End of the Jetty.* 1937. Pen and ink, 11 1/4 × 8 1/4 inches. Collection Mr. and Mrs. Lee V. Eastman, New York. *Ill. p. 95*

280 *May 1940.* 1940. Ink on graph paper, 8 5/8 × 6 5/8 inches. Collection F. C. Graindorge, Liège

PICHÉ, Roland. British, born London, 1938; lives in London

281 *Sunset and Deposition in a Space Frame.* (1966). Polyester resin, fiberglass, and aluminum, 20 inches high × 17 inches wide × 14 inches deep. Collection Joseph Bernstein, Metairie, Louisiana. *Ill. p. 117*

POLLOCK, Jackson. American, born Cody, Wyoming, 1912; died East Hampton, New York, 1956

282 Untitled abstraction. 1943. Oil and enamel paint on canvas, 25 × 22 inches. Joseph H. Hirshhorn Collection, New York. *Ill. p. 176*

RAUSCHENBERG, Robert. American, born Port Arthur, Texas, 1925; lives in New York

283 *Bed.* (1955). Combine painting, 75 1/8 × 31 1/2 inches. Collection Mr. and Mrs. Leo Castelli, New York. *Ill. p. 59*

RICHTER, Hans. American, born Berlin, 1888; lives in Southbury, Connecticut

284 *Autumn.* (1917). Oil on canvas, 31 × 24 3/4 inches. Collection the artist, Southbury, Connecticut

285 *Rhythm 23.* 1923. Oil on canvas, 27 inches × 13 feet 5 1/2 inches. Collection the artist, Southbury, Connecticut. *Ill. p. 41*

ROTHKO, Mark. American, born Dvinsk, Russia, 1903; lives in New York

286 *Slow Swirl by the Edge of the Sea.* (1944). Oil on canvas, 6 feet 3 inches × 7 feet 1/2 inch. Collection the artist, New York. *Ill. p. 180*

de SAINT PHALLE, Niki. American, born Paris, 1930; lives in Paris

287 *Ghea.* (1964). Construction in papier-mâché with painted toys, mounted on wood, 70 7/8 × 43 3/8 inches. Alexander Iolas Gallery, New York. *Ill. p. 183*

SAMARAS, Lucas. American, born Kastoria, Greece, 1936; lives in New York

288 Untitled. (1961). Glass filled with pins, nails, and razor blades, 9 inches high × 4 inches diameter. Collection Mrs. Richard Millington, Santa Monica, California

289 *Accordion Box with Mirrors and Tacks.* (1964). Painted wood, mirrors, and metal tacks, 16 inches high × 24 inches wide × 10 inches deep. Collection Mrs. Richard Millington, Santa Monica, California

SCHAD, Christian. German, born Miesbach, 1894; lives in Keilberg

290 *Schadograph 60.* (1962). Photogram, 17 3/8 × 8 1/8 inches. Collection the artist, Keilberg, Germany

SCHAMBERG, Morton L. American, born Philadelphia, 1881; died Philadelphia, 1918

291 *Machine.* 1916. Oil on canvas, 30 1/8 × 22 3/4 inches. Yale University Art Gallery, New Haven, Collection Société Anonyme. (NY). *Ill. p. 36*

SCHULTZE, Bernard. German, born Schneidemühl, 1915; lives in Frankfurt am Main

292 *Mannequin-Migof.* (1967). Painted polyester resin, 70 1/2 inches high × 28 3/4 inches wide × 23 5/8 inches deep. London Arts Incorporated, Detroit. *Ill. p. 55*

SCHWITTERS, Kurt. German, born Hanover, 1887; died Little Langdale (near Ambleside, Westmorland), England, 1948

293 *The "And" Picture (Das Undbild).* 1919. Collage of pasted papers, wood, and metal, 14 × 11 inches. Marlborough-Gerson Gallery, Inc., New York. *Ill. p. 55*

294 *Revolving (Das Kreisen).* 1919. Metal, wood, string, and oil on canvas, 48 1/2 × 35 inches. Marlborough-Gerson Gallery, Inc., New York

295 *The "Worker" Picture (Das Arbeiterbild).* 1919. Collage of wood and pasted papers, 49 1/4 × 36 inches. Moderna Museet, Stockholm. *Ill. p. 56*

296 *Fec. 1920.* 1920. Collage of pasted papers, 7 1/8 × 9 3/4 inches. Marlborough-Gerson Gallery, Inc., New York. *Ill. p. 54*

297 *Merz Picture 29 A with Flywheel.* 1920. Construction in wood and metal, 33³/₄ × 41³/₄ inches. Marlborough-Gerson Gallery, Inc., New York. (LA, C)

298 *Smallest Merz Picture in the World.* 1920. Collage, 1⁷/₈ × 1¹/₈ inches. Collection Dr. Lotti Steinitz-Sears, Courtesy Mrs. Kate T. Steinitz, Los Angeles

299 *Cathedral.* 1926. Wood relief, 15³/₈ × 5⁷/₈ inches. Collection Frau Hannah Höch, Berlin

300 *Merz Picture with Rainbow.* (1939). Oil and wood on plywood, 61⁵/₈ × 47³/₄ inches. Collection Mr. and Mrs. Charles B. Benenson, Scarsdale, New York. (NY). *Ill. p. 52*

301 *For Kate.* 1947. Collage of pasted papers, 4¹/₈ × 5¹/₈ inches. Collection Mrs. Kate T. Steinitz, Los Angeles. *Ill. p. 57*

SELIGMANN, Kurt. American, born Basel, 1900; died New York, 1962

302 *Star Eater.* (1947). Oil on canvas, 46 × 35 inches. Collection Mrs. Ruth White, New York. *Ill. p. 160*

SMITH, David. American, born Decatur, Indiana, 1906; died Albany, New York, 1965

303 *Interior for Exterior.* (1939). Steel and bronze, 18 inches high × 22 inches wide × 23¹/₄ inches deep. Collection Mr. and Mrs. Orin Raphael, Oakmont, Pennsylvania. *Ill. p. 119*

SPOERRI, Daniel. Swiss, born Galati, Romania, 1930; lives in Paris

304 *Marcel Duchamp's Dinner.* (1964). Cutlery, dishes, and napkins mounted on wood, 24⁷/₈ inches wide × 21¹/₈ inches deep × 8¹/₄ inches high. Collection Arman, Nice. *Ill. p. 59*

STAMOS, Theodoros. American, born New York, 1922; lives in New York

305 *Sacrifice.* 1948. Oil on composition board, 36 × 48 inches. Collection the artist, New York. *Ill. p. 180*

TAEUBER-ARP, Sophie. Swiss, born Davos, 1889; died Zurich, 1943

306 *The Soldier and the Army* (marionette for *Roi Cerf* by Carlo Gozzi). (1918). Painted wood, 16¹/₈ inches high × 5³/₈ inches wide. Kunstgewerbemuseum, Zurich

307 *Dada Head.* 1920. Painted wood, 11⁷/₈ inches high. Private collection

TANGUY, Yves. American, born Paris, 1900; died Woodbury, Connecticut, 1955

308 *Fantômas.* (1925–1926). Oil with collage of cardboard and cotton, 19¹/₂ × 58¹/₂ inches. Private collection. *Ill. p. 101*

309 Title unknown. (1926). Oil on canvas with string, 36¹/₄ × 25¹/₂ inches. Private collection. *Ill. p. 101*

310 *A Large Painting Which Is a Landscape.* 1927. Oil on canvas, 46 × 35³/₄ inches. Collection Mr. and Mrs. William Mazer, New York. *Ill. p. 102*

311 *The Certitude of the Never Seen.* (1933). Oil on wood with carved wood frame, 8⁵/₈ inches high × 9⁷/₈ inches wide × 2¹/₂ inches deep. Private collection. (NY). *Ill. p. 103*

312 *Letter to Paul Eluard.* 1933. Pen and ink, 10¹/₂ × 7¹/₂ inches. The Museum of Modern Art, New York. *Ill. p. 95*

313 Title unknown. 1933. Oil on wood, 1⁵/₈ × 1³/₄ inches. Collection Mr. and Mrs. Richard L. Feigen, New York

314 *Decalcomania.* 1936. Gouache, 12 × 19 inches. Collection Marcel Jean, Paris. *Ill. p. 139*

315 *From the Other Side of the Bridge.* (1936). Painted wood and stuffed cloth, 19 inches long × 8³/₄ inches wide × 5³/₄ inches high. Collection Mr. and Mrs. Morton G. Neumann, Chicago. *Ill. p. 147*

316 *Indefinite Divisibility.* 1942. Oil on canvas, 40¹/₈ × 35 inches. Albright-Knox Art Gallery, Buffalo. *Ill. p. 103*

317 *At the Four Corners.* 1943. Oil on canvas, 18 × 16 inches. Pierre Matisse Gallery, New York

318 *Through Birds, Through Fire, but Not Through Glass.* 1943. Oil on canvas, 40 × 35 inches. Collection Mr. and Mrs. Donald Winston, Los Angeles. (NY). *Ill. p. 104*

319 *My Life, White and Black.* 1944. Oil on canvas, 36 × 30 inches. Collection Mr. and Mrs. Jacques Gelman, Mexico City. *Ill. p. 104*

320 Title unknown. 1944. Pen and ink, with gouache on pasted paper, 8 × 10¹/₂ inches. Richard Feigen Gallery, New York and Chicago

321 Untitled. 1946. Gouache, 14¹/₂ × 12 inches. Estate of the artist

322 *Imaginary Numbers.* (1954). Oil on canvas, 39^1/$_8$ × 32^1/$_8$ inches. Pierre Matisse Gallery, New York. *Ill. p. 105*

TINGUELY, Jean. Swiss, born Basel, 1925; lives in Paris

323 *Méta-Matic No. 12.* 1959. Motorized construction; iron and steel, 6 feet 6 inches high. Collection Mrs. Phyllis Lambert, Chicago

TROVA, Ernest. American, born Saint Louis, 1927; lives in Saint Louis

324 Model for *Venice Landscape.* (1966). Polished silicone bronze, 14 inches high × 20 inches wide × 12 inches deep. Pace Gallery, New York. *Ill. p. 119*

VAIL, Lawrence. American, born Paris, 1891; lives in Paris

325 *Bottle.* (1944). Painted bottle with pasted paper, cork stopper with eyeglass frames, brush, and cloth, 16^1/$_4$ inches high. Collection Miss Yvonne Hagen, New York. *Ill. p. 145*

WESTERMANN, H. C. American, born Los Angeles, 1922; lives in Brookfield Center, Connecticut

326 *A Close Call.* 1965. Wood, glass, and stuffed animal-head, 15 inches high × 15 inches wide × 9^1/$_2$ inches deep. Allan Frumkin Gallery, New York

WOLS (Alfred Otto Wolfgang Schulz). German, born Berlin, 1913; died Paris, 1951

327 *Whales in Water Flowers.* (1937). Oil on paper, 10^5/$_8$ × 13^3/$_4$ inches. Galerie Europe, Paris. *Ill. p. 177*

328 *Electric Contact.* (1938). Gouache, 12^3/$_8$ × 9^1/$_4$ inches. Galerie Europe, Paris. *Ill. p. 177*

329 *Anxious Face.* (1946). Oil on canvas, 25 × 20^1/$_2$ inches. Collection Mr. and Mrs. Morton G. Neumann, Chicago. *Ill. p. 178*

330 *Memory of a Town.* (1950). Gouache, 8^1/$_8$ × 6^3/$_8$ inches. Galerie Europe, Paris

WRIGHT, Clifford. American, born Aberdeen, Washington, 1919; lives in Glumsø, Denmark

331 *Untitled.* (1950). Gouache and ink, 12 × 18 inches. Collection Harry Torczyner, New York

Index

Photographic Credits

Except in those cases listed below, all photographs of the works of art reproduced have been supplied by their owners or custodians. Unless indicated otherwise the numbers refer to the numbers given in the captions.

Courtesy Harry N. Abrams, Inc., New York, 87; A.F.I., Venice, 250; Attualita, Venice, 195; Oliver Baker, New York, 106, 269, 270, 272; George Barrows, New York, 245; Serge Béguier, Paris, 29; D. Bellon, Images et Textes, Paris, 239, 240, 241, 242; Paul Bijtebier, Brussels, 119, 168, 201; Brassaï, Paris, 178, 238; Rudolph Burckhardt, New York, 17, 18, 30, 57, 76, 77, 145; The Art Institute of Chicago, 181; Geoffrey Clements, New York, 33, 121, 123, 125, 159, 163, 173, 190, 197, 207, 229, 278, 282; George Cserna, New York, 172; Delagénière, Paris, 108, 204, 215; Dom De Domenic, Jr., Pittsburgh, 167; P. Richard Eells, Milwaukee, 180; Richard Feigen Gallery, Chicago, 85, 286; Thomas Feist, New York, 182;

David Gahr, 19; Claude Gaspari, Paris, 84, 133; Giacomelli, Venice, 35; Grosvenor Gallery, London, p. 90; G. D. Hackett, New York, 218; Carl Haebler, Horgon, Switzerland, 44; Niedersächsisches Landesmuseum, Hanover, 73, 75; Hickey and Robertson, Houston, 208; Jacqueline Hyde, Paris, 128, 147; Josse-Lalance, Arcueil (Val de Marne), 41, 42, 49, 51, 52, 53, 61, 111; Peter A. Juley, New York, 217; courtesy Mrs. Frederick Kiesler, New York, 254; Walter Klein, Düsseldorf, 115, 291; H. Paul Lack, Milford, New Jersey, 294; Lacoste, Paris, 24, 114; Galerie Louise Leiris, Paris, 94, 97, 177, 184, 247, 255; Maurice Lemaître, Paris, 68; George Platt Lynes, New York, 246; Galerie Maeght, Paris, 192; N. Mandel, Paris, 25, 28; Man Ray, Paris, 8, 11, 34, 38, 221 (courtesy Marcel Jean and Editions du Seuil, Paris); Marlborough Fine Arts Ltd., London, 160; James Mathews, New York, 7, 78, 146, 150, 153, 154, 174, 176, 199, 205; Pierre Matisse Gallery, New York, 136, 141, 142, 188, 193, 253, 257, 258, 259, 261, 263, 264; Robert L. McElroy, New York, 70, 80; Rollie McKenna, Stonington, Connecticut, 157; Ken Molino, San Rafael, California, 210; O. E. Nelson, New

York, p. 52, 72; Gallery of Modern Art, New York, 155; The Solomon R. Guggenheim Museum, New York, 162, 225, 231; courtesy Editions Jean-Jacques Pauvert, Paris, 243; Galerie F. Petit, Paris, 232, 233, 234, 235, 236; Eric Pollitzer, New York, 120, 203, 226, 277, 279, 281, 284, 285; Nathan Rabin, New York, 97, 139, 171, 175, 209, 248, 293; Walter Russell, New York, 200; Neil Sauer, Saint Louis, 165; John D. Schiff, New York, 20, 93, 127, 134, 252; Galleria Schwarz, Milan, 290; F. Wilbur Seiders, Houston, 191; courtesy Mrs. Kate T. Steinitz, Los Angeles, 74, 79; Moderna Museet, Stockholm, 26; Adolph Studly, New York, 202, 237, 251; Soichi Sunami, New York, 4, 9, 10, 16, 22, 31, 39, 45, 47, 54, 58, 62, 64, 65, 83, 88, 98, 100, 102, 103, 116, 122, 138, 144, 148, 151, 162, 166, 169, 179, 183, 187, 194, 213, 222, 256, 266, 268, 271; Jann and John F. Thomson, Los Angeles, 289; courtesy Galerie Jacques Tronche, Paris, 112; Malcolm Varon, New York, 227, 228, p. 65, p. 162; Marc Vaux, Paris, 90, 109; Sidney Waintrob, New York, 186; Michel Waldberg, Paris, 60, 131, 132; John Webb, London, 105, 152, 216; Dietrich Widmer, Basel, 161, 170

Trustees of Participating Museums